TH
PRIN MAK NG
IBLE

THE PRINTMAKING BIBLE

THE COMPLETE GUIDE TO MATERIALS AND TECHNIQUES
BY ANN D'ARCY HUGHES & HEBE VERNON-MORRIS

CHRONICLE BOOKS
SAN FRANCISCO

First published in the United States in 2008 by Chronicle Books LLC.

Copyright © 2008 by RotoVision SA.

Library of Congress Cataloging-in-Publication Data available.

ISBN: 978-0-8118-6228-8

Manufactured in China.

Design: Jonathan Raimes at Foundation Publishing
Cover Design: Eloise Leigh
Art director: Tony Seddon
Studio photography: Simon Punter

Published and distributed outside of North America by RotoVision SA.
Route Suisse 9
CH-1295 Mies
Switzerland

10 9 8 7 6 5 4 3 2

Chronicle Books LLC
680 Second Street
San Francisco, CA 94107

www.chroniclebooks.com

The authors would like to thank all the artists who kindly gave their time and permission for reproduction of their work in this book.

We would also like to thank:
Helen Brown, Heike Roesel, and Jane Sampson from Brighton Independent Printmaking for their support in writing the book.

Ian Brown (Monotype), Harvey Daniels (Lithography), and Simon Brett (Wood engraving) for proofreading the history sections.

Ian Brown for writing and compiling the Screenprinting section.

The University of Brighton, UK, and Hastings College of Art, UK, for allowing us to use their premises for photography.

The Brighton Royal Pavilion, UK, for kindly allowing us to reproduce the wallpaper printed by Ian Brown.

All the workshops and galleries mentioned in the book who kindly gave their time and support.

contributing authors

Eric Bates
Photo etching, pp. 72–74

Ian Brown
Screenprinting, pp. 310–321
A brief history of stencils, pp. 323–324
Screenprinting process: photographic stencils, pp. 342–343
Step by step: photographic stencils, pp. 344–346

Jon Crane
Blind embossing, p. 158
Screenprinting process: cut stencils, pp. 325

Terry Gravett
Screenprinting process: drawn and painted stencils, pp. 334–337
Tools and materials: drawn and painted stencil, p. 338–339
Step by Step: drawn and painted stencil, pp. 340–341

Julian Hayward
Step by step: process for "Dark Sun," pp. 120–121
Collage, pp. 159–161

Belinda King
Printing "Fool Tries to Catch a Lover's Dream," pp. 214–215

Troy Ohlson
Giclée prints, pp. 288–289

Jane Sampson
Screenprinting process: direct stencils, pp. 331–333

featured artists in step by steps

Pat Bennett
Step by step: monotype printing, pp. 380–381

Ann d'Arcy Hughes
Linocut, pp. 198–201

Ray Dennis
Mezzotint, pp. 101–105

Juliet Kac
Step by step: stone lithography, pp. 260–265

Colin Kennedy
Wood engraving, pp. 229–230

Andrew Mockett
Hardwood woodcut, pp. 174–177
Reduction print, p. 206

Heike Roesel
Step by step: zinc plate lithography, pp. 272–277

Hebe Vernon-Morris
Step by step: printing a single block with a simple blend, pp. 243–245
Multiple block cut with jigsaw, pp. 246–247

contents

1 intaglio

2 relief

3 lithography

4 screenprinting

5 monotype

6 resources

Below: **Ann d'Arcy Hughes**
Three-dimensional etching on zinc.

introduction

The aim of this book is to excite, enthuse, and inform the reader. It is a compilation of some of the most creative and diverse prints being produced by contemporary artist–printmakers. It is intended both as an inspirational source book and a compelling insight into the lives and work of artists who are fascinated by printmaking processes and in developing their personal imagery through the production of original prints. The brief overview that we give to each medium offers only a glimpse into what is possible, leaving the reader to research more fully their personal area of interest.

This book in no way attempts to make a definitive statement concerning any area of printmaking, as there are numerous routes by which to arrive at a similar destination. The explanations on process are led by the imagery, informing the viewer of the choices and decisions made by the artist, explaining why this approach was taken, and how it was achieved.

It is a common, and healthy, practice, that artists, master printers, and workshops continually develop personal printmaking procedures that are individual and specifically tailored to their needs. This point is further illustrated by observing the different work being produced in the various print workshops, artist studios, and university departments.

A print, however it is produced, is considered an original artwork (albeit in multiple form) if it has been conceived by the artist for the chosen medium. It can be derived from a painting or drawing using the artwork as source material, and can still be considered an original. However, if the work is directly transposed onto a screen, block, or plate by photographic, or other means, solely in order to produce it in duplicate form, then this is not considered an original print but a reproduction, and should be labeled and sold as such.

If a work is printed by a master printer, the image must be first created by the artist and then printed under their supervision if it is still to be considered an original artwork. The usual practice is to decide on the number to be printed, which the artist will then sign and number in pencil. Smaller editions can command higher prices than very large numbers. In days gone by, the early numbers were considered more desirable as the image would be sharper, the plate or block being less worn down by wiping or pressure. However, while it is now possible to steel-face softer plates to prolong their life, most artists who print their own work generally prefer to move on to their next image before the plate or block deteriorates.

In the latter half of the twentieth century there were three developments that affected the practice of printmaking. First was the arrival of computer graphics. Because of its instant results, many artists were seduced into feeling that the traditional methods were by comparison too slow and expensive. However, we think it is now generally recognized that the computer is a hugely important, and exciting, complement to many forms of printmaking. For example, screenprinting, polyester lithography, and photo etch would not have developed in the same way without the use of computer technology. That said, it is important that the tradition of hands-on printmaking, with its unique qualities, continues to be passed on to future generations, as it can never be replicated or replaced.

The second development concerns health and safety issues. Obviously, concern for safety is paramount; therefore, it may be necessary to adapt procedures and practices that have been carried out for centuries to ensure they are safe for use today. In most cases adaptation is preferable to radical change, which may not be much safer in the long run, and may not retain the qualities gained through the original techniques. To use etching as an example, in some areas a new procedure called "safe etching" has been

Wendy Morosoff Smith
(Canadian)
The Whispering of the Grasses
18 x 25in (46 x 63cm)
Carborundum print; Daniel Smith
etching ink on Rives BFK White
280gsm paper
Edition of 10 printed by the
artist on a Glen Alps press at
Malaspina Printmakers Studio,
Vancouver, Canada

adopted, but the results are different than those achieved by traditional etching, which is the practice generally presented in this book.

The third development is the decline, due to stretched financial resources, of vocational and part-time classes in universities and colleges, and the practice of modular teaching on degree courses. Modules allow students only a taste of each subject but no time to establish any in-depth relationship with the medium. Without allowing practicing artists and students to develop their skills to a high standard, there will not be new teachers to hand down the essential skills to new generations, who are just as interested and talented as any of those who went before them.

A network of privately run workshops has emerged to address the need for the provision of facilities and expertise in teaching—to cite the UK as an example, such workshops exist in Aberdeen, Edinburgh, Brighton, Bristol, Leicester, and London, to name a few. These workshops and studios attempt to bridge the gap by providing experienced tutors and access to specialist facilities. Unfortunately, the difficulty of obtaining any financial support in the form of grants for teaching means that many individuals have to work as unpaid volunteers. They face the constant pressure of trying to cover overheads, resulting in an uncertain future for this resource.

While printmaking today is respected as a fine-art medium, in the past prints were used to provide information to a wider public, passing on matters of news, religion, or instruction. As communication techniques developed, and as artists discovered the potential of making prints, the practice has more than survived the passing years and has matured,

developed, and gained in popularity. Printmaking in all areas is far from being an outdated visual language and art form. It is an up-to-the minute method of expression for fine artists in the twenty-first century.

This is an image-led resource book to introduce the reader to the printmaking medium. The aim of the book is to inspire through the imagery, by offering examples of the rich and diverse work being created by contemporary printmakers. The work speaks for itself, presented as a testament to the possibilities inherent in the printmaking medium.

The book is split into six sections. The first five cover the five main areas of printmaking: Intaglio, Relief, Lithography, Screenprinting, and Monotype. The sixth section is devoted to Resources.

Each of the five sections opens with a brief history—not intended as an in-depth discussion of each genre, but to give the reader some context as to the development of the process and of the artists who have gone before.

The chapters within each section focus on the varying techniques within each genre. To use the Intaglio section as an example: Step-by-step photographs and text explain the stages of preparing a plate, drawing an image, illustrate a variety of different ways in which to create tone and texture, and conclude with a chapter dedicated to the printing of the intaglio image. Within these stages, a number of processes are presented— metal engraving, drypoint, mezzotint, and collagraph—to provide the reader with an awareness of the diversity and potential of the intaglio image. Interspersed with the practical steps are images from international

artists that serve to reinforce the techniques explained, enabling the reader to see how these aspects are used within the creative process.

The aim is to provide a general understanding and awareness of what each technique involves. This book is by no means a comprehensive "do-it-yourself" manual. Printmaking is a living art, and within the boundaries of each technique the individual refines the process to develop their own working practice. The information and imagery is presented to allow the reader a sense of each genre and to understand the potential of the printed image before beginning their own educational route within an educational establishment or a studio workshop.

This book is truly international in scope. Within the sections there are examples of work and profiles featuring artists from the United States, Canada, South America, Europe, Asia, Australia, and Africa. Within these texts the reader is privileged to obtain an insight into how these artists view their work, their inspiration, their artistic process, and to understand what printmaking means to them as individuals. Art is created for many reasons, but what is clear from the profiles is that, to the artists, the work becomes an entity in its own right. The images exist separately from the artist once created, but remain at the same time inextricably linked.

This book has been created to share the enjoyment and fascination of printmaking. We hope to enthuse the reader with examples of the infinite possibilities of the printed image and to inspire with the vast range of styles evident in the images. The book is an introduction into what is a magical combination of tradition, innovation, process, and imagination.

Ann d'Arcy Hughes
(British)
From Root to Crown
8 x 13in (20 x 33cm)
Etching—multiple plate printed à la
poupée; T. N. Lawrence oil-based etching
inks; Fabriano Artistico paper
Edition of 50 printed by the artist
at Brighton Independent Printmaking, UK

Andrew Levitsky
(Ukrainian)
Railroad
8¼ x 41½in (21 x 105cm)
Intaglio; etching ink; Canson paper
Edition of 25 printed by the artist in
Kiev, Ukraine

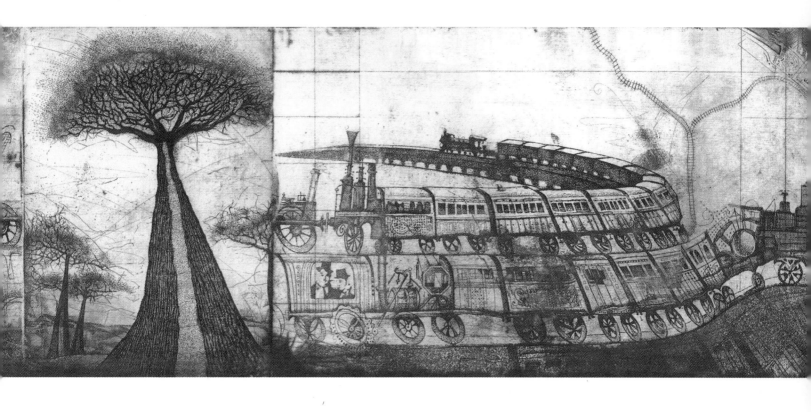

intaglio

1

introduction to intaglio

The term "intaglio," meaning "to engrave" or "cut into," refers to the process by which an image is created by gouging, biting, or incising lines into the surface of a metal plate. The print is produced by filling the recessed marks and lines with ink in order to transfer the image to damp paper. In the final piece, the image will print in reverse from the design on the plate and the ink will stand proud of the surface of the paper.

There are two main subgroups within the medium of intaglio: etching and engraving. We explore these in the first two chapters of the book. Within these two categories there exist a number of processes.

Etching

With etchings, acid is used to incise the line into the metal surface. The plate is covered with an acid-resistant surface and a needle is drawn through to expose the metal beneath. It is the acid that creates the depth of the line by reacting with the areas of exposed metal. The longer the bite, the deeper the line.

A number of processes are grouped together under the etching category, as we explore in Chapter 1. These include hardground and softground, aquatint, sugar lift, marbling, spit bite, and photo etching.

Engraving

A metal engraved image is generally produced on copper with the use of a burin. The tool is eased into the surface, exerting gentle pressure at a slow pace. As the line cuts, a spiral of metal will appear. The burr is removed before the print is taken from the incised line.

Drypoint and mezzotint methods are also included in the engraving category, as we explore in Chapter 2.

Collagraph

Collagraph generally comes under the intaglio umbrella, despite the absence of a burin or the use of the acid, due to the fact that the incised mark can be the vehicle to hold the ink. Collagraph images may be printed by the intaglio process, although contemporary blocks also incorporate the relief method. We explore this technique in Chapter 3.

Carborundum grit, generally used to grain lithographic stones, can also be applied to a plate or block to create areas of rich, intense tone within intaglio images. We also discuss this method in Chapter 3.

A brief history of intaglio

It has been suggested that it was the availability of paper that prompted the emergence of intaglio printing as an art medium in its own right in the fifteenth century. Previous to this, there had been a tradition of metal engraving. However, the focus was not on the transference of images to paper, but on the decoration of three-dimensional objects. Goldsmiths,

silversmiths, and armorers were important members of medieval society and the earliest prints are thought to have evolved from the need of these craftsmen to retain their designs for future use or to record work in progress. The prints originally taken from these works were practical items, but it is considered that these were the first steps toward regarding engraved and etched works as objects in their own right.

Artists such as Albrecht Dürer (1471–1528) and Rembrandt (1606–1669) were attracted to intaglio techniques because of the flexibility of the medium. In their hands, the engraved and etched line lent itself admirably to the creation of shape, tone, and shadow, and the skills of these artists helped establish the intaglio image as a respected artform.

Until the spread of the rolling press in the fifteenth century, prints were transferred from the plate by hand-burnishing. Paper is placed over the plate and pressure is applied to the back of the paper in an even, circular motion to encourage the ink to adhere to the paper. However, a mechanical press proved to be a far quicker and more effective way in which to print from the plate and therefore greatly increased the popularity of the printed image.

As intaglio methods developed, the medium was embraced for the use of reproduction, originally religious imagery, playing cards, copies of master paintings, and portraits, and leading on to the printing of books, newspapers, political literature, and maps. Although the engravers were highly skilled technicians, intaglio as a creative medium suffered.

While the works of Spanish artist Francisco Goya (1746–1828; see p. 18) provided momentary relief during the decline of the medium, it was not until the twentieth century that movements such as Expressionism, Modernism, and Surrealism encouraged a new approach to intaglio printmaking. Stanley William Hayter (1901–1988; see p. 149) was an important figure, who inspired a generation of European and North American artists and printmakers in his workshops, Atelier 17, based in Paris and the United States. This was followed by establishments such as the Pratt Graphic Center and the Universal Limited Art Editions studio in the United States, and art colleges such as the Slade in London, which strove to revive the approach to creative intaglio works.

As the works in this section reveal, intaglio continues to flourish as a printmaking medium today.

chapter 1 **etching**

Ana Maria Pacheco
(Brazilian)
Tales of Transformations I, 1997–98
15½ x 20½in (39.5 x 52.5cm)
Multiplate color etching; Charbonnel
inks; Somerset Satin 410gsm paper
Edition of 35 plus 5 artist's proofs,
2 printer's proofs, and 4 archive
proofs, printed on a Rochat press by
Martin Saull
Plates made and proofed at Pratt
Contemporary Art
Published by Pratt Contemporary Art

a brief history of etching

The etched line differs from the engraved line primarily because of the use of acid. Whereas an engraved line is characterized by its smooth, crisp appearance, an etched line bears witness to the bite of the acid and, while defined, possesses a slight irregularity. This was especially evident in the early experiments with etching in the sixteenth century, when artists used iron plates. Such images lack the precision of the engraving, but the etchings possess a more spontaneous quality.

The technique of using acid to incise a line into metal evolved from armorers, who, in order to overcome the difficulties of engraving into iron with a burin, began to use acid to etch their designs. The surface of the armor was protected with a substance that would resist acid, such as wax, the line was drawn through to create the design, and the acid was then applied.

This process was also adopted by gold- and silversmiths, and a number of the first artists to experiment with etching were trained in this skill. For example, Dürer (see p. 15) was originally a goldsmith; he created six etching plates on iron, but preferred the clarity of the engraved line.

Etching in the seventeenth and eighteenth centuries

The medium of etching began to blossom in the seventeenth century, following developments in the chemistry of the process and the introduction of copper plates. Innovations in the process were led by artists such as Jacques Callot (1592–1635), who produced more than a thousand small etchings before creating what is considered his masterpiece, *The Fair at Impruneta* (1620). One of Callot's innovations was to improve the acid resist used on the surface of the metal plates. The waxy ground, once in the acid, would often chip or bleed around the line, which affected the delicacy and design of the image. In order to achieve a clean bite, Callot developed a hardground that would replace the waxy surface applied and prevent the drawing being compromised by foul biting.

Rembrandt (see p. 15) is considered to be one of the most influential printmakers. Through the various states of his prints, it is possible to witness his creative and technical process working simultaneously. There are a number of examples that demonstrate the development of a particular image. In *Christ Presented to the People* (1655), there is evidence that Rembrandt returned repeatedly to the plate and reworked it until the composition achieved the required balance.

Rembrandt used etching and drypoint in combination and experimented with biting times in order to achieve a richness of tone and line in his work. In addition to his paintings, he produced more than 300 prints.

During the eighteenth century, etching was carried forward by Italian artists such as Antony Canale (1697–1768; better known as Canaletto) and Giovanni Battista Piranesi (1720–1778). Both produced works that celebrated the architecture of the cities they resided within.

Originally a set painter in the opera houses of Venice, Piranesi demonstrated his fascination and interest in engineering in his collection of works "Invenzione Capricciosa di Carceri" (the "Prison" series).

Experiments with color

In Germany, Jacob Christoph Le Blon (1667–1741) began investigating a three-color process, of which the underlying theory was that all tonal values are composed of red, yellow, and blue. He overprinted the three color plates, adding a fourth plate for the black, but was thwarted by the refusal of the colors to merge in some areas.

Relatively few color etchings were produced until the late nineteenth century. However, before this there were experiments with color that resulted in two methods. The "crayon manner" involved the emulation of a crayon effect through the painstaking application of a series of dots peppering the surface of the plate. The "pastel manner" required multiple plates to be printed in a variety of colors to simulate the delicacy of pastel, and has the appearance of the more contemporary softground technique.

The influence of the Japanese woodcuts that had become prolific in Europe in the late nineteenth and early twentieth centuries further encouraged the use of color, and aquatint was utilized as a tool to experiment with printing techniques. Jean Baptiste Le Prince (1734–1781) introduced the aquatint method for the purpose of tonal work in the latter half of the eighteenth century, and it proved to be a means of applying areas of color using multiple plates. Following the emergence of registration methods in the early 1700s, color printing soon developed via this method, along with the à la poupée process of applying a variety of colors on one plate.

Mary Cassatt (1844–1926) studied the Japanese woodblock prints and produced many color etchings using aquatint. Her imagery predominantly featured women and children, and combined the ornamental aspects of the Japanese style while incorporating unusual viewpoints of her subjects. Edgar Degas (1834–1917) also embraced the aquatint method and experimented constantly with his images until he had reached a level of perfection that was acceptable to him. One such example is his print *At the Louvre: Mary Cassatt* (1876). He developed this image through 20 states before achieving the finished print.

Etching as social commentary

Goya (see p. 15) experimented further with aquatints, using the method as a powerful tool for expression and mood. A contemporary of renowned British artist and printmaker William Blake (1757–1827; see p. 82), Goya produced innovative and highly individual works that serve as a commentary for the brutality and inhumanity of war. Originally known as a painter and a designer of tapestries, he traveled to Rome in the 1770s and, it is assumed, he saw and was inspired by Piranesi's prints.

Goya became the official court painter to the Spanish royal family in 1787 and it is thought that this experience developed his consequent horror and disdain for the corruption within the monarchy, clergy, and government. This in turn inspired the political satire and social commentary so evident in his works. One such series is his well-known, and still influential, "Desastres de la Guerra," ("The Disasters of War"), c. 1820, which documented the impact of the French occupation of Spain. Because of the scarcity of metal, Goya was forced to rework old plates, which resulted in a more textured surface on this series of prints.

Political comment and the reflection of the social discontent of the populus are recurring themes in the work of many artists. For example, the German Expressionist Käthe Kollwitz (1867–1945) produced many images expressing the poverty and extremes of the lives of the poorest in the society around her using the qualities of etching to great effect.

Contemporary etching

Contemporary artists such as William Kentridge (b. 1955; see pp. 77–79) continue the tradition of expressing social commentary through etching. Kentridge was born in South Africa during the apartheid years, and his works discuss the issues of collective memory and the danger of normalizing abuse and oppression. He expresses the importance of retaining the sense of shock and horror following tragic and violent events to ensure that society acknowledges responsibility for what has occurred.

Jake and Dinos Chapman (b. 1962 and 1966), better known for their part in the "sensationalist" movement, have also produced two series of etchings. The first was based on Goya's "Desastres de la Guerra," detailing the brutality of war.

Other contemporary artists featured in this section, who work across all the techniques of etching, include the renowned Brazilian artist Ana Maria Pacheco, Ukrainian artist Fedorenko Oleksiy, German printmaker Elisabeth von Holleben, and the South African artist Penny Siopsis.

This is the time...

And this is a record of the time.

I. Last night I had the strangest dream or was it???

II. "Behold! I am the power of the Matriarch," it said.

IV. Is there a moral to this story?...Only time will tell.

III. It is said there is power in the collective conscious.

**J. Catherine Bebout
(American)**
The Coming Matriarchy
**Small book format
Etching and silkscreen—accordian-
fold structure; Graphic Chemical
etching ink; Somerset paper
Edition of 50 printed by the artist
on a Chas Brand etching press
at Women's Studio Workshop,
Rosendale, NY**

The practice of etching will take the artist in many directions, and the range of different processes can require a long list of tools and materials. However, it is possible to start with a few basic items.

The metal plate used for etching can be zinc, copper, or steel (see p. 22). Aluminum is suitable for drypoint (see pp. 86–93).

1.1.2

tools and materials: **etching**

A ground is the acid-resistant material used to protect the plate. It has a consistency that allows a needle to be drawn through it without the surface cracking. It is composed of resin and bitumen powders (the acid-resistant components) held together by beeswax.

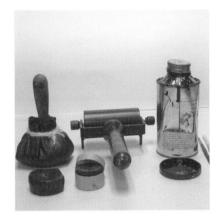

Dabber, hardground, softground, small roller, stop-out varnish, car spray, parcel tape.

Ground can be applied with a dabber or a roller. Stop-out varnish is the liquid acid-resist used for painting out the edges and any area on the plate that is not required to be bitten. Car spray or parcel tape is used to protect the back of the plate.

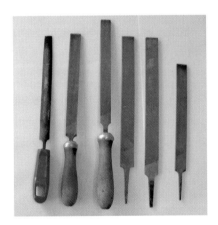

Files are used for beveling the edge of the plate.

In addition to the materials illustrated, acid is required to bite the plates, while methylated spirits, mineral spirit, or vegetable oil are used to clean the plate. Rags and old newspapers are used for wiping the ink out of the lines in the intaglio plates after printing.

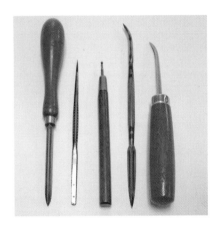

Left to right: Scraper; etching point with flat scraper; ball burnisher; scraper-burnisher; burnisher.

A scraper is needed to shave down the filed edges, to remove unwanted marks from the plate, and to work into aquatint tones. A point is required to draw into hardground and check the depth of a bitten line. A burnisher is used to smooth to a shiny surface any areas that have been scraped.

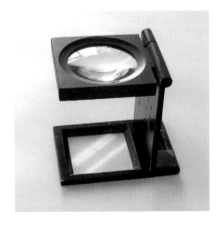

A magnifying glass is useful for checking the depth of a bitten line.

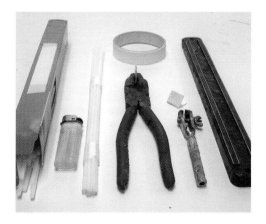

Tapers, lighter, pliers, magnetic strip.

Tapers are used to smoke a hard-ground plate. The metal, if zinc or copper, is held in a pair of pliers with a small piece of card to prevent scratches. If the plate is steel it will attach to the magnetic strip.

Traditionally, the grinding of ink is carried out with a glass muller.

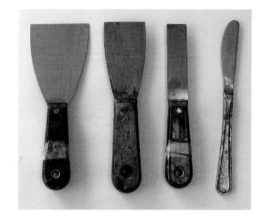

Palette knives are used to mix ink.

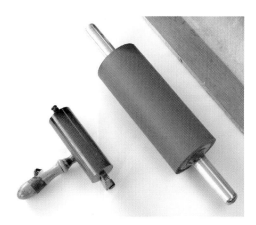

Pin and hand rollers are required to apply ink to the relief surface.

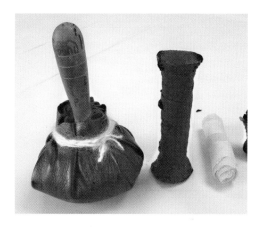

The ink is applied to the plate with a dolly, which may be a leather dabber, a wound piece of blanket, a slice from a squeegee, or just a piece of card.

Powder ink etching pigments. These are mixed with copperplate oils to produce the consistency required.

Lithographic or relief inks are used when rolling color on the surface.

The three most commonly used metals for etching are zinc, copper, and steel (1 to 1.6mm thickness or 18 to 22 gauge). There are various reasons why an artist would choose one metal over another.

Copper

Traditionally, copper was the most popular choice. However due to the increasing cost and difficulty of obtaining this metal, many artists and colleges changed to zinc.

Copper is harder than zinc but softer than steel. It produces a clear, crisp line and a white background, if sufficiently wiped. Tones are created through the use of aquatint (see pp. 44–55). In spite of the expense it is still a highly valued metal and a perfect choice for engraving.

Copper can be bitten in an acid bath of nitric, ferric chloride, hydrochloride, or dutch mordant. For convenience, nitric acid (2 parts water to 1 acid) is the most common choice. This is often due to lack of space because, for safety reasons, acid baths need to be kept within an extractor unit. The fact that the acid bites slightly sideways as well as down is sometimes considered a disadvantage as it narrows the spaces between the lines. However, this can be controlled by biting in a slower mix. The copper will turn the solution blue as it bites.

Ferric chloride produces a much cleaner bite with no sideways action; it also does not produce the poisonous fumes that nitric acid does. However, it is a very slow bite, and the solution is an opaque brown so biting cannot be observed. It is advisable to put the plate in upside-down with Blu Tack on each corner to prevent the lines from becoming blocked while biting.

Copper adversely affects color to a lesser degree than zinc.

Zinc

Zinc is possibly the most popular metal as it is more affordable (although not cheap) and widely available. It produces a fine, clear line (although not quite as crisp as copper), and it can be thoroughly cleaned to create a white background. Tones, gray to black, are produced through aquatint. Zinc is not suitable for color as it affects the pigments: yellow turns to green, white to gray, and all other colors darken.

Zinc can be bitten in nitric, ferric chloride, and hydrochloric. Zinc is a fairly soft metal so the mix of nitric is weaker: 5 parts water to 1 of acid is used for an average bite, which will require 10 minutes for a fine line and 20 for a deeper line. Tones should be bitten in an acid mix of 10 parts water to 1 part acid. They bite much quicker than a line, with 20 seconds as the first bite.

Steel

Steel is the cheapest, hardest, and most widely available of the three metals. It has a natural coarse grain that makes the lines appear rough in comparison to the other two metals. Unless the surface is highly sanded, the grain produces a background tone. This means the artist works with a middle-tone gray, scraping back where whites are required and adding aquatint where darker tones are wanted. Steel is an ideal metal for color as it does not affect pigments.

Steel can be bitten in a mix of 5 parts water to 1 part nitric acid. The effect of the acid will vary depending on the temperature and the amount of use it has provided.

The eyes receive less glare if the copperplate surface is not highly polished while engraving is carried out.

Zinc plates can be purchased with an acid-resistant backing (jet plate) and a plastic coat protecting the polished side.

Steel has a dull gray appearance due to its natural grain.

step by step: **preparing an etching plate**

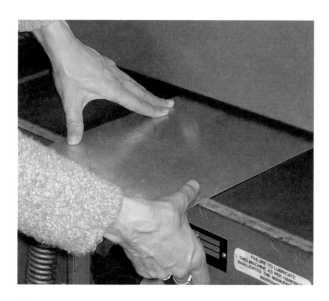

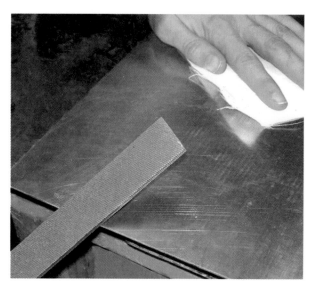

1.1.3

1 Zinc, copper, or steel make suitable etching plates. Cut the plate to size on a metal guillotine, or buy a ready-cut piece from a metal merchant or art suppliers.

2 File the top edges with a diagonal up-and-down motion. Avoid a vertical action as it creates ridges, which will retain the ink. Hold the plate down with a G-clamp or a piece of clean cloth to prevent grease from the hand penetrating the metal.

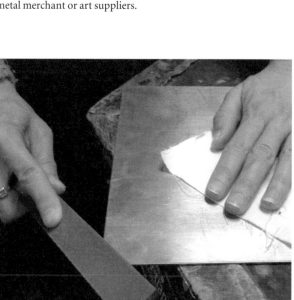

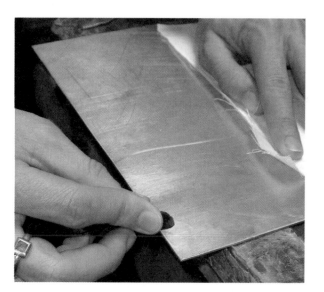

3 Round off the corners to prevent any sharp edges cutting through the printing paper or the press blankets. A 90-degree smooth beveled edge will provide a surface that is easy to wipe and consequently ensures a clean edge to the print.

4 Use a three-sided scraper-burnisher to remove the ridges left by the file. This creates a smooth finish that will not retain ink when printing. The burnisher tool, with a little oil, may be used to smooth the sides further if desired. Should the acid accidentally bite into the edges, this procedure will need to be repeated before printing. Take extreme care to prevent small filings from being left in the bitten groves, as these will create scratches when inking.

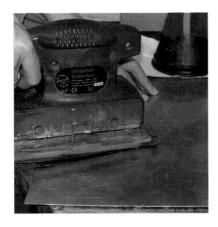

5 Unprepared plates can be sanded down to remove scratches. Use fine-grade (1000, for example) wet-and-dry sandpaper, rubbing by hand or with an electric sander. Cover the plate first with a little mineral spirit or water. "Prepared" plates, which come with a protective sheet, do not require sanding.

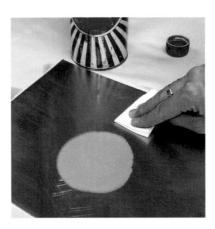

6 Polish the plate to a high shine with metal polish. This will prevent the surface areas from retaining unwanted ink, thereby allowing the whites to be more pure.

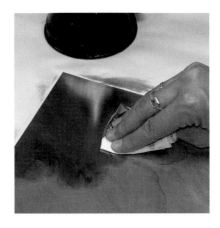

7 Remove the residue left by the polish with mineral spirit. This allows the degreasing agent, at the next stage, to be more effective.

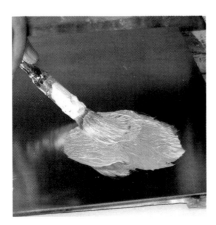

8 Degrease the plate. Traditionally, a paste made from whiting powder and ammonia is painted on the top surface. If this is not available, an ammonia-based non-abrasive household cleaner will suffice. Work over the plate until the paste lies evenly over the whole area.

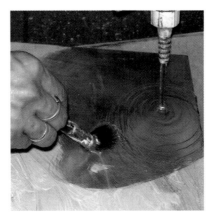

9 Thoroughly rinse off the degreasing agent with running water until all paste residue is removed. Water moving evenly over the surface will show that it is free of grease.

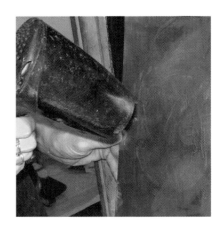

10 Dry the plate, back and front, immediately to prevent rust occurring. This is particularly important with steel, which rusts extremely quickly. Deep rust marks will print and therefore damage the plate. The plate is now ready for the next stage—a "ground" to draw through, or an aquatint.

Frances Quail
British

1.1.4

profile: **Frances Quail**

"I began enjoying art at eight years old. I remember reading fairytales about witches, which I used to cut out and draw.

"My grandmother was at the Slade School of Art in London and had a studio in Bloomsbury, where she became involved with the Bloomsbury Group. As we did not have a television, my dad, who is a stained glass artist, encouraged my brothers and me to draw and create watercolors when we were bored.

"I completed my Foundation course in Norwich, which is where I was first introduced to printmaking. There was a large screenprinting bed where, using the stencil method, I printed onto a long roll of fabric. I also used stencils to create a free interpretation of birds inspired by Matisse's cutouts and the paintings of Jackson Pollock.

"I took my degree at Newcastle, where during the first year I concentrated on life drawing. In the second year I joined an exchange program and went to Chicago to study fine art. The influence there was more biased toward the imagination, whereas my work had previously been mostly observational. Subsequently, I juxtaposed the two approaches within my imagery. On my return, I began to explore etching and consequently my degree show comprised both etching and painting. I would make an etching a day, starting in the morning and finishing in the evening. After finishing at Newcastle, I joined an adult education class in printmaking and became a member of Kew Studios in London as it had etching facilities.

"I was drawing jazz musicians at the time, inspired by German Expressionism. I enjoyed printmaking because my drawing seemed slight on paper, but in etching I found a commitment to the plate. I began linocuts during my MA at Brighton, where I also explored lithography. Within my imagery I visually translate my experiences and imagination to combine the mythical and the mundane. I would visit many different cafés in Brighton, drawing and observing the life around me. These observations transformed the mythical world of my work. Initially I let my intuitive side lead with the imagery and just let my feelings guide me. It is an intimacy with the material, the process of making the plate, that is important. It feels like alchemy and helps with the creation of the image. In the making of the plate, I add a variety of tone through aquatint, and I control the marks through biting the metal in the acid. I like the random mistakes—the marks speak to me and this leads to the solution. When I draw and paint, I do not get the same response.

"A competition led to my creating a book, which I felt was a natural development from my previous work as a narrative artist. It was exciting to let the story unfold, as I did not know what the conclusion would be. This is the direction in which I would like to continue, as I find prints can look fresher in a book than behind glass. The intimacy with the print sometimes gets lost on the wall.

"In Brighton I get a lot from being in a community with other artists. If I ever moved away, it would be very important for me to find a printmaking workshop. Printmaking and art are very high on my agenda."

Frances Quail
(British)
Creative Extension
17 x 8in (45 x 20cm)
Etching on single steel plate;
oil-based etching ink; handmade
hot-pressed paper and Fabriano
Artistico 300gsm
Printed à la poupée by the artist on
a hand-operated Rochat etching
press at Brighton Independent
Printmaking, UK

Right: **Frances Quail**
(British)
Angel over Brighton
4 x 3in (10 x 8cm)
Etching on single steel plate; oil-based
etching ink; handmade hot-pressed
paper and Fabriano Artistico 300gsm
Printed à la poupée by the artist on a
hand-operated Rochat etching press at
Brighton Independent Printmaking, UK

Below: **Frances Quail**
(British)
Dream the Dream
15 x 11in (38 x 28cm)
Etching on single steel plate; oil-based
etching ink; handmade hot-pressed
paper and Fabriano Artistico 300gsm
Printed à la poupée by the artist on a
hand-operated Rochat etching press at
Brighton Independent Printmaking, UK

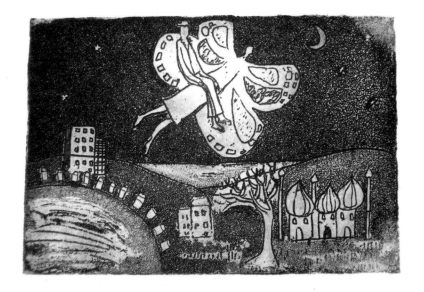

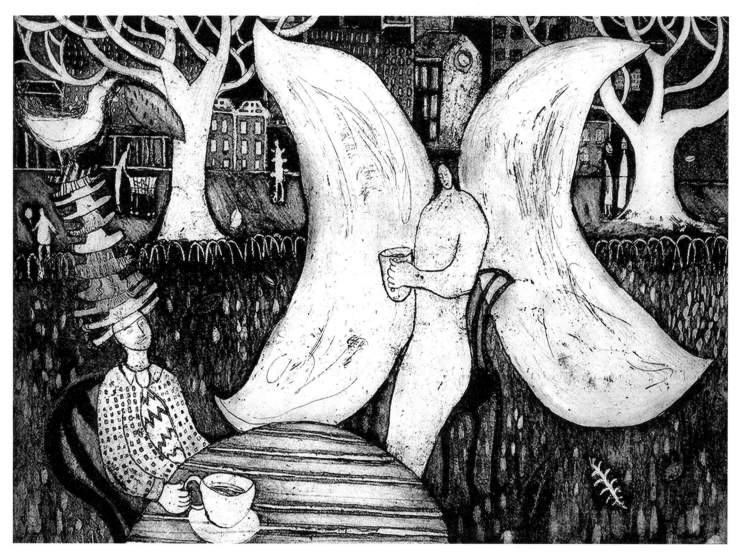

etching process: **hardground**

Hardground can be purchased from printmakers' suppliers in large or small balls. There are various recipes, but basically the substance is made from two parts of Syrian bitumen, one part resin (these are the two acid-resistant ingredients), and two parts Gambia beeswax (which is used to hold the ball together).

1.1.5

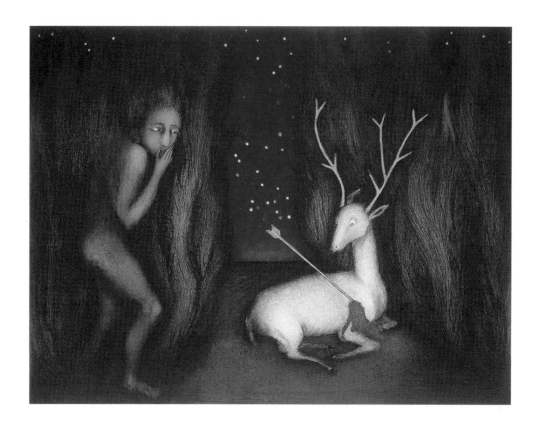

Ana Maria Pacheco
(Brazilian)
Tales of Transformations III, 1997–98
15½ x 20½ in (39.5 x 52.5cm)
Multi-plate color etching; Charbonnel
inks; Somerset Satin 410gsm paper
Edition of 35 plus 5 artist's proofs,
2 printer's proofs, and 4 archive proofs
printed by Martin Saull on a Rochat
Press. Plates made and proofed at
Pratt Contemporary Art.
Published by Pratt Contemporary Art.

**Ana Maria Pacheco
(Brazilian)**
Tales of Transformations IV, 1997–98
15½ x 20½ in (39.5 x 52.5cm)
**Multi-plate color etching; Charbonnel
inks; Somerset Satin 410gsm paper
Edition of 35 plus 5 artist's proofs,
2 printer's proofs and 4 archive proofs
printed by Martin Saull on a Rochat
Press. Plates made and proofed at
Pratt Contemporary Art.
Published by Pratt Contemporary Art.**

The hardground

1.1.6

step by step: **hardground etching**

Applying the hardground to the plate

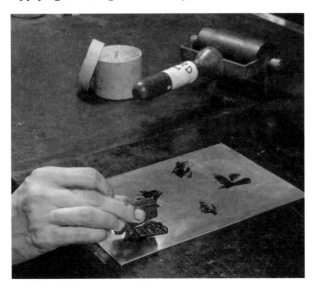

1 The metal, which can be zinc, copper, or steel (see p. 22), is prepared, degreased, and dried. It is placed on a hotplate where the ground ball is melted onto the surface. If the plate is too cool the ground will not melt and therefore will not roll out evenly.

2 The ground is rolled over the surface of the plate in an even layer. If the ground is too thin the acid will bite through where it is not required; this is called "foul biting." If the ground is too thick or uneven, the drawn lines will appear irregular when bitten. If too much ground has been used, the plate should be moved onto a cold surface; when the roller passes over the cooling metal much of the excess ground will return to the roller. This excess can be used on the next plate.

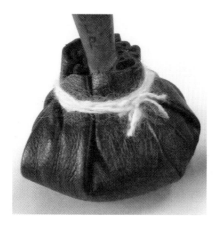

3 Some artists prefer to use the traditional method of a dabber to apply the ground.

Smoking the plate

Traditionally the ground was darkened simply to make it easier for the artist to see their work. However, the procedure also evens out the wax layer and further hardens the ground, adding increased resistance to the acid.

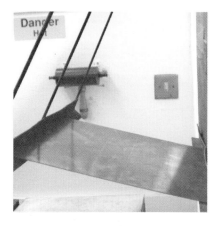

4 To darken the surface of the plate, the ground is smoked with tapers. The heat loosens the beeswax, which absorbs the soot from the flame. The wax hardens again when it is cool. The plate is balanced on an improvised plate so that the tapers can be held up to the waxed surface.

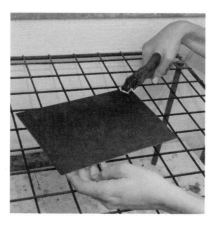

5 If the plate is handheld, the metal will require a small piece of paper wedged under the teeth of the pliers or handgrip to prevent scratching. Steel will attach to a magnetic strip used for holding kitchen knives, which can also be handheld. Seven or eight wax tapers, warmed and twisted to hold together, are now needed to produce a flame.

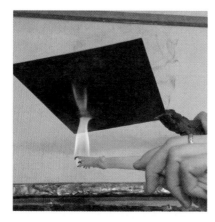

6 The taper is held up to the wax surface, making sure that the flame alone comes in contact with the ground, and not the taper itself. The plate is held by one corner while the smoking is begun at the opposite corner. The ground will first appear dull, but as it heats and the beeswax melts, the surface becomes shiny and the soot from the flame can be absorbed. The tapers are moved slowly across the surface as the shine appears.

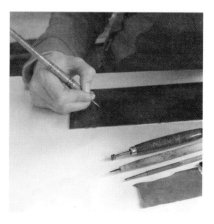

7 When the plate is cold it is ready to work on. There is a vast range of needles and roulettes in various sizes that can be purchased in specialist printmaking and hardware stores. However, any tool sharp enough to scratch through the surface of the ground so that the metal is visible will suffice; you could use a dart, compass point, sewing needle, or gimlet. A fine piece of sandpaper can scuff the surface to create a soft, scratchy mark, while mineral spirit on a cotton bud will remove the ground and leave an "open bite." On zinc, an open bite appears as a grazed surface with a darker edge, which can be polished in chosen areas.

8 It is not necessary to press hard to obtain a mark—only the ground needs to be removed, as the acid will create the incision into the metal. The initial mark may be just a line structure acting as a guide for further marks and tones to be added at a later stage. A magnifying glass will help to assess whether the tool has penetrated through to the metal.

Biting the plate in acid

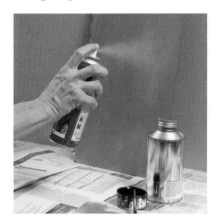

9 It is necessary to protect the back of the plate before it is put in the acid, or the energy from the acid will be expelled on the expanse of metal, and the plate will become thinner. A car spray metal primer can be applied after the surface has been degreased. This can remain on throughout the various processes that the plate will need to go through, without being removed even at the final printing.

An alternative is parcel tape, but this must be removed each time the plate is heated for an aquatint or put on the hotplate, as the glue forms into bumps that affect the plate.

Stop-out, or straw-hat varnish, can be used, but again this will need to be removed each time the plate is heated.

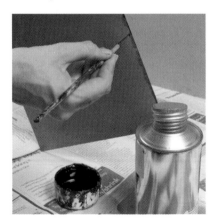

10 The sides need to be protected with stop-out varnish to prevent the acid spoiling the smooth bevel. If this is not done the nibbled edge will hold ink, which will appear as a distraction in the print.

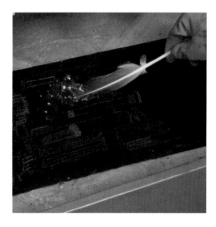

11 If the plate is bitten in a bath of nitric acid it will be possible to see bubbles forming. These need to be removed occasionally with a feather, to prevent the line biting in an irregular fashion.

An average line on a zinc plate in a bath of nitric made from 5 parts water to 1 part acid will take approximately 20 minutes. The plate can be removed earlier to paint out lines that are required to be quite fine, or left in the bath longer for lines that are to be heavier.

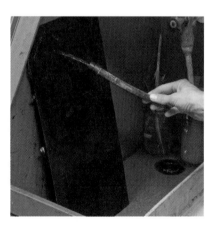

12 The plate needs to be washed back and front with water before it is removed from the acid area.

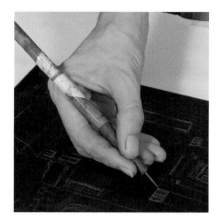

13 The depth of line bitten by the acid can be checked using a magnifying glass, and by testing with a needle to feel the ridge that will eventually hold the ink. If the lines have a golden look, and the needle does not catch in the mark, this means there is a slight skim of ground preventing the acid getting through; it may be necessary to rescratch those lines.

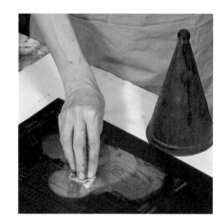

14 When the plate appears to be bitten, it is good practice to take only a small area of the ground off initially to check the depth of line. If the bite is insufficient then the area can be re-covered and the plate returned to the acid. If the line is good then the whole plate can be cleaned with mineral spirit and a rag.

The plate is now ready for the first proof to be printed.

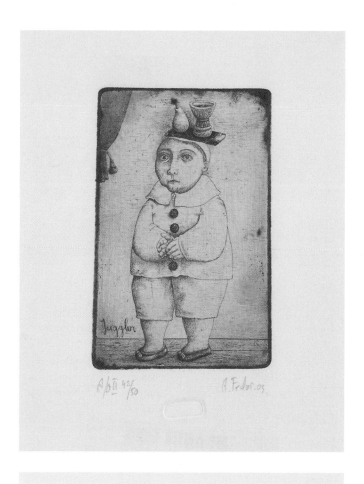

Fedorenko Oleksiy
Ukrainian

1.1.7

profile: **Fedorenko Oleksiy**

"I first remember enjoying art
in childhood. I don't remember exactly
how old I was, but I saw art reproduced in books.

"I have a formal art training, having graduated from the Faculty of Design at art college and from the Faculty of Graphic Art at the Academy of Fine Art in Kiev. It was during my studies at the Academy that I first turned to the printmaking medium and used the etching process. I do not use a master printer as I usually print my works myself.

"Different things inspire me to create my prints and I also illustrate books with my work. I do not admire any particular artist. At different times I have liked different artists and now different artists continue to be interesting to me. I do not consider one artist to be outstanding.

"Printmaking is an important influence in my life; this is my work.

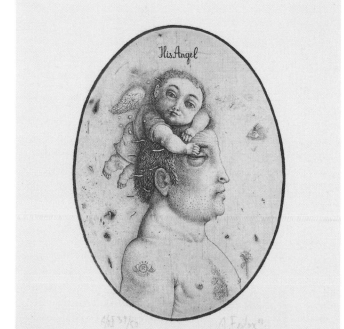

Top: **Fedorenko Oleksiy**
(Ukrainian)
Juggler, 2002
4 x 2½in (10 x 6.5cm)
Etching
Edition of 50 printed by the artist

Bottom: **Fedorenko Oleksiy**
(Ukrainian)
His Angel, 2003
4¼ x 3in (11 x 8cm)
Etching
Edition of 50 printed by the artist

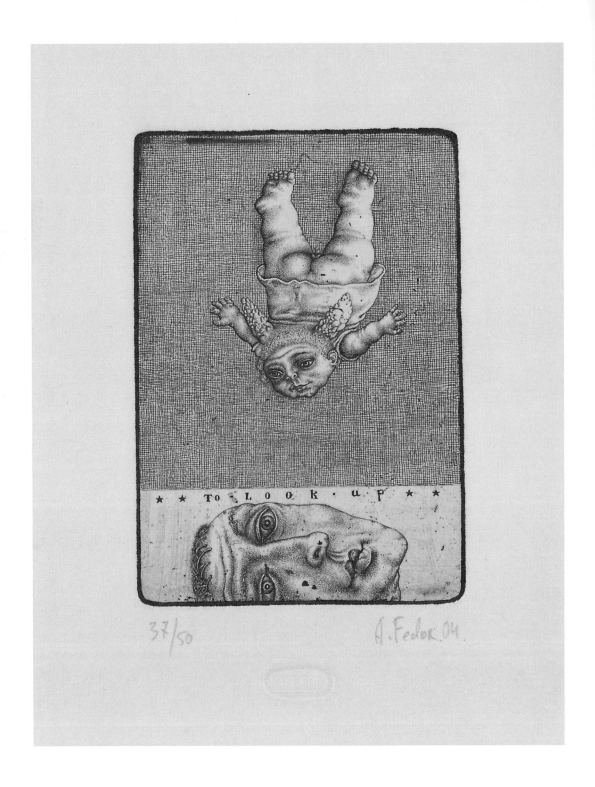

Fedorenko Oleksiy
To Look Up, 2003
4 x 2¾in (10 x 7cm)
Etching
Edition of 50 printed by the artist

Below: **Fedorenko Oleksiy**
Angel With Matches, **2001**
5½ x 5½in (14 x 14cm)
Etching
Edition of 50 printed by the artist

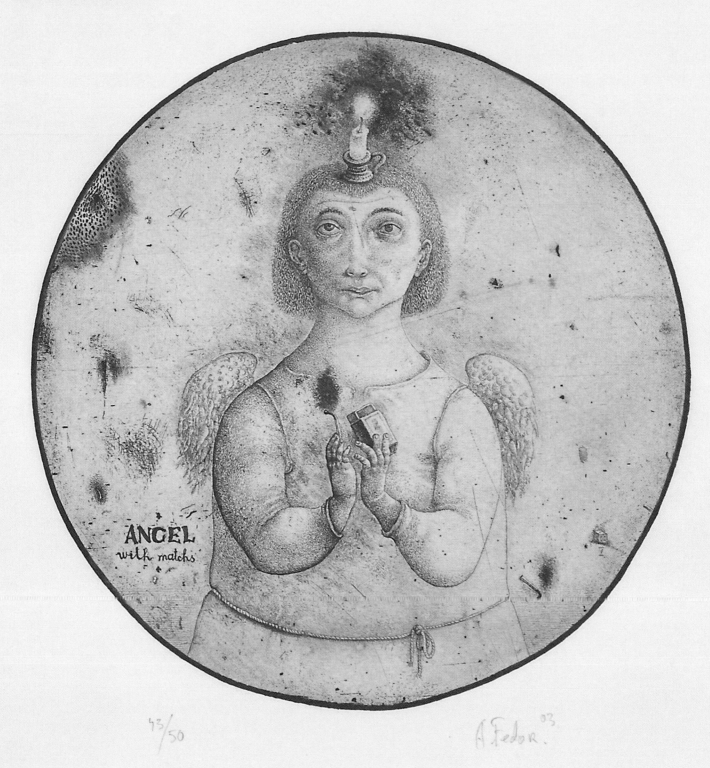

43/50 A Fedor 03

etching process: **softground**

Softground is a nondrying, acid-resist surface that allows textures to be transferred to the plate. Soft lines can also be produced by drawing through paper. Softground contains approximately 60 percent grease and will therefore not dry to a hard surface but remains tacky. The use of this ground is to take impressions of soft objects, or it can be used to draw directly with a pencil onto the surface through paper. Due to the high content of grease, it is unnecessary to degrease the plate before use. The ground is not smoked after application, as this would harden the surface and defeat the intended purpose.

1.1.8

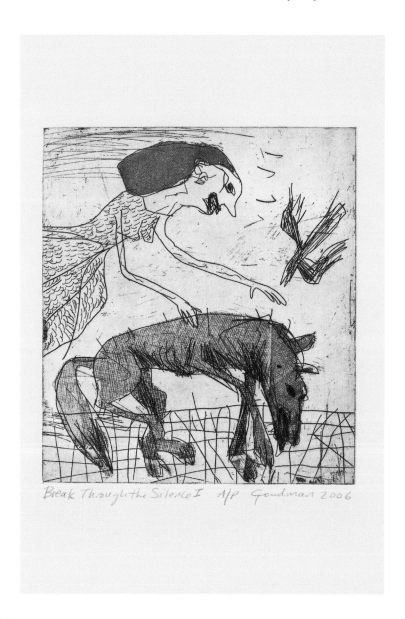

Gary Goodman
(British)
Break Through the Silence I
6 x 7in (15 x 18cm)
Etching with softground
Artist's proof, printed by the artist

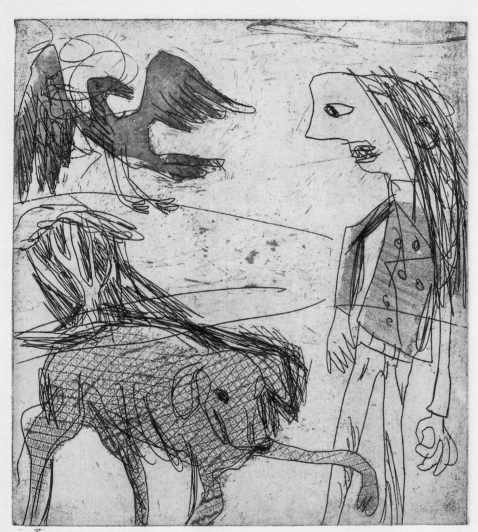

Once I Had Mountains II A/P Goodman 2006

Gary Goodman
(British)
Once I Had Mountains II
6 x 10in (15 x 25cm)
Etching with softground
Artist's proof, printed by the artist

1.1.9

step by step:
softground etching

The ground can be applied to zinc, copper, or steel. The metal should be prepared in the normal manner: file and scrape the edges, remove any surface scratches, and polish to the required finish. A hotplate is necessary to melt the substance, and a firm roller to apply the ground evenly.

1 The application should produce a deep, rich brown color. If the ground is too thin this will cause foul biting through the protected areas, but if it is too thick the texture will not remove sufficient ground to allow the acid to bite.

If the plate has already been bitten, first push the ground into the incised lines with a ball of tissue as a protection, then finish rolling the top surface substance, and use a firm roller to apply the ground evenly.

2 To obtain a good impression, the materials used to create the texture need to be soft enough to put through the press; for example, fabric, wool, string, lace, gauze, dried leaves, and net. The pieces are placed on the plate; it is not necessary to cut the exact shape required as stop-out varnish can be applied to the surface before it is bitten in the acid.

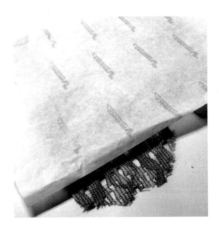

3 Place a sheet of waxed paper over the entire plate to prevent the excess ground from marking the blankets, and run the plate through the press.

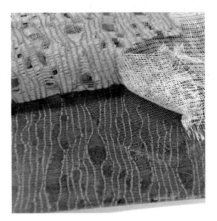

4 Initially a corner of the fabric is lifted to access the impression, which should be clearly visible. Where the metal can be seen the acid will bite, thereby creating a groove that will hold ink and print. If there is no impression, run the plate through the press again with increased pressure.

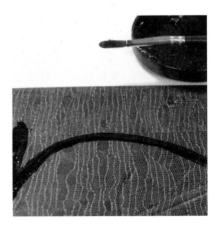

5 Stop-out varnish is used as a resist against the acid. This confines the texture to the required area, and it must be completely dry before being placed in the acid bath.

6 Before the plate is put in the acid, the back is protected. The tape is overlapped to prevent the acid seeping underneath. An extra piece can be left on either side to provide a handle for easy removal from the acid bath. Primer car spray or straw-hat varnish can also be used as an acid resist.

A softground zinc plate is generally placed in a relatively slow mix of 1 part nitric acid to 10 parts water. A fine line could be achieved in around 6 minutes, but an average line takes 15–20 minutes. The plate can be removed from the bath at intervals and areas stopped out before it is returned to the bath; this produces a variance in the depth of mark. The longer in the acid, the deeper the mark and therefore the darker the print. A feather is not used to remove the acid bubbles as it could scratch the softground.

7 New lines and marks can be made using a pencil dragged across the surface, a cotton bud or rag dipped in mineral spirit, or a wire brush. The plate can then be returned to the acid for further biting.

8 With softground it is especially advisable to check the depth of line with a needle, and then take only a small area of ground off the image before cleaning the entire plate. The impression may have left a residue of ground, which will prevent the acid from biting initially and therefore the plate may require longer in the acid than expected. If tape is used to protect the back of the plate it must be removed before printing, as the heat will melt it, producing lumps. Primer car spray is an easier option, as it does not need to be removed. The intaglio plate is inked up and wiped off with gauze and tissue in the normal way. After the first proof a hardground or aquatint may be applied to the plate to build up a complete image.

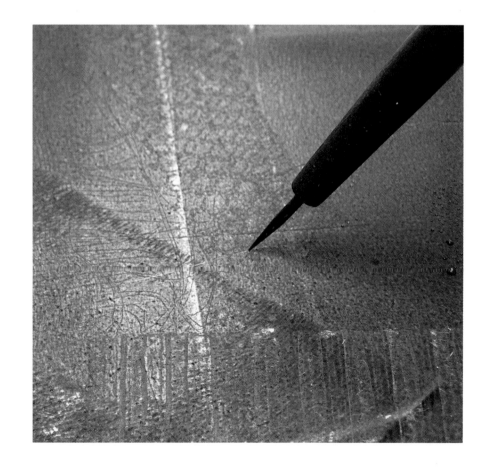

step by step: **softground: drawn image**

1.1.10

1 Place a clean sheet of lightweight paper onto the surface of a freshly rolled, but cold, softground. Layout paper is ideal, but computer printout paper will suffice. Tracing paper is generally too hard, and newsprint too absorbent. Place the paper, accurately fitting it into one corner; this can then be returned to exactly the same position should you need to do so.

2 Using a soft graphic pencil, draw onto the top surface of the paper, making sure that you create enough pressure so that the ground transfers onto the reverse side. Insufficient pressure will not absorb enough ground from the plate to allow the acid to penetrate the metal in order to bite a sufficiently deep mark to hold ink.

3 Lift the corner of the paper occasionally to check that the metal is revealed beneath the drawn line. Be careful not to put pressure on the plate where you do not require the ground to be removed. When the drawing is complete, remove the paper, protect the back of the plate, and bite in a medium-slow acid bath. An average line on zinc will take about 20 minutes.

Softground: Troubleshooting

Problem:	Cause	Solution
Foul biting through ground	**1.** Softground applied too thinly.	**1.** Apply a thicker surface of ground to allow for a thin layer to be removed when taking an impression of the texture.
	2. Excess pressure exerted with the hand on the background areas while drawing through paper onto the plate.	**2.** Put a box of matches either side of the plate with a ruler across from one to the other to rest the hand on when drawing.
	3. Too much pressure when the texture was rolled through the press to take an impression.	**3.** Remove a blanket when running the textures through the press.
Hand-drawn plate through paper— line does not bite	**1.** Pressure of hand is insufficient to absorb the ground onto the back of the paper.	**1.** Press harder on the back of the paper, check that the metal is visible before moving the drawing.
	2. Incorrect paper used.	**2.** Use layout or thin computer paper.
Texture—the material is not removing the ground from the plate	**1.** Pressure on press too weak.	**1.** Increase pressure on press or add another blanket.
	2. Material, for example plastic, is not absorbent.	**2.** Use more absorbent materials, preferably of a similar light weight.
	3. Softground is old and has hardened.	**3.** Remove ground and put on a fresh one.

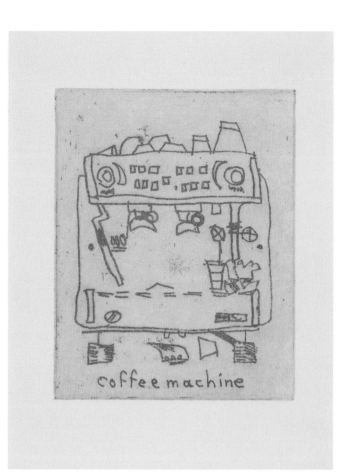

Susan Donne
(British)
Coffee Machine
4½ x 3½in (11 x 8.5cm)
Softground etching with drawn-through paper; oil-based etching ink; BFK Rives 250gsm paper
Printed by the artist on an etching press at the University of Brighton, UK

Susan Donne
(British)
Pier
11½ x 3½in (29 x 8.5cm)
Softground etching with drawn-through paper; oil-based etching ink; handmade paper
Printed by the artist on an etching press at the University of Brighton, UK

1.1.11
softground in practice

etching process: **aquatint**

Aquatint is the process through which tone is achieved. Resin or bitumen powder is used to create an acid-resistant physical dot structure.

1.1.12

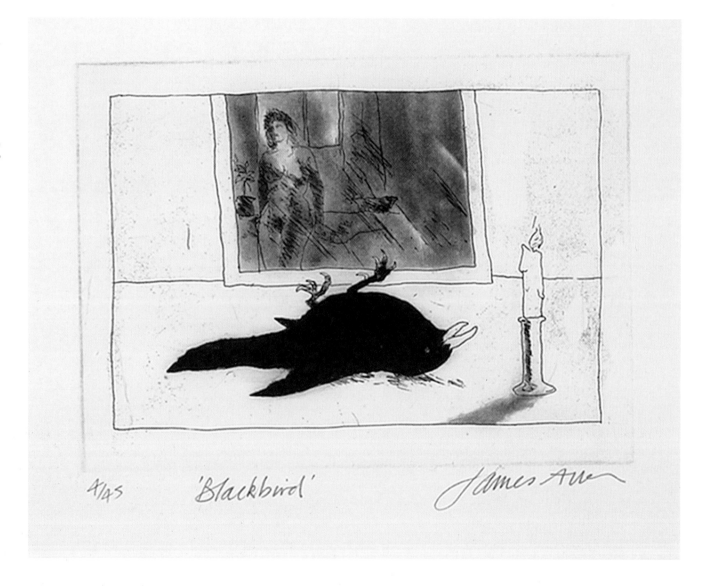

4/45 'Blackbird' James Allen

**Jim Allen
(Irish)**
Blackbird
**5½ x 7½in (14 x 19cm)
Aquatint and drypoint; intaglio
Velvet Black etching ink; Somerset
White 300gsm paper
Edition of 45 printed by the artist on
a Rochat etching press at his studio**

Jim Allen
(Irish)
Noah's Dove
21½ x 15in (54.5 x 38cm)
Aquatint; Charbonnel etching inks;
Somerset Soft White handmade paper
Edition of 45 printed by the artist on a
Rochat etching press at Belfast Print
Workshop, Northern Ireland

Safety note
This process requires the use of dangerous materials, so the wearing of a mask is strongly advised.

The purpose of an aquatint ground is to create a tonal area on an etching plate either within an already bitten image, or as an image in itself. The plate can be bitten to various depths by the acid, which will produce tones of differing values within the print. Zinc, steel, or copper can be used. However, as steel already has a grain, the contrast of the tone is not so pronounced.

1.1.13

step by step: **fine and coarse aquatint ground**

Fine aquatint

1 After the metal has been degreased and dried, a fine resin or bitumen powder is applied using a resin box. This has powder at the bottom, and the floor, located at the center, can be rotated by turning a handle. This action throws all the resin into the air, the floor is then stabilized, and the plate put in the box for a minute. The powder will settle onto the surface in a thin layer, leaving gaps in between the particles.

2 The plate is removed carefully and slowly from the box, as the powder is extremely light and can be easily displaced. It is put on a wire grid and heated from beneath. This secures the particles to the metal. The resin becomes transparent when heated and sticks to the plate.

Coarse aquatint

3 A coarse aquatint ground can be applied by filling a jar with resin and securely attaching a number of layers of wiping cheesecloth to the top.

The jar is held just above the plate with the left hand while the right hand taps the base to release just enough powder to drop onto the plate. The coarse aquatint is heated in the same way as with the fine aquatint. It becomes transparent, which makes it easy to see through to the image beneath. This can then be protected by applying stop-out varnish on the areas that are not required to bite.

4 The nature of coarse aquatint is to have a random, irregular dot structure made up of large and small particles. The powder must not be applied too heavily as the particles expand when it is heated. If there is too much resin the spaces in between will close up and the acid will be unable to bite.

Biting in the acid bath

5 An aquatint will bite much more quickly than a line. A light tone can be obtained in a few seconds using a nitric acid solution of 10 parts water to 1 of acid. Several grades of tone can be achieved in the first 4 minutes by putting the plate in and out of the acid while painting out new areas each time: 4–6 minutes will increase the depth of the tone; 6–8 minutes will produce a dark tone; and 8–10 should result in black.

Left in the bath too long aquatints can break down and will then produce a patchy, open bite. All acids bite differently depending on the conditions; if an accurate result is essential, a test strip on the day of biting is advised. Methylated spirits will be required to remove the particles of resin before printing.

Sophie Aghajanian
Armenian

1.1.14

profile: **Sophie Aghajanian**

"From the age of two I always wanted to draw.
I had a very turbulent childhood as Palestine was caught up in the war
between the Arab and the Jewish communities. When I was five, my family and I were refugees in
Jordan and I remember one of the greatest pleasures was to be given a pencil to work with.

"I do not remember what I was drawing, but it was a comfort, almost a kind of therapy. When we went to start a new life in Cyprus, I began to do sketches of the people around me—cartoon strips really. My father brought offcuts of blank paper home so my sister and I made films of stories and fairy tales.

"My mother is very good at art, very creative with sewing and embroidery, and she did wonderful paintings. It is a pity that she could not take it up, but circumstances prevented it. She had a talent and always said she wanted to be a dress designer. She was born in Turkey and was a survivor of the Armenian genocide in which she lost many members of her family, including her father.

"My grandmother was a remarkable woman; her newborn son died of starvation as the women and children were driven through the desert. They were rescued by Bedouins, who found them hiding among bodies pretending to be dead. After that harrowing journey, they were rescued and ended up in Jerusalem. My father's family is from one of the oldest families in the Armenian quarter of Jerusalem. They may have arrived with the early pilgrims from Armenia, who set up an enclave in the city. As the family originated from Edessa, they may have arrived with the Crusaders.

"Both my parents encouraged my sister and I to go to England, where we went to Ravensbourne College of Art. I was nineteen and college was a terrible shock. At the time I thought I would always be working from the human figure, but art college temporarily put an end to that. It was the 1960s, when art was all hard-edged, abstract imagery. We were positively discouraged from drawing from the nude. It was a difficult time for me. As I needed to do what was required to get by, I made abstract work, which was not me at all. I felt very depressed, as I wanted to draw and paint my own figurative imagery. I then studied printmaking in Brighton, as I felt that it was something that I could get my teeth into, something you could learn—a craft. There I met my husband, Jim Allen, who was from Belfast. In 1977 he was offered a Fellowship by the Northern Ireland Arts Council to return to Belfast and set up the Belfast Print Workshop, where he eventually became full-time director.

"At the time my daughter was born in Brighton, I rediscovered my creativity and had returned to drawing while we were living there, before we moved to Belfast. Something was freed in me and I did this very big, black and white drawing of the interior of the flat we were living in. It was a new beginning. I transferred the drawings into small black and white etchings, all taken from my immediate surroundings.

Sophie Aghajanian
(Armenian)
Evening Garden
9 x 8in (22.5 x 20cm)
Aquatint; spit bite; intaglio etching
inks; Somerset Satin White paper
Edition of 50 printed by the artist on a
Rochat etching press in her workshop

Sophie Aghajanian
(Armenian)
Dark Projection
21½ x 16in (54.5 x 42cm)
Aquatint; spit bite; G. Schmidt
etching inks; Somerset Satin
White paper
Edition of 35 printed by the artist
on a Modbury etching press
at the Belfast Print Workshop,
Northern Ireland

"The 'Troubles' in Northern Ireland were at their height, so it was a difficult decision to move to Belfast, but we were lucky to find ourselves living in a gate lodge, adjacent to the workshop, set in eleven acres of beautiful landscape within the city. There was a big garden, with blossoms on the trees in spring and a vegetable patch at the back; it was like being in the country. With all the tensions and violence outside, it was an oasis. I remember creating a series of etchings based on the view from the window, of the small wood behind the gate lodge.

"I like etching, using aquatint, because you do not know exactly how it is going to turn out. With painting you make a mark and that is it, but with printmaking it is almost as if the medium takes over. I actually like accidents to happen and for things to go wrong. I also love the fact that the image is in reverse, and I enjoy using the backs of plates because of the random marks. Spit biting has become the way I work, as it is a more fluid, direct, and spontaneous way of creating imagery.

"For a time I was not able to paint so I started working in pastels. I would rub black pigment into the paper before slowly introducing subtle colors. I then moved to monotypes, using rollers and wiping away. Now I do both painting and etching as they complement and help each other. Being involved with the Belfast Print Workshop, I was working with painters who had no idea what printmaking was about. It was wonderful to see how excited they became with the medium.

"Printmaking is as valid as painting, but sometimes I value a print more than I do a painting. My work is observational; I may start by looking out of the window at images of my surroundings, then go into my studio and work from what is around me. Reflections became very important to me, and they still are. I have an old, cracked, marked mirror, which I place things in front of. It is covered in dust so when the sunlight hits it, the reflection and the shadow become more important than the actual object. I am obsessed with this, as the object is not a straight reflection; it moves into the abstract.

"The best thing people can say about my work is that they can look into it and see things beyond the representational. I do not want to be absolutely aware of what I am doing. I pursue something and I know when it is right; I do not want it to be static. Printmaking is almost meditative for me."

1.1.15

fine aquatint ground: scraping and burnishing

A scraper-burnisher has been used in the dark tonal areas of Peter Kosowicz's image, shown right. The scraper, held by two of the flat faces to enable the use of one of the three sharp blades, is used to remove the bitten tone. This returns the metal to a shine that will not hold ink, and will therefore print white.

**Peter Kosowicz
(British)**
Untitled, 1986
**14 x 5¼in (36 x 13.5cm)
Etching with fine aquatint—zinc plate bitten in nitric acid, with a fine aquatint scraped and burnished to create soft light areas; oil-based etching ink; handmade paper
Artist's proof printed by the artist on an etching press at the University of Brighton, UK**

After scraping the metal, the curved burnisher end of the tool, having been dipped in a little oil, is smoothed over the scraped area to improve the shiny surface. The purpose of this procedure is to create a soft atmospheric mark with a gentle broken edge. It is possible to see the use of the scraper within the form of the hat and in the bottom right-hand corner of the print.

A fine resin powder, when applied to a plate and heated, can be bitten for a varying amount of time in the acid to create a range of tones.

In the print shown at right, a hardground was used to create the lines, followed by an application of a fine aquatint over the whole plate. The white areas were protected by stop-out varnish and the rest bitten for about 2 minutes in a bath of nitric acid (10 parts water to 1 part acid). The top lighter tone was then covered with acid-resist varnish and the plate returned to the acid to bite for a further 5 minutes. This produced the darker tone at the bottom of the plate.

The lighter tone at the top was then gently smoothed in chosen areas with a small piece of wet-and-dry sandpaper and a little mineral spirit. This action created pools of light where the metal had become shiny and therefore held less ink.

1.1.16

aquatint in practice

**Cheung Chung-chu
(Chinese)**
Sketch, **2006
35½ x 19¾in (90 x 50cm)
Etching; Charbonnel etching ink;
Xuan paper
Edition of 10 printed by the artist
at Hong Kong Open Printshop**

Peter Kosowicz
(British)
Dwarf Chrysanthemums 1
12 x 24 in (30 x 60.5cm)
Etching (3 plates, 3 colors);
Charbonnel ink; Somerset White
300gsm paper
Edition of 35 printed by the artist
on a Rochat press at Thumbprint
Editions, London, UK

Three plates were used, with one
color on each. The first plate was
made by putting it into the aquatint
box with flowers laid on the surface.
From this plate the image was offset
onto new plates. The ink residue
from the offset acted as a resist
while etching the images onto the
new plates. This was an attempt to
get away from drawing and let the
process form the image.

Peter Kosowicz
(British)
Silver Flower
12 x 24 in (30 x 60.5cm)
Etching; Charbonnel ink; Somerset
White 300gsm paper
Edition of 35 printed by the artist
on a Rochat press at Thumbprint
Editions, London, UK

**Chris Gilvan-Cartwright
(British)**
Monkey Temple
**6 x 8in (15x 20cm)
Etching with aquatint; oil-based ink;
Somerset paper
Edition of 50 printed by the artist on an
etching press at Brighton Independent
Printmaking, UK**

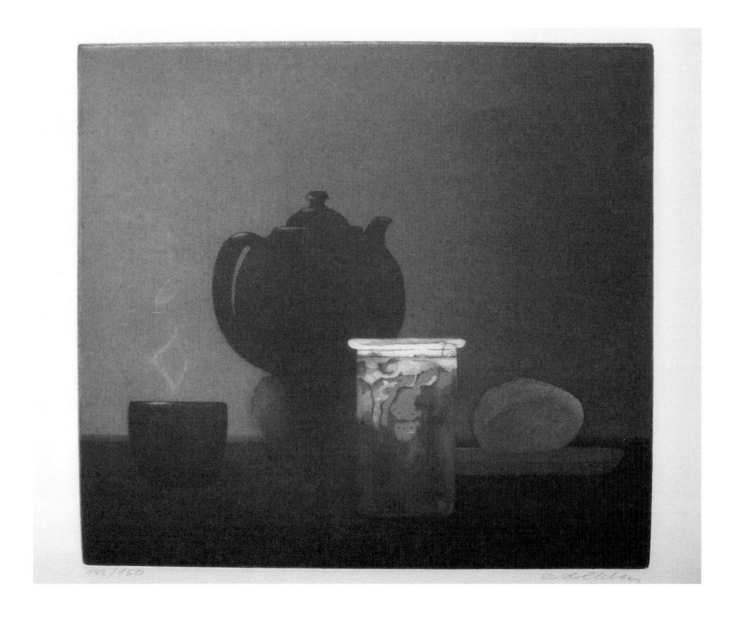

**Elisabeth von Holleben
(German)**
Steaming Cup and Teapot
**13 x 14in (33 x 36cm)
Etching and aquatint (3 plates,
5 colors); Schneider & Co ink;
Hahnemühle paper
Edition of 150 (100 published by
Christies Contemporary Art) printed
by Michael Schlemme on a Hunter &
Penrose press in Berlin, Germany**

**Elisabeth von Holleben
(German)**
Cup and Saucer
**8 x 12in (20 x 30cm)
Etching and aquatint, roulette
(3 plates, 5 colors); Schneider
& Co ink; Hahnemühle paper
Edition of 100 printed by Michael
Schlemme on a Hunter & Penrose
press in Berlin, Germany**

etching process: **sugar lift**

Sugar lift (also known as lift-ground aquatint) is a method that allows you to paint marks, lines, or broad areas onto a metal plate (zinc, steel, or copper) to produce a positive mark that will print. This is different from the usual practice in etching of painting stop-out as a resist, thereby producing a negative mark, or nonprinting area. The mark produced can vary from an irregular line to a broad globular area. The tonal value is determined by the amount of time the plate is left in the acid to bite. Because the solution can be applied in a controlled or random way with a brush, cotton bud, pen, or stick (you can also dip fabric into the sugar solution and blob it onto the plate), such application produces a more painterly, flowing mark than that created through the more usual processes of etching.

1.1.17

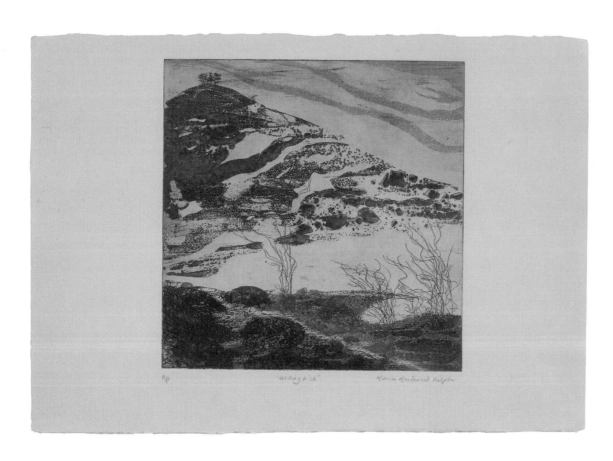

Left: **Monica Macdonald Ralph (British)**
Waking Hill
11 x 11in (28 x 28cm)
Etching; oil-based etching ink; handmade Somerset paper
Artist's proof printed by the artist on an etching press in her studio

Line drawn through hardground using a nutmeg grater. Fine aquatint under sugar lift with additional coarse aquatint. Steel plate bitten in nitric acid. Printed à la poupée

Right: **Monica Macdonald Ralph (British)**
Dancing Hill
11 x 11in (28 x 28cm)
Etching with sugar lift and coarse aquatint; oil-based etching ink; handmade Somerset paper
Artist's proof printed by the artist on an etching press in her studio

Texture impressions made through softground using seaweed, gauze, and string. Fine aquatint under sugar lift with additional coarse aquatint. Steel plate bitten in nitric acid. Printed à la poupée

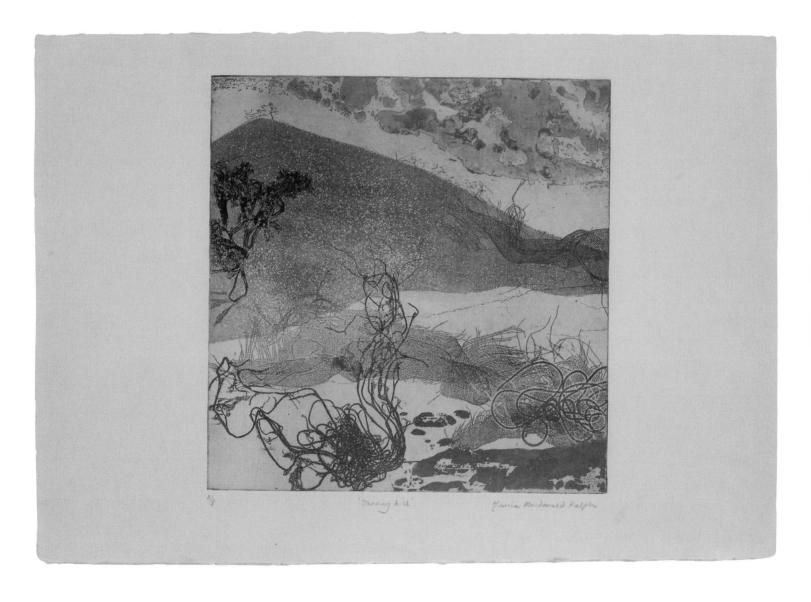

A/P 'Dancing hill' Monica Macdonald Ralph

step by step: **sugar lift**

How to make the solution

You will need: Water, sugar, dish detergent, gum arabic, ink, a container, and a source of heat.

There are many formulas, but the one that works well is as follows:
• Dissolve the sugar in a little water over a hotplate or gas stove.
• When the sugar is thick and begins to crystallize, take it off the heat.

• Add a few drops of dish detergent. This allows the solution to flow easily when used.
• Add a small quantity of gum arabic; this will help the solution to stick to the plate securely.
• Finally, add a little Indian ink or other coloring to color the solution, so that you can see where it is applied.

It is also possible to buy readymade solutions at good printmaking suppliers.

How to use the solution

1 Prepare the plate in the normal way, removing scratches and filing the edges. Degrease the metal and apply a fine aquatint. The aquatint will give a "tooth" onto which the solution can hold.

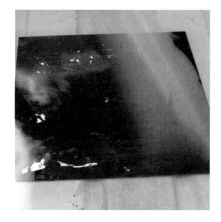

2 Apply the sugar in your chosen way; it is normally painted on with a brush. The area to which the solution is applied will be the part of the plate that bites in the acid, and therefore holds the ink and produces a printed mark. Leave the sugar to dry, or put it on a hotplate for a short time to harden, before going on to the next stage.

3 Holding the plate upright in a tray, pour liquid ground over the image, completely covering all areas. Let the excess solution drain off into the tray, leaving a thin, even layer on the plate. The residue in the tray can be returned to the bottle to be used again.

Alternatively, put a little mineral spirit into stop-out solution and paint a thin layer over the whole plate. Make sure the solution is not too thick or it will prevent the sugar from lifting at a later stage. Boil a kettle and prepare a bath of fairly hot (not boiling) water.

4 When the liquid ground or stop-out is completely dry, place the plate in the bath of water. Agitate the bath, or sweep the plate gently with a feather. The heat of the water will melt the sugar, which will lift and remove the ground or stop-out, thereby revealing the painted areas.

Biting the plate

5 When all the sugar has melted, lift the plate out of the bath. Protect the back of the plate before putting it into a slow acid solution. Remember that this is an aquatint and will therefore bite quickly. As with any aquatint ground, various tones can be achieved by biting areas for differing lengths of time, removing the plate from the acid and stopping out, before returning to the bath.

Finally, clean the plate with mineral spirit to remove the ground, use methylated spirits to remove the aquatint, and print on the hotplate in the normal way.

Detail of dissolved sugar lift on the plate before it goes into the acid. The white area is the exposed metal that will bite when placed in the acid. The dark areas are protected by the remaining liquid ground and will not bite.

Detail of sugar lift in the sky area, bitten for a short time in slow nitric acid (1 part acid to 10 parts water), to obtain a delicate, globular mark. (See p. 55 for complete image.)

Detail of the sugar lift area on the hill. A strong acid was used (1 part acid to 5 parts water) to obtain a deep, coarse bite, thereby creating a strong area in the print. The globular nature of the mark is characteristic of sugar lift. (See p. 54 for complete image.)

Left: **Detail of sugar lift painted with a small brush onto a fine aquatint. In this case, the procedure is used to create a broad irregular line, as opposed to the very fine line normally produced by using a needle through hardground.**

Above: **Peter Gates (British)**
Hygena 1
9 x 6in (22.5 x 15cm)
Etching and aquatint; oil-based etching ink; handmade Somerset 250gsm paper
Artist's proof printed by the artist at the University of Brighton, UK

Sugar lift on fine aquatint to create a broad line on zinc plate. Blocks of fine aquatint areas to hold color on steel plate. 2 plates printed in registration one after the other.

Sugar lift: Troubleshooting

Problem: Sugar will not lift in bath

Cause	Solution
1. Stop-out or ground too thick.	**1.** Remove ground with mineral spirit and put on a thinner one.
2. Water not hot enough.	**2.** Add more hot water from the kettle.
3. Sugar too thin.	**3.** Next time paint the sugar on more thickly.

Problem: The background comes off where there was not any sugar

Cause	Solution
1. The water bath was too hot.	**1.** Put cold water in the bath.
2. The plate was not properly degreased.	**2.** Next time thoroughly degrease the plate before applying the aquatint.
3. Ground was not completely dry.	**3.** Make sure ground is completely dry.

**Andrew Levitsky
Ukrainian**

1.1.19

profile: **Andrew Levitsky**

"It is thanks to my granny that, from early childhood, I enjoyed art in her home. She had old furniture and good etchings on her wall. I trained in art at the Ukrainian Academy of Fine Art in the faculty of Graphic Arts from 1986 to 1992.

"I then took a postgraduate course in the faculty of Graphic Arts at the Ukrainian Academy of Fine Art in Kiev from 1993 to 1996. I achieved a Masters in Graphic Art and graduated with a distinction.

"I was first introduced to the printmaking medium at the Academy of Fine Art in Kiev. In 1987, I participated in my first printmaking exhibition in the Ukraine and continue to exhibit internationally. I like to work every day and begin with a blank sheet of paper, as I consider the best picture evolves from this starting point. As I am a professional artist and printmaker, I print my own works myself. I always study and learn from those who create rather than those who destroy.

"What inspires me to create my imagery? I aim to live without fuss and without losing harmony, and my family and friends too are very important. I think it is from these sources that I gain inspiration. I work with a couple of etching plates at the same time and I never have enough time to get tired of a single work due to the process. The drawing is transferred from paper to zinc and copper, then it is corroded with acid, and then printed. Printing is half the success of intaglio. It is such an interesting and exciting process.

"In terms of my influences, the Ukrainian School of Graphics is outstanding, so my teachers are at the top of my list. I take great pride in being part of the Ukrainian Graphics Guild, which facilitated the three Japanese exhibitions that I have been honored to take part in. The Japanese appreciate my etchings very much.

"Printmaking is an important influence in my life. Art is my game and I try to play professionally. All my art prints are my children. I am responsible for them and I am responsible for what I do. Bad work will bring bad energy into the world and it could cause harm from which I will suffer too. It is completely the opposite with good work, as this will bring personal joy to the viewer. I could be proud of my most recent works, but I feel anxiety when looking to the future. The best work is not yet done. Life and Art, Art and Life, they are similar—they are either present or absent!"

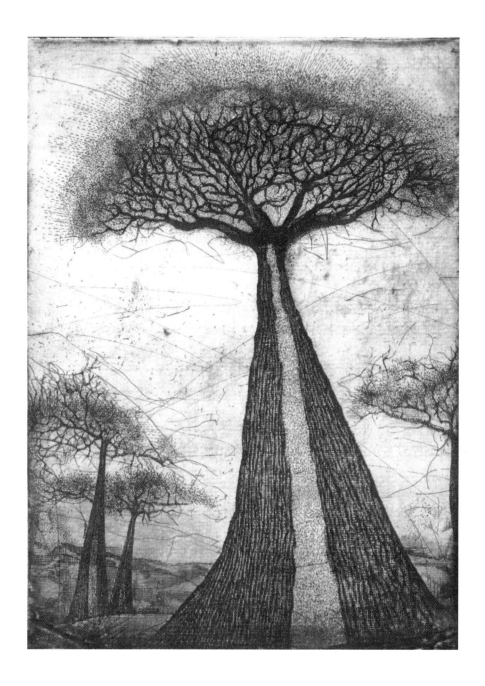

Andrew Levitsky
(Ukrainian)
Red Trees
12½ x 11½in (31.5 x 29cm)
Intaglio; etching ink; Canson paper
Edition of 25 printed by the artist in
Kiev, Ukraine

**Andrew Levitsky
(Ukrainian)**
Rose III
**41½ x 5¼in (105 x 13.5cm)
Intaglio; Chabrole etching ink;
Canson paper
Edition of 25 printed by the
artist in Kiev, Ukraine**

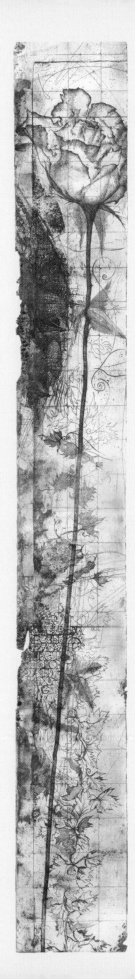

etching process: **marbling**

A mottled effect resembling marble can be achieved by transferring stop-out varnish, on water, to an aquatint on a metal plate. A satisfactory result requires some trial and error. Copper, zinc, or steel may be used. It is advisable to apply a fine or coarse aquatint to the surface of the plate initially; this produces a "tooth" for the solution to attach to.

1.1.20

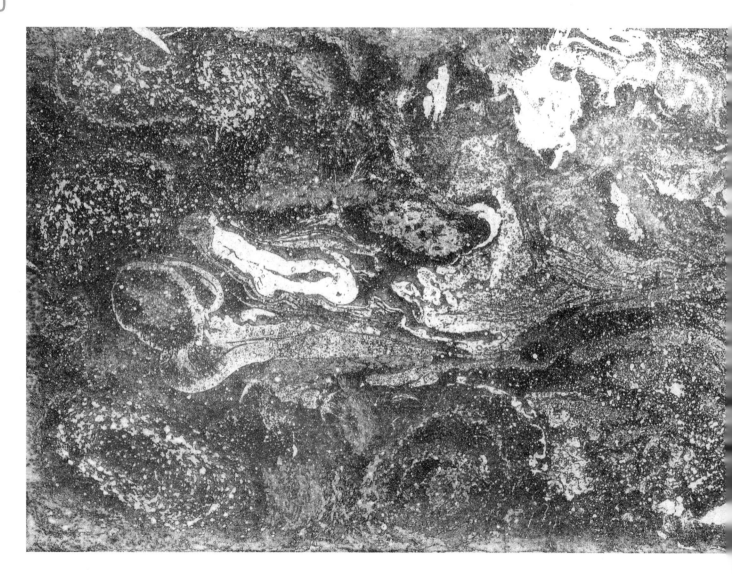

Safety note
This process requires the use of dangerous
solutions. Every care should be taken
to protect the user by working in a well-
ventilated room with the appropriate
apparatus, in addition to wearing protective
clothing, such as rubber gloves, goggles,
and an apron.

Marbling sample using fine aquatint
on a steel plate, printed à la poupée.

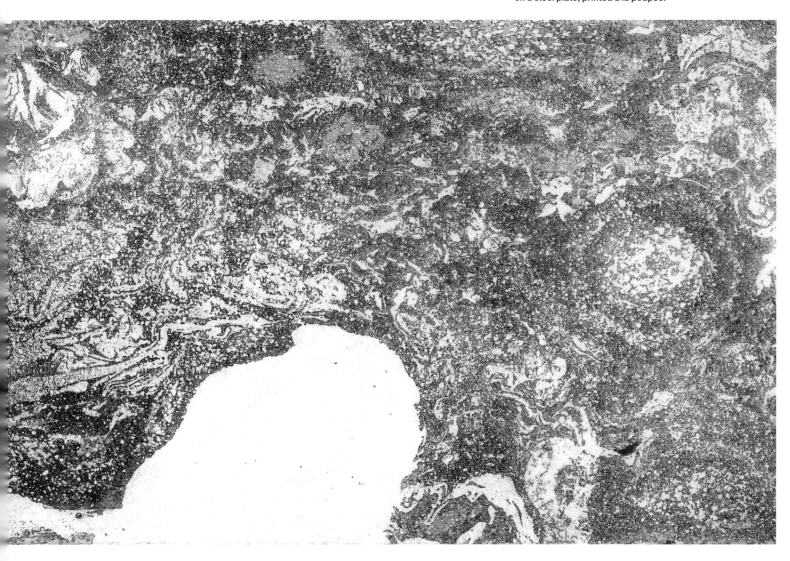

step by step: **marbling**

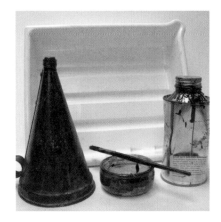

1 Prepare the plate in the normal way, removing any scratches and filing the edges. Alternatively, you may apply the marbling to a plate that you have already drawn and bitten. Having applied the aquatint to the plate, prepare a bath with fairly warm water. Mix a few drops of mineral spirit with stop-out varnish, and pour a very small quantity of the solution onto the surface of the water.

2 As it floats, move the solution around gently with a brush. When you are pleased with the result, carefully hold your plate face down onto the water, allowing it to absorb the acid-resist varnish, then quickly remove it.

3 It is possible to put the plate in the bath first and raise it extremely slowly once the solution is on the water; however, this can have a tendency to stretch the marks.

4 Lay the plate down for a few minutes to allow the solution to settle. If the marks are unsatisfactory they can be removed with mineral spirit, but the plate must then be degreased before the procedure may be started again. Paint out any areas that you wish to protect before putting it in the acid.

5 Protect the back of the plate. If masking tape is used, a flap can be left beyond the end of the plate to use as a handle for easy removal from the bath. Remember this is an aquatint and will need only a short time to bite. Some areas can be painted out at an early stage, and others left to bite longer for a darker result. If using nitric acid you can see that it is biting where the plate is showing small white bubbles.

6 When the acid has bitten, remove the stop-out varnish with mineral spirit and the resin aquatint with methylated spirit, then take a proof.

Hebe Vernon-Morris
(British)
Surrounded By the Universe
7 x 4in (18 x 10cm)
Etching—zinc plate, hardground line
drawing with marbling, first state;
oil-based ink, Fabriano paper
Artist's proof printed by Ann d'Arcy
Hughes on an etching press at
Brighton Independent Printmaking, UK

Marbling: Troubleshooting

Problem: Solution hardened on surface of water

Cause	Solution
Water was too cold and caused it to set.	Start again with more hot water in the bath.

Problem: Marks closed up too quickly, leaving no gaps

Cause	Solution
Too much solution on the water.	Use much less stop-out to create the marks on the surface of the water.

Problem: The stop-out does not grip onto the plate

Cause	Solution
The plate is not properly degreased.	Degrease the plate with a mix of whiting and ammonia, or a degreasing agent. Do not use methylated spirits as it will remove the aquatint.

etching process: **spit bite**

Spit bite involves the direct application of a strong acid onto a metal plate with an aquatint ground using a paintbrush. This method of applying acid to an etching plate obtained its name due to the fact that saliva was added to the acid by spitting into it, which had the effect of breaking the surface tension. This would allow the acid to move freely and remain where it was painted. Dish detergent can be used as an alternative. The plate is prepared in the normal way; the edges are filed, and the surface is cleaned and polished. The metal is degreased, dried, and a fine aquatint is applied.

1.1.22

Cecil Rice
(British)
Westminster Bridge
7 x 4in (18 x 10cm)
Etching and spit bite—hardground,
fine aquatint with spit bite
Artist's proof printed by the artist on
a polymetal electric etching press at
Brighton Independent Printmaking, UK

Penny Siopis
(South African)
Siestog
27¼ x 38½in (69 x 98cm)
Spit bite aquatint and sugar lift
aquatint with monotype and hand-
stamping; custom mixes of 15
individual ink colors for à la poupée
wiping on all 4 plates and painting
on the monotype; Hahnemühle
Bright White 350gsm paper
Edition of 15 printed on a Sturges
etching press: Collaborating
printer Randy Hemminghaus;
edition printed by Tim Foulds,
Robert Maledu, and Jillian Ross

at the David Krut Print Workshop,
Johannesburg, South Africa

Siestog was created by Penny
Siopis in collaboration with master
printer Randy Hemminghaus in April
2003. The print began with a 2-color
monotype that was created by the
artist, followed by 2 large copper
plates, measuring 27½ x 39¼in (70 x
100cm), and 2 inset plates that were
all printed consecutively. The first
inset plate measures 5½ x 5in (14
x 13cm) and is located on the top
right-hand corner of the image and
the second inset plate measures

5½ x 8in (14 x 20cm) and is located
on the bottom center of the image.
Once dry, the artist hand-stamped
the word "shame" in a variety of
colors on the lower right side of the
image. The edition was printed in
May 2004.

step by step: **spit bite**

Safety note

This process requires the use of dangerous solutions. Every care should be taken to protect the user by working in a well-ventilated room with the appropriate apparatus, in addition to wearing protective clothing, such as a mask, rubber gloves, goggles, and an apron.

1.1.23

Spit bite: Troubleshooting

Problem: Mark too delicate

Cause	Solution
1. Acid too weak.	**1.** Strengthen the acid.
2. Acid left on plate too short a time.	**2.** Paint it on the plate in the same place several times.
3. Aquatint is not on plate.	**3.** Put an aquatint on the plate.

Problem: Mark too heavy

Cause	Solution
1. Acid too strong.	**1.** Dilute the acid.
2. Acid not washed off early enough.	**2.** Use acid more sparingly.
3. Brush too big.	**3.** Use a smaller brush.

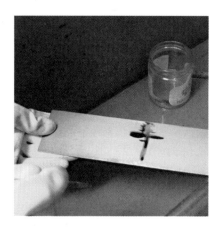

1 It is essential to wear sturdy gloves and eye protection as well as using the solution in an extractor cabinet. A small amount of nitric acid is mixed (20–30%) in a glass or plastic container. A cheap brush is used to paint directly onto the surface of the plate. The acid will bubble and fizz, turning to a brown color as it bites.

According to the strength of the acid, and the fact that an aquatint ground bites more quickly than a line, a tone will be produced in a matter of minutes. However, if a coarse aquatint has been used the period of time for biting the plate will be longer. The strength of the acid will diminish on the plate. Therefore at intervals it will be necessary to wash it off under the tap and paint new acid on the same area to continue the bite.

2 Acid painted directly onto a dry plate will give a mark with a sharper edge than if the plate is first washed down with water before the acid is applied with a brush. The solution will move in the water and create a much softer, more irregular mark, as the bite will have been diluted more in some places than others.

If there are areas that are definitely not required to be bitten then it is advisable to protect them with stop-out varnish.

A copper plate will require a stronger acid than a zinc plate. The tone that appears on the plate is always darker than it will look when printed; however, over-biting of a plate can cause the aquatint to lift.

3 It is essential that the plate is washed thoroughly, back and front, after biting to remove any residue of the strong acid. The aquatint can now be dissolved with methylated spirits before the first proof is taken.

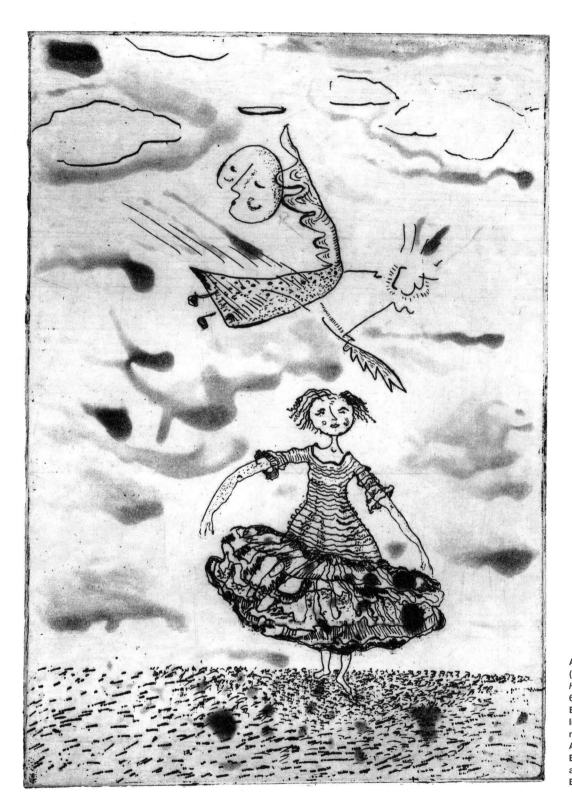

1.1.24

spit bite in practice

Ann d'Arcy Hughes
(British)
Happy Together
6 x 8in (15 x 20cm)
Etching—spit bite on fine aquatint,
line on hardground, zinc plate bitten in
nitric; oil-based etching ink; Fabriano
Artistico paper
Edition of 50 printed by the artist on
a Polymetal electric etching press at
Brighton Independent Printmaking, UK

etching process: **photo etching**

Photo etching is the transfer of a photographic image to a light-sensitive etching plate.
We assume that you have first produced a good-quality positive for this process.
One method is outlined below, although there are many possible ways.

1.1.25

Eric Bates
(British)
Angel
4¼ x 4¾in (11 x 12cm)
Photographic etching; Fabriano paper
Artist's proof printed by the artist on
a Rochat etching press at Brighton
Independent Printmaking, UK

1/30 "Adele" eric Bates

**Eric Bates
(British)**
Adele
**5 x 6¾in (13 x 17cm)
Photographic etching—
monochrome of original watercolor;
Charbonnel ink 55985;
BFK Rives paper
Edition of 30 printed by the artist on
a Rochat etching press at Brighton
Independent Printmaking, UK**

Safety note
This process requires the use of dangerous solutions. Work in a well-ventilated room with the appropriate apparatus, in addition to wearing protective clothing, such as a mask, rubber gloves, goggles, and an apron.

1.1.26

step by step: **photo etching**

Eric Bates is a British artist based in Brighton, UK. He is currently the Media Manager for the Victoria and Albert Museum in London, UK.

Before you begin: Producing bitmap images using Photoshop

A bitmap image is one that contains only black or white (clear when printed onto film) data and no grayscale information.

The notes below assume you are producing an image to print A4 (8¼ x 11¾in) or smaller and that your image will be printed the same size as the scanned image.

1. Scan your image; **File** > **Import** > [name of scanner software].

2. In the scanner settings, select SCALE as 100%.

3. Set the resolution to 250dpi (you will be printing at this resolution).

4. If need be, make any corrections to your image, such as contrast or cropping.

5. At this point you could be creative with Photoshop.

6. Once you are happy with your image, you can prepare it for printing.

7. If your image has large black areas you will need to add tone to these areas so they retain ink, avoiding open bite areas. Rather like adding an aquatint, this is done by making the image semitransparent.

8. To make the image semitransparent you first need to turn the background layer into a layer that allows transparency (background layers cannot have transparency). To do this, double-click on the background layer in the Layers palette.

9. This will ask you to name your new layer. You may then use the layer transparency slider (also in the Layers palette), selecting 70% transparency or 80% for subtle images.

10. You are now ready to turn your file into a bitmap and print it.

11. Select **Image** > **Mode** > **Bitmap**.

You will be required to flatten your image and select 250dpi. You can also select a dot method; I suggest diffusion dither, but you can experiment with others such as halftone.

12. In your printer's settings, make sure you are printing in grayscale and onto transparency. Once you have a positive that you are happy with, you are ready to begin.

The photo etch process

1 We will be using the following products: Aqua blue zinc—jet plate zinc coated with a photosensitive emulsion.
Aqua blue developer—for developing the Aqua blue zinc plates.

We are also assuming that you are familiar with the exposure time required by your exposure unit.

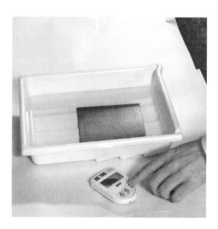

5 After the necessary time has elapsed, turn the exposure lights off, open the unit, and immediately place the exposed plate in a bath of room temperature developer for 3 minutes.

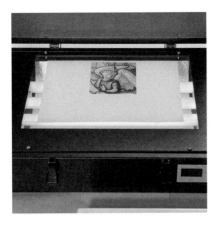

2 It is important to warm up your exposure unit lights before exposing your positive to the photosensitive plate. This will ensure that the lights are always at the same temperature and will yield the same exposure time.

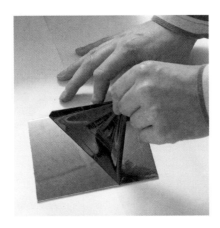

3 Peel the protective film from the surface of the plate to reveal the photosensitive emulsion applied to the plate. Do this in subdued light—certainly not bright daylight. You can handle the plates for a short time in such conditions, but keep this to a minimum and peel the protective layer off just before you expose the plate.

4 Place the printed surface of the positive in contact with the photo emulsion. If you require a reversed image, print a reversed image; do not simply turn the image over, as light bleeds into the thickness of the film with the positive printed on it and can yield a blurred image that may not develop satisfactorily. Place these face down on the exposure unit toward the lights. Close the exposure unit and start the timer.

6 Cover and do not agitate. This is important as you are trying to create absolute constants that allow you to make informed changes to exposure times or development times in order to achieve the required results.

7 The plate should now be washed under running water, preferably using a gentle water spray.

8 Once the image is revealed, force-dry the plate with warm air. This stops any of the emulsion creeping into the clear areas and acting as a resist to the acid.

The emulsion at this point is still quite soft and will perform better if allowed to harden further in daylight for an hour or two.

9 Etching can now take place in a bath of nitric acid at aquatint strength 5:1. Watch for bubbles forming on the surface and gently remove them with the use of a good-quality feather gently dragged over the surface. This strength of acid should produce good results in about 8 minutes, but it is best to inspect the plate from time to time with a good-quality eyeglass to check the amount the plate has etched. Wash the plate under running water to remove any acid residue.

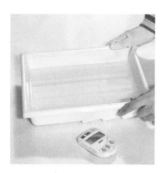

10 The photo emulsion is now ready to be removed. This can be done by either leaving the plate in the developer for 3–4 hours or by placing the plate in a reasonably strong bath of caustic acid. Be careful if this is your preferred method.

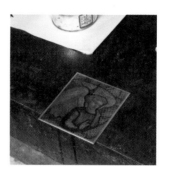

11 Once the emulsion is removed the plate can be treated as any other traditional etched plate. I would recommend a light polish and beveling the edges of the plate before inking up and taking a first print.

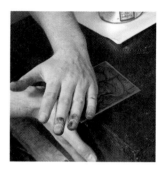

12 After the image has been inked up on the hotplate, the relief surface is gently wiped with the hand.

Photo etching: Troubleshooting

Problem: Image appears too coarse when printed

Cause	Solution
Acid is biting too fast.	Try a much weaker acid and bite for longer.

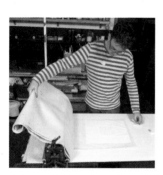

13 The plate is passed through the etching press using three blankets, two felts, and a swanskin.

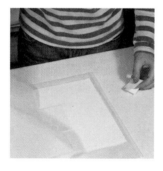

14 The tissue paper is removed from the back of the print. This prevents the size in the damp printing paper from being absorbed by the blankets.

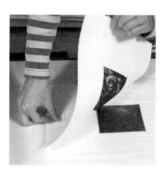

15 The paper is peeled back from the plate using small card clips to prevent finger marks on the print.

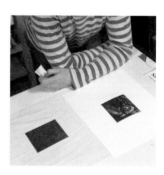

16 Having taken the first proof, you can now decide whether further work is required on the plate.

photo etching in practice

1.1.27

Jo Ganter
(British)
Set 6
28¼ x 36½in (72 x 92.5cm)
Photo etching and aquatint; ink
mixed from pigment (various
shades of black/brown and gray on
each of the plates);
Somerset White Satin paper
Edition of 4 printed by the artist on a
Takach motorized etching press at
Glasgow Print Studio, UK

1.1.28

color separations for etching with Photoshop

For color separations:

1. Scan the image and import it into Photoshop (or an equivalent program).

2. Under Mode, click on CMYK (Process Colors).

3. Open your Channels window by selecting Palettes under the Window menu, and going to Show Channels.

4. Select the Cyan channel only, select all, and copy the channel for Cyan.

5. Create a New File, and paste the contents of the Cyan channel into it.

6. Give your new file a name that contains the color it represents (for example, "MypictureCyan").

7. Under Mode, convert this new file first to grayscale, and then to a bitmap. This will make a black and white version that can be printed out onto film. Experiment with different forms of dithering, and different resolutions (dpi) to print.

8. Repeat steps 3 through 7 with the magenta, yellow, and black channels of the original scanned image.

9. Print the files, choosing Registration Marks under Options in Page Setup, under the File menu. These can be used as a guide when trimming the plate prior to printing. Under the Screen button in the same dialog box, insert these values to help avoid moiré patterns if you are printing halftones:

Cyan – 75
Magenta – 15
Yellow – 0
Black – 45

You can print a negative or positive image, depending on your needs.

They may be directly printed onto acetate using a laser printer or inkjet printer.

10. When you prepare your paper or other printing substrate, put some Scotch blue-plaid removable tape on areas where the registration marks will appear on each surface you will print on. That way you can use the registration marks, and then peel off the tape without scarring the print after you have finished printing all the colors.

Inks

Process colors are available in most brands of printmaking ink, and you can print with the appropriate cyan, magenta, yellow, and black inks. You may want to print with other colors, or with an ink other than the "correct" colors for some interesting effects.

William Kentridge
South African

*(Photograph courtesy of
Merwelene van der Merwe)*

1.1.29

profile: **William Kentridge**

William Kentridge's work examines issues of accountability, social and political memory, the impact of historical and recent oppression, and the importance of acknowledging and retaining an honest and undiluted reaction to societal and global tragedy and abuse.

While continuing to be a prolific printmaker, he is widely known for his theater work and animated films. He studied for a BA in Politics and African Studies at the University of the Witwatersrand, followed by a Fine Art diploma taken at the Johannesburg Art Foundation. In the early 1980s he studied mime and theater in Paris at the Ecole Jacques Lecoq.

Born into a Jewish family in 1955, William Kentridge grew up in a South Africa turbulent with the realities of apartheid. He describes his household as "progressive"; an environment that promoted an awareness of the actions of the society around him. He suggests that as South Africa has traditionally identified as a Christian country, to be Jewish developed awareness of being different. The importance of collective memory is a pertinent one when considering Jewish history and this sense of retaining the essence of previous experience is something Kentridge has acknowledged to be an important theme in his work.

Kentridge investigates and challenges the way society reacts, absorbs, and assimilates media images of traumatic events. He discusses the potential to accept and normalize the horror of violent situations and strives to retain and express the initial response inherent when one witnesses or becomes aware of an event that is shocking or unjust.

Kentridge states that his work does not attempt to illustrate apartheid, but is fueled by the impact and aftermath of these years as evidenced in South African society. His film *Ubu Tells the Truth* (1997) is a response to the experiences disclosed in the testimonies heard by the Truth and Reconciliation Commission. These themes of the perception of truth, memory, and identity continue to be investigated in a series of prints; the "Birdcatcher" (2007). In these works, it is ambiguous as to whether the dominant force is the figure or whether the birds have the position of power. The series "Zeno Writing" (2002; see p. 78) discusses the contradiction between the representation of war as a heroic endeavor as opposed to the realities of the political and individual experience. This issue of perception is further explored in a series of "Stereoscopic Photogravures" (2007). These twin images were presented side by side on a flat surface. When focused together using optical equipment installed above the works, the prints become one image, thereby altering the depth of field and creating an altered sense of the scene.

**William Kentridge
(South African)**
Zeno Writing (Chorus) **(from "Zeno
Writing," suite of 9 prints), 2002
Image 8¼ x 10¾in (21 x 27.5cm);
Paper 15½ x 21in (39.5 x 53.3cm)
Stereoscopic photogravure with
drypoint and burnishing,
from 1 copper plate;
Hahnemühle 300gsm paper
Edition of 40 printed by Randy
Hemminghaus at Galamander
Press, New York**

Stereoscopic images are dual
images produced and presented
side by side. The images are
viewed from above through a
stereoscope. This allows the
two images to merge into one
to produce a three-dimensional
viewpoint.

A/P

William Kentridge
(South African)
Etant Donnée (from
"Underweysung der Messung,"
suite of 6 prints), 2007
Each image 9 x 9in (22.5 x
22.5cm); paper 13½ x 22½in (34.3
x 57cm)
Photogravure with drypoint and
burnishing, from 1 copper plate;
Hahnemühle 300gsm paper
Edition of 40 printed by Randy
Hemminghaus at the Brodsky
Center, New York

chapter 2 **metal engraving**

Una Beaven
(British)
Dreaming With Open Eyes
13½ x 10¼in (34 x 26cm)
Drypoint; oil-based ink; Somerset
Smooth paper
Printed by the artist on an etching
press at Brighton Independent
Printmaking, UK

a brief history of metal engraving

An engraved mark can be described, in the most simplistic terms, as the result of an action that forces an edge or point, blunt or sharp, of one resistant object against the surface of another. The act of gouging a line in a piece of metal, a wall, or the ground is the basis of engraving. Evidence of this practice can be traced back to the cave art of prehistoric times.

As a fine-art form, an engraved work can be recognized by its crisp, sharp, clarity of line. While it was not until the fifteenth century that it developed as a creative art medium, the basic principles of engraving were utilized by goldsmiths and armorers, both of whom were important members of society in the 1400s. The art of the goldsmith was highly refined and the expense and delicacy of the metals used raised the profession from trade to skilled practitioner. It is plausible to consider that the engraving medium may have arisen from the need to record decorative designs incised in gold or on armor. Once paper became more easily available, it was only a small progression to reach the point where the paper prints became valued as objects within themselves.

Early masters in Germany and Italy

The dominant centers for the evolution of the engraved image during the fifteenth century were Germany and Italy. There were clear technological and stylistic differences that distinguished the work developing in these two countries. In the north, the artist–engraver designed and executed the whole image and enjoyed the benefit of a drum or roller press, which allowed for a greater and more even quality of line and tone during printing. The Italians were at the forefront of the Renaissance, so the

imagery they produced had a freedom and invention not apparent in the works created in Germany. However, initially some works were still hand-burnished, which resulted in a less uniform final print, and more than one individual contributed to the production of the engraved image. Andrea Mantegna (1431–1506) is an example of this ethic, as he chose to work with craftsmen who completed a majority of his engravings. Consequently, there is doubt as to whether he personally engraved more than eight of the 25 plates ascribed to his hand. However, his style is said to have had a great influence on other artists, in part due to the fact this his works were widely distributed across Europe.

In Italy, Florence emerged as an important force with the development of two styles of engraving: the Fine Manner and the Broad Manner. It is thought that the Fine Manner style originated from the "Niello" process used by silversmiths. A series of fine lines were engraved closely together into the silver. The incised lines were then filled with a substance similar to enamel, which forged with the metal when heated. Once the surface was polished, the design remained black against the silver background. A similar pattern of delicate line work can be seen in some engravings of the time. While the Fine Manner created a sense of the tones found in wash drawings,

the Broad Manner is characterized by broader, simpler lines with occasional crosshatching that is more reminiscent of pen drawings. One of the most important works to incorporate both these styles was *The Battle of the Naked Men,* created by Antonio Pollaiuolo (1432–1498). Originally a painter, he is acknowledged to be one of the first artists to study human anatomy.

In the north, the first significant engravers were anonymous artists: the Master of the Playing Cards and the Master of the Housebook. The first named copperplate engraver was Martin Schongauer (1440–1494), who was born in Germany and trained as a gold- and silversmith. He influenced one of the most prolific printmakers, Albrecht Dürer (see p. 15), who engraved his own intaglio designs and also experimented with etching. During the sixteenth century, the potential of the line-engraving technique was enhanced by the work of Dutch artist Hendrick Goltzius. He did not revert to crosshatching to create tonal variations in his images but relied on his skill with the burin.

Engraving in the seventeenth and eighteenth centuries

By the seventeenth century, the engraving medium was being exploited by the contemporary painters of the era. Artists such as Raphael, Rubens, and Van Dyck employed professional engravers to reproduce their paintings as a marketing venture. The reproduction of artists' work in print form could further their careers by heightening public awareness through the sale of the engraved copies. However, the stylized nature of the prints reduced the art of engraving to one of reproduction rather than that of a medium capable of creative or original design.

In England, William Hogarth (1696–1764) had discovered the very same fact. He was self-taught in the rudiments of drawing and painting, having originally trained as a silver engraver. While his paintings gained a level of fame, the engraved copies of his series "The Rake's Progress," "The Harlot's Progress," and "Marriage à la Mode" proved far more lucrative.

In contrast, William Blake (1757–1827), a contemporary of Goya's (see p. 18), is recognized for his sense of original design and creative thought. He experimented with engraving and color techniques to create illustrated books of his own poems and writings that incorporated text and figures in flowing, swirling designs. He printed every edition of his work to order on his press and developed a transfer method for adding additional color. This involved the painting of his design in tempera onto a card, which he then offset onto the print. It was not until his death that Blake's work began to be recognized; during his lifetime, his work was largely unappreciated.

Contemporary artists

More recent advocates of the engraving medium include Stanley William Hayter (1901–1988; see p. 149), who was regarded as one of the most influential latter-day printmakers due to his experimental approach and achievements. Anthony Gross (1905–1984), a friend of Hayter's, is also recognized for his explorations into the potential of the etched and engraved line.

Drypoint

The drypoint technique falls within the boundaries of the engraving medium, and we devote a section to this technique (pp. 86–93). A hard needle is forced across the plate surface to create a scratch. This action creates a burr—flanges of metal that fold back from the edge of the scratch. It is these flecks of metal that retain the body of ink. The characteristic of a drypoint is a softer, more furry line in comparison to the controlled clarity of the engraved line. Considered to be a complementary technique, drypoint is often used in combination with the engraving and etching mediums as well as standing alone as a process in itself. The drypoint plate is very fragile and generally does not sustain more than 20 good impressions unless the surface has been steel-faced.

Some artists who have exploited the medium include Rembrandt, who applied the drypoint technique to produce strong, rich tones in his compositions. Max Beckmann (1884–1960) used drypoint with an etched line to enhance the contrast of line and tone, and French artist Louise Bourgeois (b. 1911) created her work *Triptych for the Red Room* (1994) with a combination of drypoint, etching, and aquatint. She followed that work with a pure drypoint, *Ode à Ma Mere* (1995).

In this section can be found examples of contemporary artists such as Gary Goodman, Pat Thornton, Una Beaven, and Ann d'Arcy Hughes.

1.2.2

a brief history of mezzotint

The mezzotint technique involves the use of a tool to uniformly roughen the entire plate surface. The aim is to ensure that enough ink is held to impart a consistent layer of ink back onto the paper. The image is formed by burnishing back the rough surface to create smooth areas, which in turn reject the ink and therefore print as tones or white. The method has been known under a variety of terms: *manière noire*, the black method, the dark manner, and *la manière anglaise* following the enormous success it found in England.

Early developments

Ludwig von Siegen (1609–1680) is credited with the development of the process in 1646. He produced his images using the reverse of the process that is used by contemporary mezzotint artists. With the aid of a wheel that was spiked, he worked from light to dark by creating pits of varying shapes and sizes in the surface of the plate.

The mezzotint technique was brought to critical attention when it was embraced by Prince Rupert of Palatinate, the son of Frederick V of Bohemia and nephew of Charles I of England. His ability to move freely within regal European society and his contact with the royal court of England is thought to have advertised the merits of the medium effectively. The time-consuming and potentially inconsistent nature of preparing the plate surface led the prince to employ an assistant, Wallerant Vaillant (1623–1677). A French etcher and portrait painter, he is thought to be the first professional mezzotint artist, having produced more than 200 works after leaving his employment with the prince.

It was in the 1670s that a Dutch engraver, Abraham Blooteling, developed the rocker, a tool that revolutionized the mezzotint method. With a curved, finely toothed edge, the tool is rocked across the surface of the plate whereby a series of uniform indentations are transferred into the metal. As the task required no specific artistic leaning, unskilled assistants were employed to prepare the plates, which allowed the engravers to concentrate on the production of their imagery.

The mezzotint process was advantageous in that worn-down plates could be reworked and errors that occurred while creating the image could be corrected relatively easily in comparison to the problems such issues posed when dealing with other intaglio processes.

Mezzotint for reproduction

Due to the ability of the mezzotint to incorporate deep blacks, stark whites, and subtleties of tone across the spectrum, the highly skilled early artists ceased to design creative images of their own in favor of meeting

commercial demand for reproductions. A growing economy encouraged the market for engraved facsimiles of oil paintings from Old Masters such as Van Dyke and Rembrandt. Works that were sold abroad were first copied by mezzotint artists to record or educate. An interesting coexistence developed for a time, as the growth of the mezzotint began to exert an influence back into the paintings created in the eighteenth century. While the earlier mezzotints mirrored the style and subjects of the painting from which they were derived, there came a point when these reproductions were used widely as reference material to support the background and outdoor scenes of the painters of the day. The studio-based painters of portraits or historical scenes had no opportunity to travel around Europe, so used the examples of architecture and countryside environments to enhance their compositions.

In the late seventeenth and early eighteenth centuries, the mezzotint industry had established itself in Europe, with centers of vast productivity appearing in Vienna, Nuremburg, and London. Alongside being used for reproduction, mezzotints began to be utilized to illustrate the current affairs of the day, and prints became prevalent covering subjects that ranged from gentle parody to biting political satire. There is evidence of political imagery in prints that advocate obvious support for the American Revolution and it is assumed that these were largely created for sale abroad.

The production of the first mezzotint on North American soil is attributed to Peter Pelham, an English mezzotint engraver who moved his family from London to Boston in 1727. The American market at the time favored the art of glass painting, and mezzotints were part of this production process. As European imagery was popular, mezzotints were glued to the underside of the glass and used as a guide by the artist who painted the design directly onto the topside.

Modern developments

It was not really until the second half of the nineteenth century that printmaking was once again embraced by artists as a means of creative and original expression. With a revived interest in the intaglio processes of etching and drypoint, enthusiasm for the tonal delicacy of the mezzotint instigated a gradual reintroduction of the technique. However, use of the medium continued to be sporadic in the twentieth century, with only a small number of practitioners engaging in the process.

Although the mezzotints of the past have been invaluable to historians, there are relatively few contemporary mezzotint artists. In the 1950s, Mario Avati (b. 1921), a self-taught mezzotint artist, moved through the techniques of etching, drypoint, and aquatint to arrive at the mezzotint. Leonard Marchant (1929–2000) and Yozo Hamaguchi (1909–2000) are two other notable mezzotint printmakers.

In the late twentieth and early twenty-first centuries, the mezzotint technique, while by no means as prevalent as in previous years, continues to be used by contemporary artists working internationally, as showcased in this section. Our illustrations include works by American artist Mary Farrell, Canadian Guy Langevin, and British artists Ray Dennis and Noreen Grant, among others.

engraving process: **drypoint**

In drypoint, the surface is scratched into with a sharp point, producing a print by trapping the ink under the burr, and in the line.

1.2.3

**Trevor Price
(British)**
The Five Senses Satisfied
**15½ x 17in (39.5 x 43.5cm)
Drypoint; intaglio etching inks;
Somerset Textured 300gsm paper
Edition of 150 printed by the artist
and his assistant Sean O'Connor
on a Rochat etching press at the
Clink Press, London, UK**

**Both images: Drypoint on
polycarbonate sheet. Image drawn
using traditional drypoint needle;
thicker lines made by melting the
plastic with a soldering iron. Intaglio
lines inked up in black ink, surface
wiped clean, and then a blended
ocher rollup over the top area of
the plate. After printing and drying,
additional colors were applied by
hand using watercolor paints.**

Trevor Price
(British)
Making Rainbows
15½ x 17in (39.5 x 43.5cm)
Drypoint; intaglio etching inks;
Somerset Textured 300gsm paper
Edition of 100 printed by the artist
and his assistant Sean O'Connor
on a Rochat etching press at the
Clink Press, London, UK

step by step: **drypoint on zinc plate**

1.2.4

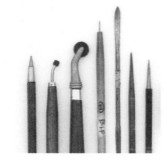

1 Drypoint tools. Left to right: diamond point; roulette; wheel roller; fine point; scraper-burnisher; heavy point; engineer's scribe.

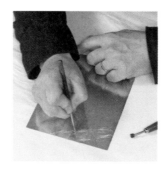

2 A tool is selected and worked directly onto the surface of the zinc plate, using a firm hand with sufficient pressure to create a visible scratch and an upstanding burr, or twist, of metal.

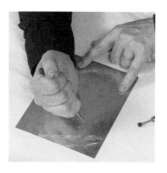

3 The position in which the tool is held in the hand may change to create the pressure required to produce a contrast in depth of line.

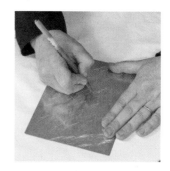

4 Changing the tool gives a noticeably different result and creates a greater variety of marks in the final print.

5 An indented wheel roller can be purchased in various sizes. It is used to produce a series of dots or lines.

6 The scratch marks, and raised burr of metal, can be easily seen on the surface of the plate. Also note the dotted lines created by the wheel roller.

7 The finished image to be printed is placed on the hotplate. It is then inked and gently wiped with gauze and tissue before being put through the etching press under a piece of dampened paper.

8 Note the rich, velvety black marks that have a soft, almost blurred quality, with the dots of the wheel roller standing out in contrast.

Gary Goodman
British

1.2.5

profile: **Gary Goodman**

"My first clear memory of art is from when I was about six years old, at primary school. I made a painting of a Scotsman in a kilt and the teacher put it on the wall. I remember being very proud of that; my teacher even gave me a little model of a Scotsman afterward. I just loved painting all the time, and as far back as I can remember I really enjoyed making marks.

"When I was slightly older, my two brothers and I became interested in football. My father was manager of a local football team, so I started designing my own fantasy football stadium. My father was also interested in art; when we children were going to bed one night he said he would make us a drawing. He did this really beautiful pencil drawing of a bullfight—it was pinned up in our living room for quite a while. Drawing and painting did not seem like schoolwork; art was something that I really loved doing. At my grammar school I had a very good art teacher who was interested in observational drawing; consequently I really, truly, believe that drawing underpins everything. I still do as much as I can and always have a notebook for recording the landscape and the world around me.

"I took a Foundation course in art straight after school in Bedford. It was in 1976, when the punk era was just starting, so it was a very exciting time. I was only sixteen and like a lot of people I did too much socializing! About that time I had a really bad accident and fell down a thirty-foot lift shaft, so it was two years before I got back into art. However I was still drawing, and I particularly remember getting a book by Ralph Steadman of his drawings of Sigmund Freud. I found the scratchy pen-and-ink images very exciting.

"A friend and I then decided to move down to Brighton. When I met Teresa, who is now my wife, she suggested I apply to Brighton University because I had all this work. I put it in a portfolio, applied for a place on the degree course in Illustration, and got in, which was fantastic. As it had been five years since my Foundation course, I was determined to make the most of this opportunity. I was a couple of years older than most of the students, so I got really involved and made good use of the time, especially studying life drawing, which I adored. Looking back, what was important was the fact that the first year was a combined Graphics and Illustration course, which I now realize subconsciously helped me with composition.

"I only really got into printmaking when I started the course at Brighton. We all had to do a bit of screenprinting, some etching, and relief printing. I particularly enjoyed etching, which I find surprising now, because I am quite a spontaneous, intuitive type of artist, and quite impatient. However, I did not mind the involved process of etching, which one might presume would get in the way. Etching is about drawing, and what I loved was being able to see the work in print. Although you can use color, there is something about that raw, black, deep etched line that you cannot get in any other medium.

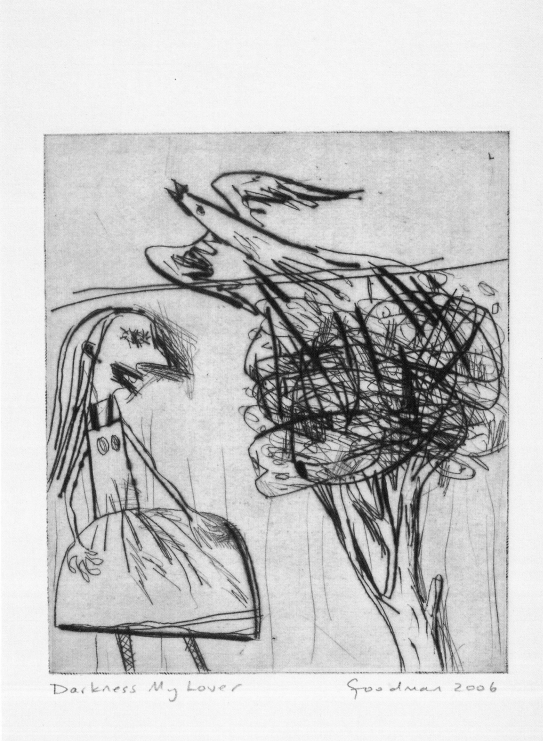

Darkness My Lover Goodman 2006

**Gary Goodman
(British)**
Darkness My Lover
**7 x 6in (18 x 15cm)
Drypoint on polished
zinc plate; oil-based
etching ink;
handmade paper
Printed by the artist
on a polymetal electric
etching press at
Brighton Independent
Printmaking, UK**

Gary Goodman
(British)
Warrior
6 x 4in (15 x 10cm)
Drypoint with Chine collé; polished
zinc plate; oil-based etching ink;
handmade paper
Printed by the artist on a polymetal
electric etching press at Brighton
Independent Printmaking, UK

"I totally believe in making a virtue of the random mark, even if it is just
a scratch on the plate. I feel that etching is as important as painting, while
my poetry is quite separate from my prints. The subject matter is either
something that I can only write about rather than make an image, or vice
versa. However, I am sure they must feed into each other. It is difficult
to say where one's inspiration comes from, as other forms of art such as
music, literature, and film often inspire me. I am a very emotional, sensitive
person so I want to make something that has a level of intensity to it.

"There are certain artists that I have stayed with throughout my life: one
is Van Gogh, for his pure honesty. Within my own work I can see great
changes over the years, but the themes are similar. I am very interested
in darkness and light—the thin curtain found in fairy tales that have a
sinister background. I hope that aspect comes through in my images.

"Boredom is one of my greatest fears; many of the things I do are to
prevent myself worrying about or pondering things. I would rather be
doing than thinking, so I am always drawing or painting. At the moment
I am working full-time, so I am even more disciplined at making good
use of my time, but I always wish I had more. Printmaking is something
that has enhanced my life. It is something that I feel passionate about, and
passionate about sharing."

Preparation

The plate is prepared in the normal way: the surface cleaned and polished, and the sides filed to a 45-degree angle and scraped.

1.2.6

step by step: **drypoint**

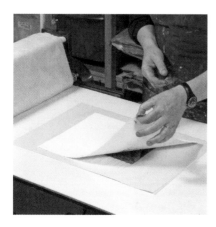

Printing

The plate is printed in the normal way for an intaglio image (see pp. 133–136), but special care is taken to wipe the surface gently to avoid destroying the burr. The ink is oil-based, and the paper pre-dampened. This is a good medium for capturing spontaneity as there is no need for the use of grounds or acid, and Chine collé (see pp. 214–222) is an immediate way of adding color.

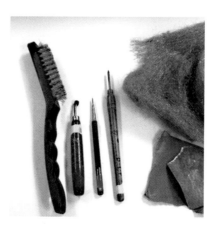

Materials

The minimum requirements to create the block are a surface to work on and a needle to scratch with.

Zinc or copper are the ideal surfaces, as they are sufficiently soft to easily work into, but survive to produce a reasonable number of prints. Copper plates can be steel-faced to produce large editions. Steel is too hard, and aluminum is so soft that it will allow only a few prints to be made. Plexiglas, or plastic, has a similarly short printing life.

Drawing

A basic sharp needle will create a mark. Traditionally, the drypoint needle had a heavy handle to aid in creating additional pressure to form the required burr. The burr retains the ink and produces the printed mark. Wheels and roulettes can also be used, as well as coarse sandpaper, wire brushes, or wool, which will scuff the surface to create a light tone.

Corrections

Unwanted lines can be removed with the scraper-burnisher, and additional marks added as required. Prior to printing, loose ink can be gently rubbed into the lines to allow the artist to see the work in progress.

Drypoint: Troubleshooting

Problem: Print is too pale

Cause	Solution
1. The incised line did not create a strong enough burr to hold ink.	**1.** Use a sharper tool and more pressure.
2. The ink was too stiff.	**2.** Add a little copperplate oil to the ink.
3. The paper was too dry.	**3.** Dampen the paper for longer.
4. Insufficient pressure on the press.	**4.** Increase the pressure on the press or add another blanket.

Problem: The proofs print well for the first few pulls, and then the prints look pale

Cause	Solution
The plate has been wiped too vigorously so the delicate burr has been squashed.	**1.** Ink up and wipe with extreme care, wiping gently so as not to pull at the metal.
	2. Add a little weak copperplate oil to the ink so that the wiping process requires less pressure.
	3. Apply less pressure on the press.

Pat Thornton
(British)
She Knows Better
6¾ x 4¼in (17 x 11cm)
Drypoint scratched onto zinc plate and
Chine collé—graphite pencil on white
tissue paper, handpainted with yellow
watercolor wash; oil-based etching ink;
Seawhite cartridge paper
Edition of 12 printed by the artist on
a Polymetal electric etching press at
Brighton Independent Printmaking, UK

engraving process: **metal engraving**

A burin is used to engrave a line into copper. The burr is removed and the print is taken from the incised line.

1.2.8

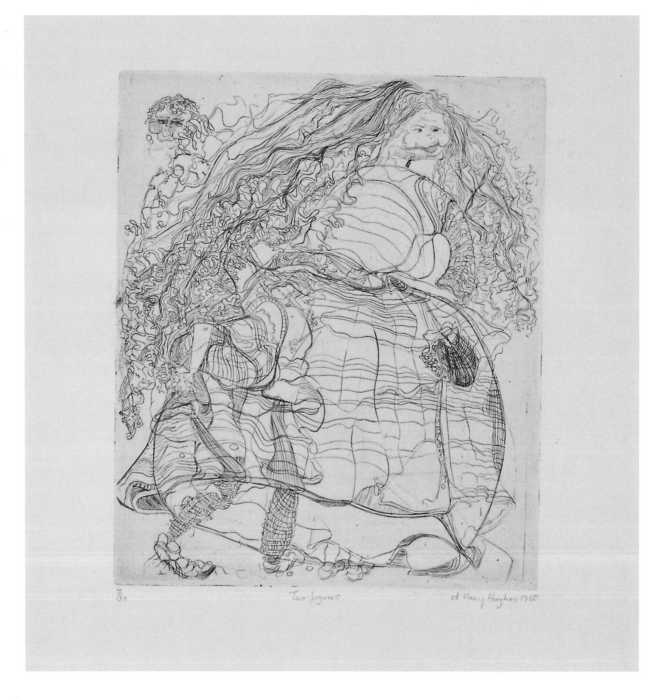

Left: **Ann d'Arcy Hughes**
(British)
Two Figures
7 x 6in (18 x 15cm)
Copper engraving
Edition of 30 printed by the artist at
Slade School of Art, London

Below: **Ann d'Arcy Hughes**
(British)
Winds
5 x 7in (13 x 18cm)
Copper engraving
Edition of 15 printed by the artist at
Slade School of Art, London

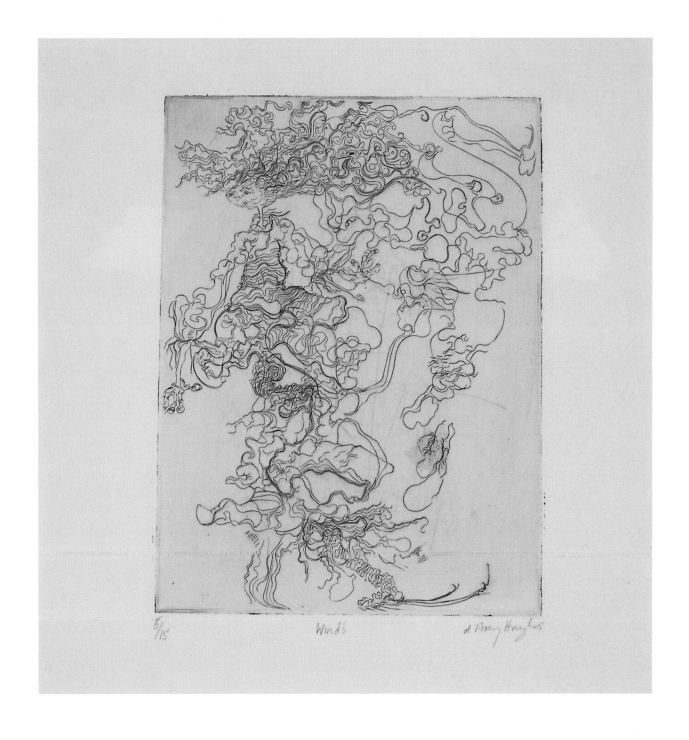

tools: **metal engraving**

1.2.9

Metal engraving is also known as burin engraving, as a burin is used to engrave a line into the copper plate. The burr is removed and the print is taken from the incised line. The character of the line is crisp, clean, smooth, and flowing. The ultimate requirement for a metal engraver is the possession of an accurately set up and sharpened tool. The burin, or graver, needs to be a personal item made specifically for the user.

A straight-rod, lozenge-shaped burin set up by printmaker Anthony Gross (see p. 82).

Setting up the tool

The burin is a square or lozenge-shaped steel rod, bent or straight. One end has been cut off to form an angle of 45 degrees to the axis of the stem; the other end is fitted into a mushroom-shaped handle that has been shaved flat on the lower side. The length of the rod should be cut to allow the handle to sit comfortably into the palm of the hand, near the base of the little finger, while the forefinger rests on top of the rod with the thumb at the side, and the other fingers curled up. A short protrusion of metal should come beyond the forefinger.

The three planes of the rod meet at the cutting point, the lower tip of the lozenge. Initially the steel is tempered to harden the metal. It is heated up to five times, quenched in water, and polished. Most burins will have been heated and quenched three to four times. However, if the metal is made too hard it will become brittle and the point will break during use. This process may leave a residue of rust, known as "skin," which is removed at the time of sharpening.

The underfaces—that is, the two parallel flat sides leading up to the point—are sharpened using a hard Arkansas stone and a fine carborundum.

The rod is laid flat on the level surface of a stone that has been rubbed with machine oil. The tool is held by the rod with the fingers and thumbs of both hands. One hand will keep the tool from rolling while the other will give sufficient pressure and move the metal evenly back and forth. When both of the long sides have been sharpened, the edge at which they meet should be as keen as a knife. Held up to the light there should not be a white line where the planes join—this would be light reflection from a third plane, which means it has been sharpened incorrectly.

The end lozenge face is then sharpened. Held to the light, a white pinpoint of reflected light will be apparent on the point of the tool; this needs to be removed. The rod is held between the thumb and the forefinger, as near to the point as possible. It is placed flat on the stone and grinding begins using a fast circular motion. It is held to the light again and if the pinhead has been removed, the point is sharp.

Cutting the line

The burin is held as described above. It is eased into the copper, exerting gentle

A bent rod lozenge-shaped burin, set up by S. W. Hayter (see p. 149).

pressure at a slow pace. As the line cuts, a spiral of metal will appear in front of the tool. The plate is rotated to create a curve.

The pressure and depth of line is kept constant. However, if a darker line is required a second one is cut close to the first, and the intervening metal is removed.

A three-faced scraper tool used for removing the burr.

It is necessary to remove the burr, as the print is taken from the cleancut engraved line. It is helpful to have two scrapers, one sharp to cleanly cut off the spiral of metal, and a blunt one to gently move back and forth across the cut line to remove any remaining splinters. The burr can also be removed with charcoal or the finest emery paper (4/000) before the plate is polished and proofed.

It is possible to produce a wide range of marks by changing the angle at which the burin is used, by making short cuts and dots, crosshatching, and parallel lines. Some lines can be ended by just stopping the cut and lifting the tool. For others the tool can be eased out, ending the line with only a fine scratch.

Copper is used, as steel is too hard and zinc and brass are too soft. It is better not to polish the surface to a high shine before starting work, as the glare can be disturbing to the eyes. A proof is taken by inking up and wiping the intaglio line in the same way as an etching. Additional lines can be added after the first proof if desired.

If a very large edition is required, the copper can be steel-faced.

mezzotint in practice

1.2.10

Mary Farrell
(American)
Rude Awakening
8 x 5¾in (20 x 14.5cm)
Mezzotint and drypoint; Graphic
Chemical #135C black etching ink;
Arches Cover White paper
Edition of 35 printed by the artist on a
Praga etching press at her studio

The entire plate was rocked and then
the image burnished and scraped out
of the ground. The artist also used
roulettes in some final passes.

engraving process: **mezzotint**

The mezzotint technique involves the use of a tool to uniformly roughen the entire plate surface. The aim is to ensure that enough ink is held to impart a consistent layer of ink back onto the paper.

1.2.11

Ray Dennis
(British)
Resting on the Road
13¾ x 6in (35 x 15cm)
**Mezzotint; French 88 ink—stiff warm
black with red; Hahnemühle 200gsm
paper
Edition of 25 printed by the artist on
an 18th-century etching press at the
University of Brighton, UK**

In the making of a mezzotint plate, tools are required first to create the burr on the metal to hold the ink, and then to remove the burr and return the plate back to a shiny surface that will not hold ink, with innumerable variations of tone in between.

Roulettes

Roulettes are made up of a toothed wheel that is able to rotate on the end of a rod and handle. They come in a large range of shapes and sizes. The difference between the tools lies in the rows of teeth that they have on the drum, which produce a particular gauge of line on the metal. The purpose of the tool is to create a burr that will hold ink, which makes them particularly useful for repairing tonal areas within a mezzotint.

1.2.12

tools: **mezzotint**

Scraper

The scraper tool is so fundamental to the creation of a mezzotint print that mezzotint engravers were traditionally known as "scrapers." The tool generally has three flat faces with three sharp blades that meet at a point. It is used in mezzotint to slice off the top of the burr to a varying degree. The more that is cut away the less ink is retained, and consequently the lighter the area will print. The action of the scraper produces differing densities of tone within the image, but not a white as it leaves a grazed surface.

Burnisher

The burnisher, which can be obtained in numerous shapes and sizes, is normally a curved, smooth, shiny metal tool ending in a point. The tool is used with a little oil to polish an area that is to be returned to white on the print. A previously scraped area can be burnished to bring up the highlights.

Alternatively, if the burr is burnished without having first been scraped then the tip will flatten and the polished top will print white, while the surround will trap ink and remain black.

Rocker

The distinctive character of the mezzotint print lies in the unique quality of the plate. A mezzotint plate is made up of innumerable little burrs that are produced on the surface by the action of a rocker. The rocker tool is made from steel shaped into a toothed blade and attached to a wooden handle or a pole device. One side is curved and smooth, and the other is flat with even vertical grooves ending in fine, sharp teeth. The nature of the ground created depends on the gauge of the teeth on the rocker and the number of times the tool is passed over the surface of the plate. The standard gauges for rockers range between 45 and 150 teeth per inch.

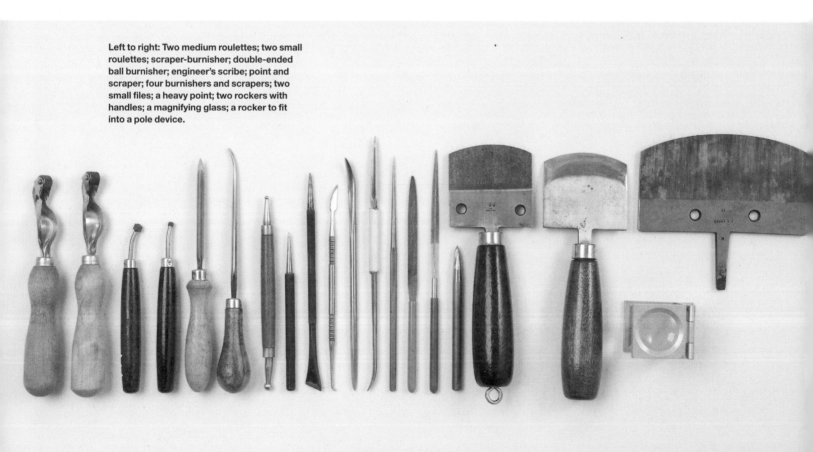

Left to right: Two medium roulettes; two small roulettes; scraper-burnisher; double-ended ball burnisher; engineer's scribe; point and scraper; four burnishers and scrapers; two small files; a heavy point; two rockers with handles; a magnifying glass; a rocker to fit into a pole device.

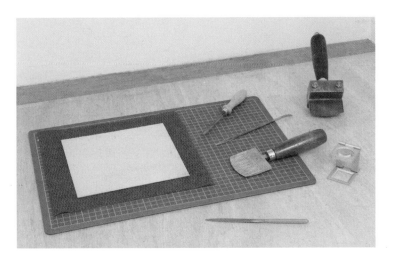

1 A thoroughly cleaned and prepared plate is placed on a flat surface, with the necessary tools to hand. A cutting mat and nonslip mat are helpful.

step by step: **mezzotint**

Preparing, rocking, and drawing the plate

Remove any scratches or tarnish from the metal (soy sauce will strip tarnish from copper) and polish it. It is not necessary to produce a high shine, but any dips or bumps in the metal will cause problems in the rocking. Repoussage is a term for hammering gently on the reverse side of the metal to restore an even surface.

File, scrape, and burnish the edges to create a smooth bevel. It is important that the bevel is wide—⅛ to ¹⁄₁₆in—with a gentle slope. This helps to prevent breaking the teeth of the rocker, a common problem when nearing the edge of the plate. A coarse crosscut file can be used to form the angle of the edge, followed by a finer file to shape the bevel. The corners should be rounded.

Place the metal plate on a cutting or nonslip mat. If the nonslip mat is made to the same size as the metal, the graph on the cutting mat can then be used to assist in the uniform calculation of the lines to be rocked.

Holding the rocker

The rocker can be held with either the fluted or the smooth side facing the user, providing that the tool is not tilted toward the beveled edge. This incorrect position would create a weak burr, and eventually break the teeth of the tool.

If the grooved side is facing the wrist the handle is slightly pulled toward the body, at an angle of 5 to 30 degrees. This not only gives a strong burr, but also helps when moving the tool forward.

If the reverse position is preferred, with the smooth beveled side facing the user, it is necessary to adopt the same angle, but tilt the tool away from the body. This angle is sometimes chosen because it is easier to achieve more pressure, and therefore create a deeper indent.

In order to obtain a uniform result it is advisable not to alternate the position once the process is started, as the curves of the arc differ in direction depending on how the tool is held. A 90-degree angle will inhibit the ability to move forward, but can be used for touching up.

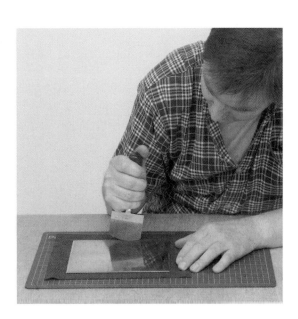

2 The artist finds a position that is comfortable, sustainable, and gives complete control of the tool, while producing the desired result.

Rocking

The reason for rocking the plate is to displace the metal and create a burr that will hold ink. The blade is generally rocked from side to side, using the whole length, in a regular rhythm to obtain uniformity.

The number of passes required to create a ground, and the pattern that the artist works to, depends on a number of factors: the metal, the rocker, and the desired result. Here, the artist took about 8 hours to rock the copper plate. The rocked passes were made vertically, horizontally, and diagonally, working from both sides.

The proximity of the rocked lines determines how coarse or fine the resulting ground appears. Making a mark to identify the center of the rocker blade will assist the user in the precise repositioning of the tool, and in sustaining a straight line. Weights can be attached to the handle of the rocker to obtain greater pressure.

Rockers can be purchased with teeth ranging from fine to coarse. You would use a coarse tooth first, and move to a finer tooth in the later stages.

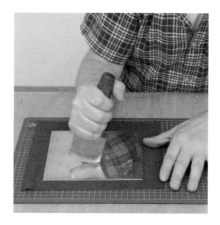

3 Start with a center pass. The plate must remain static.

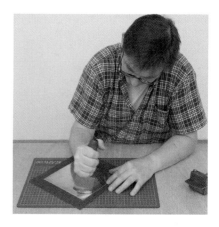

4 A diagonal pass.

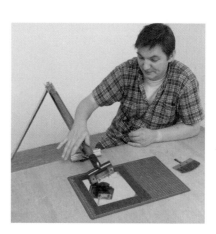

5 This tripod, made by the artist, derives from an ancient design.

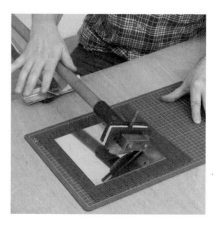

6 Note the weight attached to the outside of the rocker, which provides the desired pressure. Note also the dipped channel to hold the handle, which produces ease and consistency when rocking.

Passes made by the rocker

There is a wide range of diagrams available to advise on the angle and number of passes required to make a good, even ground. It is a matter of personal choice.

The tripod legs of the illustrated pole stand are adjustable, to enable the angle of the rocker to be changed as desired. The additional weights attached to the front of the blade can be removed or increased, according to need. The depth of the ground is dependent on the amount of pressure afforded by the toothed blade of the rocker.

This diagram shows the structure used by the featured artist.

Positioning the rocker

As the rocker moves up the plate in each pass, the space left between each rocked line is referred to as "open" or "closed." When the gap left is wider than the width of an individual rocked line, this is considered an open ground. When the distance is narrowed, and the individual lines become more indistinct, this is referred to as a closed ground.

Another consideration is whether the individual passes overlap or butt up to each other. As long as the same procedure is followed each time the outcome will be satisfactory.

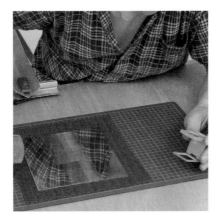

7 The artist is checking the overlapped passes with a magnifying glass, noting the accuracy of the distance between each pass, and the depth of the burr.

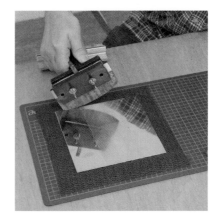

8 The rocker is carefully repositioned to continue the process. Regular spacing between each pass is essential.

The image

A soft graphite pencil or colored crayon can be used to draw directly onto the ground. However, should the image need to be reversed on the plate (to produce a print that is the same way round as the original drawing), a tracing can be made. The tracing is turned over and drawn onto the plate over carbon paper, taking care not to harm the burr by pressing too hard.

Tools

For the mezzotint artist, the two most important tools, besides the rocker, are the scraper and the burnisher.

The scraper

The scraper is held by two of the faces of the three-sided scraper. The side of the blade is used to scrape away the burr, not the point, as it can produce scratch marks. The scraper blades must be kept sharp, and the action of scraping on a mezzotint ground should be cautious and gentle, to allow for the production of gradations of tone. The fine copper dust produced should be removed at intervals.

9 The image is drawn gently onto the prepared plate with a soft graphite pencil.

10 Using a three-sided scraper, the artist begins to work into the burr, removing the points and thereby creating a flat area that will hold less ink and, when burnished, print as a white. Note the various sizes of scrapers and burnishers ready for use.

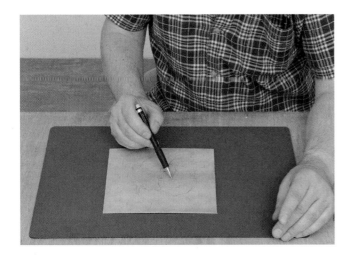

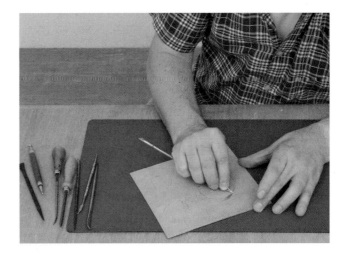

The burnisher

The subtle gradations of tone that are produced by the scraper may be what is desired. However, if it is necessary to produce pure whites, this action should be followed by the use of a burnisher. A little light oil on the plate, or the end of the tool, is recommended when burnishing. This prevents friction between the metal surfaces, stops scratching, and makes the tool easier to handle.

A burnisher can be used without first using a scraper. This may be required if gentle tones, rather than whites, are desired. There is a range of burnishing tools available that produce varying results. Experimentation is the best way to find the right tool for your needs. A magnifying glass is the only way, before proofing, to check the progression of the marks produced.

11 A tiny drop of light oil is put onto the rounded end of the burnisher. The tool is then used on the scraped areas, flattening the surface to a smooth shine.

12 Any areas that need retouching may be worked with a roulette wheel, thereby recreating the rough surface to allow further scraping and burnishing as required.

13 The finished work is checked with a magnifying glass before proofing.

14 The finished plate. Note the gradation of tone from the highly burnished areas, which will print white, to the various grades of tone, back to the untouched areas where the burr will produce a black. (See p. 137 for print.)

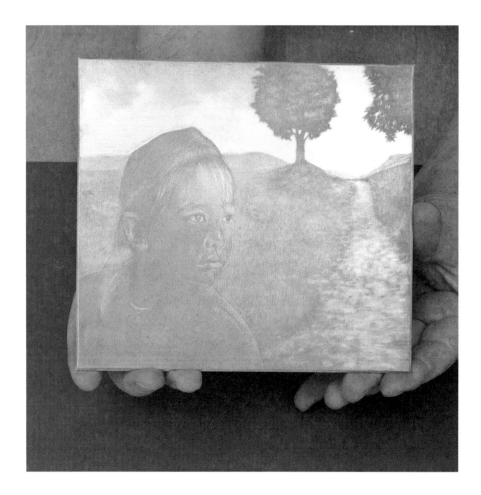

Mezzotint: Troubleshooting

Problem: Print pale all over

Cause	Solution
1. The plate was not rocked sufficiently to produce a strong burr.	**1.** In future, rock the plate more thoroughly, and if desired take a print from the rocked but undrawn plate to assess the density of black. If the black is pale the plate can be re-rocked.
2. The ink is too thin.	**2.** Mix slightly stiffer ink.

Problem: White specks within the print

Cause	Solution
The plate has not been saturated with ink.	**1.** At the start of proofing, ink up the plate a couple of times without printing in between; this will build up the ink within the burr.
	2. While the print is still wet, use the tip of a wooden toothpick to smooth ink gently across the white area.

Problem: Burr wears down too quickly

Cause	Solution
1. Copper is too soft or too thin.	**1.** When buying copper "half hard" is required, not "soft." Engraving quality is available, but it is expensive. 1mm or 1.2mm is a suitable thickness. In the past, metal was sold in 16-gauge or 18-gauge categories.
2. Large edition of prints required.	**2.** Steel-face the plate; this will prevent the surface from wearing down.

Problem: Tooth broken off rocker

Cause	Solution
Inappropriate use, or the tool has been dropped.	The area can be reground by an experienced person.

mezzotint in practice

Noreen Grant
(British)
Ancient Cap
39½ x 30in (100 x 75cm)
Mezzotint; Charbonnel 55981 ink;
Hahnemühle paper
Printed by the artist

Guy Langevin
Canadian

1.2.15

profile: **Guy Langevin**

"As long as I can remember, drawing was a passion for me.
There were six children in my family and my father was a manual laborer,
so expensive toys were not commonplace in our house. However, paper and pencils were not expensive
and our energy as children was easily captured by the idea of creating a story on paper.

"Of course, my parents never dreamed it would become a 'metier,' a passion. As regards a formal art training, I got a diploma from Université du Québec à Trois-Rivières in 1977. It was 1979 when I began printmaking and I used the lithography process for many years. I was introduced to mezzotint in the mid-1980s. I was very interested in the way in which one has to approach and think about the image by drawing with light as opposed to shadow. This process is compulsive, like an obsession, and I was, and am, deeply touched by it.

"I complete the whole process myself and print my own works, not because I believe it is better or by any excess of tradition, but because in Canada there are few master printers and of course it can be very expensive. The printmaking market is very difficult here, so artists have to be aware of their production costs.

"I deeply believe that the most important inspiration for artists is what we call in French 'le mal de vivre.' It can force you to go further into yourself, to examine yourself deeply, to discover the sense of life, at least for oneself. Throughout my creative life, the struggle between life and death has been the motive, the theme, the common element of my work. The approach I use may differ, but the subject itself is the same. In fact, from my point

of view, artists have only one thing to tell in their whole artistic life and then they repeat it in different ways.

"My recent works are based on forgetfulness and keepsakes. Life, as with light and time, is fleeting and fugitive. Memory is the same but some impressions, some blurry images, are like scents. They are unforgettable; they resurface and come back into the mind. I express this struggle through the use of opposites: blur and precision, black and white, rough and smooth … and let the viewer imagine their own story in front of my work.

"I like to work with very traditional tools such as rockers and burnishers and also modern equipment like photography and the computer. I need to utilize opposites within the way I work, and I think this appears in my imagery.

"Many artists have influenced my work, but very few in terms of imagery. I really appreciate artists who work in a very different way from me. The way they create their work makes my own way of working freer. Some artists such as René Derouin, one of the most important Canadian printmakers, have broken some of the barriers in printmaking. An artist such as Derek Michael Besant from Calgary, west Canada, encourages and forces me to

Guy Langevin
(Canadian)
Mon Songe
27½ x 19¾in (70 x 50cm)
Mezzotint and drypoint; Graphic
Chemical and Charbonnel inks;
Fabriano paper
Edition of 15 printed by the artist on
a homemade press at Atelier Presse
Papier, Trois-Rivières, Canada

**Guy Langevin
(Canadian)**
Icône Profane
**35½ x 27½in (90 x 70cm)
Mezzotint and drypoint; Graphic
Chemical and Charbonnel inks;
Fabriano paper
Edition of 15 printed by the artist on
a homemade press at Atelier Presse
Papier, Trois-Rivières, Canada**

push on and continue to research, to never stop the evolution of the image. There are few mezzotint artists in my list of chosen artists, but of my preferred practitioners is Maurice Pasternac from Belgium. His work is not only a matter of technique—in fact, technical prowess does not interest me. In his work there is an atmosphere; something uncomfortable that touches me.

"Many aspects of printmaking have changed my way of creating and making art. One of the very first things the medium brought to me was working in a group, all of us together with the same goal, using the same tools. The manner in which printmakers share experiences is very unique in the world of art. We can go anywhere in the world and we will find a place to work, a 'milieu.'

"The mezzotint technique has changed the way I understand and produce images. This medium allows me to use my two central points of interests in art—photography and drawing—and to make something different and deeply related to my own personal questionings.

"Printmaking allows me to mix my interest in the traditional and my interest in new images. Mezzotint gives me the possibility to use light as

an instrument of meaning and the human body as a catcher of light to support this meaning. In fact, the mix of these two elements produces the atmosphere, the feeling, and the viewer has to interact and be a part of the experience.

"All aspects of my artistic production are ruled by the fact that I use the mezzotint technique. Painting, drawing, lithography, even photography, I construct as mezzotints. The furtiveness of light is a common element, but my main concern is how to build the image, how to create the image, how to think about the image.

"Printmaking rules the whole of my professional life. Besides my own work, I am proud to be one of the founders and the artistic co-director of the Biennale Internationale d'estampe Contemporaine de Trois-Rivières, which is the most important biennial in Canada. This foolish idea came to us more than ten years ago, after participating in biennials all around the world. I became interested in bringing the very best printmakers to my own small town.

"Does printmaking have an influence on my life? It rules it! Is mezzotint a sickness, an obsession? If yes, then I am deeply affected by it."

O fierce bird
stab me, guard me
so I never die

The spurt of the fountain –
Never dry up, never die
I'm sure I'll never grow old

I am the fool
of the comic garden

I'm the fool and the food,
the child in the belly of the fruit
My mother's the bird of desire

Nothing is right
and nothing is wrong
forever and ever and ever

in the garden of earthly delight.

**Carolyn Trant
(British)
From the book** *The Garden of
Earthly Delights*
**Collagraph; oil-based ink; Zerkall
handmade paper
Edition of 14 printed by the artist on
a Rollaco etching press at her studio
Printed by the relief process using
a "dolly"**

a brief history of collagraph

Collagraph is one of the more contemporary, experimental processes that evolved during the twentieth century. The term stems from Greek, "colla" being derived from the verb "to glue." The collagraph is composed of layers of materials ranging from string and eggshells to found objects that are glued or attached to a block of wood, metal, or card. The block can be printed as a relief or an intaglio plate or without ink to create an embossed image.

American artist Glen Alps (1914–1996) is said to have created the term "collagraph" in the late 1950s. However, it is difficult to attribute an exact date to the introduction of the process, as there were a number of artists experimenting with collage and adhesives in combination with other techniques. There is evidence that some of the first experiments were undertaken in the nineteenth century by a French sculptor, Pierre Roche (1855–1922). He experimented with the application of layers of adhesive onto his zinc and copper plates to produce embossed prints. However, it is generally acknowledged that the development of the process as we recognize it today evolved from experimental approaches generated in the early twentieth century.

Art movements such as Cubism, Surrealism, and Dadaism explored abstraction in both thought and imagery, with the dominant artists of the day adopting highly experimental approaches to the work they produced. Artists including Paul Klee (1879–1940), Pablo Picasso (1881–1973), George Braque (1882–1963), and Kurt Schwitters (1887–1948) began to use collage and found objects in their works in the 1920s. Rolf Nesch (1893–1975) is suggested as the first printmaker to adopt the idea of constructing layers on the surface of a plate before printing. In the early 1930s, he developed what was known as the metal print by drilling and sewing metal to his plate surface. Further experiments with collaged cardboard prints were produced by Edmond Casarella in 1947/48. By the 1950s, with the widespread availability of new adhesives and cheap materials, the collagraph became popular as a means of expression, especially in the United States. There had been an influx of European artists to New York during World War II. This congregation of avant-garde artists had an enormous influence in the development of the Abstract Expressionist movement in North America. The Surrealist ideology prevalent in Atelier 17 run by S. W. Hayter (see p. 149) and the German Bauhaus train of thought through the likes of Joseph Albers (1888–1976) and László Moholy-Nagy (1895–1946), provided a springboard for artists working in the latter half of the twentieth century. The use of collage, found materials, and mixed media evident in the Pop Art movement in the 1950s and 1960s showed that there were no boundaries, and collagraph proved to be a suitable process in which to experiment within this vein.

The collagraph medium continues to be used as a means in itself and in combination with other printmaking techniques by contemporary artists such as Brenda Hartill, Ian McKeever, and Hughie O'Donoghue.

Carolyn Trant
(British)
From the book *The Garden of Earthly Delights*
Collagraph; oil-based ink; Zerkall handmade paper
Edition of 14 printed by the artist on a Rollaco etching press at her studio
Printed by the relief process using a "dolly"

Carolyn Trant
British

1.3.2

profile: **Carolyn Trant**

"I wanted to be a poet first, I think, as soon as I could write things down. Then I was always making little books. I have still got some of them, folded pieces of paper, with plaited embroidery silks to hold the pages together. I wanted to write words and make pictures. It has taken me a long time to get back to that.

"Education at the time dictated that you were either a writer or a painter, so eventually I went down the art side. There was no concept of 'Artists' Books' then and I did not want to be an illustrator, so I avoided doing that. I did not really know what this concept was that I wanted to do, but now the idea of 'Bookworks' has developed, and been accepted in the art world.

"My parents were both musicians, so they were sympathetic to creativity. My mother's father was an artist who died when I was very young. I remember the house, in Rayners Lane (northwest London), that we all lived in with my grandmother until I was three—my grandfather had painted murals all over the walls. He was a commercial artist, quite Art Deco, as he became established before the Second World War. My mother says I suddenly started producing painted Egyptian mummies out of papier mâché, just as my grandfather had done, so his imagery may have affected me, although my parents did not have any particular artistic taste. I did not have any siblings until I was sixteen; my brother also has the visual ability to make things and he is now an engineer. All my children are very good at art and one son is a successful artist.

I don't know that I was always encouraged in my art, as I would make a lot of 3D work with junk that my mother would then throw away, because she was tidy and I was not. But when I was eleven I went to North London Collegiate School, because I was bright, and it had the most fantastic art school. All the art teachers had to work part-time, allowing them time to be artists. The school had a separate building for the art school, and you could go there and forget everybody else.

"I went straight from school to the Slade, where I wanted to paint in egg tempera as I was fascinated by real pigments. It was there that I went into printmaking. It was practical and cosmopolitan in the printmaking department, and I thought Stanley (Jones) was wonderful.

"I was painting on wood and plaster, so my work was slightly three-dimensional. I loved wood and I wanted to produce Japanese-style prints. It was Lynton Lamb's last year of teaching; he taught me wood engraving, and helped me with woodcuts. I used to go to the Victoria and Albert Museum where they had all the tools spread out. Lynton Lamb also told me to go to the British Museum to ask to see the Japanese prints in storage, and then try to work out how they were done. He got me a job while I was still at the Slade, teaching wood engraving at Heatherleys, a private art school. I continued to do lithography with Stanley, but I mostly did woodcuts and painting.

'Procession' from the garden of Earthly Delights 1/20 Carolyn Trant 2014

Carolyn Trant
(British)
Procession, from the book *The Garden
of Earthly Delights*
Collagraph block (opposite page)
and color print; oil-based ink; Zerkall
handmade paper
Edition of 20 printed by the artist on a
Rollaco etching press at her studio
 Printed by the relief process using
a "dolly"

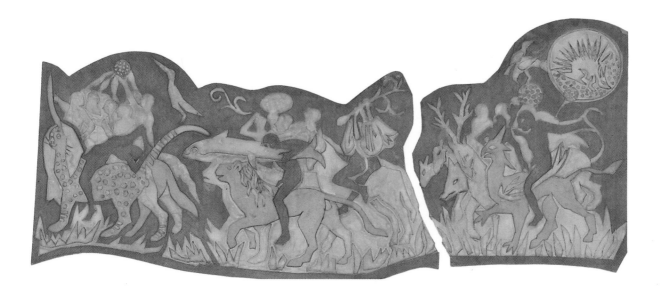

"I had my first exhibition of paintings straight after leaving the Slade at the New Grafton Gallery. They did not exhibit prints; printmaking was seen as a separate discipline. I have always been battling to say that I am an artist, whatever medium I use. At present I am back to painting books and making installations, so my work is all nicely tied up under the title of 'Artists' Books.'

"I am not in the Fine Press tradition and I do not use letterpress type. My books are often very big in size, and are produced in small runs or singles. Having the text printed by silkscreen is a good solution, but I have also cut text by hand; I print my imagery myself, and the books are all completely bound by me. My inspiration is to do with imagery and storytelling; a sense of having something to say. It is definitely not decorative, and in a way it is quite conceptual, but with the ideas produced through one's hands.

"I am inspired by poetry, but the idea of performance and music is interesting as well. People are standing on their heads trying to be new and different but it is not always necessary to force it. Performers of music have a dialogue with a given text; audience perception is always different, a story is retold with a new audience, new materials.

"My choice of medium goes back to the dialogue with the materials, and it is also about markmaking—the properties of wood, paper, metal, leather. German Expressionism, and the intensity of storytelling in medieval painting, possibly influenced me more than anybody contemporary at first; then I got very excited by Anselm Kiefer. However, I also have hand-printed wallpaper for Peggy Angus, who taught me at school—she was great friends with Edward Bawden and Eric Ravilious.

"I make my collagraph blocks from a lot of recycled materials, but the images in *The Garden of Earthly Delights* are all made from thin layers of card, stuck one on top of the other, and then varnished with button polish. The different levels are then inked up in different colors in one go. The images are highly colored in that book; the bigger ones took four hours each to ink up. I print from the relief surface, putting the ink on with 'dollies' in different sizes made from fine cotton. You have to do it this way to ensure that you have the light coming through from the white paper. If you roll the block, the image looks flat. I print with damp paper and a lot of pressure so that the result is quite embossed."

Collagraph tools and materials:

Mat board, cutting knife, pencil, tracing and carbon paper, shellac, glue, brush, gauze, fabric, net, wool, tissue.

1.3.3

step by step: **collagraph**

1 A pencil drawing is made on the mat board as a guide. A sharp blade is then used to cut into and remove the top layer, creating a recess to hold ink.

2 The assembled pieces are cut and laid in place, ready to be stuck down.

3 The adhesive is painted onto the various materials, making sure that they are securely attached to the base.

4 Blobs of glue can be left to harden on the surface of the mat board, before being cut into and sanded at a later stage.

5 When the glue is quite dry, the block is given at least three coats of shellac, on the front and the back. Each coat is allowed to dry before applying the next. This keeps the image secure while it is printed and cleaned. A shellac varnish that is too thick, or a coat that is applied too heavily, will clog up the fine lines and reduce the definition of the image when printed. Methylated spirits will be necessary to clean the brush.

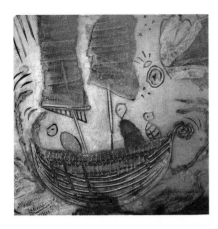

6 The block is examined before printing. Note that the glue blobs in the bottom left-hand corner have been worked into shapes that will hold ink.

7 The block is printed in the same manner as any intaglio image, by placing it on a hotplate, putting the ink on with a piece of mat board, and removing it with gauze and tissue. As the marks can be of a deeper nature than an etching plate, an old toothbrush may help to get the ink into the deeper areas.

8 Papers of between 200 and 350gsm are suitable for collagraph prints. Pre-damp and blot the handmade printing paper to allow the fibers to soften and thereby mold into the block when printed. This allows as much ink as possible to be transferred to the printing paper. Use an etching press, with blankets, to push the damp paper into the recesses of the block to remove the ink. Etching oil-based inks made up from pigment, or ready-mixed in a tin or tube, produce the best results, but water-based inks can also be used. The oil-based inks are removed with mineral spirit.

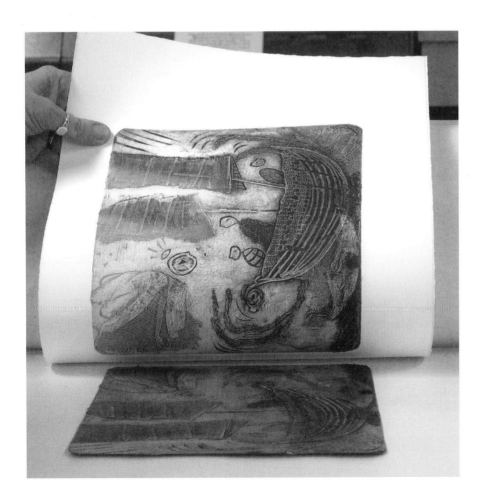

9 The damp paper removes the ink from the block with the aid of the pressure from the press, and the soft quality of the blankets. More detailed information on printing is given in Chapter 4.

The block: detail of tissue and gauze.

The print: detail of tissue and gauze.

The block: detail of layer of card cutaway, fabric, and string.

The print: detail of layer of card cutaway, fabric, and string, with glue blobs in bottom right-hand corner.

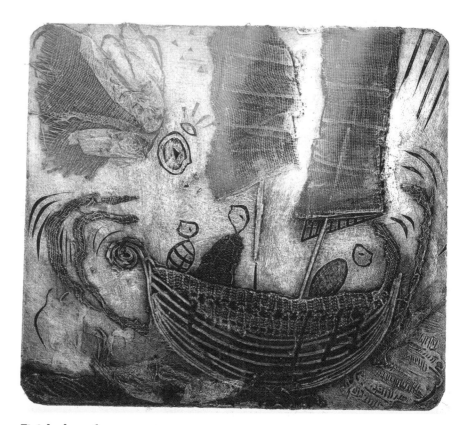

Finished proof
An edition of prints can be made in these colors, or the block can be washed off with mineral spirit and inked in different colors.

collagraph in practice

The block

Above and right: **Jane Sampson (British)**
Egg Box
12 x 16in (30 x 42cm)
Collagraph; oil-based etching ink; handmade 300gsm paper

An egg box, dampened and passed through the press to flatten. Coated with three layers of shellac, and printed intaglio.

Below: **Jane Sampson (British)**
Lotus
22 x 17in (56 x 45cm)
Collagraph; oil-based etching ink; Fabriano paper

A Chinese leaf is attached to a piece of thin card, coated with three layers of thin shellac, and then printed intaglio.

The print

The block

The print

step by step: **process for "Dark Sun"**

British artist Julian Hayward explains the foil and sandpaper method with which he produced the image shown opposite.

For this method of making an image the basis is sandpaper, which, like the mezzotint (see pp. 98–109), will produce a very dark tone. However, unlike the mezzotint, highlights are produced by layers of aluminum foil being laid on top of the raised surface of sandpaper. The greater the numbers of layers of foil, the whiter the image. Tonal shifts across the plate can be achieved by staggering the layers of foil.

Details, using other materials, can be applied on top or underneath the foil layers. Normally, a maximum of five prints can be made at any one time. The plate is then cleaned and left to dry out, since prolonged exposure of the petrol-based glue to the plate oil, and mineral spirit, will start to separate the different parts of the plate. If this happens, they can be refixed, but only when everything is dry and clean, after which printing can be resumed.

Below: **Two blocks plus a component detail made of a twisted and beaten strip of aluminum kitchen foil. It is curled and stuck down on the block as required.**

1.3.5

Note: Some foil and papers contain carborundum, which can loosen in the printing process. Therefore, protection of the blankets and the machinery is important to prevent damage, particularly to the top roller.

Making the block

1 The base is made of card or mounting board.

2 Medium-grain sandpaper is glued onto the card with repositional spray mount, and the block is then run through the press under blankets.

3 Layers of aluminum cooking foil are stuck onto the sandpaper, followed by successive layers glued over each other.

4 The block is run through the press a second time.

5 Details are stuck to the block with repositional or permanent spray mount. Small and linear details are attached with contact glue and hammered down. Fragile pieces, such as leaves, can be protected by overlaying with very thin foil, and then glued down as before.

6 The assembled block is put through the press again, with a layer of paper between the block and the blankets to ensure that the blankets are protected from the sandpaper. Considerable pressure is needed to ensure that all components are firmly fixed down. It is also worth noting that repeated passes through the press will darken the tones of the plate as the foil beds further into the sandpaper. This tonal change will eventually stabilize. If the image requires more than one plate, further plates are constructed as above.

Printing the blocks

1 The ink prepared for printing needs to be thinner than that used for traditional etching or collagraph, since heat cannot be applied to a block made by this method. A generous quantity of ink is taken and pressed into the recesses using a piece of card and, if required, a stiff brush.

2 The heavy coating of ink is first removed by lifting off with scrim. Exposed sandpaper cannot be wiped, therefore it is a matter of judgment as to how much ink should be left in the grain. Too little will create white unprinted areas, whereas too much will spill over the edge when passing between the rollers and ruin the image.

3 The continued wiping of the block is done with cotton or linen fabric, as scrim is likely to catch on the components. When sufficient ink is removed the details can be delicately cleaned with tissue.

4 The plate can be printed in the normal way; however, as the block is made of lightweight card it is necessary to hold it down when lifting the paper.

**Julian Hayward
(British)**
Dark Sun
**11 x 9in (28 x 22.5cm)
Collagraph
Edition of 5**

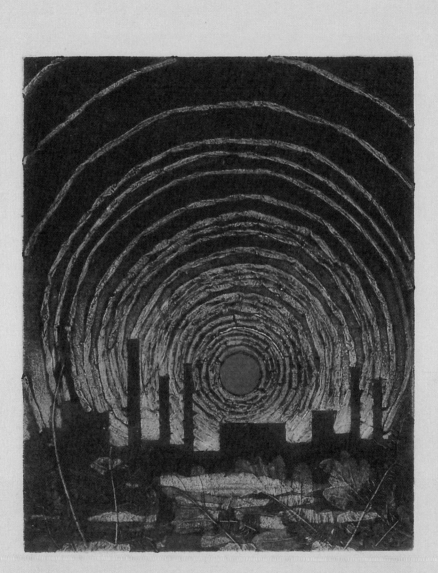

4/5 Dark Sun 1 Julian Hayward '97

collagraph process: **carborundum**

The carborundum method is a way of creating tone on a metal plate, card, or Perspex using carborundum grit.

1.3.6

Richard Denne
(British)
Half and Half (1–8)
18 x 18in (46 x 46cm)
2-plate carborundum intaglio
print; Geranium Red and
Charbonnel copper press inks,
Graphite and Graphic Chemical
etching inks; Somerset Satin
300gsm paper
Edition of 20 printed by the artist
on an electric polymetal etching
press at his studio

Carborundum grit comes in three grades—coarse 240, medium 120, and fine 80—and is generally used to grind down lithography stones. However, this gritty texture is ideal when trying to create areas of intense tone, either on an etching plate or a collagraph block.

1.3.7

step by step: **carborundum**

1 As the rough quality of the grit creates a strong tooth for the ink to easily adhere to, the fine grit (80) is generally used on smaller plates, whereas medium or coarse may be required on large blocks. Placing the grit in a jar, and piercing the lid, creates a convenient dispenser. The block may be made of card, metal, or Perspex. Card is inexpensive, but metal may be needed if a strong tone is required. Perspex, being transparent, is ideal if several colors are to be used, as each plate can be placed over a master drawing, or previous block, to identify the exact registration. The glue can be a strong PVA or a resin wood glue, or a mix of the two. Acrylic paint or pigment can be added to the glue to make it easier to see when working, and a little water to thin the consistency.

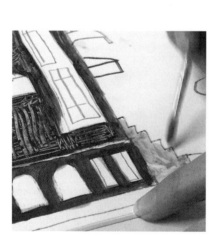

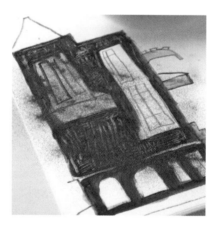

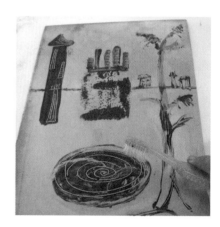

2 The glue mixture is applied to the base with a brush or piece of card in the areas where the tone is required. A thick layer will absorb a larger quantity of grit, therefore holding more ink, which will produce a more intense tone. A thin layer will hold less grit and create a lighter, more delicate tone.

3 The carborundum grit is shaken evenly all over the glue, and then the block is stood on end and the excess is shaken off. The glue is left to harden for several hours. If a card base is used, it is advisable to paint the plate back and front with a coat of button polish or thin varnish. When it is dry, apply a second coat. This will make the plate more durable when printing.

4 If a metal plate is used it must be prepared in the normal way, by removing scratches, polishing, and filing the edges. Before the glue is applied, the surface of the metal must be degreased and dried, to allow the glue to get a firm grip. The grit is shaken onto the glue, and the excess removed by standing the plate up and tapping it on a hard surface. When the glue has dried, it can be brushed with an old toothbrush to remove any loose particles of grit. If left these could damage the plate when printing.

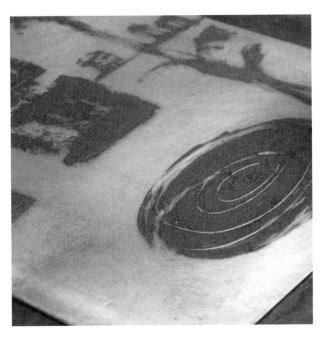

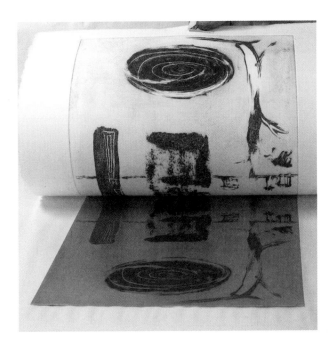

5 The plate is put on the hotplate and the first proof is taken in the normal way. Ink is applied with a dolly, making sure that it gets well into the gritty areas, and wiped off with a medium scrim followed by tissue. The wiping of a carborundum plate demands care and attention. The gritty area is rough and will hold a greater quantity of ink than normal; therefore close attention is needed to remove the required amount. It may be desirable to use a cotton bud to clean small areas.

6 Because of the greater amount of ink held by the grit, a more intense color will be achieved in the print than is normally obtained from a regular aquatint. Further work, or a secondary plate, can be made at this stage. As with most etchings, there will be several trial proofs and changes carried out before the final state is reached.

Carborundum: Troubleshooting

Problem: The grit comes off when printing

Cause	Solution
1. The glue was not dry.	**1.** Leave the block to dry overnight.
2. The glue was not strong enough.	**2.** Check that the PVA glue is labeled "strong," and make sure that the wood glue contains resin.

Problem: The ink will not wipe off; the surface is so rough that it tears the scrim

Cause	Solution
Too much glue on the block, which is holding too much grit.	Sand the block down, and next time thin out the glue and apply more sparingly.

chapter 4 **printing the intaglio image**

1.4.1

an overview of printing the intaglio image

The finished intaglio image is the result of two distinct steps, the first being the establishment of the image on the plate, and the second being the transference of the image from the plate to the paper. The printing of the image is as creative a process as the making of the plate. The variables are considerable, and the quality of the print can be extremely diverse depending on the method of printing that is chosen.

Left: **Harry Rochat etching press, Hastings College of Art, UK**

Below: **Etching press with wooden star wheel, Cowfold Workshop, UK**

1.4.2

equipment: **etching presses**

The style of the etching press has changed very little over the centuries. Originally these presses were made in wood—there is a very good example on display on the lower ground floor of the British Library in London. This press has the blankets held up at both ends with cord, so that dirty hands were never able to mark them while printing. Even the beds of these presses were made of elm. However, by the early 1700s, they were being constructed from cast iron. Presses made today are still constructed in the basic style of the early presses, although there are now also excellent electric and hydraulic models on the market.

The early presses were not geared; the star wheel handle as we now know it evolved from the use of poles to move the top roller. However, the geared presses that we have today are smooth and easy to wind.

There are many presses that still have the wooden star wheel, and there are some that have a similar contraption in metal.

Etching presses, University of Brighton, UK

Harry Rochat pressure screw

Polymetal electric press pressure screw

The pressure screws are found either side of the top central roller. Their adjustment controls the amount of pressure used on the print. To reset the pressure on the Rochat, always start with the bed centrally placed under the press roller. Wind the screws full down, making sure that you have them even, then let each side off an equal number of turns and put in the blankets. Test with a plate and a damp piece of paper, checking at the back that the impression from the plate is sufficient, and is even on both sides. It is helpful to have an arrow on the top of each pressure screw to enable you to assess the number of turns, and the final position of each screw.

If you are concerned that the bed could fall out, "stops" can be fitted to either end of the underside of the bed. These are metal strips that will catch the bed should it slip.

On the electric press you may find it necessary to feed in the blankets while the bed is still at the central position, before you tighten down the pressure.

Left: **A good set of blankets is expensive, but the quality of the blanket is reflected in the standard of print produced.**

As a rule, three blankets are used at a time: two felts that are placed nearest to the printing paper, as they do not have a weave; and one swanskin, which is a soft woven blanket that helps to push the dampened paper into the incised lines.

Left: **Acid cabinet with extraction and washout area**

The press is the most expensive item to be acquired when setting up a workshop, but consideration also needs to be given to the acid area, where an extraction unit and a wash-out system are essential.

step by step: **mixing up etching inks**

1.4.3

1 Etching inks can be purchased ready-mixed in tubes or cans, which are convenient as they save time, but mixed inks have a limited shelf life and are expensive. Dry pigments, however, can be purchased by the ounce and will survive indefinitely.

2 It is necessary to buy quality powders, as cheap substitutes are not generally lightfast. A glass muller or palette knife is used to mix in the oil.

3 Glass mullers come in various sizes. Their purpose is to grind the pigment and the oil together to create a smooth, shiny, well-fused ink.

4 Copperplate oil is used to bind the pigment. It is produced in viscosities of strong (heavy), medium, or weak (light). Linseed oil is burnt to a greater or lesser degree to create the different oils. The pigment is first sprinkled onto the glass and inspected for any unwanted lumps. Then a small quantity of strong copperplate oil is put beside the powder. This will allow a controlled amount to be added as required.

5 The strong oil will continue to be added until all the powder pigment is collected into "breadcrumbs." It is advisable not to pour the oil directly onto the powder, as too much will make the ink tacky—this can remove the top surface of the paper when printing. The weak oil is added to the "breadcrumbs" by putting a small quantity beside the powder, gradually introducing it to the ink, then mixing thoroughly.

6 The finished ink should move easily, with the oil and pigment completely combined. When held up on the knife, the ink should drop off in blobs, like heavy cream, not run off. If the ink has not been sufficiently worked with the muller or knife, it will have a dull appearance and the powder granules will be noticeably separate. This ink will produce a poor print. If the ink is too loose it will wipe out of the lines.

Making black ink

There are many ways of making black ink,
but one recipe is given below:
50% Frankfurt black (slightly brown)
50% French black (slightly blue)

Mix with:
1) strong copperplate oil
2) weak copperplate oil

Add a small scoop of "easy wipe compound."
"Easy wipe" is not required in the colored
inks as the powders are more refined.
Unused ink can be preserved for a short
period of time by being covered with saran
wrap to protect it from the air, or by being
dropped in a jar of water.

Penny Siopis
(South African)
Shame: Home
Paper size: 17 x 15in (45 x 38cm);
image size: 5½ x 7¾ in (13.6 x 19.6cm)
Sugarlift aquatint and scraping and
burnishing with photocopy transfer;
ink: Plate 1 GC Cadmium Red, Plate 2
Custom mix of Charbonnel Madder Lake,
Graphic Chemical Process Magenta, and
Charbonnel Prussian Blue; BFK Rives
300gsm white paper
Edition of 20 printed by collaborating
printer Randy Hemminghaus; edition
printed by Tim Foulds, Robert Maledu,
and Jillian Ross on a Sturges etching
press at the David Krut Print Workshop,
Johannesburg, South Africa

Shame: Home is part of a series of
ten prints created by Penny Siopis in
collaboration with master printer Randy
Hemminghaus in February 2004. The
three-run print began with a photocopy
transfer through the press followed by
two copper plates, measuring 5½ x 8in
(14 x 20cm) each, printed consecutively.

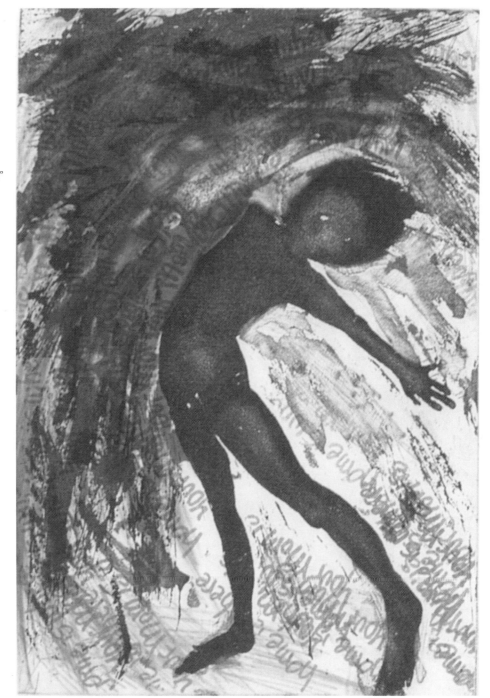

Damp paper is required to remove the ink from the incised lines when taking a print from an etching plate.

1 The paper is dampened first by submerging it in a bath of clean water for about 10 minutes.

2 The paper is lifted and placed on a stiff plastic sheet to have the excess water removed from the surface with a sponge. This will prevent the blotting paper from becoming saturated.

3 The sheet is placed between two pieces of blotting paper.

1.4.4

step by step: **damping the paper for printing**

4 A soft roller is applied to the top side of the blotting paper, allowing the paper to emerge as damp but not wet. Any surface water would repel the ink and appear as a white in the print.

The paper is now ready for use. If an edition is to be made, each prepared sheet may be laid one on top of the other between two pieces of plastic, with a board placed on the top. These will then remain damp and ready for use for a couple of days.

Delicate or unsized papers can be patted with a damp sponge, or printed dry while backed by a piece of soaked paper. It is advisable to dampen heavy papers, such as Zerkall, the day before they are required and leave them in plastic overnight to make sure that they are thoroughly damp.

5 After the print has been taken it is necessary to dry and flatten the paper. The print is placed on a piece of blotting paper on a board. A sheet of tissue is put over the image,

followed by another piece of blotting paper and another board. The prints will take about 24 hours to press and dry. However, this process can be speeded up by sandwiching the prints with corrugated card while blowing a flow of air through from the back with the help of a fan.

Alternatively, the ink can be allowed to dry before the paper is re-damped. The ink will not move, and can be put under the boards to flatten.

Ball-drying rack

Flat-drying rack

Safety note
This process requires the use of dangerous solutions. Every care should be taken to protect the user by working in a well-ventilated room with the appropriate apparatus, in addition to wearing protective clothing such as rubber gloves, goggles, and an apron.

1 The etching ink is prepared as required. It can be made up from pigment, or used direct from a can or tube. A small quantity of weak copperplate oil may be added if the consistency appears to be too thick or heavy. Adding a touch of red to the black will make it warmer, whereas blue will make it cooler.

Other items that may be required include card for applying the ink; scrim, tissue, and cotton buds for removing the ink; and a rag for cleaning the edges of the plate.

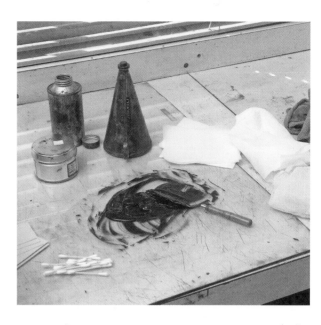

1.4.5

step by step: **printing an intaglio image**

Inking up a single plate in a single color

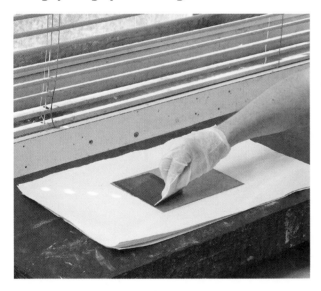

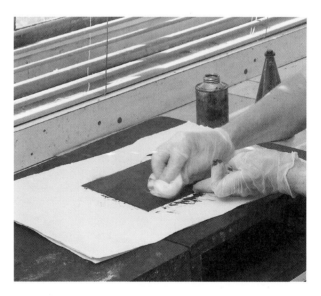

2 Whether the plate is made of zinc, copper, or steel, the printing procedure is similar. The metal is put on a warm hotplate. The purpose of heating the plate is to loosen the oil in the ink to allow it to penetrate the incised lines. It is important that the metal is only allowed to become warm; if it becomes too hot to handle, the oil in the ink will dry out and the pigment will not be transported to the printing paper.

The ink is applied with a piece of card (although some artists prefer to use a dabber, or a dolly made of wound blanket). Use your fingers to make sure that the ink is pressed well down into the marks, otherwise the print will have white unprinted areas.

3 The plate is gently wiped with a medium gauze, known as scrim or tarlatan. If the material is new it is necessary to rub, or rinse and dry it, to remove the stiff size. The result should be semi-soft and absorbent. The fabric is folded to form a comfortable pad held in the palm of the hand. The plate is first wiped in a horizontal direction, then the metal is turned several times while cleaning in different directions. This ensures that the wiping is even all over the surface. Finally, the scrim is used in a circular motion over the whole area.

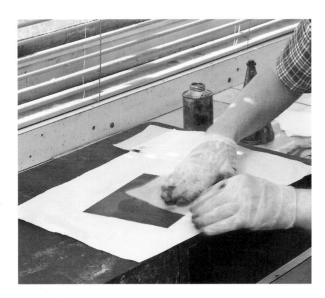

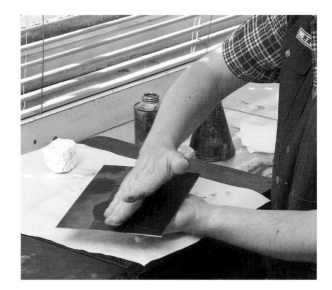

4 Once the main body of surface ink has been removed and the image can be easily seen, refine the white surface areas of the plate by wiping with tissue paper. Acid-free tissue paper, with a firm surface on both sides, is required. Manageable cut pieces of the paper should be clipped between the fingers and kept absolutely flat while wiping to prevent any ink from being pulled from the incised areas of the plate.

A little pressure from the tips of the fingers on selected areas can help to clean individual surface marks as required. The amount of ink remaining on the surface of the plate can be gauged by the amount shown on the tissue after wiping. Some artists like to leave a light plate tone, whereas others prefer to wipe the surface quite clean—it is a matter of personal choice.

5 Hand-wiping is a traditional practice that allows greater control of the wiping procedure. It is possible to see the image at all times and therefore make selective choices of the areas to be wiped and the amount of ink to be removed. The skin has natural oils and will also have collected a certain amount of ink; therefore, to "dry" the hand, rub it onto a slab of whiting powder and remove the excess on a rag or apron.

The hand is passed lightly and evenly over the surface of the plate several times, skimming the areas to be cleaned. This method takes practice, but when perfected gives greater control of the amount of ink removed, and the plate tone remaining. The plate can be wiped while laid on a cold surface or, if preferred, held in the hand.

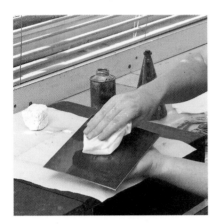

6 If a plate tone is required, the traditional way of wiping is to finish the plate by using a fine gauze called a dragging muslin. This is a soft fabric that is folded into a small pad and dragged gently across the surface of the plate, leaving a delicate but even plate tone. This gauze must never be used during the initial wiping of the plate, as it will pull away too much of the ink from the incised marks.

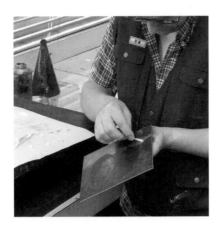

7 If small areas are required to be highlighted, where it is necessary to remove the surface ink entirely in a soft but sensitive way, it is possible to use a cotton bud that will readily absorb the ink.

8 When the plate is satisfactorily prepared for printing, carefully wipe the sides clean along the beveled edge.

Printing the plate

9 Place a prepared registration sheet on the bed of the press, over a clean sheet of paper. Using a fine permanent pen, the outer edges of the printing paper and the plate are marked on the underside of the sheet of Plexiglas or Trugrain (see p. 140). This gives a reliable guide for the continuous accurate positioning of the print, producing continuity throughout the edition.

10 The inked plate is put carefully in place.

11 Using protective paper clips, the printing paper is held by opposite corners for control, while the pre-damped handmade sheet is laid accurately in position.

12 A sheet of acid-free tissue is laid over the back of the printing paper to protect and keep it clean. This also prevents the size in the damp paper from transferring to the blankets, which when dry will harden in the fibers, necessitating the blankets being washed more frequently, or the quality of the subsequent prints being compromised.

13 The three printing blankets are laid down. The two felts are nearest to the print, as they do not have a weave, which would transfer to the image. The top blanket, or swanskin, is needed to provide extra, gentle pressure to push the damp fibers of the paper into the incised marks of the plate, to remove the ink.

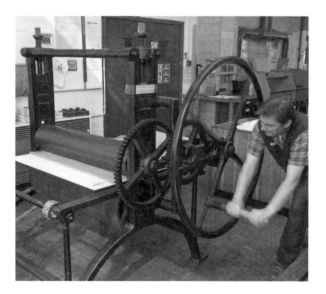

14 The bed is wound through the press.

15 The blankets and the tissue are removed and the print revealed.

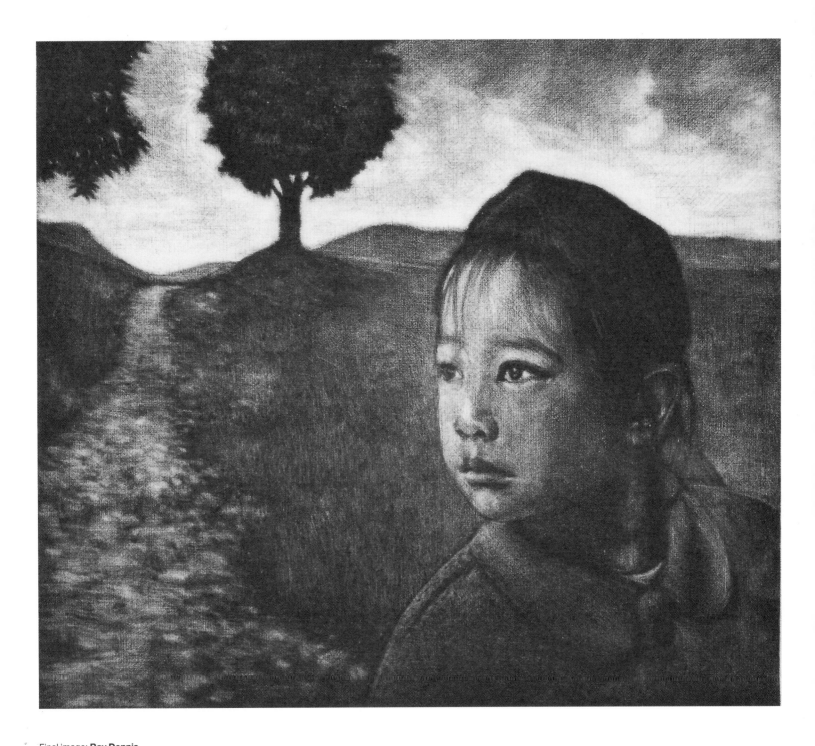

Final image: **Ray Dennis**
(British)
Halie
7½ x 6¾ in (19 x17cm)
Mezzotint—copper plate prepared by
the artist; French 88 stiff warm black ink
with red; Hahnemühle 200gsm paper
Printed by the artist on an etching press
at the University of Brighton, UK

intaglio in practice

1.4.6

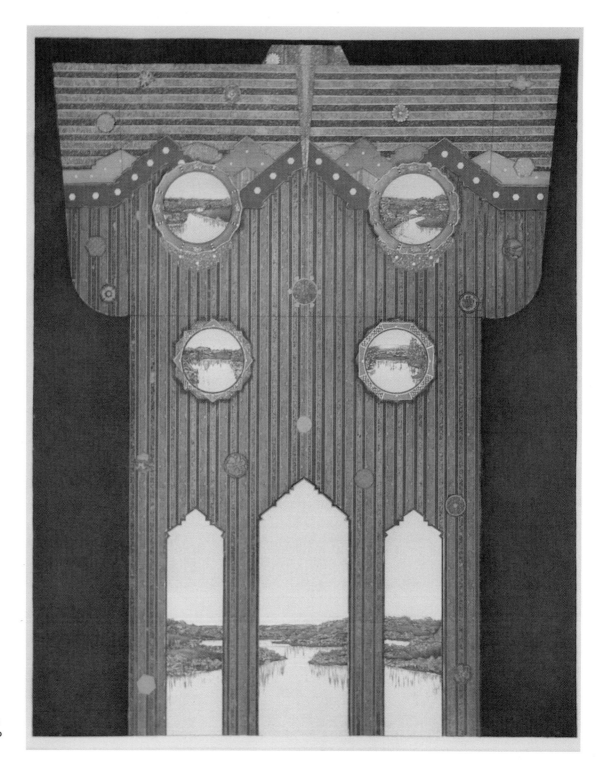

**Noreen Grant
(British)**
Kimono VI
**20½ x 16½in (52.5 x 42.5cm)
Etching
Edition of 75 printed by the artist at
her studio**

This has a brown master plate;
a Venetian red plate plus green
for landscapes and a turquoise-
blue plate. The master plate has
crosshatching and drop aquatint,
burnished in parts to create some
tonal difference. The master plate has
a proportion of the blue color added to
the brown to give a tonal equilibrium.

Noreen Grant
(British)
13 x 18½in (33 x 47.2cm)
Kashmir Fan
Etching
Edition of 120 printed by the artist at her studio

This plate has a brown master plate; a pink plate plus green, and a blue plate. The background has a lighter tone of aquatint in order for the brown to create a greenish tone when printed on top of the blue seen in the flower pattern. The flower designs were stopped-out on the master plate before biting its background aquatint. The pattern on the spokes of the fan is achieved by burnishing a black aquatint as one would a mezzotint. Other textures are produced by drop aquatint, lines, and aquatint; the landscapes are stippled and aquatinted.

step by step: **color printing using one plate**

1.4.7

This technique is sometimes referred to as "à la poupée," which means "with a dolly." The term "dolly" refers to anything that is used to apply the ink to the surface of the plate, such as a piece of card, a squeegee blade, a dabber, or a piece of scrim or wound blanket.

Many colors can be printed from one plate at one time, using very careful application of the ink, and wiping of the surface. This printing process is shown to best effect on aquatint or mezzotint plates.

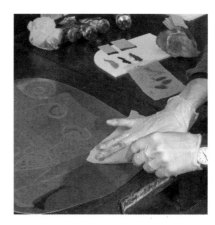

2 The first color is applied, as accurately as possible, in the required area. It is wiped carefully with the gauze and tissue, then hand-wiped if desired.

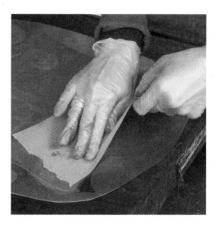

4 The rest of the colors are individually inked up and wiped off until the plate is ready to pass through the etching press under pre-damped paper. Each ink is applied and wiped clean before the next color is introduced, so there is no accidental mixing of the colors where it is not desired, and complete control can be kept at all times.

Zinc plate cannot be used if accurate color is to be retained. The impurities in the metal affect the pigments, turning yellow to green, white to gray, and making all colors a darker shade. Copper does not affect the color to such a degree in this way; however, steel is the ideal metal for preserving the exact color. The plate tone retained by the steel plate due to the grain can be lessened by sanding the metal before use.

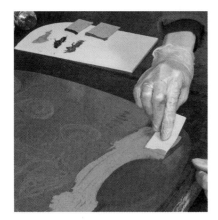

1 First prepare all the required colored inks. They can be mixed up from pigments or used direct from a tube or can. In order to keep the colors as pure as possible, it is necessary to have a separate dolly for each color. You will also need clean pieces of scrim and tissue.

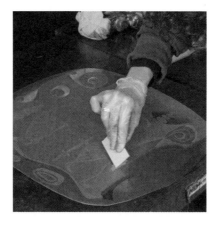

3 The second color is applied in the same way, taking extreme care to keep it within the area required. It is advisable to overlap the inks very slightly rather than buff them up to one another, as any white or uninked areas, however small, will stand out in the final print and be very distracting. It can sometimes be desirable to purposefully overlap the inks to produce an extra color; the merging of the pigments gives a soft, muted blend. However, if a hard edge is required, this is possible with patience and practice.

step by step:
creating,
registering,
and printing
a multiplate image

When producing a print that requires more than one plate, it is necessary to make the plates with a clear method of registration. This ensures that each one fits identically in position with the next.

The plates need to be cut to exactly the same size. If one plate is slightly larger than another it will make accurate registration more difficult, and will be apparent in the final print. If the margin is only small it is possible to file away the protruding area.

In this example, zinc was used for the key plate as a clear, fine line can be achieved, with a clean background without plate tone. This will not affect the quality of the color produced by the second plate. The second plate is made of steel, as it will allow for purity of color without contamination from impurities in the metal, which is not possible if zinc is used with color.

1 A registration sheet is prepared. This can be Plexiglas, or preferably Trugrain (which is also known as mark resist, and is used in screenprinting). It has one surface with a tooth, which, when laid on the press, will not move during printing. Trugrain does not have a tendency to crease, which can happen with acetate. A fine-point permanent marker pen is used to identify the position of both the plate and the paper. The marks are made on the underside of the sheet so that they will not pick up on the damp printing paper, or be removed when cleaning between prints.

2 The first plate is prepared, drawn, and bitten in the normal way. The image is placed on the hotplate and inked up ready to print. It is printed on a rough piece of paper, which is long enough to remain trapped under the roller of the press, while the plate is accessible.

1.4.8

3 Two weights are placed to identify the bottom left-hand corner of the plate. Any two sides can be chosen providing the same corner is used when printing the two plates at a later stage. The first plate is removed, and the second is put in exactly the same position. The second plate has been prepared with a fine aquatint.

4 The weights are removed, and the paper is lowered onto the new plate and run back through the press.

5 Due to the pressure of the press, the damp ink will transfer from the print to the second plate, giving a clear guide to indicate where the new marks should be placed.

If a third plate is required, it is possible to take another transfer from the damp print, providing the paper is still firmly trapped under the roller of the press so that it cannot change position. The print is then discarded, as the marks will have been squashed during the transfer process.

8 The original registration sheet is placed on the bed of the press and the color plate is put down first. A dampened piece of good-quality handmade paper is laid over the plate, allowing sufficient length beyond the image for it to remain trapped under the roller once it has passed through the press.

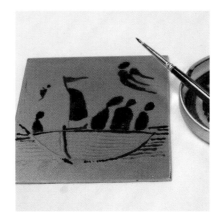

6 Protective stop-out varnish is painted on the areas that are not to be bitten by the acid. These areas will therefore not retain ink when the plate is printed. As the transferred ink is only a guide indicating where to paint on the plate, it will easily rub off. Therefore, when considering a color change within the image, it is advisable to paint marks that will guide you as to where to put the different colors when you are inking up.

When the varnish is quite dry the plate can be put in the acid bath to bite. This steel plate was placed in a nitric acid bath of 5 parts water to 1 part acid. As it is an aquatint, and therefore bites more quickly than a line, it was bitten in 6 minutes.

It is possible to paint some of the areas out and return it to the acid to obtain a varying depth of tone. However, as color pigments vary enormously in tonal value, in most cases this does not make a vast difference.

Once the plate is bitten, the stop-out is washed off with mineral spirit. Then the resin from the aquatint must be removed with methylated spirits. The plate is now ready to have a proof taken.

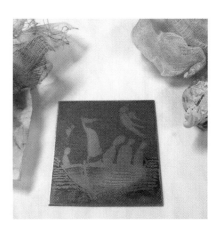

7 The steel plate is placed on the hotplate and inked up in the normal way. A dolly of a suitable size is used to apply each color individually, after which the area is wiped clean with gauze and tissue before the next color is applied. The edges are then rubbed down carefully with a rag. The zinc plate is also inked up and prepared for printing at the same time.

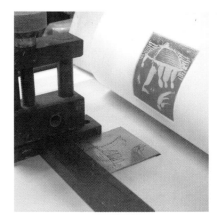

9 The weights are replaced in their original position, the steel color plate is removed, and the line zinc plate is put in its place, taking special care to put it down the correct way up.

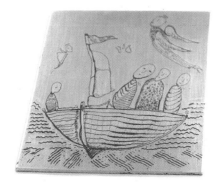
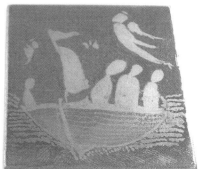

Zinc plate (right); steel plate (left)

**Ann d'Arcy Hughes
(British)**
A Safe Passage
**3 x 3½in (7.5 x 9cm)
2-plate etching; oil-based etching
ink; Fabriano Artistico paper
Edition of 50 printed by the artist at
Brighton Independent Printmaking,
UK**

10 The weights are carefully removed, making sure not to knock the plate out of position, and the paper is gently lowered down onto the plate. It is possible to check if the plate is still in the correct place by pressing gently on the corners to see whether the indent fits exactly into the impression made by the previous plate.

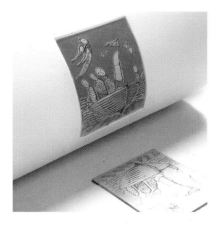

11 The plate is run through the press for a second time. When the paper is lifted, the print reveals the image produced by the two plates. To take a second print, both plates need to be re-inked as before.

After printing has finished, both plates must be cleaned with mineral spirit to prevent the residue of ink from drying in the lines. Plates can be protected from rust by being covered, back and front, with a mixture of half mineral spirit and half engine oil. Alternatively, Vaseline will do the same job. The plates should then be wrapped in a clean sheet of paper and stored in a dry place.

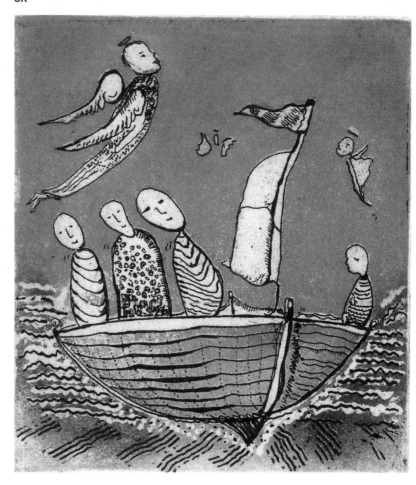

1.4.9

papers: **printmaking**

Handmade paper is the most ideal surface for a fine-art print. Such papers are made from fibers, generally from the cotton plant, which are mixed with water to form a pulp. Each piece is made individually by hand in a mold with a deckle frame that produces the traditional deckle edge.

Mold-made papers are also made from high-quality materials, but they are produced by an automated process using a cylinder mold.

Handmade papers are the most desired surface to print on when work is to be presented at an exhibition or sold in a gallery. However, good mold-made papers may be used for economic, or other reasons, and provide a very acceptable substitute.

The range of papers available is vast; only a small sample is mentioned here, and you will see from the captioned images in this book that our featured artists have used many brands and types other than those listed below. A visit to a paper merchant's or good-quality paper store is advised.

Japanese papers
Tosa Washi (23gsm)
Usumino Shiro (17gsm)
Kinugawa Ivory (22gsm)
Tosa Shoji (40gsm)

Standard handmade papers
Arches Velin: Noir 250gsm, Blanc 160gsm, Crème 160gsm
BFK: Rives 180gsm, Cream 280gsm, Tan 280gsm, Gray 280gsm
Fabriano Artistico 300gsm
Fabriano Rosaspina 220gsm
Fabriano Tiepolo 290gsm
Hahnemühle Etching Natural 230gsm
Hahnemühle Etching White 300gsm
Moulin du Gue 270gsm
RKB Arches 300gsm
Somerset Antique 280gsm Velvet
Somerset Black 250gsm Velvet

Somerset Buff and Gray 280gsm Velvet
Somerset Cream 250gsm Textured
Somerset Radiant White 280gsm Velvet
Somerset Soft White 250gsm Textured, 250gsm Velvet
Somerset White 250gsm Textured, 250gsm Velvet, 300gsm Satin
Zerkall Cream and White 225gsm Rough
Zerkall Etching Cream 250gsm

Other papers
Some other papers to consider include Indian Khadi paper ("Khadi" means "cotton"). The Khadi Paper Mill in Karnataka, India, produces a wide selection of white, cream, and colored papers made in various thicknesses. The most delicate papers are ideal for Chine collé (see pp. 214–222).

In addition, Nepal produces traditional handmade papers from lokta bark fiber, and also a Japanese Washi that is suitable for printmaking.

Ann d'Arcy Hughes
British

1.4.10

profile: **Ann d'Arcy Hughes**

"I recall enjoying art from a very young age.
One of my first memories is of being surrounded by old books that lay
around the house, such as Heath Robinson and Rupert Bear.

"My great-aunt and my grandmother were excellent artists who painted, drew, and did gesso work. My parents and my aunt always encouraged me to draw, but sadly my schools did not consider art an important subject, unless it was related to religion.

"I went to art college, which was a delight; I felt an enormous freedom. To be allowed, and actually encouraged, to work in all the art mediums every day, was quite a different experience from the confines of a convent— I thought that I had died and gone to heaven. After my degree, I took a year out to work as an au pair in Stockholm, Sweden. Being away from the art world, it was here that I realized how much I missed the involvement. I had had a taste of printmaking and I knew that this was the area in which I needed to develop my skills and ideas.

"When I returned to England, I was accepted on the postgraduate course at Brighton College of Art, which was run by Jennifer Dickson and Harvey Daniels. This was a wonderful year. I was taken on as technician in etching, which forced me to involve myself fully in the working of the department—a grounding that I would never regret.

"From here I became assistant to Anthony Gross at the Slade School of Art in London. Those four years were a diverse and exceptional period in my life. I had to buy the materials, which meant finding my way up the ancient wooden stairs in Bleeding Heart Yard to see old Mr Lawrence, which was an experience in itself. Gross insisted that, where possible, the etching materials should be made in the school, so mornings were spent with me boiling up the beeswax, mixing in the resin and bitumen, before dropping the whole into a bowl of warm water, where I would disappear into a cloud of steam to mold the required balls of ground.

"Gilbert and George, in their early days, used to stand as silent statues on the stairs or in the courtyard; David Hockney would put his head round the door to speak to the students; and Stanley Jones was orchestrating the lithography department. The late 1960s were an exciting and invigorating time to be in London.

"Hayter's Atelier 17 in Paris was my next place to work. The atmosphere was excellent at the studio. It was the time of Woodstock, and life seemed very multicultural; the two technicians were American and Argentinian.

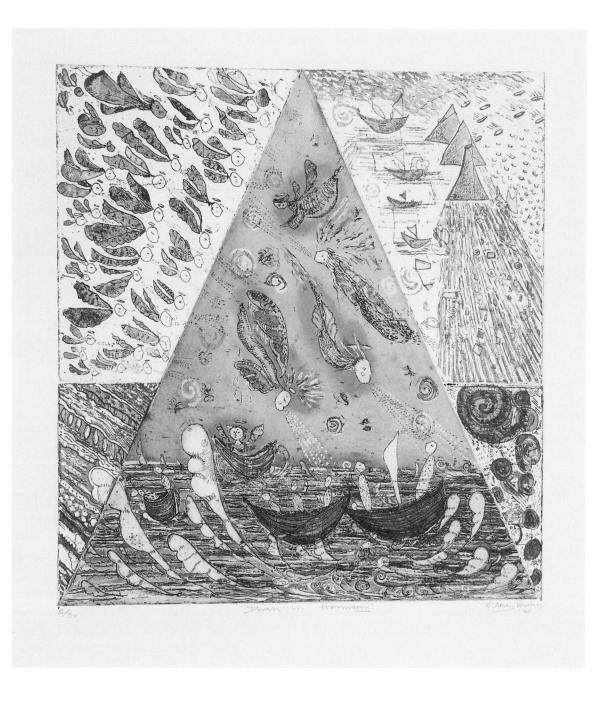

**Ann d'Arcy Hughes
(British)**
Dwell in Harmony
**4 x 13in (10 x 33cm)
Etching—6-plate multiple plate
etching; oil-based etching ink;
Fabriano handmade paper
Edition of 30 printed by the artist on an
etching press at Brighton Independent
Printmaking, UK**

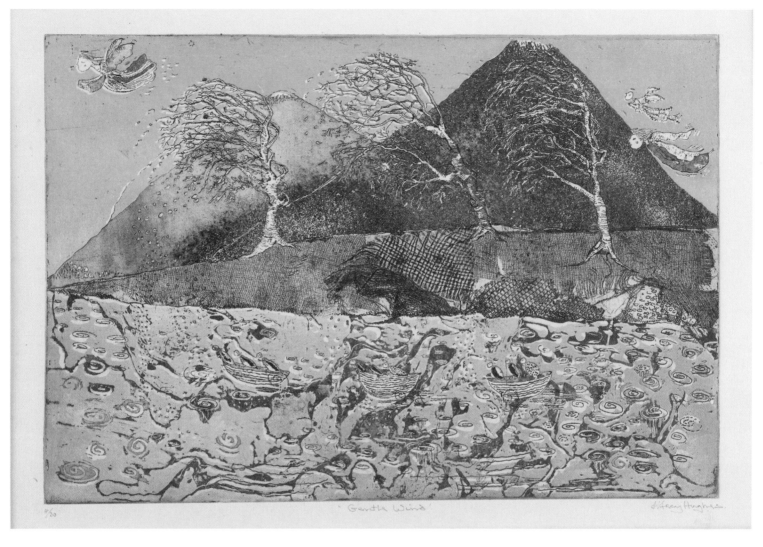

We ate hard-boiled eggs at the corner café for breakfast and learnt to etch counterpoint drawings in the day. In the evening we would help Hayter to print his big viscosity prints.

"I have now taught printmaking at the University of Brighton for more years than I care to remember, and in April 2000 I founded, with a colleague, an open-access print workshop, Brighton Independent Printmaking (BIP). There seemed an obvious need in Brighton for a place where students and experienced artists could come to work together, where they could further develop their prints and learn new skills, while being able to mix with like minds, and discuss common themes. In essence, to use printmaking as a creative and inspirational platform for their work.

"My own work is very important to me. I could not consider being unable to produce prints as 2D or 3D images, or in book form. I hope that the imagery speaks for itself; the audience will take for themselves what they see. The intention is that it will bring them pleasure and hope for the future—that the energy passed on will only be good."

**Ann d'Arcy Hughes
(British)**
Gentle Wind
**13 x 19in (33 x 48.5cm)
Etching—2-plate colored etching, hardground, softground, and open bite with marbeling, printed à la poupée; T. N. Lawrence ink; Fabriano handmade paper
Edition of 30 printed by the artist on an etching press at Brighton Independent Printmaking, UK**

Ann d'Arcy Hughes
(British)
Levels of Perception
14 x 10in (36 x 25cm)
Etching—open bite and aquatint,
2 plates printed on cutout and
folded; oil-based etching ink;
handmade 350gsm paper
Printed by the artist on a polymetal
press at Brighton Independent
Printmaking, UK

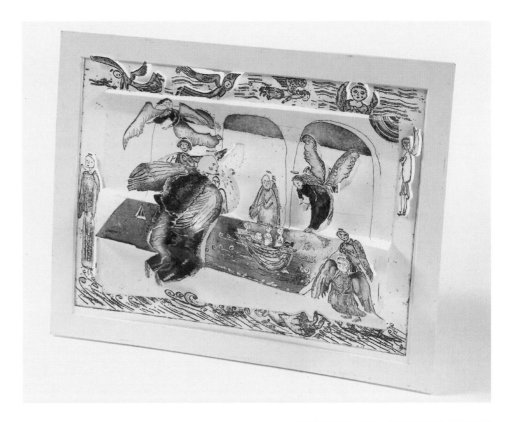

Ann d'Arcy Hughes
(British)
The Angel, the Guide and the Human
5½ x 6¼in (14 x 16cm)
Soft Japanese ply woodcut print,
cut out and constructed as a paper
sculpture. The book also contains
12 2D black and white woodcut
images.

1.4.11

profile: **S. W. Hayter**

Considered to be one of the most important printmakers
of the twentieth century, Stanley William Hayter (1901–1988) had a
profound impact on the development of printmaking, both technically and stylistically.

Through his experimental approach and open-door policy at his Paris and New York studios, he worked with, and by association influenced, some of the best-known artists of the day—Pablo Picasso, Joan Miró, Alexander Calder, Julian Trevelyn, Marc Chagall, and Louise Bourgeois, to name just a few.

Hayter was born in London to a family of painters. Despite his artistic family environment, he chose to study science at King's College in London and trained as a chemist, but after trying other employment he eventually decided to concentrate entirely on art.

In 1926 Hayter moved to France and in 1927 opened a printmaking studio that developed into the renowned Atelier 17. For the duration of World War II, he relocated to New York, where he re-established his studio in the New School for Social Research. The mix of European surrealist printmakers working alongside North American artists such as Jackson Pollock influenced the development of Abstract Expressionism in the US.

Both in France and New York, Hayter's focus was on the experimental rather than the traditional. Possibly influenced by his scientific background, he pushed the technical boundaries within the medium. Like the Surrealists, he was interested in the theory of the unconscious, and power of impulse and this transferred into the study of the potential ebb and flow of the engraved line. His philosophy was one of collaboration with the materials in order to achieve and enlarge the potential of the medium. His aim was to explore printmaking as a means of creative expression rather than one of commercial reproduction.

Hayter's explorations with color printing from a single plate have been the most applauded in terms of innovation. His experiments focused on aspects of multi-level printing, which involved varying the hardness of the rollers to access the differing levels on the plate. His chemical background perhaps aided him in his investigation of the chemical behavior of inks, which resulted in the method of viscosity printing (see pp. 150–155). This relied on the manipulation of the viscosity of the ink to allow the color to deposit in lines of varying depth. Color was also applied using screenprint and stencils and, as Hayter did not use aquatint, softgrounds were investigated to expand the potential for tone and texture.

Hayter produced more than 300 prints in his career, the most significant considered to be those made after World War II. The British Museum bought his personal archive of work and has a collection of Hayter's prints produced before 1960. While essentially recognized as an engraver, it was Hayter's enthusiasm for advancing the technical creation of the image that excited contemporary artists. He showed at the London Surrealist exhibition in 1926 and, it is said, was recognized as a Surrealist by André Breton. Hayter's avant-garde approach to the medium engendered a unique atmosphere at Atelier 17. Although the New York studio closed in the 1950s, the Parisian Atelier 17 remains open to this day.

printing process: **viscosity**

The method used in fine-art printmaking known as viscosity printing or the Hayter method was invented by S. W. Hayter (see p. 149). It utilizes the potential for a single plate to be printed in many colors, depending on the surface levels of the plate, the hardness of the rollers, and the viscosity of the ink.

1.4.12

Ann Kresge
(American)
The Heavenly Maiden **from the book**
Journey Tales
11 x 14in (28 x 36cm)
Color viscosity etching, letterpress
(on the text pages), handbound folio;
etching inks for intaglio, litho inks for
viscosity rolls; Arches Cover Buff paper
Edition of 30 printed by the artist on a
Printmaker's Brand etching press at
Women's Studio Workshop, Rosendale,
NY; letterpress printed on a
Vandercook Letterpress at
Pratt Institute, NY

This image comes from a handmade limited-edition artist's book, including the stories of maskmaker Suzanne Benton, which were collected from women around the world. Includes 6-color viscosity etchings and 6 letterpress broadsides.

Derek Vernon-Morris
(British Caribbean)
Sea Piece
12 x 10in (30 x 25cm)
Viscosity etching; oil-based intaglio ink
for the line, relief ink for the surface roll;
handmade paper
Artist's proof printed by the artist on
an etching press at the Slade School,
London, UK

The single steel plate is deeply bitten.
The line is inked as an intaglio image. The
relief surface is rolled up using hard and
soft rollers and stiff and loose ink.

The potential for a single plate to be printed in many colors depends on the surface levels of the plate, the hardness of the rollers, and the viscosity of the ink. The term viscosity, as related to inks, refers to the flow capacity or the consistency. The poise is the standard unit of measurement for viscosity, 1 poise being very thin and 700 being the thickest. In the US, the lithographic varnish numbers are used, 00000 being the thinnest and 10 being the thickest. The more viscous an ink is, the less it will flow.

A dry ink will be coated by an oily ink as it will absorb it, whereas an oily ink will repel a dry ink. S. W. Hayter also employed the use of hard and soft rollers, and he would carefully bite the metal plate to varying levels and depths. The ink used in the incised bitten line is intaglio etching ink, which is pushed into the lines and marks of a warmed metal plate and removed with scrim and tissue in the normal way. The various inks that are rolled onto the surface areas are generally litho inks, as they are capable of giving a strong, thin film of ink with less density and weight. This is due to the amount of pigmented color being in higher proportion to the vehicle that carries it.

Although Hayter, possibly due to his thorough understanding of the chemistry of inks (he originally trained as a chemist), could obtain a very wide range of colors from one printing, most artists today simplify the process by confining themselves to one color in the line, and two or three more on a range of hard and soft rollers, the viscose consistency of each ink being slightly different from the previous one.

1 This plate has been bitten deeply. Orange ink has been pushed into the lines and the grazed surface of the deeply bitten areas. The top surface has been wiped clean. A blue ink has then been rolled over the top surface, and where the metal was clean the blue will be clear. A soft roller was used with a little pressure applied. This has resulted in the blue touching down on the background areas, consequently creating a glow of pure orange around the raised shapes. If a hard roller had been used the background area would have remained entirely orange, as the blue would have been confined to the relief surface only.

2 The line of the same plate has been inked up in scarlet and the surface wiped clean. The same soft roller has been used, but the violet ink has had 30% transparent medium added. This gives a translucent quality to the proof.

Monica Macdonald Ralph
(British)
Glacier Moon
11 x 11in (28 x28cm)
Viscosity; oil-based ink;
handmade paper
Edition of 20 printed by the artist
on an etching press at her studio

viscosity printing in practice

1.4.13

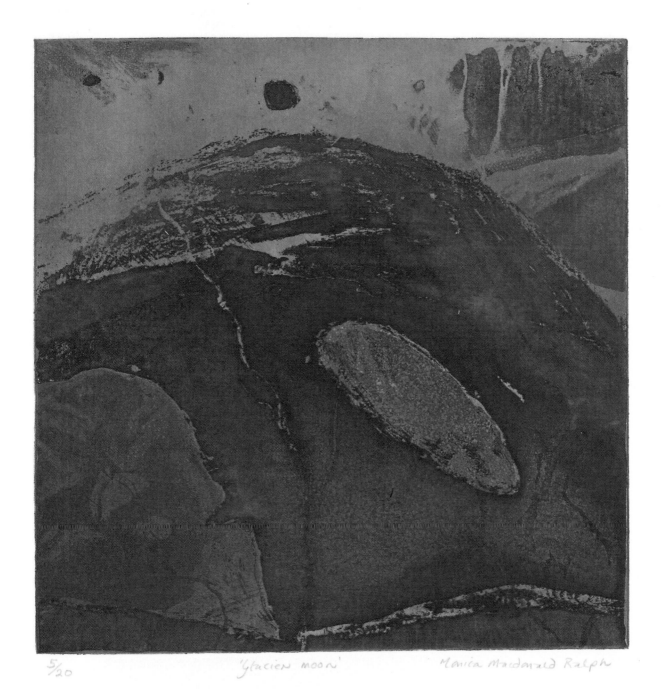

5/20 'Glacier moon' Monica Macdonald Ralph

Monica Macdonald Ralph
(British)
Dewpond Sunlight
11 x 11in (28 x 28cm)
Viscosity
Edition of 20 printed by the artist in her studio

Hale Balta
(Turkish)
My Hands
4 x 5¾in (10 x 14.5cm)
Viscosity etching—intaglio line blue, viscosity surface, first orange then yellow; Brodie & Middleton pigments and van Son rubber-based ink; Somerset Textured 250gsm paper
Edition of 100 printed by the artist on a copperplate printer's press at the University of Brighton, UK

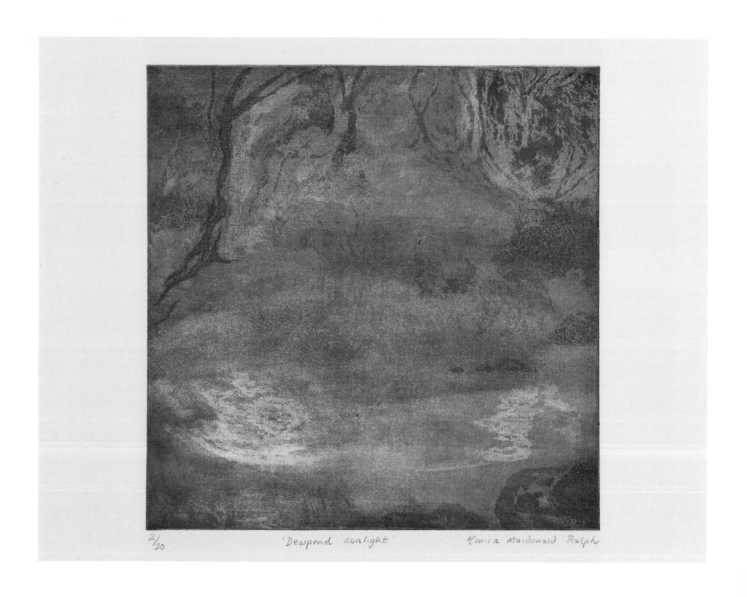

'Dewpond sunlight' Monica Macdonald Ralph 2/20

printing process: **blind embossing**

The term "blind emboss" means to bite a metal plate deeply and then print the result without ink.

**Jon Crane
(British)**
Circus
**7 x 10¼in (18 x 26cm)
Blind emboss
Edition of 10 printed by the artist on an intaglio etching press at the London College of Printing, UK**

Right: **Jon Crane
(British)**
Bows
**5¼ x 7in (13.5 x 18cm)
Blind emboss
Edition of 10 printed by the artist on an intaglio etching press at the London College of Printing, UK**

British artist and printmaker Jon Crane discusses his innovative blind embossing techniques.

I was not fully satisfied with traditional blind embossing techniques, so decided to develop the technique further. I experimented with small, flat objects found around the house, such as buttons, clips, pins, and coins. Initially I put them onto a base, usually made of cardboard. Having cut a piece of 180gsm dry paper, I would place it over the objects and run it through the press.

1.4.15

techniques: **blind embossing**

Some of the earlier trials were more satisfactory than others. If the objects had sharp edges and there was too much pressure on the press, they would cut through the paper surface. I corrected this by using damp paper with less pressure, which provided much better results. I found that the lighter-weight papers, 140 to 220gsm, gave a better impression with clear, precise edges.

After extensive experimentation, I developed a clear idea of what type of object produced an exciting blind emboss print. For example, while traveling in Spain and Italy I came across metal plates with details of human limbs impressed into them, which were used in the Roman Catholic Church as prayer tokens. These small, flat objects proved to be excellent for blind emboss printing.

Some of my most interesting images have come from a fascination with cut and folded paper. I used origami techniques in folding paper to create different levels of thickness, then glued the object to a card base and coated the surface with a varnish that would resist the moisture from the damp paper when printed. This technique produced some remarkable effects with clarity of the defined shapes.

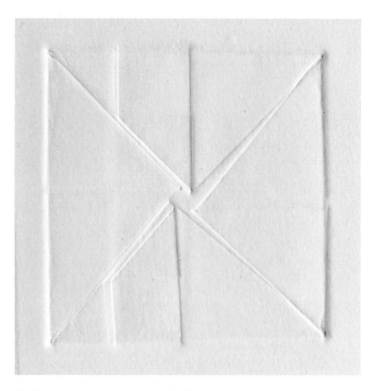

Jon Crane
(British)
Multiple Shapes
4 x 4in (10 x 10cm)
Blind emboss
Edition of 10 printed by the
artist on an etching press

Jon Crane
(British)
Keys Unlock The Secret
3 x 5in (8 x 13cm)
Blind emboss
Edition of 10 printed by the
artist on an etching press

The idea behind the collage is similar to that of a stage set: the backdrop remains constant, but objects can be moved around in front of it.

**Julian Hayward
(British)**
Summer Suns Are Glowing
**This image shows the
etching plate with copper
components on steel. See
opposite for the final print.**

1.4.16

**Copper components can be
attached to the steel base as
and where required.**

Copper image (left) ready to be stuck onto the steel plate. The use of hardboard to back the copper while cutting prevents damage to the copper and allows the cutting of finer details.

British artist and printmaker Julian Hayward explains how he created his images "Summer Suns Are Glowing" using mild steel and copper foil etching via the collage method.

1.4.17

Printing process: **collage**

The collage method utilizes copper components that can be attached to the steel base as and where required. This enables different configurations of the copper images to be made, or for new copper components to be introduced. The small copper images are glued to the surface of the steel plate. They can be displaced, by being eased off with a palette knife while heated, either from above or below, with a blowlamp.

1. The base plate is made of steel, into which an image is etched that forms the background to the copper foil pieces subsequently fixed to it.

2. A thin sheet of copper foil is coated with acid-resist ground and strengthened by being glued to a backing sheet of stiff plastic, or similar.

3. Images are then drawn with a needle and etched into the copper foil, both to mark the shape and treat the surface. Nitric acid is suitable for this process.

4. The copper foil is cleaned with mineral spirit to remove the ground, detached from the plastic, and attached to a piece of 6mm hardboard.

5. The images are cut out with a fine-tooth fretsaw.

6. The etched images are lifted carefully off the hardboard with the aid of a blowlamp, which softens the glue. The copper is then cleaned and degreased on the underside.

7. The steel plate is also degreased. Permanent spray-mount glue is applied to the underside of the copper images and allowed to almost dry. The images are then positioned on the base plate.

8. The plate is put through the press under pressure, using the blankets to ensure very good adhesion of the copper pieces to the base plate. Paper should be inserted between the plate and the blankets to prevent excess adhesive getting onto the blankets.

9. The plate is now ready for printing.

Printing

1. The ink, slightly thinner than normally used, should be applied liberally using a piece of card. Care should be taken to make sure that the ink gets well into the edges of the copper images.

2. Before trying to remove the excess ink by lifting it off with scrim, the plate should be slightly warmed. Having removed the excess ink, the plate can be wiped either with very fine scrim or cotton. Extra caution must be taken not to catch the edges of the copper images, which can be damaged or lift off. If this happens, a damaged area may be gently beaten down with a hammer. As with traditional etching, the wiping of the plate is completed with tissue paper.

3. Printing proceeds in the normal manner.

4. When cleaning the plate after printing, mineral spirit should be used sparingly to avoid displacing the copper images by dissolving the adhesive.

Julian Hayward
(British)
16 x 12in (42 x 30cm)
Summer Suns Are Glowing
Etching; oil-based etching ink;
handmade paper
Printed by the artist on a Rochat
etching press at Brighton Independent
Printmaking, UK

The two printed images use the same
etched steel background plate, while
the various copper components are
removed and reattached as required.

intaglio in practice

Clive Vosper
(British)
Tectonic Drift 1
17 x 16in (45 x 42cm)
Etching

The photo-etching was made with 2 plates, each holding an image of the land surface taken from photographs of Iceland. Each plate was inked independently with up to 3 colors and then overprinted in a random way. The idea came from the two colliding tectonic plates that are beneath Iceland and give it its unique geology. The plates were made using image on light-sensitive film pressed onto the plate surface and exposed with UV light source using inkjet-printed positives.

Right: **Richard Denne**
(British)
9 by 9 (1)
22 x 22in (56 x 56cm)
Etching—9 colors and 81 steel etching plates; handmade inks mixed by the artist and friends; Somerset Satin 300gsm paper, 100% cotton acid-free and buffered. It has 2 deckled edges and 2 torn edges and is watermarked. Unique print printed by the artist on a manual press at Brighton Independent Printmaking, UK

Helen Brown
(British)
South Downs Way
47¼ x 17in (120 x 45cm)
Woodcut on soft Japanese plywood
(2 blocks used with multiple rollers);
oil-based relief inks; handmade
Fabriano 300gsm paper
Edition of 20 printed by the artist on a
Columbian Eagle relief printing press
at Brighton Independent Printmaking,
UK

relief **2**

introduction to relief

A relief can be defined as an impression made by a hand or an object that has been transferred onto an alternative surface. The origins of relief printing are ancient and varied. Evidence of carved reliefs can be traced to the Sumerian civilization of c. 4000 BCE. In Mexico, the Olmec Indians used baked clay tubes decorated with relief designs to create repeat patterns between 1000 and 800 BCE.

There is a strong history among early societies of using stamps and seals made of wood, brick, clay, metal, and latterly wax, to transfer information. Uses included the branding of criminals with symbols to identify the nature of the crime committed; the branding of animals to indicate ownership; and the use of seals on clothing and buildings to demonstrate status.

While the use of relief objects was in evidence internationally, it is accepted that the skill of printing multiple images onto first silk and then paper originated in China. The use of a carved seal, dipped in color and transferred onto a silk document, can be considered the first example of relief printing. Paper was invented in China in the second century CE, and the creation of wooden blocks to print imagery and religious teachings followed soon after. The relief-printing process was considerably slower to develop outside China; paper was not manufactured in Europe until the twelfth century.

A relief print can be produced from any material that has a raised surface, flat enough to hold ink, and strong enough to endure the pressure necessary to transfer the inked image onto the surface. Traditionally, relief prints are created using a block of wood or linoleum. Using knives, gouges, or engraving tools, the image is developed with a variety of delicate and broad lines and marks. The areas that have been cut away and exist below the surface of the block will not print, as the ink remains on the raised surface. The unprinted areas (sometimes referred to as the negative space) are integral to the image and will stay the color of the paper or receptive surface used. Once the block has been cut and the surface covered in ink using a roller, the paper, sometimes dampened in order to receive the ink more readily, is placed over the top of the block. Pressure is then applied either through the use of a printing press or by rubbing the topside of the paper with the hand or a burnishing tool. If the pressure is applied evenly, the ink will transfer onto the paper. The final image is printed in reverse, so the design will be a mirror image to the one created on the block.

Although the traditional methods of creating a relief print use wood (either in the form of a woodcut or a wood engraving) or linoleum, it is also possible to print from contemporary materials such as found objects, metal, plastic, cardboard, or natural printing blocks such as leaves and bark.

Historically, relief printmaking was initially utilized for religious and social purposes, to spread the teachings of Buddhism in the East and Christianity in the West. During the fifteenth century, the artists Albrecht Dürer (1471–

1528), Hans Holbein (1497/8–1543), and Lucas Cranach (1472–1553) raised the profile of relief printing from that of industry to fine art, and produced an enormous body of work.

Enthusiasm for relief printing as an art form began to decline in Europe after the sixteenth century. However, in terms of manufacturing, it was the method used for the printing of both books and newspapers until the invention of the photographic printing process following 1820. It was between the seventeenth and nineteenth centuries that the Japanese *Ukiyo-e* artists excelled using the relief methods, and their influence extended widely into America and Europe. At the close of the nineteenth century, released from the ties of commercialism and reproduction following the development of the photomechanical process, the European avant-garde returned the relief printing process to one of creative expression and aestheticism.

In the United States, the Works Progress Administration of the 1930s aided a revival of interest, and following the two world wars in Europe, a focus on the next generation and an attempt to rebuild the present for the future encouraged a new wave of self-expression. In the middle of the twentieth century, there was an increased interest in color and the relief process following works by artists including Picasso (1881–1973). The Op and Pop art movements in America sought to further experiment with the boundaries of color within printmaking.

More recent developments such as etched lino (see pp. 210–213) have encouraged interest in the relief printmaking process, further aided by exponents such as Michael Rothenstein (1908–1993), Maggie Hambling (b. 1945), and Angel Botello (1913–1986), whose imagery demonstrates the versatility of the process.

woodcut or wood engraving?

It is useful to define the difference between a woodcut and a wood engraving. The distinction lies in two areas: the type and area of wood used for the block, and the tools utilized. Both of these affect the quality of the image.

Wood engravings utilize the end grain or cross grain of the wood—the surface evident when slicing across the trunk of a tree. The wood is harder and has a denser, smoother, more compact surface. The grain is tighter and therefore the texture of the wood will not affect the surface of the design. This allows for a finer, more delicate result within a design that relies entirely on the lines and marks incised into the surface of the wood. The print will be positive, and the image defined by the white lines that have been cut into the block. Preferred woods are boxwood, apple, and cherry. The Japanese *Ukiyo-e* artists worked with wild cherry wood, cut both with the grain and against it to allow the highly intricate line achieved in their images.

**Ann d'Arcy Hughes
(British)**
The Overlighting Angel
19¾ x 15¾in (50 x 40cm)
**Soft Japanese ply woodcut with
Chine collé; oil-based relief inks;
thin Japanese handmade papers
and Fabriano Artistico 300gsm paper
Edition of 30 printed by the artist on
a Columbian Eagle relief printing
press at Brighton Independent
Printmaking, UK**

Historically, the tools employed are fine engraving tools, such as spitstickers and gravers, akin to those that are traditionally used in metal engraving.

Woodcuts use the side grain or long side of the wood. The plank is cut parallel to the length of the trunk, following the direction of the grain and sap. Softer woods are used, such as pine, fir, pear, or sycamore. These are less inclined to hold an intricate, detailed line, but are easier to work and lend themselves to a more spontaneous, loose mark. The grain and coarseness of the surface texture require consideration, as the natural pattern of the wood can affect the image. Consequently, the contemporary approach has led to less "pure" woods being used, such as ply, driftwood, weathered, charred, and distressed woods. This aspect has been exploited to aesthetic effect by artists such as Paul Gauguin (1848–1903) and Edvard Munch (1863–1944), who incorporated the textural surface of their wood blocks within the body of the image.

Woodcuts use knives and gouges rather than the finer engraving tools. These result in a less linear approach, the result being broader marks and more open cut areas.

Dmitry Sayenko
(Russian)
Illustration from Daniel Kharms'
Kharmsli Vslukh (Thinking Aloud)
9 x 12¼in (22.5 x 31cm)
Woodcut
Edition of 9 printed on a relief press;
5 copies printed on *Soviet Magazine*,
published 1929–1933, 4 copies printed
on Korean paper

Sayenko likes to use wood (pear,
lime, or rough ply), as he sees this
material as a "primeval plate for self-
expression and creation."

2.5.2

a brief history of woodcut

The use of wood blocks as a printing medium, albeit on textiles, has its origins in the sixth century and can be traced both to Korea and Eygpt. The development of transferring woodcut images onto paper is attributed to China in the ninth century during the T'ang Dynasty (618–906). Early prints incorporated both text and imagery that were cut from the same printing block using a method referred to as plate printing.

The individual plates of text and imagery were joined together into concertina folds and the unprinted pages glued to each other. The sequences were bound together to create the first printed books, known as block books. Subjects for these block books included medicine, botany, agriculture, poetry, and literature. *The Diamond Sutra* (868 CE) is a surviving example of an early Chinese block book. This laborious process was replaced in the early eleventh century, when image and text began to be cut and printed from separate blocks.

Woodcut images from China have been discovered dating from the ninth century, but it was not until the end of the fourteenth century that Europe truly embraced the woodcut printing method, this being greatly influenced by the introduction of manufactured paper. Germany and the Netherlands were important centers for woodcut printing and, as religion was integral to medieval life, it was biblical imagery that was produced. As most people were illiterate, the woodcut provided society with instructional images that could be produced in multiples and were accessible to all levels of the population. Items such as playing cards, charms, and images of saints and churches were inexpensive and served an educational purpose. In the western hemisphere, instructional publications were produced in

Mexico from 1539 for use by the Church to aid the conversion of the Aztec population to Catholicism. It is documented that the first book was printed in two languages: Nahuatl, the language of the recently overpowered Aztecs; and Spanish, the language of the conquistadors. In order to aid the establishment of the new government, engravings and woodcuts were also used to create heraldic prints, portraits of government officials, topographical views, and maps. To accommodate demand, artists began to employ skilled craftspeople to cut the images they had drawn directly onto the wooden blocks.

As the technique became more sophisticated, painters of the era began to take an interest in the medium. In the late fifteenth century, Albrecht Dürer raised the profile of the woodcut to that of fine art. His draftsmanship, influenced by Italian Renaissance art, incorporated a more refined use of line and tone that served to define the art form. Dürer and his contemporaries, such as Hans Holbein (1497/8–1543), produced an enormous body of work through the use of skilled craftspeople who cut the wood blocks to their design. The quality of work produced ensured that the woodcut achieved an independent and respected status.

Japanese woodcut artists, who produced a tremendous amount of work during the Edo period (1615–1868), furthered this process of collaboration. As Europe's enthusiasm for the medium diminished toward the seventeenth century, the Japanese *Ukiyo-e* woodcut artists flourished. The term *"Ukiyo-e"* has its origins in Buddhism and refers to "the floating world"—that is, the ephemeral entertainments of fashionable city life, and the everyday pleasures enjoyed by the merchants and townspeople of the period.

The early woodcut collectives usually allocated particular aspects of an image to individual craftspeople. One might work on the face, another the garments, and another the scenery. Although several people worked on each block, the finished print was attributed solely to the artist.

The early prints were in black and white, but by the mid-eighteenth century the technique of multiple-block color prints was developed. The subject matter evolved into the nineteenth century, with artists such as Katsushika Hokusai (1760–1849) and Andô Hiroshige (1797–1858) depicting aspects of the natural world such as birds, animals, and flowers.

From 1860, *Ukiyo-e* prints had a strong influence in Europe, in particular after the Paris Exposition Universelle, where a large number were exhibited. The avant-garde in Paris, such as Paul Gauguin (1848–1903), Henri de Toulouse-Lautrec (1864–1901), Edgar Degas (1834–1917), Edouard Manet (1832–1883), and Camille Pissarro (1831–1903), admired *Ukiyo-e* for its strong design and composition, and were influenced by its style.

The resulting woodcut prints produced by Gauguin (which were also influenced by the Maori culture in the Pacific) attracted interest because of his use of broad, open areas that incorporated the pattern of the grain within the image. In turn, apparently inspired by Gauguin's woodcuts, Edvard Munch (1863–1944) began a series of wood blocks in Paris in 1898. Munch experimented with color separation when producing his woodcuts. At times he used independent blocks; on other occasions he used one block, cut into distinct pieces, inked separately and regrouped for printing.

Unlike their predecessors, artists in the late nineteenth and early twentieth centuries did not delegate the cutting and printing of the wood block to craftspeople, but were personally involved in the entire creative process. This ideology appealed strongly to the German Expressionist movement. The imagery emerging from this group depicted the emotional, internal world of the individual, reflected in a stark use of line and tone.

In Germany in the early twentieth century, artists such as Käthe Kollwitz (1867–1945) and Emil Nolde (1867–1956), both part of the Die Brücke ("The Bridge") group of artists, exploited the woodcut as a suitable medium for their bold use of line and composition. The Die Brücke artists sought a simple and direct style, and looked to medieval woodcuts as inspiration for their own work. The direct nature of the woodcut allowed an immediacy of expression that produced a powerful response to the social and political turmoil of the age.

In Mexico, José Guadalupe Posada (1852–1913) created a series of graphic woodcuts as a response to the social, political, and religious upheaval before and during the Mexican Revolution of 1910–1920. His works are cited as influencing three of the most prolific South American artists of the last century: Diego Rivera (1886–1957), José Clemente Orozco (1883–1949), and David Alfaro Siqueiros (1896–1974).

In Britain during the 1890s, both the Kelmscott Press, headed by William Morris (1834–1896) and the Vale Press, run by Charles de Sousy Ricketts (1866–1931) and Charles Shannon (1863–1937), returned to woodcuts as a form of expression for their publications. From the end of the sixteenth century, copper engraving and the etching process had been the methods of choice for printmakers. However, Morris admired the woodcuts in fifteenth-century books, which influenced the vision he had for his own publications. His intention for his longest work, *The Earthly Paradise*, was to produce and publish 500 woodcut illustrations based on the drawings of Pre-Raphaelite artist Edward Burne-Jones (1833–1898). Morris cut 50 blocks himself, but the project was later abandoned.

Morris was the inspiration for the Vale Press, which produced two magazines as well as books with woodcuts created by Lucien Pissarro (1863–1944), Edward Calvert (1799–1883), and Thomas Sturge Moore (1870–1944).

One of the most celebrated woodcut exponents of the twentieth century was Flemish artist Frans Masereel (1889–1972). His work reflected his pacifism and democratic beliefs, speaking out against the violence, wars, and injustice he felt existed in the world. He produced books as well as prints. *The City: A Vision in Woodcuts* was a visual journey without words, as was *Passionate Journey: A Novel in 165 Woodcuts*.

Contemporary artists continue to produce woodcuts despite the advancements in digital technology. Finland has an unusually strong and enthusiastic woodcut movement, while American artists such as Jim Dine (b. 1935), known predominantly for his involvement in the Pop art movement in the 1960s, and Irving Amen (b. 1918), continue to produce woodcuts in the twenty-first century.

In contemporary woodcut practice, the wood used is generally pine or birch plywood. However, there are numerous hardwood and softwoods to choose from, both new and recycled. We explore both processes in this chapter. It is usually availability, cost, and personal choice that dictates what type of wood is suitable for the artist's needs. Personal research is the only solution to finding the best material for the project in hand.

woodcut process: **hardwood**

In the relief process, the relief, or top surface, is the printing area, and the incised, or cut-away, marks remain white. As some types of wood have an attractive grain, artists may choose a particular material to incorporate these organic marks into their image. Commonly used hardwoods include mahogany, poplar, apple plywood, cherry plywood, ash, birch, beech, elm, and maple.

2.5.3

Above and right: **Andrew Mockett (British)**
Chap Book of English Tat
8¼ x 11½ in (A4/21 x 29cm)
A series of books created in woodcuts and printed in silkscreen
Edition of 200 printed by Daniel Langlois at Colourgraph London, UK

Andrew Mockett was commissioned by Virgin EMI to create a box to house a music CD and various other related items including a poster. The final image of the poster is shown on p. 177.

Safety note
Always wear eye protection for this kind of work, as splinters from the wood can flick up into the face.

2.5.4

step by step:
hardwood woodcut

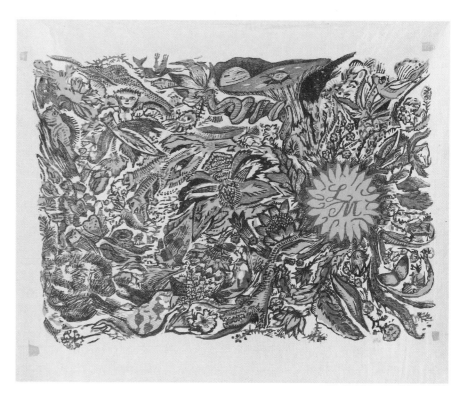

1 The master copy of the design is drawn up to actual size, using the three colors to be printed: 1) red; 2) yellow; 3) violet. Three sheets of acetate are cut exactly to the size of the design, one for each color. Three sheets of 9mm birch ply are cut, also exactly to the size of the design, to allow for perfect registration when printing.

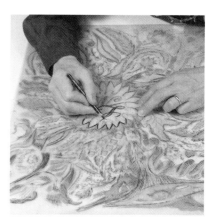

2 A sheet of acetate is laid accurately over the design in order to trace off the areas needed for the printing of the first color; in this case, red. When printing, it is generally the practice to print the lightest color first followed by progressively darker tones until finally the key block, but as shown here this is not an unbreakable rule.

3 A tracing is taken onto the sheet of acetate using a soft chinagraph pencil. Every mark is carefully copied to ensure accurate registration at the printing stage.

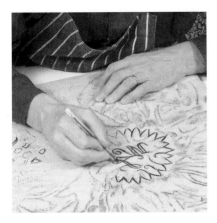

4 The completed acetate sheet is turned over, with the chinagraph marks resting directly on the surface of the new piece of wood. It is necessary to turn the sheet over as a woodcut relief block will always print in reverse; there is no offset system, and therefore this method counteracts the problem of lettering coming out the wrong way round. The sheet is then securely taped down to prevent any movement, which would result in the registration becoming inaccurate. A ballpoint pen is rubbed firmly over the back of the chinagraph marks to transfer them to the wood.

5 Red chalk is rubbed over the surface of the wood to allow the artist to easily see the newly cut areas, as they will appear white against the background. The chalk is repelled by the greasy chinagraph pencil lines.

6 The artist works from the center outward, and then returns to any areas that need further attention. Note that the tool is held firmly in the right hand for pressure, while the fingers of the left hand are used to guide the motion. (Obviously, this would be reversed for a left-handed person.)

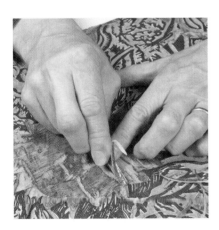

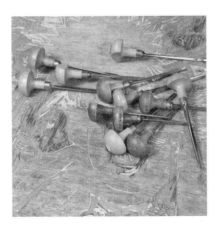

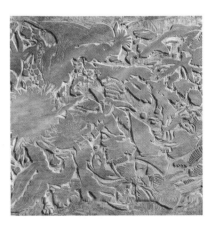

7 The violet block is produced in the same way as the previous one. The top left-hand corner of each block is left bare to be used as a registration corner when printing. A fairly broad tool may be chosen when clearing out an area to prevent it from printing. This will then allow the color from one of the other blocks to show through.

8 The yellow block is created in the same way as the red and the violet. Andrew starts work with 40 tools, which he experiments with until he ends up with approximately 12 that he will interchange over the whole cutting period.

9 When the yellow block is complete the woodcut is ready to proof print.

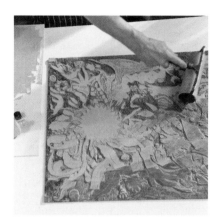

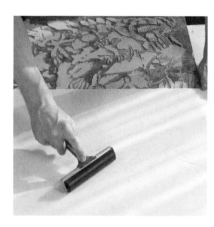

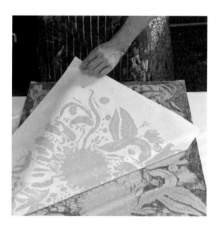

10 Hardwood can sustain the use of either oil-based or water-based ink, as it does not have the tendency to swell that softwood has. The ink is rolled onto the surface of the block. Initially this will require a substantial number of passes with the roller, but once the ink has built up and a satisfactory proof has been taken, subsequent prints will require less rolling up.

11 A trial proof is taken by laying down a piece of paper on the surface of the wet ink. It is smoothed flat with the hands and rolled over with a firm roller. Alternatively, it can be put through a relief press.

12 The paper is pulled back to check the quality of the proof. If the body of ink is sufficient, it can be re-inked and printed on good paper in the order of color required.

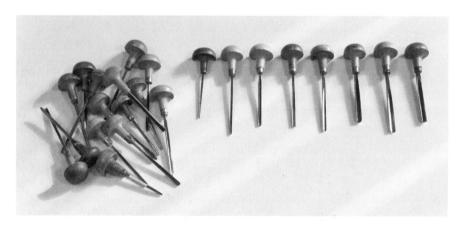

13 Handheld wood-cutting tools can be similar to those used for linocut (see p. 198). Traditionally, these have a mushroom-shaped handle that should fit comfortably into the palm of the hand. The stem or shaft may be straight or bent. If the stem is too long it can be removed from the handle and shortened with a hacksaw. The metal is then heated and pushed back into the wood.

The tools can be purchased with a V or a U cutting shape. They are all referred to as gouges. There are broader U-shape tools sometimes termed "sweep" gouges. The V gouge can be purchased as small as 0.5mm, with a range of sizes up to 4mm. The U is available from 1mm to 5mm, with the sweep gouge being as broad as 10mm. There are also much heavier tools designed to be used with a mallet, and a wide range of power tools, for larger projects.

For the novice, it is possible to buy a set of tools. However, it might be best to select two U gouges and two V gouges of various sizes, and of a higher quality, until you can decide what other tools you might need. Good-quality gouges will come ready-sharpened. They should be resharpened at regular intervals using the wide range of sharpening and finishing stones available in various shapes and sizes. These are obtainable from specialist printmaking suppliers and quality tool stores.

Final image: Andrew Mockett (British)
Laura Marling Poster
Woodcut
Commissioned by Virgin EMI to advertise the *Laura Marling Song Box*.

woodcut in practice

Manuel Lau
(Peruvian–Chinese–Canadian)
Mont-Royal IV
22 x 30in (56 x 75cm)
Woodcut—reduction and addition
method plus stencil; Handschy
Lithographic B15 series inks;
Somerset Soft White paper
Edition of 9 printed by the artist on
a French-American etching press at
Atelier Circulaire, Montreal, Canada

2.5.5

Harvey Daniels
British

2.5.6

profile: **Harvey Daniels**

"I did not have to rebel to be an artist, as my parents were enthusiastic—in fact, from a very early age, my father used to give me visual projects. My father was a watercolor artist. He wanted to be a fine artist but he was called a commercial artist. I also have a cousin, Alfred Daniels, who has been a painter all his life and is a successful artist.

"One of my earliest recollections of art was of being in a hotel in Brighton with my parents—I must have been about eight or nine years old. The hotel had a small book of black and white images by Matisse. Although I did not understand them, I knew that there was something there, so in a sense Matisse started me off and has impressed me throughout my life.

"As a Londoner, I started my art training at Willesden Technical College when I was 15 years old, and was taught by tutors such as Liz Frink and Terry Frost. Prunella Clough also taught there, and she became an important influence—I was very impressed when she became a totally abstract artist. When I studied at the Slade I also had tremendous admiration for Ceri Richards, as a tutor and as an artist.

"I always saw myself as a painter. After the Slade, when teaching in a London secondary school, I was exhibiting in a solo exhibition in New York and various other cities and decided that I wanted more time to do my own work. I applied to various art colleges around London for teaching posts but when called to interview, it was continually suggested that I must be a printmaker as usually I had some prints in my portfolio. I always replied that I was actually a painter. Having been turned down by a number of places, at the next college, when

they asked if I was a printmaker, I said 'Of course.' Mind you, if they had asked me to teach Ceramics I would have done. So that was how I became a printmaker.

"Having taught at the Central School in London I then went to teach in Brighton in the 1960s and became head of the Printmaking department in the 1970s. I always did my own printing in those days as you could work in the college, alongside the students. They could see what you were doing and you could teach at the same time. I really enjoyed that way of working. It was an exciting time, but then art fashions changed in the 1980s and printmaking became unfashionable.

"I continued in printmaking because I found that I could work my ideas in painting and then take them into printmaking and vice versa. The printmaking process is very important as one is enormously influenced by the way the marks develop. It has nothing to do with the number of prints one can make—some of my editions ran to only five prints or fewer. I have always felt that printmaking is very exciting and in the early 1970s I wrote one of the first books that covered all or most aspects of printmaking. People have contacted me saying that the book made a lot of difference, but obviously the publication has been superseded now."

Harvey Daniels
(British)
Oriental Suite: Fan
39¼ x 22in (100 x 56cm)
Color woodcut on hardwood dyed
after printing with water-based dye;
oil-based ink; handmade paper
Edition of 12 printed by master
printer Michael Waight on a relief
printing press at Peacock Visual Arts,
Aberdeen, Scotland

Harvey Daniels
(British)
Roundel
32¾ x 31½in (83 x 80cm)
Color woodcut on birch plywood;
oil-based ink; handmade paper
The image is one of a pair printed by
master printer Michael Waight on a
relief printing press at Peacock Visual
Arts, Aberdeen, Scotland

"I enjoy doing other projects, too. Recently I painted an actual guitar that went into the 'Born to Rock' exhibition in Harrods. I designed a cow for 'Cow Parade,' which was placed in one of London's subway stations and was later sold by Sotheby's for charity. I also created a design for a 200-meter stretch of road made in aggregate, stretching from the station to the shopping mall in Southampton.

"For a long time I fought against becoming an abstract artist and my work has changed very slowly. At a point of crisis, I decided to cease being an artist as I was becoming upset at the evolving abstraction in my work. However, while I decided to consciously say that I did not care about art any more, I found that I still wanted to make things with my hands. I was in Brighton and a dandy, so I decided to go on making paintings and prints about clothes and other things that I was interested in. As we all know, whatever you make can become art and I realized that I was becoming more abstract only because I left things out. I tried to think about the really important things, which gave me an opportunity to be quite precise.

"Printmaking has been very important to me in my life: it is the imagery and the way it looks that I really enjoy. Now I cut woodcuts and have them proofed by a master printer in the Peacocks Workshop in Aberdeen. Having worked for many years in silkscreen, I came to woodcuts when it was suggested to me that I try using a router on wood. Although reluctant, I tried it and it was marvelous. I now want to go back to lithography and do some very simple things. Thinking about Miró, for example: his printmaking, painting, and ceramics are all part of the same creative processes."

Left: **Harvey Daniels**
(British)
Jigsaw wood block
49 x 21¼in (124 x 54cm)
Birch plywood; oil-based ink
Cut by the artist with a router
and knives

Right: **Harvey Daniels**
(British)
Jigsaw
49 x 21½in (124 x 54.6cm)
Color woodcut; oil-based ink;
handmade smooth 144gsm paper
(originally white and dyed after
printing with water-based dye)
Edition of 12 printed by master
printers Arthur Watson and Michael
Waight on a relief printing press
specifically constructed to print large
woodcuts, at Peacock Visual Arts,
Aberdeen, Scotland

Note that the block on the left prints
the image in reverse, as shown by the
print on the right.

woodcut process: **softwood**

There is general consensus that softwoods are easier to work than hardwoods; this attribute can encourage a freer, more spontaneous, approach. Commonly used softwoods are white pine, larch, and cypress. However, many contemporary artists find Japanese plywood to be a very practical and expressive material that is readily accessible.

2.5.7

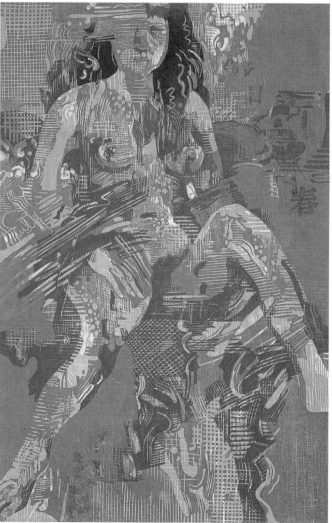

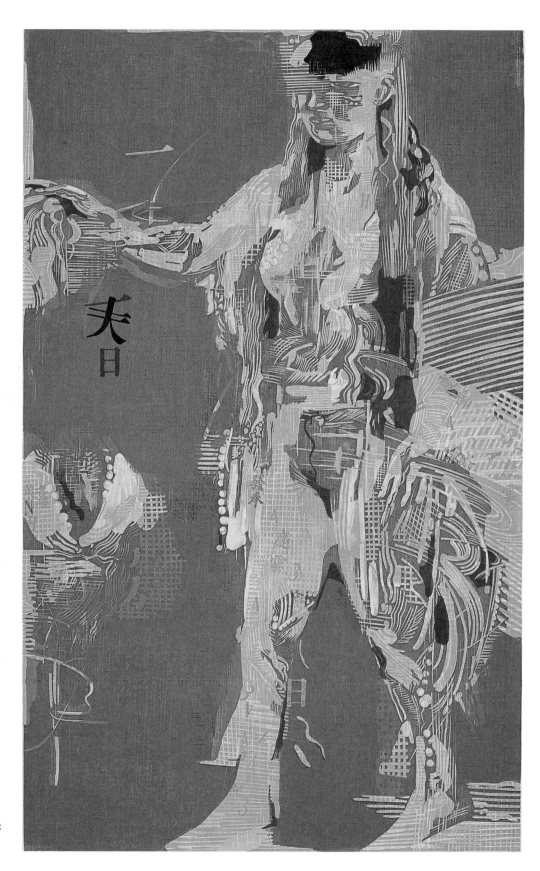

**Zhang Guanghui
(Chinese)**
Valentine's Day 1 **(left);** *Valentine's
Day 2* **(right)**
**(1) 30¼ x 19in (77 × 48.5cm);
(2) 30¼ x 38¼in (77 × 97cm)
Chromo xylograph with overlay
print; Sakura printing oil colors;
Xuan paper
Printed by the artist on a Philoprint
press at the North Bank Studio,
Hong Kong**

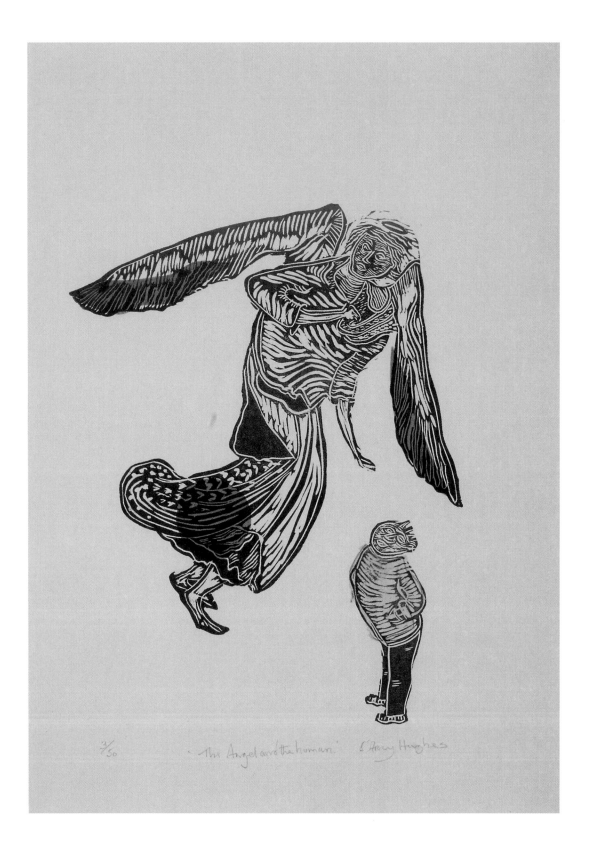

Ann d'Arcy Hughes
(British)
The Angel and the Human
10 x 6in (25 x 15cm)
Woodcut print; blend of red and
black inks; Fabriano Artistico
300gsm paper

The ink was rolled diagonally
onto the block. Pieces of gold
Chine collé paper with glue applied
to the reverse side were placed on
the inked-up surface. Handmade
printing paper was laid over the
block, and it was put through a
relief press.

Columbian relief press built in London in 1844.

This is commonly known as an "Eagle" press because of the elaborate counterweight in the form of an eagle on the upper arm. This press was originally used to print posters, newssheets, maps, and books. The motion is downward, transferring ink onto paper from the upper surface of the block. It is now used to print woodcuts and lino prints, although it can still be adapted to print letterpress. The press is too labor-intensive to be used for commercial printing today.
(Photo courtesy of Laurence Olver)

Soft Japanese plywood block for *The Angel and the Human*

The image has been cut using Japanese woodcutting tools, as shown. The shape has been entirely cut out using an electric jigsaw. The block has been inked up in oil-based relief inks ready for printing.

The four Japanese woodcutting tools used to cut the block. Left to right: Aisuki flat chisel; Komasuki 3mm U gouge; Sankakuto 1.5 V gouge; Komasuki 1mm U gouge.

A wide range of tools is available from specialist stores (see suppliers, pp. 404–405).

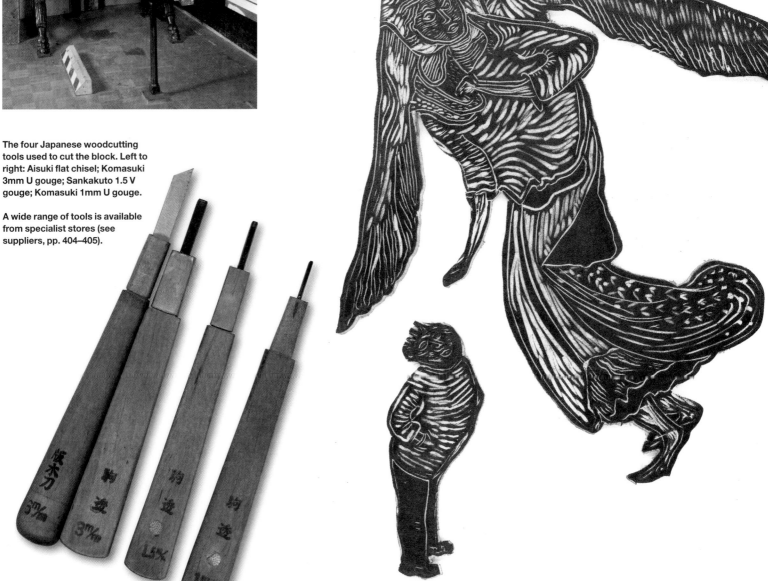

Tools

It is better to buy two or three good-quality tools rather than a cheap set. They may have straight or mushroom handles, and basically are the same tools used for lino cutting. The V gouges start at 1mm and produce a clean, defined line. They are also convenient for crosshatching or parallel lines at various widths. The U gouges also start at 1mm and create the appearance of a broader, more curved, line. The larger sizes are useful for clearing out large areas. The knife has a 45-degree angle on one side, with a sharp edge and point. It has innumerable uses, including clearing or cutting lines, while the point can be used for small, delicate areas.

2.5.8

step by step: **soft Japanese plywood**

Left to right: Graphite stick; gouges:
**V & U 1mm, V & U 1.5 mm, U 3mm,
V 1.5mm, U 4.5mm, U 1.5mm; knife 3mm**

Softwood: Troubleshooting

Problem: Image does not print evenly

Cause	Solution
Block is uneven.	**1.** When purchasing, check that the block is level by placing it on a flat surface.
	2. Store blocks in a dry environment.

Problem: At the second time of printing the wood has swelled and the fine lines have narrowed

Cause	Solution
1. Water-based ink has been used, which will affect the wood in this way.	**1.** Use oil-based ink only.
2. After the previous proof the ink was washed out with mineral spirit.	**2.** Any fluids will swell the wood, but vegetable oil or just a dry cotton rag will adequately remove the ink.

Problem: The wood chips when being cut

Cause	Solution
The tool is blunt.	Sharpen the tool yourself or return the tool to the supplier to be resharpened.

1 Draw or paint the design directly onto the surface of the wood in pencil, or a medium of your choice. The areas that are cut away will be white, leaving the uncut top surface to hold the ink and produce the print.

2 You can use carbon paper under a traced design to transfer the desired drawing. This may be required if the image needs to be reversed, or if the artist is working from a master drawing to make multiple blocks. The block will print direct (that is, the opposite way to the original sketch).

3 Gouges should be comfortable in the hand. To exercise control and pressure, the end of the handle sits in the palm, the forefinger rests on the top of the brass sleeve, and the thumb and the second finger are placed either side. A board with a strip of wood attached to the top, and another to the back, will produce a safe and convenient rest on which to secure the block while cutting.

4 A fine V gouge is used to produce fine lines. The graphite stick has been rubbed over part of the cut surface, defining the dark and light areas produced so far.

5 The U gouge is used to clear out some of the broader areas. It is not necessary, or advisable, to dig deeply into the wood to obtain a nonprinting area.

6 The block can be proof-printed using oil-based black ink, and then reworked if required. The excess ink should be removed using a dry rag, as mineral spirit or water-based inks can make the wood swell and lose the clarity of the fine lines.

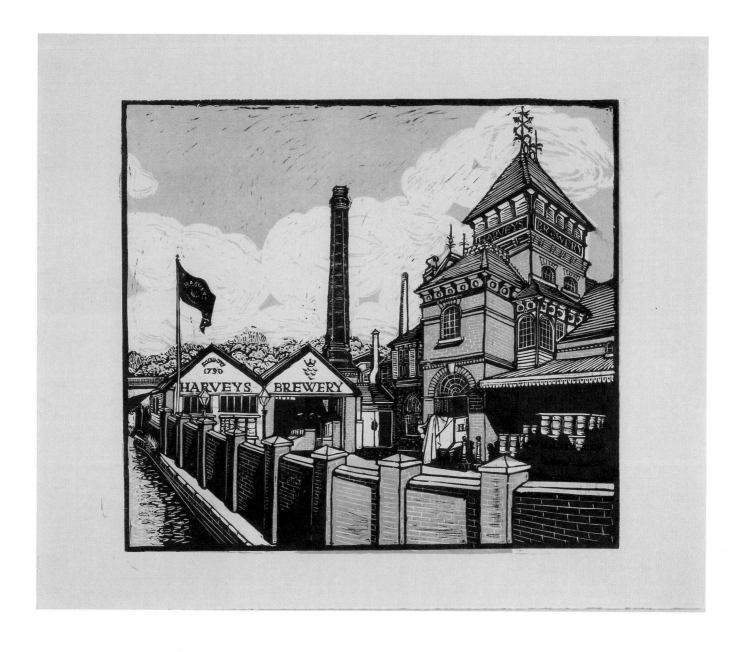

Judy Stevens
(British)
Harvey's Brewery
17 x 13½in (45 x 34.3cm)
Woodcut on soft Japanese plywood;
oil-based relief ink; Fabriano paper
Printed by the artist on a Columbian
press at Brighton Independent
Printmaking, UK

Sarah Young
British

2.5.9

profile: **Sarah Young**

"My father was a sculptor and a teacher and administrator
at Reigate School of Art and Design. I have early memories of his studio
in the front room being an exciting place where things were in all stages of being made or altered.
My mother was a fashion designer and made beautiful clothes and toys for us.

"I always have three-dimensional objects alongside my two-dimensional work. I can remember going every year to the degree show at Reigate, especially to view Illustration, which had such wonderful variety. I loved illustrated books; I wrote and painted my own and made clay objects during Saturday-morning pottery classes. My sister and I made all sorts of things for Christmas and put on plays where we created all the scenery—they were probably interminably long!

"I did a two-year Art Foundation course at Reigate, which was absolutely brilliant. I studied for my BA in Illustration at Brighton University. I had done some linocuts as a child and later a very small amount of relief, etching, and lithography at Brighton, but it was much later that I really became interested in printmaking.

"I became a pavement artist to pay the bills and took my dog with me, so sometimes we would be given a lovely bag of chocolate rolls and dog food. It was satisfying to have my rucksack so laden down with money that I could hardly lift it. However, I soon decided that a traveling puppet theater would be much more enjoyable. I knew it would really need two people, which is when I met Jon Tutton. It took us many months to make puppets, sets, and a booth. We had an old fruit van on top of which we usually tied

the booth, but one day the wind took it. It flew off and nearly decapitated some very good-natured passers-by. The shows were quite gentle and lyrical, except for the devils in Dr Faustus and a rather frightening Neptune. We performed in pub and tea-room gardens and museums. During the winter months we made papier-mâché objects, including three-feet fish and jewelry, and produced linocuts that we printed without a press by burnishing with the back of a spoon. We sold our work at craft fairs around Britain, but gradually the prints took over so we started to exhibit at art fairs.

"I love printmaking because the possibilities seem endless. The simplest cardboard cut or silkscreen stencil can transform an image into something much more powerful. I've found that the 'craft' or method of printmaking can remove you slightly so that you do not over-think. It can make work more natural or intuitive because your concentration is divided. I think it can be very useful if you have a tendency to be too controlling or under-confident. Each method has limitations that strangely help toward freeing the work. The idea can dictate the printmaking method, or vice versa.

"I am interested in imagery from stories—whether dreams, myths, or fairy tales—and in dance, journeys, metamorphoses, performers, the shapes

Sarah Young
(British)
Interval II
6¼ x 6in (16 x 15cm)
Woodcut; Fabriano Artistico paper
Edition of 100 printed by the artist
on a Columbian Eagle relief press
at Brighton Independent
Printmaking, UK

Sarah Young
(British)
Brighton Pavilion
23½ x 17¾in (60 x 45cm)
Woodcut—soft Japanese plywood
block, Chine collé; oil-based ink;
handmade paper and Fabriano
Artistico 300gsm; Chine collé
paper: lightweight colored
Japanese papers
Edition of 150 printed by the
artist on a Columbian Eagle
relief printing press at Brighton
Independent Printmaking, UK

Bottom: **Sarah Young**
(British)
Satyrs
9½ x 8¾in (24 x 22cm)
Relief print; oil-based ink;
Bhutanuse handmade paper
Edition of 150 printed by the
artist on a Columbian Eagle relief
press at Brighton Independent
Printmaking, UK

of plants, and small domestic moments such as rock-pooling or hanging out the prints. My work is mostly figurative and I do not seem to be able to make a picture without adding at least a passing fox.

"I feel most work is completely interrelated and equally valid; preconceptions of what is more or less worthwhile can be destructive and inhibiting. I love work that crosses boundaries and cannot be pigeonholed, and I hope to apply my printmaking to other areas of work in the future.

"Jon and I work both as a team and individually. I am very lucky that he can help me print linocuts on the Albion press at Brighton Independent Printmaking, where we do nearly all our printmaking. At the same time, I may be printing collagraphs on the etching press. These are quite labor-intensive, even though I only make an edition of 30. We attempt to make a living from something that is enjoyable, varied, and exciting."

chapter 6 **linocut**

James Dodds
(British)
Pioneer in Frame
23¾ x 20in (60.3 x 50.8cm)
Linocut—2 blocks; K & E Nouvavit ink;
Zerkall 225gsm Smooth Cream paper
Edition of 85 printed by the artist on a
Western Proofing Press at Wivenhoe,
UK

a brief history of linocut

Linoleum was originally developed as a flooring material constructed on a backing of hessian, burlap, or jute and made with a variety of ingredients, including linseed oil and powdered cork. During the early twentieth century, artists adopted the thicker, plainer variety named "battleship" lino (so called as it was used to floor ships) as a printmaking material.

The discovery of lino as an effective medium is primarily attributed to German Expressionists such as Erich Heckel (1883–1944) and Gabriele Munter (1877–1962). Russian Constructivist artists also turned to the linocut following the founding of their movement in 1913. Their ideology celebrated abstract and geometric imagery inspired by the technological and mechanical environment of the new century. Wassily Kandinsky (1866–1944), a pioneer of abstract imagery, and Alexander Rodchenko (1891–1956), whose work featured flat, geometric designs and elemental, abstract forms, both used lino as a means of expression.

Lino was introduced into the USA in 1910, and arrived in Britain a year later. The first black and white linocuts to appear in the UK are attributed to Horace Brodzky (1885–1969) in 1912, while the development of the color linocut was driven by the influence of Claude Flight (1881–1955). Between 1926 and 1930, Flight taught linocut at the Grosvenor School of Modern Art in London. His passion to promote the print as a universally accessible art form led him to embrace the medium of linocutting. It was a new material with neither tradition, in terms of technique, nor historical precedence.

Linoleum was an immediate, inexpensive material. It is softer than traditional hardwood and therefore allows an ease of line. As the surface of lino lends nothing of itself in terms of texture or grain, there is no impact on the quality of the final print. Consequently, it allows for clean design and is a neutral springboard for color.

The linocuts of Claude Flight, and those that resulted from the Grosvenor School, demonstrate an approach similar to that of the Italian Futurists of the early twentieth century. Futurist imagery celebrated modernity, and captured the sense of speed and movement associated with advancements in machinery, transport, and communication. Sweeping forms and angular lines expressed the dynamic, ever-changing world. Flight and his contemporaries used the linocut to expound on similar themes evident around them as London evolved into a modern capital city. The school also encouraged international artists such as Swiss-born Lill Tschudi (1911–2001) and Australian artists Dorrit Black (1891–1951), Ethel Spowers (1890–1947), and Evelyn Syme (1888–1961). All of these produced and exhibited linocuts from the mid-1920s to early 1930s.

Judy Stevens
(British)
Parc Guell, Barcelona
17 x 13½in (45 x 34.3cm)
Linocut; oil-based relief ink; Fabriano
paper
Printed by the artist on a Columbian
press at Brighton Independent
Printmaking, UK

The linocut was cut into shapes and
attached to a baseboard to ensure
correct registration.

During this time, British artist Ben Nicholson (1894–1982) was also experimenting with the medium. He created a number of linocuts, printed in small editions on paper, and printed and exhibited a number of fabrics printed with linoblocks.

Artists such as Picasso (1881–1973) and Matisse (1869–1954) were also exponents of the linocut. Picasso produced his first linocuts in 1939 and continued to push the technical boundaries of the material until the early 1960s. He made complicated multicolor works that culminated in the creation of a process to create multicolor prints taken from one linoblock. The "reduction" or "elimination" process involves the gradual cutting and reworking of the block, the image on the lino being continually reduced in accordance with the color requirements. At each stage, the block is reprinted, the ink being overlaid on the final print until the image is complete. Editioning has to take place at each color stage as the resulting block is unusable at the close of the process because the image has been vastly reduced.

Toward the latter half of the twentieth century, African artist John Ndevasia Muafangejo (1941/3–1987) produced an enormous body of linocut prints. His work conveyed the culture and experiences of contemporary North African tribal life. He was born a Kwanyama, the largest of the eight Owambo tribes that exist on land that is now part of northern Namibia and southern Angola. He learned English in an effort to ensure that the words he included in his work could be understood by a wider audience. Through the use of English text and imagery, he sought to express the everyday dilemmas, routines, and scenes of his life and of the society around him. The text serves both as explanation and personal expression. The versatility of the lino medium ensured that his work retained the detail and intensity that the content demanded.

Artists continue to use the medium either on its own or in a combination with wooden blocks to create spontaneous and exciting images. In this chapter, examples include Ann d'Arcy Hughes, Bernard Lodge, Hugh Ribbans, and Helen Brown, who were among seven artists commissioned to work with large lino blocks printed with road rollers to celebrate the opening of the Brighton Art Fair in the UK (see pp. 200 and 393). A similar event is held in San Francisco (see p. 392). The linocuts of Belinda King and Annette Routledge demonstrate the reduction technique, while featured artists G. W. Bot, Jenny Ulrich, Hebe Vernon-Morris, Judy Stevens, James Dodds, and Emily Johns demonstrate the diversity of style and composition in contemporary linocuts.

Hugh Ribbans
(British)
Hayley's Terrapin
9 x 10in (22.5 x 25cm)
Linocut—3 blocks: yellow, blue, black;
T. N. Lawrence relief inks;
Somerset paper
Edition of 20 printed by the artist on a
Columbian press at Herne Bay,
Kent, UK

Hawley Hussey
(American)
*You Can Have Him, The Mansion Is
Mine*
7½ x 74in (19 x 188cm) folded to 7½ x
5½in (19 x 14cm)
Linoleum-print artist's book;
handmade paper matchbook folder
Edition of 122 printed by the artist
at the Women's Studio Workshop,
Rosendale, NY

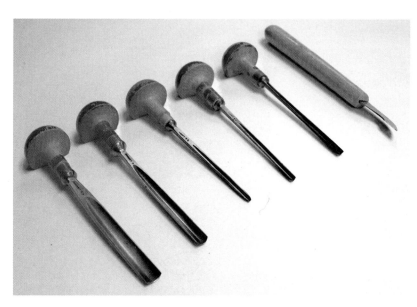

Traditional lino tools with mushroom handle. U- and V-shaped gouges.

2.6.2
step by step: **linocut**

Linoleum is made as a floor covering from oil and resin, and has a woven hessian backing. (In Latin, "linum" means flax and "oleum" means oil; this refers to the linseed oil processed from the flax that is used in the production of lino.) Linoleum is one of the cheapest and easiest materials to use for a handcut relief print. It is soft to work with and can be easily cut into shapes with a knife or scissors.

Red lino is quite hard to use unless heated at regular intervals over a hotplate, radiator, or hot-water bottle. This makes the material pliable and simple to cut into. It is readily accessible through flooring stores and builders' suppliers, where vinyl is also available in packs of 12-inch square tiles. These products may need preparation, as they are often protected with a shiny varnish. The surface should be degreased with methylated spirits, or another degreasing agent, and lightly sanded with fine sandpaper.

Artists' gray lino is considerably more expensive, but has a soft, pliable quality that makes it very easy to work into without heating. It does not need any preparation.

There is a vast range of tools on the market, but it is a false economy to buy a cheap set as they generally do not resharpen, and the handles are badly fitted. A good-quality steel tool that will resharpen and has a mushroom-type handle that fits comfortably into the palm of the hand is essential to provide the control required. Although these tools are more expensive, a number can be collected over a period of time with the assurance that, if well cared for, they will last a lifetime. V-shaped and U-shaped gouges

are available in a wide range of sizes and can be purchased from good-quality art stores and printmaking suppliers.

Japanese woodcutting tools are ideal to use on lino. These can be ordered at specialist printmaking stores. A large graphite stick is useful to rub over the surface when the cutting is completed in each section. This will give an idea of how the print will look when rolled up in black. The print is the reverse image of the block.

An offcut of lino can be used to demonstrate the different marks created by each tool. This is useful to refer to when working on an image.

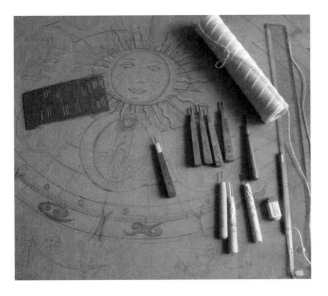

1 An image can be drawn onto the lino in pencil or felt tip, or, if preferred, it can be traced through carbon paper. Circles can be drawn with a pair of compasses or a piece of string can be held at the center with a pencil at the outer edge. Once the design is roughed out, cutting can begin. Bear in mind that what is cut away will be white in the print, and what is left is black when inked up.

2 The tool is held comfortably with the handle in the palm of the hand while the forefinger guides from the top, exerting a calculated pressure. The thumb keeps the tool in place by resting on the side. The sharp blade removes a coil of lino as it is pushed forward.

3 An oil-based relief ink is rolled out. The block is inked up with a small hand-roller.

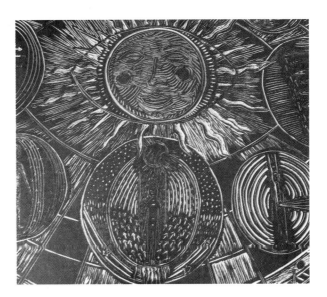

4 For the first proof, the roller will need to be frequently recharged to establish sufficient ink on the block to produce a print. The ink will need to be topped up between prints.

5 If the block is too large to fit in a press, or if there is no press available, printing can be carried out by burnishing on the back of the paper. A lightweight paper will be easier to obtain a print from. This can later be mounted on a heavier paper for support.

6 The official term for a burnishing tool is a baren. These are available in a variety of forms. There is the traditional bamboo version, also made in plastic; a PVC baren with ball bearings; or a simple wooden mushroom-shaped handle with a felt pad. However, the best solution is a piece of hardwood rubbed down to a flat shiny surface, with one end cut at an angle to create a shoulder. You could also use a wooden spoon.

7 If the proof appears too pale when a corner of the paper is lifted, providing that the position of the paper is not changed, the block can be re-rolled in sections, and the paper put carefully back in place. Continue the burnishing until the proof is satisfactory.

8 Alternatively, a small road roller, a piece of carpet, an old blanket, and a board will produce a good print.

Final image: **Ann d'Arcy Hughes (British)**
The Universe
39¼ x 39¼in (100 x 100cm)
Linocut; oil-based relief ink;
Toshi Washi paper

The first print was printed with a road roller in Brighton Pavilion Gardens as part of opening events for the Brighton Art Fair (see p. 393). The rest of the edition was printed by the artist and hand-burnished with a baren at Brighton Independent Printmaking, UK

linocut process: **reduction method**

The process of reduction linocuts involves a number of color overprints made from a single block, with more of the block being cut away for each overprinted color.

Belinda King
(British)
A Stroll in the Park
13 x 12in (33 x 30cm)
Reduction linocut; Yorkshire
Printmakers oil-based litho and relief
printing ink; Somerset Satin paper
Edition of 10 printed by the artist on a
Britannia relief press at Gainsborough
House Print Workshop, Sudbury, UK

Right: **Annette Routledge**
(Irish)
Please Keep Your Dog On a String
10 x 12in (25 x 30cm)
Reduction lino; relief ink
Edition of 6 printed by the artist on
an Albion press at the University of
Brighton, UK

2.6.3

2/6 Please keep your Dog on a String A. Routledge.

Here, British artist Belinda King explains the process for printing the image "Fool Tries to Catch a Lover's Dream," shown opposite.

printing "Fool Tries to Catch a Lover's Dream"

My prints have been made from a single block that has had progressively more of the surface removed as each color is overlaid. In the case of *Fool Tries to Catch a Lover's Dream*, the first color to be gouged out was the white, with the yellow being printed over the rest of the image leaving the white paper where the block has been cut away. The second stage was to gouge out the areas to remain yellow and print the rest of the image in green. I then removed all the areas to remain green and printed the rest in mauve and so on until finally there was very little of the block left for the final color—gold. The colors are all opaque; when printing a light color over a dark one, I have occasionally had to repeat the printing twice.

Some of my colors involved a "rainbow roll-up." An example of this is the trees, which change from red to yellow. Red and yellow inks are placed next to each other at the top of the inking surface and the roller, while picking the color up, is moved slightly from side to side to mix it in a smooth rainbow effect.

Most of the lino surface has been removed with a variety of woodcutting gouges. Where the edges are softer and textured, as in the mauve of the sky, I have etched the lino using a solution of caustic soda thickened with wallpaper paste. This has been painted on to a surface, left for an hour or two, then washed off with plenty of water and scrubbed with a soft scrubbing brush.

The final step is the gold used for the stars. This pigment is unusual and does not behave like the other pigments. Any color can be printed on the area that is to be gold, as the gold pigment is dry powder so is brushed over the wet ink. The print is then left to dry flat for a few days. Care has to be taken that all the previous colors are quite dry first. Once one is sure the ink is fully dry, excess pigment is gently brushed off with a paintbrush, or rubbed off with bread.

Belinda King
(British)
Fool Tries to Catch a Lover's Dream
14¾ x 14½in (37.5 x 37cm)
Reduction linocut; Yorkshire
Printmakers oil-based litho and relief
printing ink; Somerset Satin paper
Edition of 20 printed by the artist on a
Britannia relief press at Gainsborough
House Print Workshop, Sudbury, UK

reduction print using two blocks

Block 1 was cut and first printed in yellow.

Block 2 was cut and first rolled up in cyan.

The block was then printed onto the paper over the yellow.

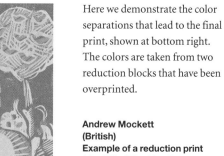

Here we demonstrate the color separations that lead to the final print, shown at bottom right. The colors are taken from two reduction blocks that have been overprinted.

**Andrew Mockett
(British)
Example of a reduction print
12 x 8¼in (30 x 21cm)
Woodcut—2 blocks; 1 yellow and red, 1 cyan and black
Artist's proof printed by the artist at his studio**

Block 1 (previously yellow) was re-cut and rolled up in red.

The block was then printed on top of the yellow and cyan image.

Block 2 (previously cyan) was re-cut, rolled up in black, and overprinted to create the final image.

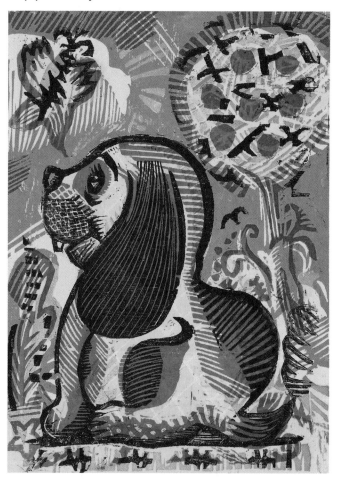

G. W. Bot
Australian

2.6.4

profile: **G. W. Bot**

"Since my earliest memories, from about the age of two, I have always enjoyed art and have enjoyed working on pieces of paper. I studied Medieval History and English at the Australian National University, but I did not have a formal art training in an art school.

"However, I did work with many artists informally and in printmaking workshops and started making art from a very early age. I was first introduced to linocuts at school in London in Hammersmith. It is a medium with which I have remained. Along the way I have worked extensively with etching and lithography, but the linocut was my first love and has remained so. I have largely printed my own work, both through necessity and choice, but I greatly enjoyed working with the Master Printer Hugh Stoneman in Cornwall, which was both a delight and an inspiration.

"In terms of my artistic inspiration; Dogen Zenji once wrote, 'The green mountains are always walking; if you do not know the green mountains are always walking, you do not know your own walking.' This in many ways sums up my inspiration—oneness with the landscape. I am inspired by the environment that surrounds me. Over the past few years I have thought of the landscape as a language that I have called Glyphs. Glyphs constitute a language suggested by the markings found in the Australian landscape. Back in the 1870s, Marcus Clarke wrote of the peculiarity of the Australian bush as 'the strange scribblings of Nature learning how to write.' I find these strange scribblings on the weathered fence posts of the paddocks that have witnessed many bushfires, floods, and the scorching

sun of many summers. Elements of this language I find on bark and trees and encoded within the shrubs, eroded gullies, and fields of grass. It is highly lyrical and profound, dramatic and tender, timeless and ephemeral. After having spent more than two decades working in the landscape, at times I feel almost like a medium through which the scribblings of nature are recorded. The relief prints at first glance have a striking boldness, but if one pauses for a second glance, there is also a great subtlety. Glyphs are never literal, but are always born of a real and specific experience in the landscape. I feel that over the years I have increasingly learned to listen to the landscape and to learn from its subtle forms. The artwork possesses a sense of order, a natural structure, and a metaphysical presence, yet it never loses sight of its origins as a handmade artefact. It is complete, but boundless, suggesting endless possibilities.

"I have never belonged to a particular style or trend in art, possibly reflecting my noninstitutional training. I have looked very closely at the work of the Aboriginal artists of Australia. They seem to have their own particular language and system of markmaking. I've also found inspiration in the medieval icon painters—I've always been fascinated by the question of how to encode spirituality in the visual arts. Of the more contemporary

G.W. Bot
(Australian)
Voice of a Seraph: Voice II, **2006**
39¼ x 27¾in (100 x 70.5cm)
Linocut; oil-based offset inks;
Magnani paper
Edition of 25 printed by the artist on a
Melbourne Etching Supplies press in
Melbourne, Australia

Left: **G. W. Bot**
(Australian)
Messages, 2006
39¼ x 27¾in (100 x 70.5cm)
Linocut; oil-based offset inks;
Magnani paper
Edition of 25 printed by the artist
on a Melbourne Etching Supplies
press in Melbourne, Australia

Above: **G. W. Bot**
(Australian)
A Traveler's Tale, 2006
27½ x 43¼in (70 x 110cm)
Linocut; oil-based offset inks;
Magnani paper
Edition of 25 printed by the artist
on a Melbourne Etching Supplies
press in Melbourne, Australia

European artists, there have been very many who have inspired me, including Morandi, Matisse, Miró, Tapies, and of course Samuel Palmer. In all instances, I have been drawn more to their graphic work and the endless possibilities of their markmaking.

"In my life as an artist, printmaking has been and continues to be a major part of my existence. What I love about printmaking is the sense of dialogue and being involved in a process. I think of working on different sorts of paper like working on different soils in a garden. You plant images and watch them grow."

linocut process: **etched linocut**

The etched lino process is a method for creating a mottled and bitten effect by biting into the surface of lino with a strong alkaline solution. Paint stripper or oven cleaner can be used, but generally caustic soda is chosen, due to the fact that it is easy to buy in crystal form.

Emily Johns
(British)
Souls in Cabinets
13¾ x 18in (35 x 46cm)
Lino etching; T. N. Lawrence stay open block-printing ink; Nepalese lokta paper
Edition of 40 printed by the artist using a wooden spoon

Right: **Emily Johns**
(British)
The Rose and the Nightingale
13¾ x 18in (35 x 46cm)
Lino etching; T. N. Lawrence stay open block-printing ink; Nepalese lokta paper
Edition of 40 printed by the artist using a wooden spoon

2.6.5

step by step: **etched linocut**

2.6.6

Safety note
This process requires the use of dangerous
solutions. Every care should be taken
to protect the user by working in a well-
ventilated room with the appropriate
apparatus, in addition to wearing protective
clothing, such as a mask, rubber gloves,
goggles, and an apron.

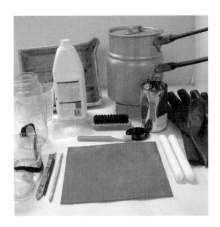

1 Put a small amount of water in a glass jar
and add the soda crystals (never do this
the other way round). Use a wooden spoon
to stir the solution while the soda dissolves.
Add more crystals until the solution is quite
saturated. The jar will become hot and
should be left to cool.

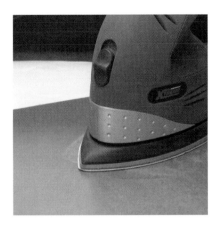

2 The surface of the lino is sanded down
to create a better tooth for the resist to
hold on to.

3 The image is painted in whatever acid
resist suits the purpose. Wax candles can
be melted in a double boiler and when fluid
painted onto the surface of the lino. The wax
can then be scratched into to create further
marks. Stop-out varnish can also be used.

4 Pour or paint the caustic soda solution
over the block and leave it to bite for 6–8
hours. Some areas can be wiped off while
others are left to bite further, resulting in a
variation in the type of mark produced.
When the etch is sufficient, the caustic must
be thoroughly washed away and the residue
removed with a scrubbing brush. The stop-
out varnish is dissolved in mineral spirit, and
the wax loosened with a hot hair dryer while
bring scraped with a palette knife. Absorbent
paper can also be ironed onto the block to
remove the final remnants of wax. When the
block is quite clean it can be rolled up in ink
and printed on a relief press, or handprinted
by rubbing on the back of the paper with a
burnishing tool or baren.

Etched linocut: Troubleshooting

Problem: The lino will not bite

Cause	Solution
1. The lino is old and has hardened.	**1.** Buy new soft lino.
2. The etch solution is weak.	**2.** Get a stronger etch.
3. The temperature is too low.	**3.** Work in a warmer environment.
4. The strength of the etch has been used.	**4.** Clean off the old etch and replace it with a fresh solution.

Emily Johns (British)
Bam Earthquake—Underground Poetry
13¾ x 18in (35 x 46cm)
**Lino etching; T. N. Lawrence stay open
block-printing ink; Nepalese lokta paper
Edition of 40 printed by the artist using a
wooden spoon**

**43,000 people were killed in the earth-
quake that destroyed the ancient city
of Bam on Boxing Day, 2003. Some of
the survivors (including Shahrbanou
Mazandarani, a woman of 97 rescued
alive after eight days in the ruins) had
sustained themselves while buried by
reciting poetry from memory:**

*The human race is a single being
Created from one jewel
If one member is struck
All must feel the blow
Only someone who cares for
the pain of others
Can truly be called human*
—Saadi, c. 1200 CE

chapter 7 **Chine collé**

Yuji Hiratsuka
(Japanese)
Freak
**24 x 18in (60.5 x 46cm)
Intaglio, relief, Chine collé;
oil-based intaglio/etching inks;
BFK/Kozo Japanese paper
Edition of 35 printed by the artist
on a Takach etching press at
Corvallis, Oregon**

a brief history of Chine collé

The term "Chine collé" originates from France; "Chine" loosely translates as "tissue" or "thin paper," and "collé" derives from the verb "coller," which means "to stick down." The process known as Chine collé refers to the application of a thin impression paper mounted on a more robust backing paper.

The Chine collé process offers three advantages. First, the thin top sheet provides a sensitive, fine printing surface that holds great detail and subtle tone. Second, the artist is able to combine multiple papers in one image to add depth and diversity to an image. Third, there is the opportunity to add color to a print without the need for a second plate or block.

The top or impression sheet was traditionally India paper from China, unsized and made from bamboo fiber; this gave a very soft, refined surface. As the Chinese papers were generally slightly different in color, they provided a subtle background to the printed image. This was particularly appreciated in the mid-nineteenth century within the medium of lithography. The delicacy of some litho images responded very well to a soft paper. In addition, the warmer tones of the impression papers were similar to the color of the lithographic limestones. Previously, some printers had applied a flat tone to the bleached European papers before printing the image in order to retain the tonal range and balance evident in the image drawn on the stone surface. A delicate impression sheet served the same purpose.

The Chine collé process was also incorporated within intaglio printing during the early nineteenth century. An intaglio manual published in Paris in 1837 describes the benefits of unsized impression paper for the engraved image. In the twentieth century, etchings by Picasso and Matisse, among many others, utilized this process to great effect. However, as availability became scarce, the papers used today tend to be Japanese in origin.

The impression sheet can either be pre-pasted and then adhered naturally during the printing process, or the image can be printed first and then applied to the sturdy backing sheet. When gluing the two sheets together, in order to avoid tearing, creases, or bubbles, it is advisable to use minimal adhesive and to consider the dampness of the two papers and the temperature of the working environment. There is no single recommended Chine collé procedure, so when using the process it is important to consider the materials being used and the size of the work. The needs of a small piece incorporating independent, colored papers onto an unprinted backing sheet will be vastly different from a lithographic or etched image printed solely onto an impression sheet. Generally, adhesives such as PVA are considered too strong; wheat starch has traditionally been used for larger works.

The above history details the traditional Chine collé process, while the following step by steps demonstrate the application of Japanese colored papers to an image to incorporate color without the need for an additional block.

step by step: **Chine collé**

2.7.2

1 Collect the materials: thin colored papers, spray mount or glue, scissors, soft pencil, small brush if required, tweezers, sharp cutting knife, and cutting mat.

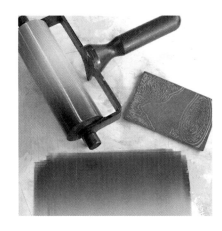

2 Cut the block, and charge the roller with the required ink.

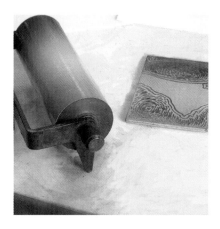

3 Roll up the block with a thin layer of ink and take a proof on dry paper.

4 Using the printed proof, trace through the thin colored paper and cut out the desired area. If the colored paper is not transparent, place it on a lightbox. Remember that the print is a reverse of the block, so turn the print over on the lightbox to trace the shapes, which will then match the block.

5 If the whole surface is to be covered by one piece of Chine collé paper, place the block face down and cut round it.

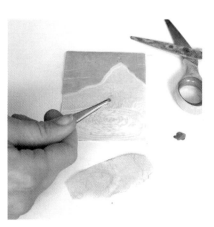

6 If a number of small pieces of thin paper are required, they become more manageable if they are stuck to a backing sheet ready for printing.

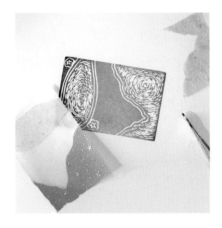

7 Cut and stuck papers ready for printing. Remember to turn the prepared papers over and spray the back. The topside should be laid on the inked-up block, and the back sprayed with glue so it adheres to the larger printing paper when put through the press.

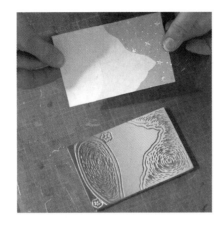

8 Check the paper and the plate for accuracy. The prepared papers will now be glued on the back and placed face down on the block.

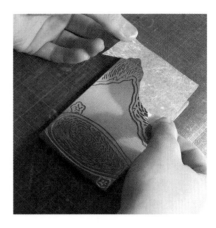

9 Individual pieces can be checked for position, glued on the back, and placed directly face down on the inked-up block ready for printing.

10 Spray or brush glue onto the back of the colored paper pieces and place them sticky side up on the block. You can use tweezers or wooden toothpicks to help move and position the pieces.

11 Place the block with the Chine collé pieces on the bed of the press and put the lightly dampened printing paper in place over the block. Do not adjust the printing paper once placed. Add sufficient packing and run through the press.

12 Slowly lift the printing paper to check that the Chine collé papers have stuck to the printing paper and the ink from the block has transferred onto the colored paper pieces. Note the registration Plexiglas sheet with the green permanent marker line on the underside to give a guide as to the placement of the block and printing paper. Use card clips to prevent fingerprints marking the damp paper.

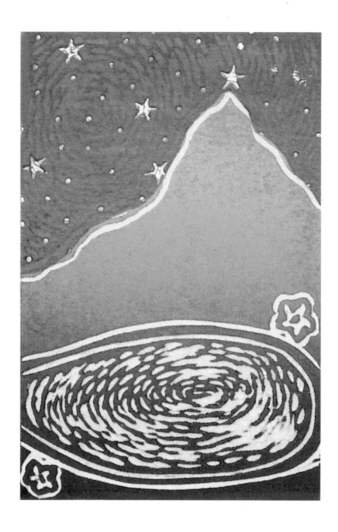

One version of the finished image. Different papers and inks can produce an inexhaustible variety of results.

Chine collé: Troubleshooting

Problem: The colors fade

Cause	Solution
Papers used for Chine collé need to be lightfast.	Colored tissue paper will fade fast. Thin Japanese papers, such as Khadi papers, are more expensive but will retain their color, and are more durable.

Problem: The Chine collé papers do not stick to the printing paper

Cause	Solution
Insufficient glue or incorrect glue	Traditionally, rice paste was used. This can still be purchased from a bookbinders or a quality paper shop. Permanent spray mount is extremely effective; however, there are other pastes and glues that are adequate providing they do not turn yellow with time.

Chine collé in practice

Yuji Hiratsuka
(Japanese)
Puppeteer
24 x 18in (60.5 x 46cm)
Intaglio, relief, Chine collé;
oil-based intaglio/etching inks;
BFK/Kozo Japanese paper
Edition of 45 printed by the artist
on a Takach etching press at
Corvallis, Oregon

Hebe Vernon-Morris
(British)
Sunny Inside
8¼ x 6in (21 x 15cm)
**Linocut with Chine collé; black oil-based relief ink; Fabriano paper
Edition of 25 printed by the artist on a Columbian press at Brighton Independent Printmaking, UK**

The colors are produced by using delicate Japanese papers, cut to the required size, which are attached to the image during the process of printing.

Right:
**Jenny Ulrich
(British)**
Pantomime Mermaid
9½ x 6in (24 x 15cm)
**Linocut on paper—linoprint with Chine collé using maple tissue paper; T. N. Lawrence oil-based relief printing ink; Saunders Waterford HP paper
Printed by the artist on a Columbian press at her home studio**

Noreen Grant
(British)
Costume in the Sky
7 x 7in (18 x 18cm)
Monoprint and Chine collé; inks:
Intaglio printmakers Lithographic
Black, Intaglio Printmakers
Lithographic White, Charbonnel
Bleu Concentre; Velin Arches Noir

250gsm paper
Printed by the artist on an etching
press in her studio
The monoprint was produced
in stages using tracing-paper
stencils through which white ink
was transferred from crushed
tissue paper. This process was
repeated a number of times until

the required tones were achieved.
Masks protected areas of the
image while it was run through the
etching press. The black costume
shape at the left of the image was
transferred to the image through
a stencil from a zinc plate partially
inked up in black litho ink. The fan
shape—perhaps a collar—sleeves,

16th-century costume piece, and
garment facings were gradually
printed on the partial background
of Bleu Concentre. The small black
and white patterned pieces were cut
from a photographically produced
etching printed on Sekishu Shi
31gsm paper and run through the
press as Chine collé.

Helen Brown
British

2.7.4

profile: **Helen Brown**

"I have enjoyed art as long as I can remember.
My first artist creations were colorful line drawings of houses and ladybirds
—which I still have, thanks to my mother. I also made a very good mud pie—so realistic that my father
was once tricked into trying to eat one. Despite this, my parents were always very supportive of my artistic ventures.

"I grew up in Cambridge, where my school had a good art department. I then did an Art Foundation course in Cambridge the year the college moved out of the town center. It's a funny story actually. My interview was in the old building. I walked in with my portfolio and the tutor asked me to put my hand into the folder and randomly pick out one piece. She looked at it, refused it, and that was my interview. I burst into tears and went back to my father's car, crying my eyes out. My father said, 'You know when the course starts and where it is, so just go along and pretend she said yes; don't pay any attention to her.' So I went along to the college and because my name was always missing, at the end of every class the tutors added me onto the register. Halfway through the course, I was called into the office because nobody could find my details. However, as all the tutors were new and a lot of information had been lost in the move, I was able to continue and finish the course even though I did not actually get accepted officially.

"My first introduction to printmaking was during GCSE and A Levels [the examinations school pupils in the UK take at 16 and 18 years old] with Kip Gresham, who had a commercial screenprinting studio. Dad helped me turn a store cupboard into a screenprinting area as the school did not have one, so I worked away using oil-based ink in the cupboard, with the door

shut. The college foundation course had a lovely printmaking room, but three weeks into the term the tutor died and was not replaced. The room was then locked and we were unable to go in. However, while I was at the college I took a job as a cleaner so I had all the keys and began using the printmaking equipment in the evenings.

"I took my degree at Brighton, where I started etching. I did big color etchings using imagery from my imagination and from my travels. I really loved it. I made etchings from sketches of people that I had drawn in India and then decided I wanted to do an observational print. I chose to make a linocut as I could take it out into the countryside, to the South Downs. I went to Devil's Dyke, just outside Brighton and cut the block while sitting outside the pub. They gave me free food and loads of people asked what I was doing. The print worked very well, and people bought it. I thought I would follow this path for a while because I enjoyed it, and it worked well with my traveling.

"Printmaking is a very practical skill and I am a very practical person. That is why I like it, but it is no use if you do not know how to use the medium to express what you want to express. I like the stages; you make the block

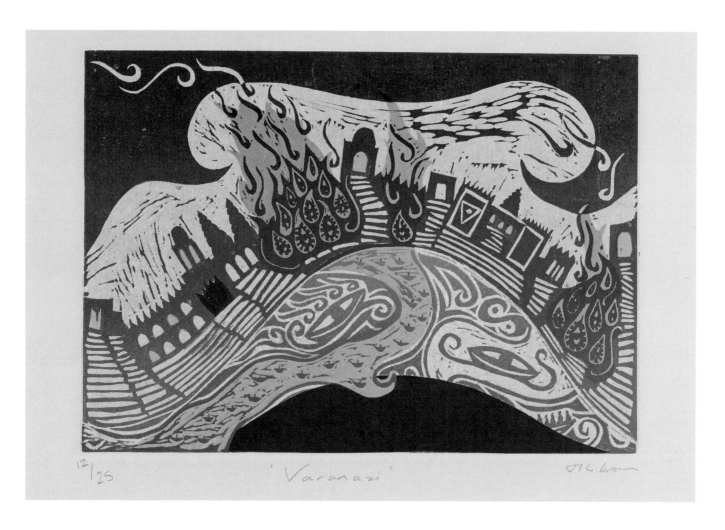

12/25 'Varanasi' H G Brown

**Helen Brown
(British)**
Varanasi
**15¾ x 11in (40 x 28cm)
Linocut—Chine collé, jigsaw block,
color merge; oil-based relief inks;
handmade Somerset Satin paper;
Chine collé paper: Mungi and Khadi
lightweight colored Japanese papers
Edition of 25 printed by the artist on a
Columbian Eagle relief printing press
at Brighton Independent Printmaking,
UK**

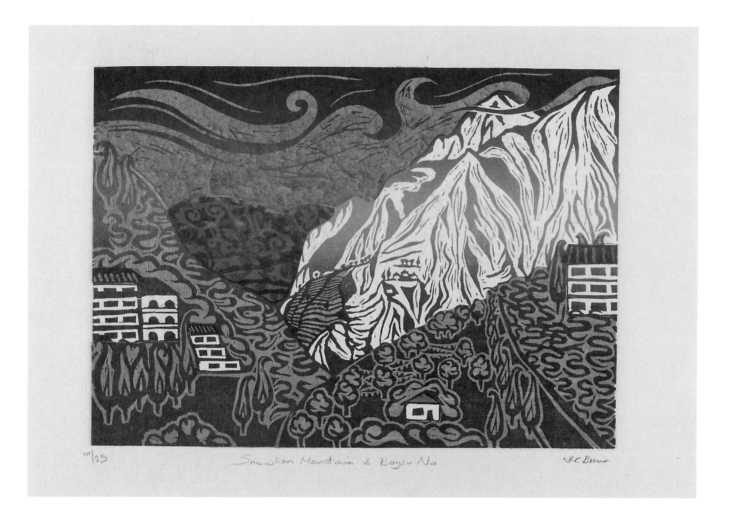

10/25 *Snowlion Mountain & Bagsu Na* H.C. Brown

Helen Brown
Snowlion Mountain and Bagsu Na
15¾ x 11in (40 x 28cm)
Linocut—Chine collé, color
merge; oil-based relief inks;
handmade Somerset Satin
300gsm paper; Chine collé paper:
Mungi and Khadi lightweight
colored Japanese papers
Edition of 25 printed by the
artist on a Columbian Eagle
relief printing press at Brighton
Independent Printmaking, UK

and then there is a never-ending choice of how to print it. I might print the block in ten different colors. I really like Chine collé, where I use colored papers that I have cut up beforehand. This technique I have taken to extremes.

"When people come to do something creative with the structure of printmaking, it supports them. In etching you do not have to draw if you do not want to, and with woodcut or linocut you could just do patterns. I have recently been thinking more about the marks, so I feel very inspired with my work. I made a lot of blocks from my last trip to Guatemala, which I print to have a bright, strong color blend, like their dyed and woven fabrics. The landscape in Guatemala is quite unreal, so using realistic colors would not seem right. That is what is good about printmaking: I can print the blocks and it might look great, or not, but I can easily change the way I print it.

"Travel is my big inspiration at the moment. I have done a lot of prints on the South Downs and I want to do more as I really enjoy drawing the hills. The Downs and the travel landscapes are very different, but very connected … there is a lot more to do."

chapter 8 **wood engraving**

Simon Brett
(British)
Marcus Aurelius VIII
3½ x 6in (8.5 x 15cm)
Wood engraving; one of a set of
13 variant portraits made for *The
Meditations of Marcus Aurelius*,
published by the London Folio
Society, 2002

a brief history of wood engraving

There is some ambiguity about the early development of wood engraving, as it has often been combined within a general history of woodcut. Before the eighteenth century, images cut from wood were worked on planks taken vertically from the tree.

While ideal for the woodcut image, side-grain wood was not suited to the fine lines and level of detail that would be achieved in a wood engraving by using the end grain of particularly close-grained woods. End-grain wood had been used within the fabric printing industry because of its hard-wearing nature, and there is evidence of Armenian wood-engraved images printed in Constantinople from the first decade of the eighteenth century, and Dutch white line engraving from the late 1720s.

Thomas Bewick (1754–1828) is credited with bringing to prominence in Europe the potential of end-grain boxwood for the purpose of illustration. Having been apprenticed to a metal engraver, Bewick applied metal engraving techniques in his approach to the end grain. He used a burin and a graver rather than a knife or gouge, and approached the image with a bias to the white line. It is suggested that as the function of the engraver's tool is to enforce a white mark into the surface of the wood, the design of the work would ideally be thought of in terms of white on black. The phrase "drawing with light" has been applied to Bewick's work as he forms his imagery using a series of intricate, fine lines that when printed allow the whiteness of the paper to provide the light and tone of the piece. The closely hatched lines create a silvery range that contrast with restrained areas of pure black and white.

While Bewick and his contemporaries Calvert (1799–1883) and Blake (1757–1827; see p. 82) approached the medium creatively, the growing demand for book illustration increasingly channeled the engraving process into one concerned with the reproduction of images for books, magazines, newspapers, and catalogues. The hard end grain of woods such as maple and box supplied a durable printing material, robust enough to allow the mass production of publications. A higher number of sharp, detailed impressions could be made from one block than from the considerably less resilient copper plates of the eighteenth century.

While technically very sophisticated, these illustrations only served to emphasize the distinction between the creative, artistic process and the process of commercial reproduction, where there was little opportunity for imagination or creativity. An artist created the drawing, which was then transferred onto a wood block, either by tracing the image or pasting the paper-based image onto the block. A commercial engraver then meticulously and, it could be suggested, mechanically cut the block. On important occasions, artists attended and made drawings of an event. The blocks with the drawings imposed were then cut up and distributed to a number of engravers. Each individual worked his own section, leaving the edges of the wood uncut. The blocks were then regrouped and clamped

Simon Brett
(British)
*The Sword That Was Broken or
The Death of Siegmund*
4¾ x 5½in (12 x 14cm)
Wood engraving from *Legends of
the Ring*, **published by the London
Folio Society, 2004**

back together to allow a final engraver to fill in the blank edge areas to create a cohesive, full image and complete the composition.

Despite the high level of technical skill and craftsmanship in all this, the soul and essence of the image were lacking. Wood engraving remained a largely commercial process until the late nineteenth century, when the photographic process had developed sufficiently to take over as a tool for the reproduction of imagery.

As a consequence, the early twentieth century witnessed a renewed enthusiasm for wood engraving in Germany, Britain, and the United States. Book illustrators and artists returned to the practice of designing and cutting their own blocks. This re-established the creative union between the concept and execution of the image and harmonized the imaginative and technical aspects of the wood-engraving process.

In 1920 the Society of Wood Engravers was established in Britain, rivaled five years later by the short-lived English Wood Engraving Society. Separated perhaps less by ideology than personality, these societies symbolized the growing importance of the wood engraving, which attracted leading artists of the day such as Paul Nash (1889–1946), Edward Burra (1905–1976), Henry Moore (1898–1986), and Eileen Agar

(1899–1991). Like Blake and Calvert before them, these artists produced relatively few wood engravings but their contribution is significant in terms of the growing interest in the medium. In Britain, wood engravers such as Agnes Miller Parker (1895–1980), Robert Gibbings (1889–1968), Gertrude Hermes (1901–1983), Blair Hughes-Stanton (1902–1981), and Joan Hassall (1906–1988) are acknowledged to be the specialists in the field. The Society of Wood Engravers continues today, with artists such as Simon Brett and Ann Desmet (both of whom are featured in this chapter) producing contemporary engravings.

In Mexico, the political movements of the early twentieth century elicited contemporary social comment in journals and posters illustrated with wood engravings. Jose Guadalupe Posada produced numerous images designed for mass publication. Another prolific artist during the 1930s and 1940s was Leopoldo Mendez (1902–1969), who used printmaking as a tool to express the ideology of the political left, campaigning to achieve a socialist society. He promoted state-funded programs to benefit the native Mexican communities and, through his wood engravings, presented satirical commentary on aspects of the capitalist culture in Mexico at the time. He was heavily involved in the Liga de Escritores y Artistas Revolucionarios (The League of Revolutionary Artists and Writers, or LEAR). This group sought to develop working-class culture through the use of art and literature and used imagery as an accessible method for communicating political messages to the largely uneducated working-class society.

In the United States, Fritz Eichenberg (1901–1990) and Lynd Ward (1905–1985) were noted exponents of creative wood engraving, with strong social and moral agendas of their own. Contemporary artists such as Carroll Dunham (b. 1949) continue to utilize the medium in a manner that incorporates the qualities of the wood engraving within works that are far removed from the traditional wood-engraved image.

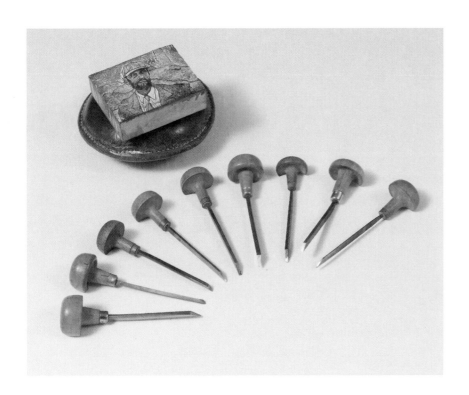

A wood engraving is a relief print. This means that the areas that are cut away are the white nonprinting areas, while the remaining surface is the part of the block that will print when inked up. The images are generally on a small scale, as the wood required is hard and taken from the end grain—as opposed to the woodcut process, which makes use of the side grain of the wood (see pp. 168–193).

2.8.2
tools and materials: **wood engraving**

Tools

The small hand tools used by the engraver are kept finely sharpened to allow the cutting of clean, fine lines in the hard surface. The basic graver, derived from the burin used in copper engraving, is a principal tool. The rod is made of tempered steel that is either square or lozenge-shaped. A mushroom-type handle is attached once the length has been cut to fit comfortably into the palm of the user's hand. The rod may be straight or slightly curved, which lessens the risk of the wood being damaged by the handle when cutting. The graver can be obtained in sizes 0 (1/16in, or 1.6mm) through to 12 (1/4in, or 6.4 mm). The lower middle range sizes are the most commonly used.

There is a range of other tools available. The spitsticker, which is an elliptical tool used only in wood engraving, has convex lower sides and is used for fine and curved lines. Scorpers are gouges that produce broader lines and can be used to clear out white areas. Flat or rounded scorpers are available. Tint tools, which have narrow blades and flat sides, are used for cutting lines of a uniform width. They come in six sizes from narrow to wide. Multiple tools have a rectangular blade that is serrated. This has a number of evenly spaced grooves that allow the user to obtain regular parallel lines. Regular engraver's chisels are also available in various sizes; these are used to clean up any uneven areas.

Most artists regularly use a range of about 12 tools, but the beginner can experiment with a much smaller range.

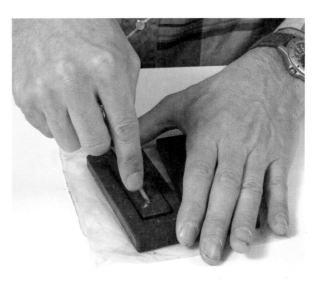

Sharpening the tool

Engraving tools have to be absolutely sharp at all times or the work will be spoilt. It is necessary to sharpen a tool at regular intervals. This means that a sharpening stone is kept to hand all the time the artist is working. If a tool is to be ground right down then a carborundum stone may be used initially, followed by an oil stone, and finally the hard Arkansas. The face to be sharpened is held flat on the stone between the thumb and the fingers and moved up and down with only a little pressure exerted. Be careful never to cut into the stone. The oil stones require the use of a thin, clean machine oil.

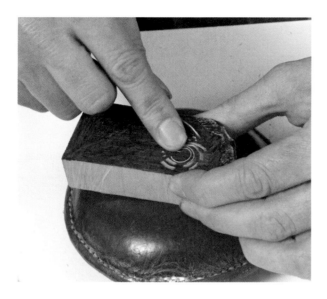

Holding the tool

A firm, controlled grip is essential, so the mushroom handle is generally placed in the palm of the hand with the little finger curled into the ridge to keep it in place. The forefinger guides and gives gentle pressure on top of the rod, with the thumb keeping the tool in place from the side. Some artists prefer to have their thumb on top. The tool remains static while the block is turned on the sandbag.

Printing

A reduction block means using the same block for all colors; therefore, minimal lines are cut at the first stage. Between each printing, further marks are made and areas removed. The number of prints required for the edition are printed in the first color, with a few extra as proofs.

The first color printed in this image was yellow. Then further work was cut and the block was re-inked in red, which was printed over the yellow. The block was locked into a chase to be printed. (A chase is a metal rectangle with furniture generally used in letterpress printing, which keeps the block in one place to ensure accurate registration.) More lines were then cut and an opaque white was printed over the two previous colors. Blue was the next color used, followed by black. Once all the colored sheets have been printed, no more can be produced in this way. However, the block can still be printed in the finished state in black.

Wood

Box is the preferred hardwood for engravers because it is consistently close in texture, and can be rubbed down to a smooth, durable printing surface. Maple and holly are reasonable substitutes, with alternatives of cherry, pear, and sycamore.

To prepare the block it is rubbed down with three grades of sandpaper, from coarse to fine. This can take about two hours, with the result being a mirror finish. This ensures that every mark will print. A felt-tip pen can be rubbed over the surface so that when the marks are cut they will be easy to see. A drawing, or tracing, can be made on the block as a guide.

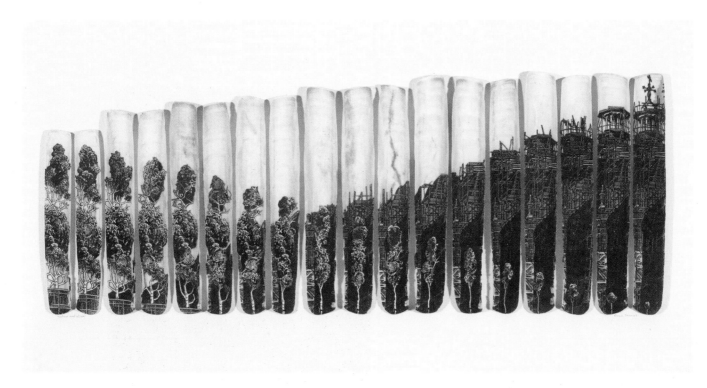

Wood engraving: Troubleshooting

Problem: The tool slips or jumps when cutting

Cause	Solution
Blunt tool.	Start with a sharp tool and resharpen at regular intervals throughout the process of cutting the block.

Problem: The line appears to cut wider on one side than the other

Cause	Solution
The tool has been sharpened unevenly.	To obtain absolutely clean-cut and well-defined lines, all tools must be sharp, true, and even. The entire process of engraving depends on the high quality of the tool and the block.

Anne Desmet
(British)
Urban Evolution
7¾ x 20½in (19.6 x 52.5cm)
Wood engraving, linocut, and collage—multiple wood engravings and linocuts printed on paper, then particular details selected and cut out from each print and collaged onto 18 razor shells; T. N. Lawrence oil-based relief printing inks in black, green, and yellow; 2 types of Japanese paper: Gampi Vellum (cream) and Kozu-shi (light beige)
Edition of 1 printed by the artist on a Hopkinson & Cope Albion relief printing press (made in 1859) at her studio

wood engraving in practice

Colin Kennedy
(British)
Saints and Sinners
6 x 3in (15 x 8cm)
Wood engraving—reduction print
cut on box wood; oil-based ink;
Arches 88 Hot-pressed paper
Edition of 30 printed by the artist on
a relief press at his studio

"I normally work on a color
design either in watercolor or
gouache and then make a line
drawing in the proportion of
the block I have chosen. I then
make the block black by using
a black permanent marker pen
and transfer the line image to the
block using white carbon paper."

2.8.3

Original drawing

Color sketch

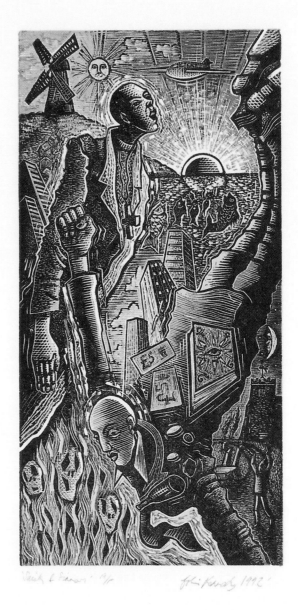

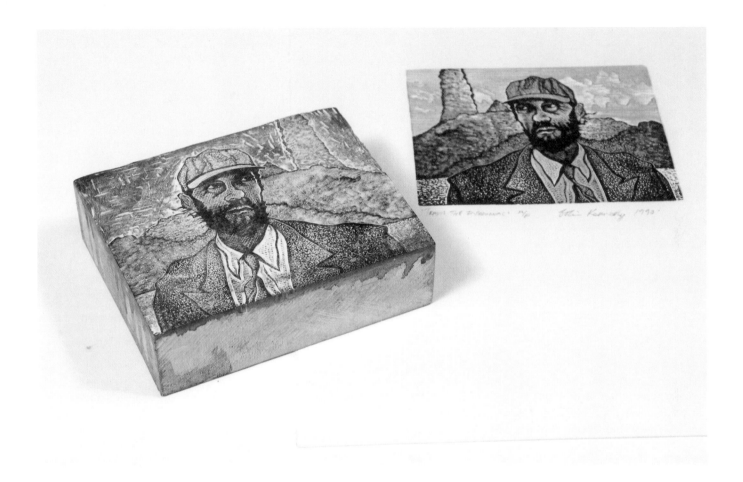

Colin Kennedy
(British)
Travis the Insomniac
2¾ x 3½in (7 x 9cm)
Wood engraving—reduction print
using boxwood; oil-based inks;
Arches 88 Hot-pressed paper
Edition of 25 printed by the artist
on a relief press at his studio.

Deborah Mae Broad
American

2.8.4

profile: **Deborah Mae Broad**

"I drew horses as soon as I could hold a crayon after watching cartoons. They were almost always my subject, and my interest in them was the driving force behind drawing for most of my life. I used to tape my dad's memos from work onto the window, and trace the letters backwards, so thinking in reverse was natural to me when working on an etching plate.

"I have a Bachelor of Arts from Hollins University in Virginia. For graduate study I went to the University of Tennessee in Knoxville, where I received a Master of Fine Arts in printmaking and studied with Byron McKeeby, a well-respected printmaker. It was a good place to learn, as Byron McKeeby was a rare printmaker and teacher. He was the strongest influence in my life as a printmaker. He taught me about lithography and to have a strong work ethic. He could tell how strong an etch was by tasting the gum. He did not like me to talk and draw on the stone at the same time, as lithography was so important to him. He taught me many things that I still think about every day. One comment he made changed my life. He said, 'If you like detail, you need to be a wood engraver. Look at the old books.' It took ten years, but I did that.

"I took an introduction to printmaking at junior college, and liked etching. When I transferred to Hollins, my teacher Nancy Dahlstrom was very enthusiastic and let me explore etching (which was my main interest), lithography, and screenprinting. She was a role model for me and I am very grateful to her for my foundation in printmaking. Hollins had a beautiful old lithography press and I was the only student at that time who wanted to use it. I had all the stones to myself; it was wonderful. The etching press

from Hollins is now mine. I love the fact that it is the one I learned on. A bearing broke on it, and I asked the president of the college to buy a new press so he sold the old one to me for $200. My dad had a new part made at the shipyard in Newport News, Virginia, where he worked. He marked the pieces so we could take it apart and move the press to Minnesota when I bought my farm. We put it in the chicken house under a tarpaulin, where it stayed for five years while we rebuilt the studio around it. Even though I would love to have a new Griffin etching press, I just can't bring myself to let go of this one.

"I prefer to do my work and not have anyone else print for me. I have had a few students who probably could print the plates and blocks, but I have never asked them to.

"My animals give me a lot of ideas. Sometimes just seeing them in a certain position or situation is a start. All of my work is about human life, too, but I use the animals because then they are not male or female, young or old, so it could be any one of us in my images. Sometimes the little daily dramas between my animals give me ideas. Whatever is going on in my life at the time is a subject for me. For example, when I retired from teaching a

few years ago to be a full-time artist, I did a group of prints about success, because I was wondering if I was successful. What is success? My print *Retired* came along when someone asked me if I was bored being retired. I said no, I could sit and watch the birds all day and be happy.

"Sometimes I feel like working but have no ideas, so I make myself start from song titles and phrases in songs, such as 'Learning To Fly,' and come up with an image based on those words. Some images just come to me and I don't know where they came from. I call these free gifts.

"My inspirations have been Rudy Pozzatti, Byron McKeeby, Lloyd Menard, Jim Horton, and Keith Howard. I am also inspired by the wood engravings of Gustave Doré, and the animal portraits by George Stubbs. I was inspired to turn to woodcuts by looking at Rudy Pozzatti's work when I was teaching. What impressed me was the variety of textures and the great contrasts. Some of his prints had a depth of feeling in them beyond the technique. His woodcuts are almost like wood engravings. I had the honor of meeting and hearing him speak in 2006 at Frogmans Press Printmaking Workshop at the University of South Dakota, run by Lloyd Menard. Lloyd is a force of nature when it comes to printmaking. He has been running

**Deborah Mae Broad
(American)**
Learning to Fly
**18 x 24in (46 x 60.5cm)
Wood engraving
Printed by the artist on a
lithography press at her studio**

"I use my lithographic press to print my wood engravings. The colors are screenprinted first and the key block is printed last in a dark blue or maroon over the colors. The paper is registered with the punch system, and paper has to be prestretched on the lithographic press before printing. I began using screenprinting for my colors because it is a nontoxic way to get color down and gives a good surface for the wood-engraving ink. This makes the ink sit on top instead of sinking into the paper and losing contrast. I print a solid color over the whole image area first. The solid is printed three times. Other colors are printed from large areas to small, so some areas get up to seven layers. I use lithographic ink to print the block. Before inking the block, I spray water lightly onto the paper, spread it around and put Mylar over it while I ink the block. It is similar to using a damp box for lithographs, as moisture level is critical. Prints are dried for one day by hanging them and left for a week to ten days in the dark to avoid bronzing of the ink. My early wood engravings were hand-colored; then I tried transparent color screenprinted over the wood engraving. Coated papers first gave me that idea."

Deborah Mae Broad
(American)
Retired
8 x 10in (20 x 25cm)
Wood engraving
Printed by the artist on a
lithography press at her studio

this workshop for 27 years. It is an important source of inspiration for me. When Rudy Pozzatti talked, the whole room was silent. I felt like we were witnessing an important part of printmaking history as Rudy talked about his background as a printmaker. The best printmakers from all over the world teach and are students at this workshop. I learned more in a week there than I did in a year of school.

"Jim Horton taught me about wood engraving. I call him the king of wood engraving. Until I met him in 1990 I had never met another wood engraver, I had only seen books. I still hold the tool the way I taught myself from the David Sanders book in 1989, but Jim Horton taught me the traditional ways. Keith Howard taught me to think about etching in a new way that will not kill me with chemicals. His nontoxic intaglio work is the most important development in printmaking since the advent of photography.

"Printmaking has been a very important influence in my life. Not only is it the vocabulary I use to communicate my ideas, it provided me with a rewarding career, allowed me to help many students, and led me to meet the great people I have mentioned previously. It continues to provide challenges every day. Even if I have no ideas, there is always something to be done in printmaking, some step to take with the process.

"I love the idea that printmaking makes it possible for 50 people to enjoy one image, instead of one person, as a painting would do. It is a very interesting time to be a printmaker."

Deborah Mae Broad
(American)
High Haven
Wood engraving
Printed by the artist on a lithography
press at her studio

chapter 9 **printing the relief image**

an overview of printing the relief image

In the relief medium, it is the nature of the mark that produces the atmosphere and energy within the image. As has been shown in the preceding pages, there are many techniques that can be used when creating a block. These incorporate a variety of tools to create the type of line or mark required. Whether the relief surface is of wood, lino, card, or found objects, the beauty of the printing process is its simplicity.

Left: **Anne Desmet**
(British)
Green Glass Light
4¾ x 4 x 1/4in (12.2 x 10.3 x 0.4cm)
Wood engraving and collage
—wood engraving printed on paper,
then cut up, reassembled, and
collaged onto 30 green-gold tesserae;
T. N. Lawrence oil-based relief printing
ink in black; Zerkall paper
Edition of 1 printed by the artist on
a Hopkinson & Cope Albion relief
printing press (made 1859) at her
studio

Columbian Eagle relief press

First invented in America in 1807, this type of press was soon imported and then manufactured in England, where it was used to print newssheets, booklets, and posters. This type of cast-iron press was, and still is, very highly regarded for printing woodcuts, wood engravings, and linocuts. Today it takes a less commercial role, being generally restricted to the work of fine-art printmakers. The distinctive eagle is the counterweight that rises and falls as the handle on the press is pulled across. The printed image produced is the reverse of the block.

The block of wood on the floor is secured for the user to push their feet against while pulling the handle across. Present health and safety guides do not permit the foot to be raised onto the bed for fear of twisting the body of the press. Neither should this be necessary, as extreme pressure is not required to obtain a good-quality print. The user should adjust the packing to obtain the correct amount of pressure to produce a good print without overexertion.

Albion relief press

The Albion was invented in England in the early 1800s, soon after the arrival of the Columbian. There are versions in various sizes but all are smaller and lighter in weight than the Columbian; they are also easier to adjust and use. These valuable little presses are much sought after as they produce excellent prints from wood engravings, woodcuts, and lino blocks.

2.9.2

presses: **relief printing**

Below left: **The Columbian Eagle relief press, University of Brighton, UK**
(Photo courtesy of Laurence Olver)

Below: **Albion relief press**
(Photo courtesy of Laurence Olver)

Hand-constructed presses

Presses can be homemade in quite a simple way. This one is constructed from wood and a car jack. Providing the pressure is even and firm the print will be good.

Relief press hand-constructed by Julian Hayward

Julian Hayward (British)
Vista III
4 x 6in (10 x 15cm)
2-block linocut mounted on wood; oil-based relief ink; mold-made paper
Edition of 25 printed by the artist at his studio on the hand-constructed press shown left

Letterpress presses

It is possible to print relief blocks on the presses used to print letterpress type. Providing the block is brought up to exactly type height, the image will print, and there will be no damage to the packing on the barrel. The block will also need to be fitted into a chase to prevent movement. The advantage is speed: a large quantity can be printed in a relatively short period of time.

Inks and rollers

Inks used on relief blocks are generally oil-based, although some artists prefer water-based inks for certain hardwoods. Most oil-based inks are transparent, which has the advantage of overprinting one color on another to produce a third color. There are also opaque inks that will cover an earlier printed area if required. Both pin and hand-firm composition rollers are suitable for rolling up a relief block.

relief printing in practice

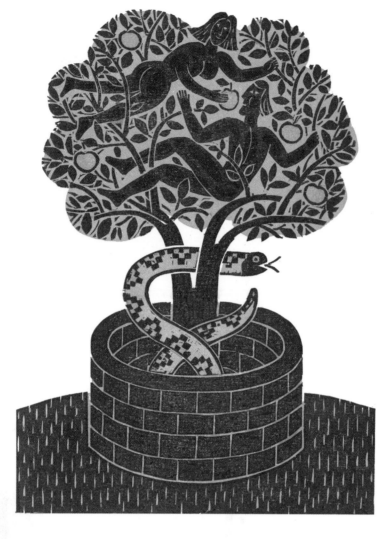

2.9.3

**Bernard Lodge
(British)**
Adam and Eve
**13 x 9½in (33 x 24cm)
Woodcut and linocut—key line cut in
wood, other two blocks in lino; oil-
based inks; Seawhite cartridge paper
Edition of 20 printed by the artist
on an Alexandra platen at
Clayton Manor Barn, UK**

**Bernard Lodge
(British)**
Ginger
**9¾ x 15in (24.8 x 38cm)
Woodcut and linocut—key line cut in
birch plywood, second color in lino;
oil-based inks; Seawhite cartridge
paper
Edition of 15 printed by the artist
on an Alexandra platen at
Clayton Manor Barn, UK**

step by step: **printing a single block with a simple blend**

1 This print is created using a Japanese soft plywood block, printed on a Columbian relief press (see p. 187). A roller is selected, with stand, which measures the full width of the block. Also ready are palette knives and oil-based inks in the required colors.

2 The width of each color required is estimated by first placing the block on the inking-up surface and then laying a small quantity of the ink in a narrow band to the required width, ready to roll out.

3 The ink is rolled out smoothly, by continuing to lift and roll onto the surface until there is a thin, even layer, with the two colors blending successfully. The roller is moved very slightly from side to side while rolling, to spread the blend evenly.

2.9.4

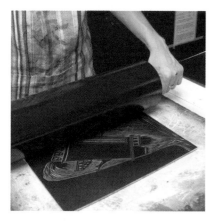

4 The roller is passed lightly and evenly over the block several times, ink is recharged as required, and the block re-rolled. After recharging the ink, lift the roller smartly off the surface and place on a stand, to prevent a line forming that will transfer onto the block and subsequently the print. If there is any "orange peel" effect on the surface of the ink, or a squelching noise while rolling, there is too much ink; this will cause the fine lines on the block to fill in. After the initial proof, the block only needs to be lightly re-inked before each subsequent print, to prevent flooding the fine lines.

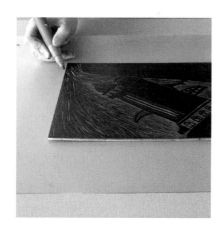

5 The registration sheet is prepared, larger than the printing paper, by using acetate or true-grain (mark resist). The position of the edge of the paper, and the block, is defined by making a mark with a permanent marker pen. Blocks, large or small, should always be placed in the center of the bed of the press. With the larger relief presses it is particularly unsafe for the printer, and can severely damage the press, if the block to be printed is not set correctly under the platen.

6 The registration sheet is placed on a clean piece of paper on the bed of the relief press. Use the tooth side of the true-grain registration sheet face down on the press, as it grips the surface and prevents movement or creasing, which can occur when using acetate. If the permanent marker is used on the underside of the registration sheet it will not be removed when cleaning the top surface.

7 Heavier handmade papers produce a sharper print when dampened, but lighter-weight papers can be printed dry. The printing paper is laid over the inked-up block, using the registration marks as a positioning guide.

8 Tissue paper is placed over the damp printing paper to keep it clean.

9 A flat pack of paper, or thin card, is placed over the tissue.

Safety note

The lever should pull across quite easily, with a little exertion needed as it reaches the printer. Then it should be replaced carefully. If it drops back hard against the body of the press, in extreme cases it can shudder and crack the brittle cast-iron structure.

10 Blankets are used as extra packing to obtain the required amount of pressure. The amount of packing used depends on the needs of the block. Trial and error is the only way to estimate the correct amount. It is unsafe, and unnecessary, to put a foot against the large Eagle presses to pull the lever across. If this action is required then there is too much pressure, and some packing needs to be removed.

11 The tympan is lowered. Do not put your fingers under the platen.

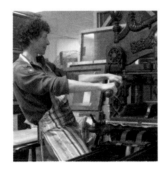

12 The bed of the press is rolled under the platen, and the pressure lever is pulled toward the artist. The lever is released gently back to starting position, against the press, with care taken to prevent it dropping back abruptly.

13 The bed is returned to the original position, the tympan lifted, and the print removed.

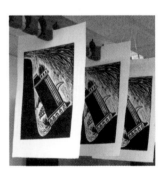

14 The prints are hung up to dry in ball clips, or placed in racks. (See opposite for final print.)

**Hebe Vernon-Morris
(British)**
This Could Take Some Time…
**9 x 12in (22.5 x 30cm)
Soft Japanese ply woodcut;
oil-based relief inks; Fabriano
handmade 300gsm paper
Edition of 20 printed by the
artist on a Columbian relief
press at Brighton Independent
Printmaking, UK**

Top: **The soft Japanese plywood
block charged with black and
red ink.**

Bottom left: **Proof print in black.**

Bottom right: **Proof print with a
black and red blend.**

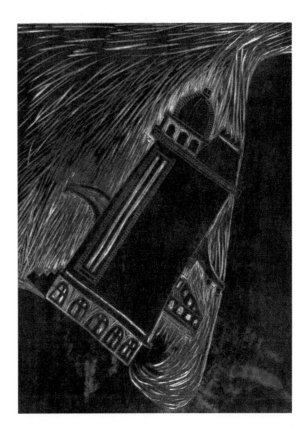

step by step: **multiplate block cut with jigsaw**

1 The fine blades of the electric jigsaw make it possible to cut intricate shapes in the softwood. Note the long arm for getting to the center of the block. It is advisable to wear eye protection due to the dust generated.

2.9.5

2 The design has been cut into shapes ready to be inked separately.

3 A registration method. The prepared block is placed on a piece of card the size of the printing paper. A cut is made around the block.

4 The window of card is placed on the prepared registration sheet, on the bed of the relief press. It rests within the guide marks of the printing paper.

5 The cut blocks are inked up in various colors as desired.

6 The chosen pieces are put in place, using the card window to provide accurate positioning.

7 The card is removed and the block is printed, as shown earlier. (See opposite for final print.)

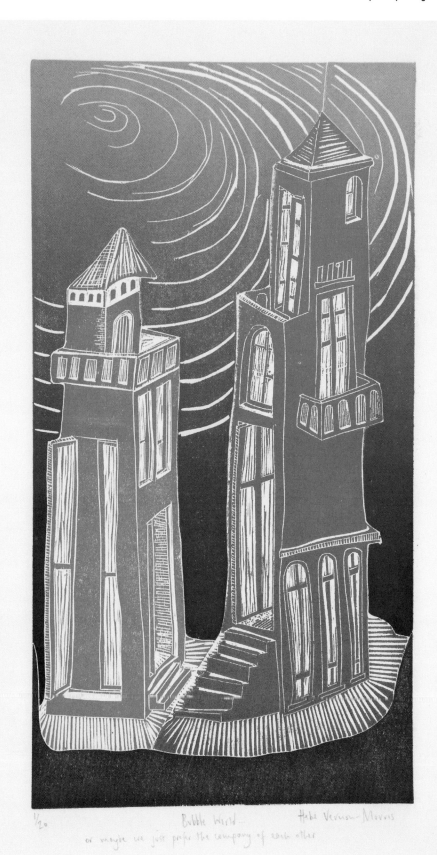

**Hebe Vernon-Morris
(British)**
*Bubble World … or Maybe We
Just Prefer the Company of
Each Other*
**12 x 8in (30 x 20cm)
Soft Japanese ply woodcut;
oil-based relief inks; Fabriano
handmade 300gsm paper
Edition of 20 printed by the
artist on a Columbian relief
press at Brighton Independent
Printmaking, UK**

relief printing in practice

Below: **Jude Clynick**
(British)
Untitled
2 x 2in (5 x 5cm)
Wood engraving; oil-based relief ink;
Toshi washi paper
Edition of 3 printed by the artist on
an Albion relief press at Brighton
Independent Printmaking, UK

Chris Daunt
(British)
Logo
3½ x 3½in (8.5 x 8.5cm)
Wood engraving on boxwood
round; T. N. Lawrence relief ink;
Zerkall paper
Edition of 75 printed by the artist
on an Albion relief press at his
studio

TRADITIONAL FINE QUALITY ENGLISH ENDGRAIN WOOD ENGRAVING BLOCKS

CHRIS DAUNT

2.9.6

³⁄₃ Jude Clynick

Coast V 14/50 Halrer

Dmitry Sayenko
(Russian)
Illustration from Daniel Kharms'
An Unexpected Drinking Bout
6¼ x 8in (16 x 20cm)
Woodcut
Edition of 20 printed on a relief press

Daniel Kharms was a well-known
absurdist writer of the 1930s. 13
of these 20 editions were printed
in Russian/English, the other 7 in
German.

Jean Farrer
(British)
Coast V
2¼ x 4¾in (6 x 12cm)
Vinyl block print; lithography/relief
oil-based ink; Japanese Ho-sho paper
Edition of 50 printed by the artist on a
Tofko press at her studio

Ann d'Arcy Hughes
(British)
Shades of the Past—Brighton
25 x 20in (63.5 x 50.8cm)
Photo-lithograph—2 plates: 1 photo-litho plate, 1 hand-drawn zinc litho plate
Artist proof printed by the artist on a Mainlander offset lithography press at the University of Brighton, UK

Ann d'Arcy Hughes
(British)
Working, Work Out
25 x 20in (63.5 x 50.8cm)
Photo-lithograph—2 plates: 1 photo-litho plate printed with a blend, 1 hand-drawn zinc litho plate
Edition of 10 printed by the artist on a Mainlander offset lithography press at the University of Brighton, UK

lithography

introduction to lithography

The word "lithography" is derived from the Greek, "litho" meaning "stone" and "graphy" referring to writing. It is a planographic medium, as the print is pulled from an image created on the flat surface of a stone or plate. There is no need for either incision or relief on the working surface, as the principle of the technique relies on the fact that grease and water do not mix.

The origins of lithography

This technique was originally christened "chemical printing" by its inventor, Alois Senefelder, who began his explorations into a fast and economical printing process in the late 1790s. Having noted the texture of the worn-down stone slabs used to construct the streets of Munich, he polished a piece of Kelheim limestone he was using as an ink slab to emulate the smoothness of a copper plate with an aim to practicing the art of writing backward. Asked to write a laundry list with only the prepared stone at his disposal, he used the opportunity to further experiment with the chemical process. Having etched the surface, he attempted to ink up, but suffered a series of false starts so cleaned the surface with water. While attempting to ink up again, he noticed that the damp areas rejected the ink while the greasy lettering attracted it. Following this breakthrough, the process developed rapidly to include transfer methods as well as direct drawing onto the stone. By 1816, he was able to print from several stones. This increased to between 12 and 15 colors by the 1830s.

Lithography in Europe

Senefelder visited London in 1800 to publicize his invention. The president of the Royal Academy of Arts in London, American-born Benjamin West (1738–1820), became one of the first artists to try lithography in England.

In 1819, Charles Hullmandel, who had studied with Senefelder in Munich, established his printing press and is credited with persuading many leading artists to try the process. He remained an important influence until the mid-1800s. In France, although the process did not prosper until the end of 1817, lithography attracted the enthusiasm of noblemen and even Napoleon, to the extent that his brother, Louis Bonaparte, in Munich in 1805, drew *Four Men of the Imperial Guard* on stone. It is rumored that Napoleon's officers returned to France with materials and technical details of the new invention following the invasion of a number of German print workshops. However, these lengths were soon no longer necessary. Despite the fact that Senefelder acquired a patent on his chemical printing method in both Austria and England, in 1809 a book called *Das Geheimnis des Steindrucks (The Secret of Lithography)* was printed by a Bavarian publisher. It disclosed the intricacies of the technique and prompted the establishment of print workshops all over Europe.

The French lithographic tradition

While the process originated in Germany, it is the French tradition that influenced its development most profoundly. Spanish artist Francisco Goya (1746–1828) worked in France following his exile from Spain. His four lithographs *The Bulls of Bordeaux* (1825) influenced the artists of the

Romantic movement; Eugène Delacroix's (1798–1863) lithographic images are a milestone in book illustration. Following a series of the Elgin marbles (1825), he produced 17 prints to illustrate *Faust*. During the early nineteenth century, lithography served as a vehicle to spread the unrest that followed Napoleon's rule. Honoré Daumier (1808–1879) printed an enormous number of politically themed lithographs—100 lithographs a year over a 40-year period. These images satirized the government and the king.

Fine-art lithography in the late nineteenth century

The popularity of lithography in France and the growing regard for lithographs as works of art refreshed enthusiasm for the medium in the rest of Europe in the late nineteenth and early twentieth centuries. German artists such as Max Liebermann (1847–1935) contributed to *Pan*, a quarterly periodical which offered lithographers an opportunity to have their work published, with inclusions by French printmakers Toulouse-Lautrec and Vuillard. The Expressionist movement, based in Germany in 1905–1930, focused on the expression of emotions rather than the representation of the external world, and artists such as Edvard Munch (1863–1944), Emil Nolde (1867–1956), and Max Beckmann (1884–1950), among others, created powerful works.

The Curwen Press played an important role in popularizing the lithographic process in England. Established in 1840 by Reverend John Curwen to facilitate the printing of religious works he used in his Nonconformist ministry, it was converted into a printing workshop when the congregation outgrew the chapel. Shortly before World War I his grandson, Harold Curwen, took over the management and transformed the ideology of the press. He encouraged a series of independent artists such as Edward Bawden (1903–1989), Paul Nash (1889–1946), Eric Ravilious (1903–1942), and Edward McKnight Kauffer (1890–1954) to work with lithography. The Curwen Press initially utilized the transfer method that Senefelder had developed to take lithographic transfers from intaglio and relief images. The transfer process was contentious—should a lithograph made via the transfer process be considered a reproduction or an original? Walter Richard Sickert (1860–1942), Joseph Pennell (1857–1926), and James Abbot McNeill Whistler (1834–1903) took the argument to court, the conclusion being that lithographs printed by a master lithographer that are created from an image made by the artist are original works.

Lithography in the United States and Mexico

The European enthusiasm for lithography had an impact on the American continent. However, it was not until 1825 that the first lithographic print shop was established, by John Pendleton in Boston. He is reported to have employed a French artist and printer to work with the ton of lithograph stones and other materials that he transported from France. The most famous lithography business of the era was that of Currier and Ives. Having opened in Boston in 1834, they moved to New York in 1836 and continued to be significant advocates of documentary lithography until 1907. The work they produced was not regarded as experimental, but it was valuable as a record of mid-nineteenth century North American life.

Lithography was introduced to Mexico by Italian nobleman Claudio Linati (1790–1832) in 1826. Following Mexico's independence from Spain in 1821, Pedro Patino Ixtolinque (1774–1835) became the director of the Academia de San Carlos in Mexico City, and introduced lithography to the curriculum in 1831. By 1836 there were a number of lithography workshops producing prints that promoted a sense of nationalism. Themes focused on customs and traditions, with the aim of encouraging cultural pride and national identity. The medium thrived during the latter half of the nineteenth century, but suffered a decline due to its commercial associations in the early twentieth century. However, by the 1930s, lithography had re-emerged. Lithographic work was produced by three of the most prolific Mexican artists: Diego Rivera (1886–1957), José Clemente Orozco, (1883–1949), and David Alfaro Siqueiros (1896–1974). The medium was utilized to great effect in subsequent years by artists involved in the political campaigns for the democratic and social rights of the Mexican population.

chapter 10 **stone lithography**

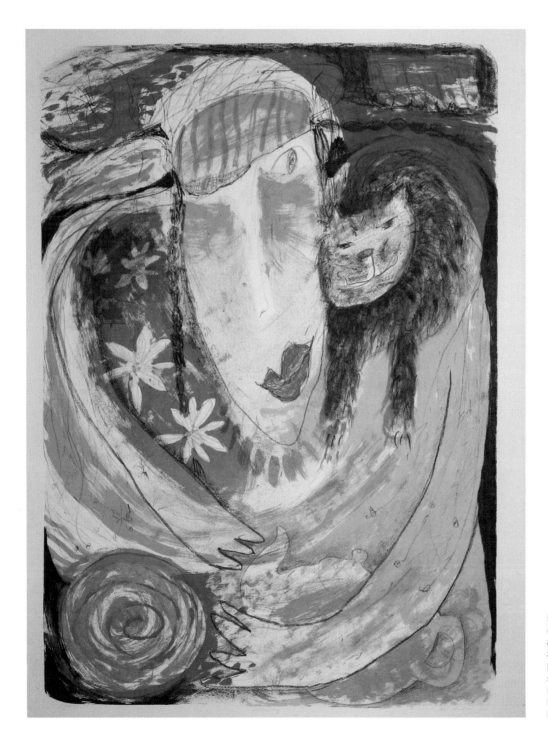

Heike Arndt
(Danish)
Summerday
30¼ x 22in (77 x 56cm)
Lithograph—9 colors printed on
stone; variable ink; Fabriano paper
Edition of 99 by the artist and Jan
Kiowsky at Grafisk Værkstede,
Næstved, Denmark

a brief history of stone lithography

The origins of lithography and its development through the eighteenth and nineteenth centuries are outlined on pp.252–253. In this section we focus on the more recent history and the contemporary practice of this printmaking medium.

Lithography suffered a general decline in early twentieth century in Europe and the United States. However, by the 1920s many leading artists were experimenting with printmaking—Wassily Kandinsky (1866–1964), George Braque (1882–1963), and Pablo Picasso (1881–1973) all produced a considerable number of lithographs.

The beginning of World War II enforced an exodus of European artists who congregated in New York. One of the most important studios that relocated from Paris for the duration of the war was Atelier 17, established by Stanley William Hayter (see p. 149). The contemporary and avant-garde European artists who worked within the studio at this time had a profound influence on the development of Expressionism in America. The theoretical strands of the Bauhaus, advocated by Josef Albers, and the Surrealist aspect embraced by Hayter provided a vibrant mix of European ideology.

The revival of fine-art lithography in the United States began in the late 1950s with, among others, painters such as Sam Francis (1923–1994), Jasper Johns (b. 1930), and Robert Rauschenberg (1925–2008). The revival was due to the establishment of the printmaking studios Pratt Contemporaries, Universal Limited Art Editions, and Tamarind, which reintroduced the expertise and technical environments necessary to facilitate access to the medium. Previous to this, North American artists who contributed to the American lithograph history, such as Whistler, created their works in Europe (predominantly in Britain and France) as late as the 1950s.

The Pop Art movement had a significant impact on the medium, with artists Roy Lichtenstein (b. 1923), Claus Oldenburg (b. 1922), and Jim Dine (b. 1935) producing works that were inspired by images of contemporary consumer society and pop culture.

In Britain, following World War II, lithography suffered a decline that did not improve until the late 1950s when Stanley Jones joined the Curwen Press. His experience of working in Paris, in printmaking workshops that had retained some sense of the nineteenth-century French lithographic tradition, enabled him to return to Britain with the enthusiasm necessary to infuse some life back into the British lithography tradition. British artists such as Henry Moore (1898–1986), Ceri Richards (1903–1971), Graham Sutherland (1903–1980), and David Hockney (b. 1937) have all contributed to the reinstatement of the medium in the public consciousness.

**Heike Arndt
(Danish)
Drunkard
13½ x 9½in (34.3 x 24cm)
Lithograph—7 colors printed on
stone; variable ink; Fabriano paper
Edition of 99 by the artist and Jan
Kiowsky at Grafisk Værkstede,
Næstved, Denmark**

Color lithography

In Europe, some of the most widely recognized lithographic images were the posters of Henri Toulouse-Lautrec (1864–1901). The success of his first poster in 1891, commissioned by the Moulin Rouge, encouraged a series that continued in the music-hall cabaret theme. His images captured the atmosphere on stage and behind the scenes at the Moulin Rouge, his subjects being the performers and clientele who populated this environment. He produced approximately 370 lithographs in both black and white and color. As the color lithography process had been predominantly embraced by the commercial printing industry during these years, it was refreshing to witness a more creative use of the medium. His images extricated the process from the world of routine, commercial reproduction back to that of the fine-art tradition. This was continued into the twentieth century by artists such as Edgar Degas (1834–1917), Pierre Bonnard (1867–1947), Henri Matisse (1869–1954), Marc Chagall (1887–1985), Pablo Picasso (1881–1973), and Joan Miró (1893–1983).

Color had been embraced within painting following the Impressionist movement, originating in France in the 1860s, and was further enhanced by the growing awareness of Japanese and Chinese prints following the World Exhibition in 1867. This prompted groups like Les Nabis and Les Fauves (of which Matisse was a member) to experiment further. Influenced by Gauguin, the Nabis artists, including Bonnard, Edouard Vuillard (1868–1940), and Maurice Denis (1870–1943), aimed to engage the audience through the simplification of outline in preference for the use of broad areas of color. All three artists produced lithographs, with Bonnard creating around 300 prints, more than 100 of which were lithographs. His atmospheric use of color is considered to most effective in *The Little Laundry Girl* (1896) and *The Child with a Lamp* (1898).

Artists and master printers

The nature of the lithographic process has led many artists to work in collaboration with a master lithographer. Historically, one of the reasons why artists have been drawn to the medium is the fact that an image can be drawn directly onto the stone or plate and will remain largely unchanged throughout the printing process. In addition, the softness of the line and the tonal qualities of the marks and washes are persuasive elements for painters wishing to experiment across mediums. However, the technical complexities of the printing process have encouraged a number of artists to work with master printers in order to achieve the full potential of their image in the final print. For example, Chagall rarely worked directly onto the stone himself; he created drawings that were transferred and executed by a third party.

Debates regarding the balance of input between that of the artist and the master printer continue to this day. The aesthetics of the image are of ultimate importance and usually the artist retains control over this aspect of the process. Consequently, the role of the printer is skill-based rather than conceptually based. The artist provides the image and the creative concept of the finished piece, and the printer is challenged to use his or her technical skills and experience to fulfill that.

Studios such as Curwen in the UK and Universal Limited Art Editions in the US, and master lithographers such as Andrew Purches (see p. 302) at the Cowfold Printmaking workshop, continue this collaboration with the artist, using their experience and technical prowess to achieve the artist's vision.

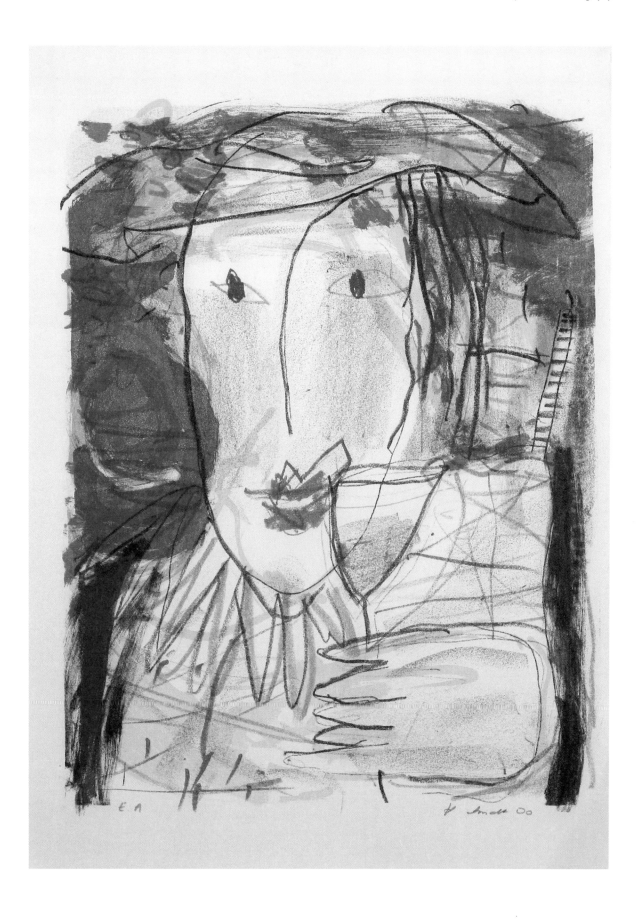

Litho stones

The finest lithographic limestone is quarried from Solnhofen and Pappenheim in Bavaria. This stone is recognized as being superior as it has a fine and even molecular structure and is slightly porous. This enables the balanced acceptance of both grease and water to allow some stability throughout the markmaking, processing, and printing process. However, no stone is identical so flexibility is required to develop an awareness of the individual characteristics of each piece.

3.10.2

tools and equipment: **stone lithography**

Although damp and soft when first quarried, the stone hardens while drying. Despite the appearance and weight of the stones, they are easily broken or chipped. If broken, the crack will part cleanly, so care should be taken when transporting or working with them. The surface of the stone is vulnerable to contamination from dust, dirt, grease, and saliva (sneezing or coughing near a stone can result in saliva landing on and marking the surface). These contaminants will show as white specks or patches when printing. When storing the unprocessed stone, protect it from the environment by covering it with a clean sheet of paper.

The stones need to be a certain thickness to survive the pressure of the printing press. Small stones should be at least 2in (5cm) thick, while larger stones should be 3–4in (7.5–10cm) thick to ensure safe printing. Older, thinner, or well ground-down stones can be backed with slate to preserve them during printing.

The stones vary in hardness, which is identified by their color:
• White to yellow stones are highly porous and soft. These suit bold, less detailed designs.

• Gray-yellow to gray are the middle range stone so will react well to a bold design and a certain level of detail.
• Blue-gray stones are hard and dense and have the least porous surface of the three colors. Suitable for fine detail, they were historically worked using a stone engraving technique for the production of banknotes and certificates.

Levigator

Also known as a jigger, this is a heavy cast-iron disk 10–12in (25–30cm) in diameter and 3in (8cm) thick, used for graining stones.

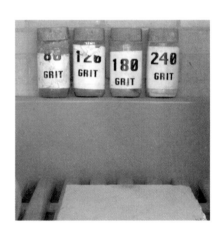

Carborundum grit

Grades 80, 120, 180, and 240 are used to grind down the stone.

Drawing materials

All materials used to produce a positive printable mark must have a high grease content. Suitable materials include:
• Lithographic crayons, which are available in five grades from hard to soft.
• Tusche—a solid grease slab diluted in water or mineral spirit.
• Water-based drawing ink.
• Chinagraph pencil.
• Asphaltum—a solid grease solution.

Additionally, to be used on stones and not plates: scalpel blades and sharp intaglio tools can be scraped into the dark areas.

Processing the stone

To process the stone, the following steps are necessary:

• Resin
• French chalk
• Gum etch (nitric acid)
• Wash out the drawing medium with mineral spirit
• Buff in asphaltum
• Sponge over with water
• Roll up with ink
• Second etch: repeat the process as with the first etch
• Proof print

Inks

Quality lithographic inks are refined oil-based single-pigment inks. These will allow good results when mixing colors and will remain lightfast.

Presses

Lithographic presses used to print stones are direct with no offset system, so they print the image in reverse. Originally these heavy presses were hand-turned, but today most have been converted to electric power.

Stones

Great care has to be taken of the stones as they can easily chip and split. Large stones are heavy, so for health and safety reasons it is necessary to use a trolley to move them from the storage area to the press.

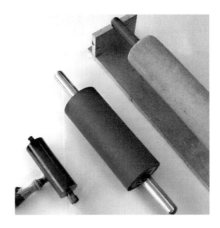

Rollers

Rollers were traditionally "nap," made of leather. However, composition rollers are now generally used, either as a pin roller on a center stem or a small roller with a handle.

Registration

This registration method was drawn up for use on a direct litho press using a zinc plate, but the principle could also be applied for stone. Tape, with a line drawn down the middle, is buffed up to the center of each side of the image. A mark is made on the stone at the center of each side, and the printing paper is given a similarly placed mark on the back.

The first stage involves grinding, beveling, and drawing. Before you start, check whether the stone is level by laying a strip of newsprint on the stone under a diagonally placed metal straight edge. If the paper can be easily released then the surface is irregular, and will need grinding accordingly. If the stone is still not level when printing, extra packing can be devised to build up the lower areas. (The final print of this image is shown on p. 265.)

3.10.3

step by step: **stone lithography**

1 Thoroughly wash the surface of the stone to remove any dirt. Keep wet while grinding.

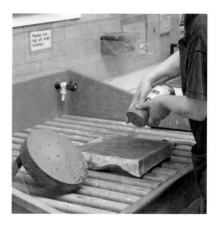

2 The process of grinding is started with a coarse 80-grade carborundum grit, which is used until the previous image is removed. A levigator is generally used to grind the grit on the stone. (Alternatively, a second stone can be used. Reverse the stones halfway through the process.) It will take two to six grindings, replacing the used grit, and washing the stone and levigator thoroughly each time.

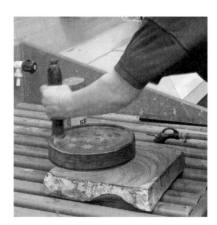

3 The levigator is worked in a regular pattern, using a circular motion, moving first diagonally across the whole surface, and then vertically, ensuring an even coverage.

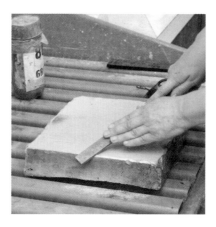

4 The next stage is beveling. This prevents the stone from chipping, and stops the ink from sticking on the edge when printing. The stone is kept wet, starting with a coarse rasp, continued with a single-cut mill file, and finished with a lump or stone pumice.

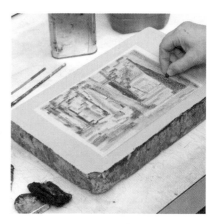

5 Thoroughly clean the stone with water and dry, then paint a margin of gum arabic around the edges of the area to be drawn on. This keeps the drawing within the printing area. Keep the surface covered with clean paper until it is used.

The basic principle of lithography is that grease and water repel each other. Therefore all materials used in making the required printable mark must be grease-based. Lithographic crayons, chinagraph pencils, liquid litho drawing ink, asphaltum, tusche,

and rubbing sticks may be used. Conté crayons, charcoal, and graphite pencils are not suitable. (See also Chapter 11 on zinc plate lithography.)

Draw directly onto the stone within the gum margin. The marks can be applied with litho pencils or crayons, a dip pen, brushes, rag, cotton buds, scrim—any method that will create a greasy, printable mark.

If the stone is stored for a period of time and requires resensitizing, use 1 part 28% ascetic acid with 3 parts water. Pour the solution onto the stone and leave for approximately 3 minutes. Thoroughly wash off with water, dry, and reapply the gum edge.

Registration

The registration marks need to be put on the stone at the time of drawing the image.

The pinhole system requires a small hole to be pushed through each sheet of paper where the dot has printed. The sheet can then be registered to the next color as shown in the diagram.

The T method requires that the paper is smaller than the stone, and that a T mark is made at the top end of the drawing, and on the back of each print. A straight line is placed on the bottom end of the image, and on the reverse of the print, so that the marks can be lined up.

For a color print, a master drawing is made from which the artist will work to produce a new drawing on the stone for each color. You normally start with the lightest color—yellow, for example. Sufficient prints will be made

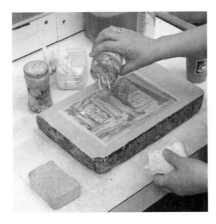

6 French chalk powder is sprinkled onto the drawn image.

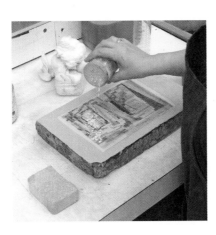

8 Resin powder is sprinkled and smoothed over the image using absorbent cotton. This powder protects the marks from the acid in the etch solution used in the next stage.

on paper, to which the subsequent colors can be registered, at the relevant stage. The unique painterly qualities that are achievable in lithography, using layers of overprinted transparent colors, are particularly rewarding.

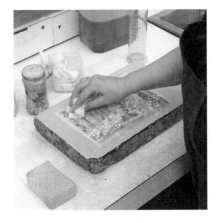

7 Using absorbent cotton, the chalk is gently smoothed over the image to prevent smudging.

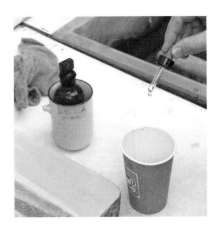

9 A gum etch mixture is made up of 1oz gum arabic to the required number of drops of nitric acid. This mixture is used to clean up the white areas, removing any dirt. The strength of the solution is mixed according to the type of stone and the delicacy of the image (see chart, p. 265). This image required 6 drops.

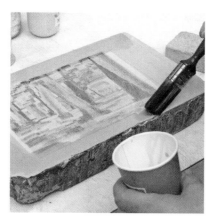

10 The gum etch is painted on the area surrounding the image.

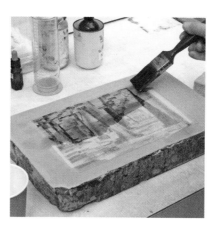

11 Gum etch is applied over the whole image. Work it back and forth for about 3 minutes, then leave it for several more minutes before rubbing it down to a thin layer with a clean rag. This stage is important; otherwise, it is not possible to remove the drawing medium at the next stage. It is then left for at least 1 hour. The gum sits on the background undrawn areas, and is repelled by the greasy drawn areas.

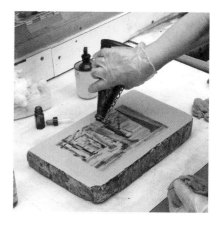

12 The drawn areas are washed out, through the holes in the gum, using mineral spirit and a clean rag. This leaves the negative shapes secured by the gum. It is advisable to wear protective gloves.

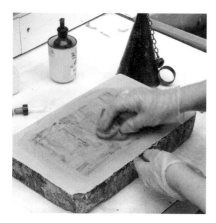

13 A clean rag is gently rubbed over the surface, removing all residues of the drawing material. A second rag is used to remove the excess mineral spirit.

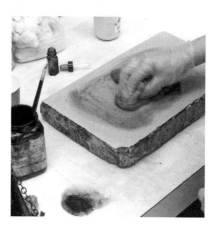

14 A mixture of asphaltum and mineral spirit is buffed in to secure the image. Asphaltum is a greasy substance that provides a receptive foundation for the printing ink. The mineral spirit makes the solution light enough to allow the excess to be washed away with the removal of the gum. The solution is gently worked through the holes in the gum, leaving the excess on the surface.

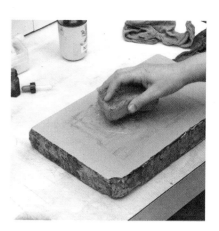

15 The gum and excess asphaltum is removed with water and a sponge, in preparation for rolling up the ink.

Second etch

After rolling up with ink, if required, the stone can be redusted with French chalk and resin and re-etched at this stage, repeating the stages as shown above.

16 Position the prepared stone centrally on the press. It is placed directly in line with the scraper, which has been cut to the exact size of the stone in order to obtain the exact pressure required.

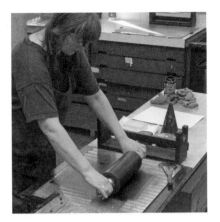

17 A strip of ink is laid down using a palette knife. This is rolled out to produce a thin, even film on the surface and, consequently, the roller. Choose a roller that is just wider than the image, but just narrower than the stone. If the roller is narrower than the image it can produce unwanted lines in the print. If it is wider than the stone, excess ink can collect on the beveled edge and appear in the print.

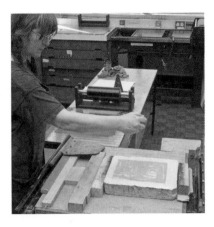

18 Wipe a wet sponge over the surface of the stone to dampen it in preparation for rolling up the ink. The water will be repelled by the grease marks, and adhere to the clear areas. If the background dries and attracts the ink, redamp the stone and roll smartly. This will create a static reaction, and the ink will revert to the surface of the roller.

The ink

Proofing is generally carried out using black ink, as it is easier to assess the quality of the tones. A nondrying black can be used direct from the can; alternatively, 50 percent drying black may be added to modify the ink. Magnesium power is used to stiffen a loose ink—this is sometimes required in hot weather, or when using certain colors. If ink is too loose or oily it may bleed out from the fine lines, or produce scumming on the background. Varnish, which comes in grades from hard to soft, can also be used to stiffen or loosen ink.

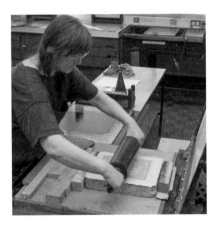

19 The inked roller is moved lightly but firmly over the surface of the stone, the ink being attracted to the grease marks and repelled by the damp background areas. The surface of the stone is redamped, and the roller recharged, before continuing to transfer sufficient ink to the image.

20 The surface of the paper is lightly damped with a sponge and the printing paper is placed on the stone.

21 Packing is generally made from thin card and newsprint, but any uncreased paper will do (creases will transfer to the print). Trial and error is the only way to estimate the amount of packing required. The size and thickness of the stone, the weight of the printing paper, and the type of press used will all affect the result.

"Make ready" is the term used for the additional thin packing made up in the shape required. Layers of tissue paper lightly pasted together, and with the edges torn rather than cut, is the best solution. This will prevent a hard, embossed edge appearing in the print. A dip in the middle requires just a circle or oval placed on top of the printing paper, before the regular packing is put down. A dropped corner can be treated likewise. A bump in the middle would require a tissue sheet the size of the stone, with the center area torn away.

22 It is essential that there is a strip of heavy grease across the tympan before each pull. This prevents the scraper from binding.

23 Note the two pieces of tape marking the position of the stone. The handle producing the pressure is pulled down at the first tape, and up at the second.

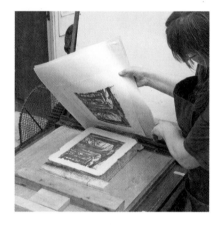

24 The scraper passes over the stone, providing the necessary pressure to transfer the ink from the stone to the paper. Then the pressure is let off and the bed travels back to the original position.

25 The first proof has been pulled. It is then necessary to redamp and reink the stone to print again. Check if any corrections are required, whether the inking is too light or too heavy, and whether the pressure on the press is correct.

Remove the ink but retain the image
This may be required when changing color. Gum up the stone, dry, wash out the ink with mineral spirit, and buff in the new color. Wipe over with a damp sponge to remove the excess gum and ink, and roll up to print. Gum retains the image in negative form, ink retains the printable marks; never remove them both at the same time or the image is lost.

Storing the image
An image can be stored in nondrying black, but if drying ink has been used the stone must be regummed, dried, and the ink washed out with mineral spirit. This will allow a fresh ink to be buffed in at a later date.

Corrections
Deletions can be made after the drawn marks have been changed into printing ink. First the area should be dampened. The

marks can then be removed using pumice powder and a rubber, or scraped away with a cutting knife. The newly worked areas will need to be re-etched carefully, avoiding the rest of the marks.

Additions can also be made during the processing, after rolling up, before the second gum. If the area needs to be resensitized to accept the new grease, a solution of 1 part ascetic acid (28%) to 3 parts water is required.

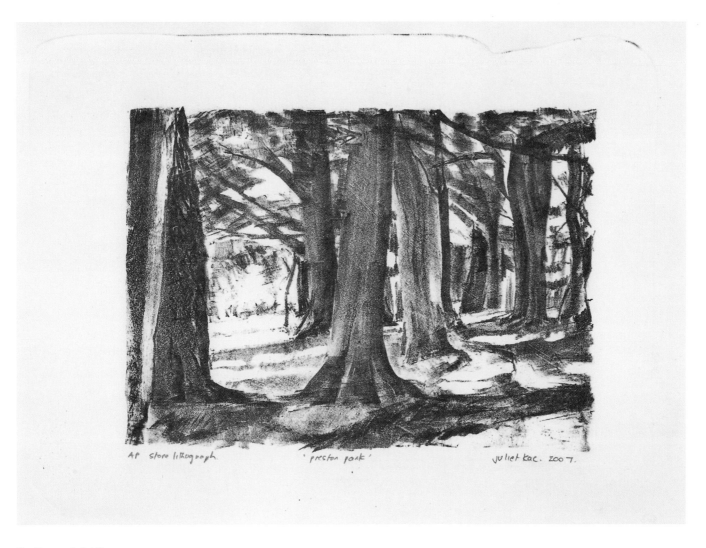

**Final image: Juliet Kac
(New Zealand)**
Preston Park
**9 x 7in (23 x 19cm)
Stone lithography; handmade paper
Artist's proof printed on a direct
litho press at the University of
Brighton, UK**

Kistler etch table

Proportion of nitric acid to 1oz of gum arabic:

Drawing strength	No. of drops of acid for stone color		
	Yellow	Light gray	Dark gray
Very delicate	0	0	3
Delicate	4	5	8
Light	6	10	13
Medium	12	15	18
Heavy	15	18	20

Stone lithography: Troubleshooting

Problem: Uneven stone surface

Cause	Solution
Uneven grinding.	Pack the nonprinting area with fragments of paper between the printing paper and the packing.

Problem: Stone cracking

Cause	Solution
1. The scraper is wider than the stone.	**1.** Cut the scraper down to the same width as the stone.
2. Scraper too hard.	**2.** If using a plastic scraper replace it with a wood and leather one.

Use the correct gloves for the required job.

Safety note
In a workshop environment every care should be taken at all times to observe and abide by the safety rules set out for the welfare of every person working within the area.

Use an industrial mask to protect against fumes and airborne dust particles.

Always have fire protection on hand.

Protect your eyes.

Use ear defenders to protect against machine noise.

Signs indicating dangerous chemicals should be observed.

Never smoke, eat, or drink around hazardous chemicals.

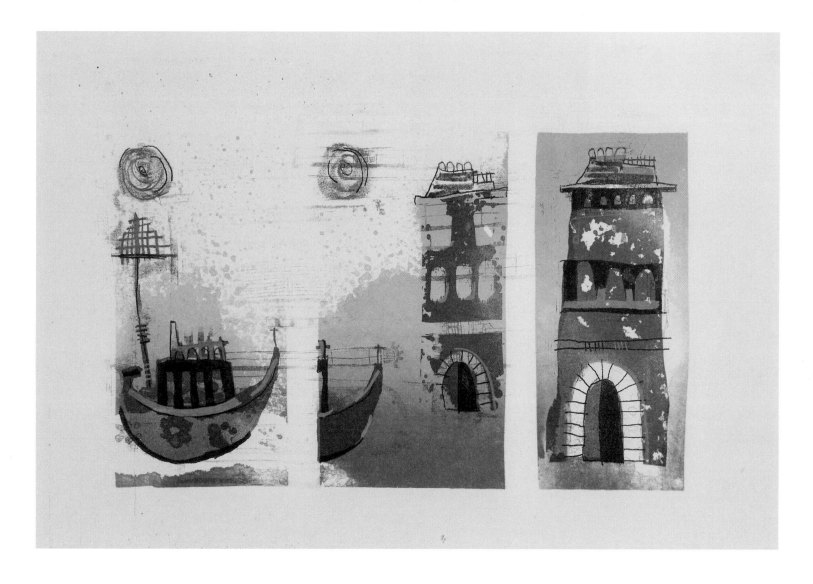

Hebe Vernon-Morris
(British)
Boating Home
15 x 10in (38 x 25cm)
Lithograph—4 zinc plates, 1: burnt
sienna, 2: turquoise blend, 3: black,
4: opaque white; Fabriano paper
Artist's proof printed by the artist
on a Globe offset litho press at the
University of Brighton, UK

Heike Arndt
Danish

3.10.4

profile: **Heike Arndt**

"I was born, an only child, in Strausberg, a village

outside Berlin in the former East Germany. From a very early age,

my grandfather encouraged me to pursue art. I used to spend weekends that were filled with painting

flowers, landscapes, and portraits, such as that of Mrs Knopse, who at 94 years old posed patiently while telling me stories of her

journeys, through Niagara Falls to desert landscapes. Just before I started school, we moved to the center of Berlin, close to the Wall in Zionskirchstrasse. Having started in the regular education system, I was soon moved to a school where 'especially intelligent children' were taught Russian to a high level in order to groom them for success. I personally enjoyed more creative subjects such as music and drawing. My dream was to become a ballet dancer, but having lost my fight to attend ballet school, I began to paint and play music more and more. During my many visits to my grandparents I practiced for hours on their piano. My future was not to be in music either though, as our apartment was too small for a piano and the noise of my playing was too loud. Painting, however, I did for hours, sometimes secretly at night when the days were too short. When I was nine years old, I won first prize in a national children's competition and began to have drawing lessons and paint seriously. I remember my first works were using wax on paper.

"At the age of 16, I moved 160km from home, with the agreement of my parents, to live in a rented room and work in a factory in order to be able to study and achieve my dream of becoming a ceramicist. By the time I had passed my final ceramic exams with high grades and considerable

appreciation and praise for my skills, I knew that I could no longer continue to work in a factory but hungered for more individual work.

"I traveled in Eastern Germany in the early 1980s and worked in Crinitz for a period of time, where I got to know Christel Kiesel. She opened up a totally new world for me, as artists such as Stötzer were working in her ceramic studio at that time. Her openness gave me the chance to meet a variety of very different people.

"In 1983 I was employed by a local vicar who was very progressive, and his wife who was a ceramicist. Being an atheist and living in a vicarage made for very interesting discussions at the evening meal, as this environment was my first introduction to religion. We talked of politics, art, and music with the many people that I met there, ranging from musicians to environmentalists who have since become strong political figures, as well as artist from all disciplines.

"In 1984 I fled illegally to Western Germany and moved to Denmark in 1985, where I learnt the language to ensure my survival in this new country. Here I began to paint seriously alongside my ceramic works. I continued to travel

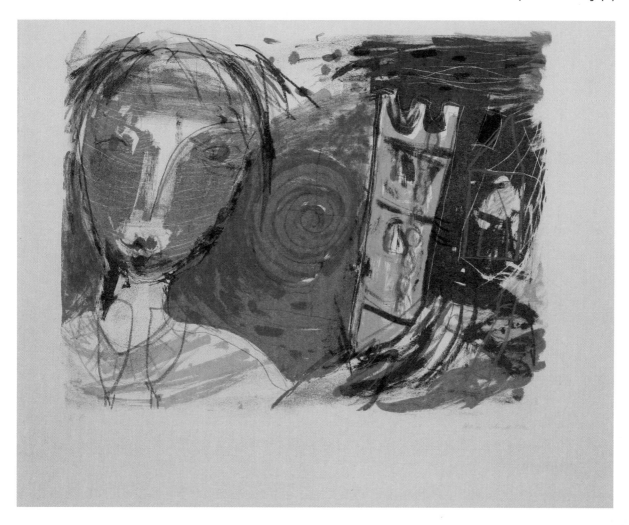

**Heike Arndt
(Danish)**
Rapunzel
**13½ x 9½in (34.3 x 24cm)
Lithograph—9 colors printed on
stone; variable ink; Fabriano paper
Edition of 99 by the artist and Jan
Kiowsky at Grafisk Værkstede,
Næstved, Denmark**

with exhibitions and remember that New York had a profound influence on me when I stayed there for a month as a participant of the National Council on Education for Ceramics. By 1988, my paintings had become central to my work, as I felt that ceramics could no longer satisfy me—I felt too limited in terms of my ability to express myself in this medium.

"At the end of 1989 I went to Porto in Portugal and learnt lithography. I spent the next decade creating work, completing commissions and exhibiting widely in Europe, Japan, and New Zealand. Following my one-woman show of 170 works in various media in 1997–1998, I began to concentrate more on printmaking and produced an edition called *Pictures of a Family*, winning Artist of the Year in 2000 for Ballerup Kommune.

"Lithography continues to be of great importance as I develop my printmaking. I am now based in China, having established my own studio in Beijing. Having spent a month in Beijing I had no doubts that this was my next destination. I was scared and fascinated at the same time and looked forward to perhaps the biggest challenge of my life so far by returning East. I have now been in China for one and a half years and have started the first private print studio in Beijing."

chapter 11 **zinc plate lithography**

Stanley Jones
(British)
Radda
30 x 21 in (75 x 53.3cm)
Lithograph
Printed by the artist at Curwen
Studios, UK

a brief history of metal plate lithography

Zinc plates were used in lithography as early as 1818. The printing trade introduced aluminum plates in 1891. Unlike limestone, zinc and aluminum plates are nonporous, so both undergo a graining process to create a tooth in the surface of the plate.

It was not until the invention of the steam-driven rotary offset press in 1895 that metal plate lithography attracted widespread popularity. Metal plate lithography was largely embraced by the commercial printing industry rather than the artist community. Consequently, developments within the process regarding chemicals and techniques were initiated by the requirements of the business.

In the United States, there is little evidence that artists involved themselves in the metal plate lithography process until the mid-twentieth century, despite brief interest in the 1930s. Technical knowledge in the first half of the century concentrated on the stone lithography process, but as the scarcity of limestone became a consideration there was a more pressing need for the development of the metal plate process.

Due to the differences in chemicals and aspects of the manufacturing process in the United States and Europe, the methods for metal plate lithography differ slightly. While in Britain zinc plates are still widely used, in the United States the fine-art world and the commercial industry have largely adopted aluminum plates. In Britain, too, metal plates were predominantly used within the printing industry in the first half of the twentieth century. Due to the stringent rules instigated by the trades unions to protect the specialist skills of the commercial plate lithographers, it was difficult and unusual for fine artists to develop the technical knowledge required to print metal plate lithographs themselves. Those who received a formal arts training did not tend to undertake a technically based apprenticeship—although Barnett Freedman (1901–1958) was a notable exception.

Contemporary artists and master lithographers continue to strengthen the lithographic tradition internationally in studios and workshops such as Pratt Contemporaries, Universal Limited Art Editions, and Tamarind in the United States, and the Curwen Press and Brighton Independent Printmaking in the UK, alongside the many other notable establishments listed in the Resources section (see pp. 396–402).

The variables within metal plate lithography are numerous—the state of the plate or stone, the temperature of the environment, the consistency and age of the inks and chemicals, and the nature of the presses. However, the joy of this process lies in juggling and balancing these components to achieve a clean and spontaneous image.

Safety note
This process requires the use of dangerous solutions. Every care should be taken to protect the user by working in a well-ventilated room with the appropriate apparatus, in addition to wearing protective clothing, such as rubber gloves, goggles, and an apron.

3.11.2

step by step:
zinc plate lithography

Zinc plate lithography: process checklist

1. Prep the plate.
2. Gum the edges.
3. Draw the image.
4. Dust the drawn image with resin powder.
5. Dust the drawn image with French chalk.
6. Evenly distribute gum etch (atzol) over the whole plate.
7. Rub down the gum with a clean rag.
8. Leave the plate to stand for a minimum of 20 minutes. Can be stored at this stage.
9. Wash the drawing medium out with mineral spirit. Can be stored at this stage.
10. Buff in a mix of ink and mineral spirit to secure the image. Cannot be stored at this stage.
11. Wash the plate with water to remove the gum, which will also remove the excess ink.
12. Keep the plate damp and roll up with oil-based lithography ink.
13. Evenly distribute a layer of pure gum arabic, and rub down as before.
14. Leave the plate to stand for 10 minutes. Cannot be stored at this stage unless nondrying ink has been used.
15. Wipe the plate over with a damp sponge to distribute the gum, in preparation for printing.
16. Keep the plate damp, roll up with ink, and blow the water dry. The plate is now ready to be run through a direct press, or attached to an offset press, to take the first proof.

Below we explore the process in more detail.

1 Lithography is a painterly medium offering the potential of color overlays and delicate washes. The process relies on the principle that grease and water repel each other. Lithography exploits the two basic properties of grease, which are that 1) it repels water, and 2) it attracts ink.

The lithograph is a print traditionally taken from a flat piece of Bavarian limestone. However, thin zinc or aluminum plates, the surface of which are grained to resemble the textured surface of a stone, are now frequently used as a convenient substitute.

The image is drawn with greasy marks that attract ink and repel water. The nonprinting areas, without grease, when processed will attract water and repel ink.

2 The process of graining the plate is normally carried out by a plate supplier or a college department. A thin sheet of zinc is placed in a graining bed. Metal or glass balls are agitated over the wet metal, with carborundum and pumice, which creates a surface with a microscopic tooth that will hold both the drawing medium, and the subsequent gum.

The graining can produce a coarse, medium, or fine tooth. Zinc and aluminum plates are prone to oxidization and must therefore be kept in a cool, dry place until required.

3 A plate is "prepped" to make it more receptive to grease and gum. Immediately after graining, the plate can be drawn on as it is clean and the surface has not had time to oxidize. If it has been stored then it will be necessary to prep the surface to remove the oxides before the plate can be used.

Prepasol is made up from dilute nitric acid, mixed with potassium alum and distilled water. A mix of 1 part prepasol to 15 parts water is the average strength of the solution required.

The plate is placed in the sink and water is run over the surface. It is necessary to pour the prep onto a damp plate to ensure the even distribution of the solution.

The prepasol is mixed 10 parts water to 1 part prep, is put into a jug and poured over the surface. The grain will show a slight change in color, to a darker shade of gray. The plate should be oscillated until the solution has adequately covered the whole area. Add a little more prep if required.

• After 1 minute the plate should be washed, front and back, with clean water.

• Drain or sponge the water off and immediately dry with a hair dryer.

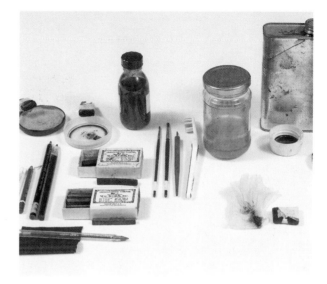

4 Pure gum arabic on a small sponge is used to protect the edges. This confines the drawing to within this margin, gives an area of the plate that can be handled, and provides a suitable amount of undrawn metal to be clipped into the press when printing. The gum can be blown dry with a cold dryer—hot air will cause the gum to bubble up, creating holes. The plate is now ready to draw on.

5 Providing the material used to draw or make marks with contains grease, the marks will print when processed. Suitable materials include lithographic crayons, chinagraph pencils, blue carbon with a ballpoint, water-based drawing ink, gum arabic, asphaltum, tusche, and rubbing sticks.

6 If a nonprinting tracing is required on the plate as a guide to where to put the greasy printing marks, specialized nongreasy carbon papers are available from printmaking or drawing suppliers. Tracedown can be bought in various colors on a roll or in a sheet. Alternatively, if red oxide powder is rubbed onto newsprint paper and laid face down on the plate under the tracing, it will do the same job as carbon and is much cheaper.

7 The artist may produce a sketch as a guide for the imagery, which can be produced freehand on the plate.

8 Lithography crayons can be purchased single, or in boxes, in differing grades from extra soft (00) to hard (copal).

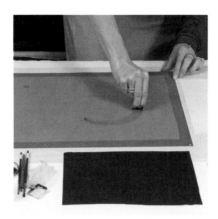

9 Korns no. 00 is extra soft and no. 5 is hard, whereas Charbonnel grade their crayons the opposite way around. They are 2in (5cm) in length and can be used by drawing from the end or the side.

10 A chinagraph pencil is convenient to hold and sharpen and gives a fairly soft line.

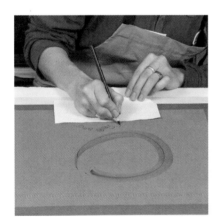

11 It is advisable to rest the side of the hand on a piece of paper to prevent grease in the skin from producing a printable mark.

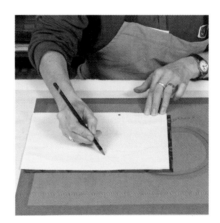

12 Blue hand-copy (not typewriter) carbon is greasy and will produce a printable line. It is placed face down on the plate with a piece of white paper on which to draw. Using a ballpoint or hard pencil, this will produce a crisp, fine line when printed.

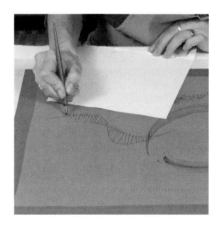

13 Water-based liquid litho drawing ink can be purchased in a small bottle or can. It may be used with a dip pen to give a sharp, fine line, or a brush to create a wash.

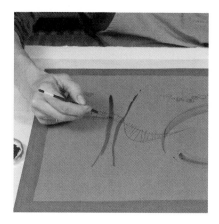

14 The litho ink can be reduced with distilled water, to produce a more delicate tone, or tap water, which will create an irregular mark.

15 Gum acts as a resist to grease, and it protects the plate when pure grease is laid over the top. Therefore, if pure gum arabic is painted or dropped in spots on the plate, left to dry, and grease painted or rubbed over it, the gum areas will print white when the plate is processed. Water-based drawing ink is not suitable to paint over a gum resist as gum is solvent in water, and will therefore not repel the ink. It is necessary to use asphaltum or litho crayon.

16 Asphaltum is solid grease and will therefore create a deep, rich tone. If the consistency is too thick it can be reduced with mineral spirit, which is also a greasy substance.

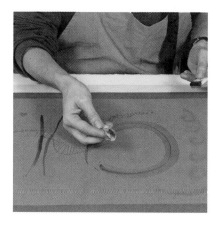

17 Stick tusche is purchased as a tablet that can be diluted in mineral spirit or water. A rubbing stick is similar but can be used to create a very soft mark, similar to charcoal, by making a pad of cheesecloth. This is rubbed first on the stick and then on the plate.

18 A puddle of water is laid on the surface of the plate, then either water-based drawing ink or asphaltum, mixed with mineral spirit, is dropped into the water.

19 As the water evaporates, leaving the pigment to settle onto the grain, the grease and water repel each other and create a random, organic mark.

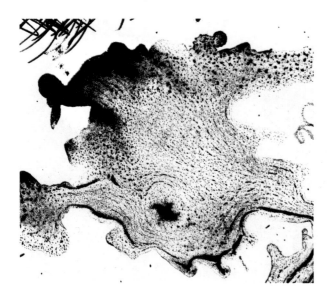

20 Where there is more grease the print will be darker; where there is more water the print will be lighter. The direction of the grease can be guided by gently blowing into the water as it dries. It will be trapped at the edge and produce a dark, irregular line.

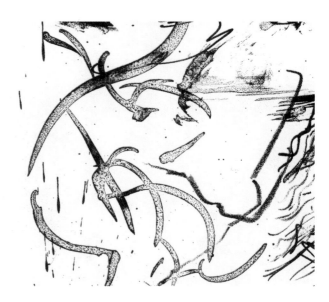

21 Small strips of water can be painted on with a brush, and grease added.

22 Splatter marks can be produced by flicking asphaltum or drawing ink from a toothbrush.

23 Grease can be dropped across the plate before or after other marks have been made. When the drawing of the plate is completed, it is necessary to process the image before printing. The drawing medium is removed and replaced by printing ink.

Zinc plate lithography: Troubleshooting

Problem: Image fills in with loss of contrast when printing

Cause	Solution
1. The inking-up roller is being used with too much pressure.	**1.** Hold the weight of the roller off the plate, just skimming the surface, rolling very lightly and quickly using a wrist action.
2. The roller has too much ink on it.	**2.** When the ink on the slab has an "orange peel" appearance, and it makes a squelching sound when rolled, then the excess needs removing from both surfaces with a palette knife.
3. The plate has begun to dry while ink is being applied.	**3.** The plate should never be rolled up after the surface has begun to dry out. Re-damp frequently as a dry nonimage area will accept ink.

Problem: Image too pale or fragmented

Cause	Solution
1. Too much water when damping the plate, the roller will slide on the surface preventing the ink from adhering to the image.	**1.** Keep the film of water to a minimum. Never allow drops of water to remain on the surface when rolling.
2. Too little ink on the slab.	**2.** Add fresh ink to the slab in small quantities, at frequent intervals, rolling it out into a thin film.
3. Direct press: Lack of pressure. Offset press: Paper is too thin.	**3.** Direct press: Screw down the press or add packing. Offset press: Put an extra sheet of paper underneath the printing paper.

Problem: Patchy image

Cause	Solution
1. Bent or pitted plate.	**1.** Pack the nonprinting areas with paper under the plate.
2. Direct press: Damaged scraper or tympan. Offset press: Damaged blanket.	**2.** Direct press: Replace scraper or tympan. Offset press: Replace blanket.

It is possible to print a litho plate on an intaglio etching press with the use of a rubber blanket in place of the felt blankets.

lithography in practice

3.11.3

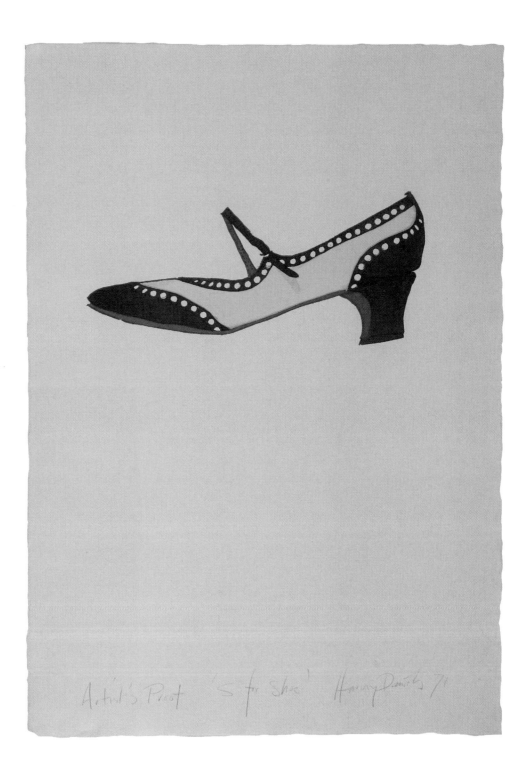

Harvey Daniels
(British)
S for Shoe
30½ x 22in (80 x 56cm)
Zinc plate lithograph—the image was
printed in part with white ink with a lot
of oil to make it change color to become
yellow or cream; oil-based inks
Edition of 10 printed by the artist on a
Mainlander offset lithography press at
Brighton Art College, UK

Manuel Lau
Peruvian–Chinese–Canadian

3.11.4

profile: **Manuel Lau**

"I first enjoyed art at around the age of 16,
when I had just produced and sent in a couple of watercolors
for The World Schoolchildren's Art Exhibition in Taipei, Taiwan, in 1983.
I was delighted when I learnt that I had been awarded a prize for my work on paper.

"In 1999 I got my first artist-in-residence position at St Michael's Print Workshop in Newfoundland, Canada. It was a nice experience visiting other colleagues in printmaking and working in a different environment. I attended the National Fine Art School in Lima, Peru, for two years, where I received only a very basic knowledge of printmaking, therefore I consider myself to be a self-taught artist.

"I started truly honing my skills in printmaking, particularly lithography, in 1994, at the Malaspina Printmakers Studio in Vancouver, Canada. It was there that I had the opportunity to work side by side with local and international artists. I learnt a lot just by watching others work, and by experimenting constantly. I would like to work with a master printer at some point, but thus far I have produced and printed all my works on my own.

"My multiple cultural heritage of Peruvian, Chinese, and Canadian origins does greatly influence my work, and the city of Montreal where I now live and work also is a very positive influence on my production. I admire the work of Paul Wunderlich from Germany, and Graham Sutherland from England. They were both prolific in lithography. I studied their work with great care, and incorporated techniques and compositions that they employed within my own work.

"I consider that printmaking is an important part of my life; without art, my life would not be the same."

**Manuel Lau
(Peruvian–Chinese–Canadian)**
Gatos and Tortugas
**20 x 24in (50.8 x 60.5cm)
Lithograph; Handschy Lithographic
B15 series ink; Somerset Soft White
paper
Printed by the artist at Atelier
Circulaire, Montreal, Canada**

Manuel Lau
(Peruvian–Chinese–Canadian)
L'enfant et Chien Blanc
16 x 16in (42 x 42cm)
Lithograph; Handschy Lithographic
B15 series inks; Somerset
Soft White paper
Edition of 9 printed by the artist on
a Charles Brand lithograph press at
Atelier Circulaire, Montreal, Canada

chapter 12 **polyester plate lithography**

J. Catherine Bebout
(American)
Big Fish Eat Little Fish, 2007
16 x 21in (42cm x 53.3cm)
Photo-polymer etching, polyester litho, and Chine collé;
Charbonnel inks; Pescia paper
Edition of 10 printed by the artist on an American French tool
press at Anchor Graphics, Chicago

a brief history of polyester lithography

Polyester plates apparently originated in India as an inexpensive alternative to stone or metal plate lithography. They have a nonporous, textured surface that will accept both drawn and computer-generated imagery, and the process does not require the plate to undergo the traditional gum etch stage, or have need for the use of resin powder. Neither is it necessary to grain the surface, which removes the need for the chemicals preposal and erazol.

It is the exclusion of these potentially hazardous chemicals that has led polyester lithography to be considered more environmentally friendly than the traditional process. As with stone and metal plates, the drawing material must be water-resistant because the guiding principle still remains, and is reliant on, the fact that grease and water do not mix.

With the ever-increasing in-house use of computers, scanners, and digital imagery it is obvious that in all printing mediums the technology will be developed to incorporate the potential offered. There are various forms of photo-litho surfaces, and the polyester plate is one of the cheapest and easiest to use.

The plates are made solely of polyester. They can be as thin as a piece of paper, are highly durable, and because there is no coating or metal plate involved their shelf life is potentially infinite. In theory, hundreds of copies can be printed off the same plate, and using a mechanical litho press where the touch is extremely light and consistent, this probably is the case. However, where the individual is hand-rolling each proof, the ability to achieve such a light touch takes time and practice; therefore the plate may scum after a number of pulls.

This can be remedied on a laser-printed plate by removing the scum with mineral spirit, redeveloping, damping, and re-rolling. Alternatively, it may be as simple to reprint a new plate as the information should still be on the computer. This method cannot be used with a hand-drawn image as the drawing materials will be removed.

If a precise quality of print is required, this medium is more suited to an individual who has used plate or stone litho and has an understanding of the subtleties and complexities of the medium.

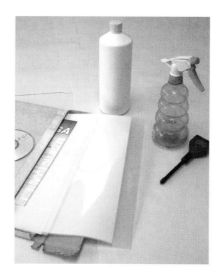

3.12.2

tools and materials: **polyester plate lithography**

Polyester plates can be purchased in boxes of 50 to 100. Similar to the zinc plate, they come with a fine-tooth grain on one side—the side to be used for the image—while they are shiny on the underside. The image can be drawn directly onto the toothed surface with any greasy substance.

Hand-drawn plates

Conventional litho materials can be used, such as litho crayons, chinagraph pencils, and tusche. Ballpoint pens, permanent markers, graphic pencils, and Indian ink also produce a printed mark. The artist is advised to experiment before committing one medium to a piece of work as different makes of products create differing results. Water-soluble materials are not suitable as they will wash off in the printing process. The grease substance must be pushed well into the grain and not be allowed to just sit on the surface.

Computer-generated imagery

Images can be produced on the computer either by using photographs or scanning in drawings that are then printed out directly

onto the polyester plate. It is essential to use a laser printer, as inkjet prints will not remain stable when water is used to print. If the image is to be printed in several colors it is possible to make color separations on the computer and print out a new plate for each color. These will then be in exact registration. Some photographs require a bitmap dot structure, but this is not essential.

3.12.3

step by step: **polyester plate lithography**

1. After the image has been prepared, the bed of the press is wiped over with a light film of diluted gum arabic. An offset or a direct litho press are most convenient, but it is also possible to print on an intaglio press, or by hand.

2. The plate is placed down, image side up.

3. The developer, a milky-white substance that can be purchased with the plates, is wiped over the entire surface. This action smoothes the plate flat and encourages it to adhere to the press bed.

4. Water containing fountain solution, to a pH value of 5, is used to spray the plate lightly when dampening the surface.

5. The water is distributed with a clean sponge and the ink is rolled up. As with conventional litho, a minimum of water is required, and a very light touch with the roller. The ink from the roller will attach to the greasy areas and be repelled by the damp background areas.

6. The printing is continued in the usual way, using dry paper.

**Ann d'Arcy Hughes
(British)**
Person, Cat, and Friends
**11 x 11in (28 x 28cm)
4-plate polyester lithographic print;
lithographic oil-based ink;
Fabriano paper
Printed by the artist on a Globe offset
litho press at Brighton Independent
Printmaking, UK**

**Ann d'Arcy Hughes
(British)**
Greetings card
**4 x 4in (10 x 10cm)
Inkjet giclée; Epson archival ink;
thin cream card
Printed by the artist on an Epson
printer at her home studio**

**The image is printed on both sides,
with accurate positioning of the
image being essential in order for
the components to interchange
as required. This will alter the
appearance of the angel
innumerable times.**

polyester plate lithography in practice

3.12.4

J. Catherine Bebout
(American)
Prophesy, 2005
8½ x 12in (21 x 30cm)
Etching, polymer litho, collagraph,
and Chine collé; Pescia paper
Edition of 1 printed by the artist

Richard Denne
(British)
Squaring the Circle
12½ x 12½in (31.5 x 31.5cm)
Polyester plate lithograph;
Charbonnel copper press inks;
Zerkall mold-made German Etch
White 350gsm paper
Edition of 25 (1 of 21 prints in a

portfolio box set) printed by the artist
on an offset litho press at Brighton
Independent Printmaking, UK

The image was made on an Apple
PowerBook using Adobe Illustrator
and then transferred to a polyester
plate via a laser printer. It was printed
by hand using an offset litho press.

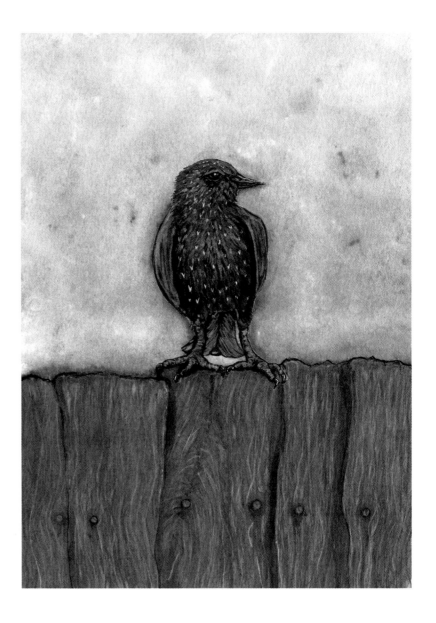

3.12.5
process: **giclée prints**

Since the invention and development of the computer, it has become a positive addition to the tools and armory of the printmaker. This new technology is an excellent complement to printmaking methods in general, presenting exciting possibilities not only in the design of an image, but also in the further development of the processes within each printmaking area. The stage has been reached where the computer is now not only a design tool, but also provides a means of printing, therefore bypassing the conventional printmaking methods, albeit producing a result of a substantially different character.

In the 1990s, a printmaker working in the new field of inkjet technology, Jack Duganne, coined the term "giclée" to describe prints printed from a digital source using inkjet printers. Derived from the French word *gicler*, which literally means "to squirt," the word "giclée" has become synonymous with high-quality inkjet prints that are created using top-quality pigmented lightfast inks on archival paper.

There is a world of difference in both quality and permanence between a giclée print and a printout from an ordinary desktop inkjet printer. Artists consider it a matter of professional honor to only produce giclée of the highest quality for sale. Sometimes artists add the words "fine art" before "giclée" to make the high level of quality clear.

Ten years of practical experience working with digital technology and three specialist courses on the subject mean that I produce limited-edition prints of my work that sell well and stand up as pieces of fine art in their own right. Buyers often comment that it's hard to believe they are looking at a print and not the original. I invest a great deal of time and expertise in configuring each image to ensure it looks good.

I maintain complete control of the entire process of print production, from initial scanning through digital adjustment and configuration to the final printing. If I am producing a large-format print I adjust the contrast,

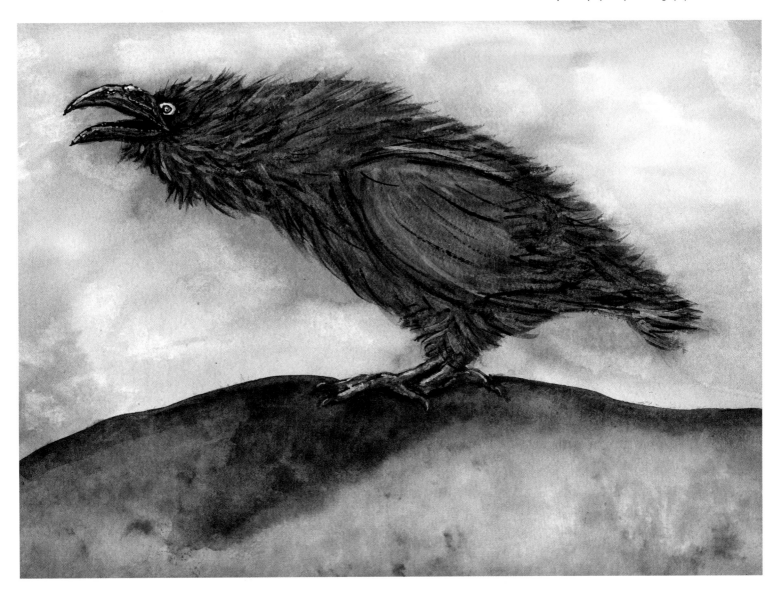

dpi, sharpness, and even tweak the colors differently than when producing the same image at A4 size (8¼ x 11¾in/210 x 297mm).

There are some artists who may still be under the impression that giclée prints are just "churned out," but there is no comparison between a professionally prepared giclée and a standard computer printout, just as there is no comparison between a professionally produced photograph and a quick snapshot.

**Troy Ohlson
(British)**
Lord of the Fence (above left); *Indigo Crow* (above)
Fine-art giclée scanned from the artist's original painting; pigmented lightfast Epson ink; archival inkjet paper
Edition of 100 printed by the artist on a specialist inkjet printer at his studio

chapter 13 **printing the lithographic image**

Heike Roesel
(German)
Spaced
16 x 20in (42 x 50.8cm)
Zinc plate lithograph; rubber-based
litho ink; handmade paper
Printed by the artist on a
Globe offset press at Brighton
Independent Printmaking, UK

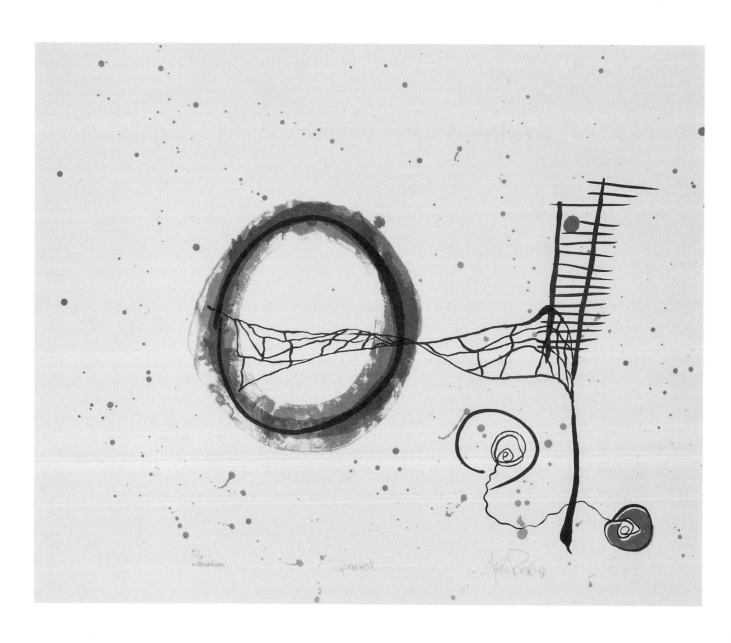

an overview of zinc plate lithographic printing

Lithography is a complex process that can be influenced by many variables such as the age of the plate, the chemicals used, the temperature and humidity of the workshop environment, the consistency of the inks, and the nature of the press.

The colored lithographic image involves the layering of colors using any number of plates. As a rule, color separations begin with the printing of the lightest color first, culminating with the darkest color or line template. There are, of course, exceptions to this, as each artist develops his or her own way of working within the boundaries of the medium.

At each color stage, the edition has to be fully printed as the technique involves the overprinting of each layer using separate plates. This allows the artist the opportunity to maximize color work within the practice of overprinting. When the run is completed, the plate is erased and re-prepped ready for the next image.

Safety note

This process requires the use of dangerous solutions. Every care should be taken to protect the user by working in a well-ventilated room with the appropriate apparatus, in addition to wearing protective clothing, such as a mask, rubber gloves, goggles, and an apron.

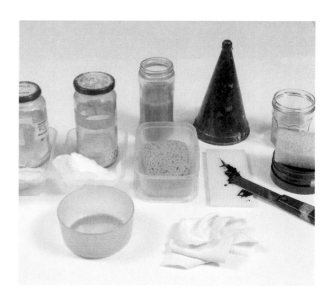

After a plate has been drawn up, and the washes are completely dry, it is necessary to process the image before printing can commence. The drawn marks are removed and replaced by printing ink. The principles behind the litho process remain the same, but there are variables within the working practice of each artist. There is no absolute right or wrong way providing the outcome is successful. Materials used in the processing of a zinc litho plate include resin powder, French chalk, gum etch (atzol), mineral spirit, printing ink, and gum arabic.

3.13.2

step by step: **processing a zinc litho plate**

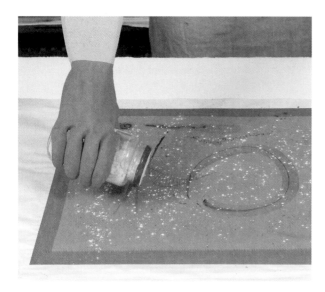

1 Resin powder is shaken onto the drawn image. It will adhere to the grease and, because the powder is acid-resistant, will protect the drawing at a later stage.

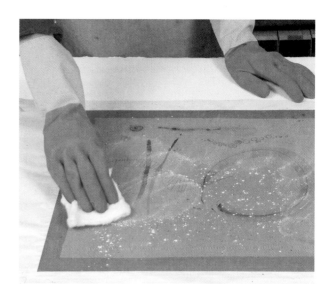

2 An absorbent cotton pad is used to pat the resin over the drawn areas. Any residue is removed by standing the plate on end and tapping it onto the work surface.

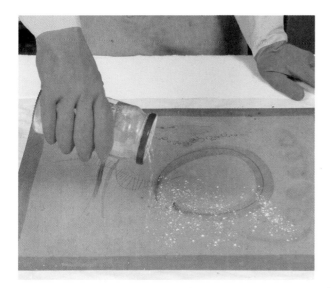

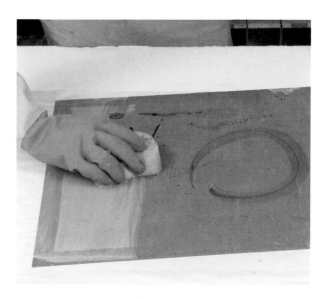

3 French chalk is sprinkled over the drawn image. It is also distributed with a cotton pad and the residue removed. The chalk will give a second coat of powder to the image, thereby preventing it from smudging during the next stage of the process.

4 Using a clean sponge, a solution of 50:50 pure gum and gum etch (atzol) is spread over the entire surface of the plate. The gum will adhere to the background nonprinting areas and be repelled by the greasy printing marks.

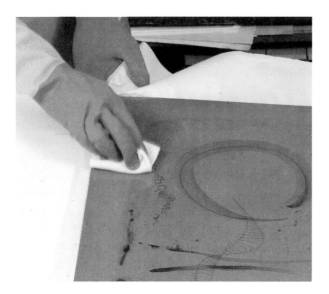

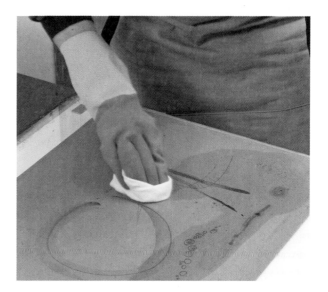

5 Using a circular motion, the gum etch is rubbed down with a clean, dry rag. If the gum is too thick or streaky it will affect the final image. The plate is now left for a minimum of 20 minutes (preferably longer) to allow the etch in the gum to clear the negative or background areas. If the gum etch is not allowed to remain on the plate for sufficient time "scumming" will occur at the printing stage.

6 Mineral spirit is put onto a clean rag and gently rubbed into the image. The purpose is to dissolve the greasy marks and remove the drawing medium completely. Some materials leave a stain; for example, blue carbon can only be fully removed with cellulose thinners. If the gum layer is too thick, it will not be possible to wash out the image and subsequently buff in the printing ink. When the plate is successfully washed out it should be difficult to see the image.

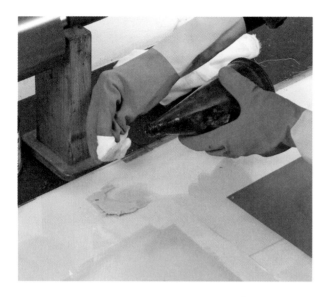

7 The printing ink is prepared and rolled onto a roller of suitable size. A small quantity of the ink is put to one side and mixed with mineral spirit to loosen the consistency.

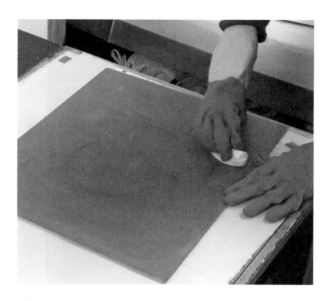

8 Using a rag the ink is buffed through the holes left in the gum when the drawing medium was removed. The excess ink remains on the surface of the gum.

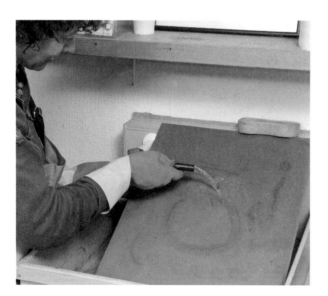

9 The plate is placed in a sink and washed with water. Gum is soluble in water and therefore is removed, taking with it the excess ink but leaving the ink in the image areas.

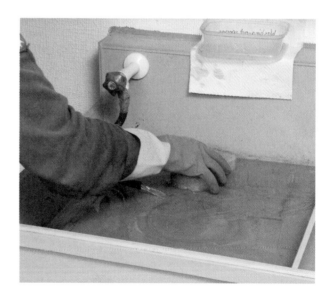

10 The plate is smoothed over with a clean sponge to remove any unwanted ink.

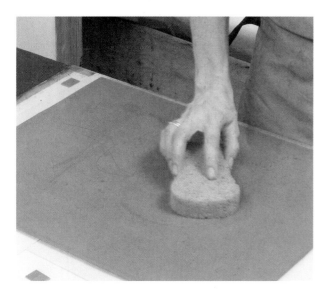

11 The plate is placed on a flat surface and dampened again with a clean sponge. The water used contains a small quantity of gum.

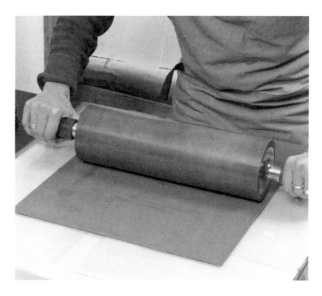

12 While the plate is damp, the ink-charged roller is passed several times over the surface. The damp background areas repel the ink, and the greasy image areas accept the ink. If the plate begins to dry the ink will attach to the background areas; therefore, the surface is regularly wiped with the sponge.

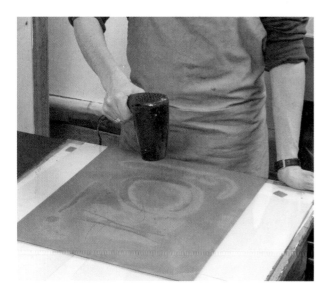

13 When the image has sufficient ink, the water is dried from the surface with warm air.

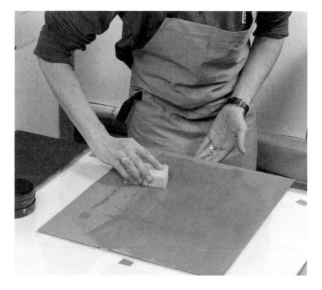

14 A second layer of gum is applied, but this time it is pure gum arabic without any etch. This must remain on the plate for at least 10 minutes. The properties in the gum help to retain the water on the background areas, which subsequently repels the printing ink when rolling up. Using a rag, the gum is rubbed down to a thin film as before.

lithography in practice

3.13.3

**Frances St Clair Miller
(British)**
Agina; Alexia; Caprinus; Melina
**Each image 12 x 8½in (30 x 22cm)
Lithography
Edition of 275 printed by the Curwen
Press, UK**
*(Reproduced by kind permission of
Shell International Ltd)*

These images are taken from a series
of six lithographic prints of shells
commissioned by Shell Oil UK in 1980.
Each of the tanker ships owned by
Shell Oil was named after a particular
type of shell, and the prints were
a part of the promotion for these
new ships. The printing restrictions
allowed just three colors for each
print. The images were printed in
pairs, therefore the colors had to be
the same in each pair.

Harvey Daniels
(British)
Smart Shoe
30 x 22in (75 x 56cm)
Zinc plate lithography; oil-based inks;
handmade paper
Printed by the artist on a Mainlander
offset lithography press at Brighton
Art College, UK

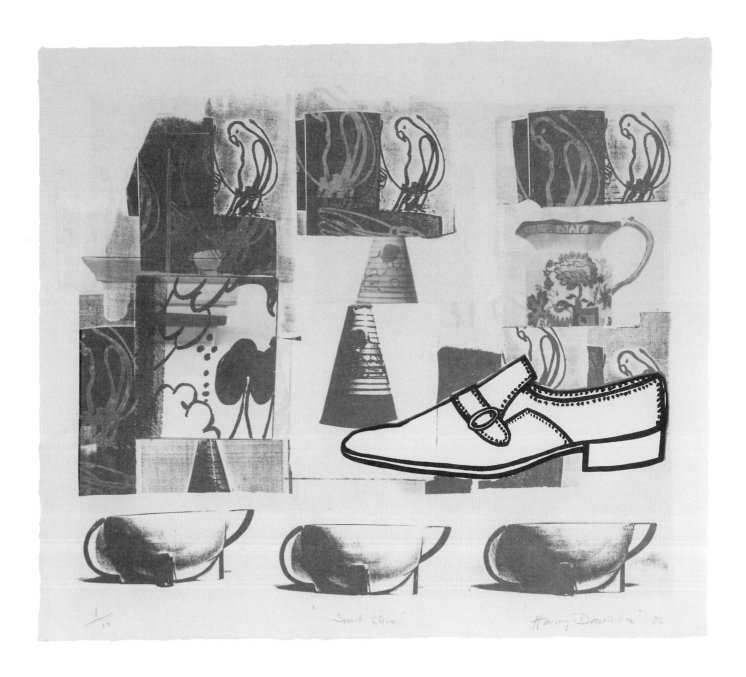

Harvey Daniels
(British)
Gentleman's Still Life
31 x 22¼ in (79 x 56.5cm)
Zinc plate lithography; oil-based inks;
Saunders Smooth White handmade
paper
Edition of 24 printed by the artist on a
Mainlander offset lithography press at
Brighton Art College, UK

"This was the nearest that I could get to
traditional still-life images in the 1960s.
This image is in various collections,
including Pop Art in Germany."

3/5 Rainbow House Hebe Vernon-Morris

Hebe Vernon-Morris
(British)
Rainbow House
15 x 13in (38 x 33cm)
4-color zinc plate lithography;
Fabriano paper
Edition of 5 printed by the artist on a
Globe offset press at the University
of Brighton, UK

Star wheel lithographic press, Cowfold Print Workshop, UK

Andrew Purches
British

3.13.4

profile: **Andrew Purches**

"The person who persuaded me to become an artist was the lithographer and muralist Hans Feibush. When I was nine years old I watched him painting a fresco in Chichester Cathedral. It was wonderful; watching him work really inspired me. There are two frescoes by him in the cathedral, one in the Bishop's Palace and others in the Chichester diocese.

"While I was at Ardingly School, I had a great art teacher called Ernest Constable. He was very enthusiastic, a good painter, and a very dedicated teacher. He was a former student of Cedric Morris and Lett Haines, who ran the East Anglia School of Art in Hadleigh; Maggie Hambling also studied there much later on.

"I continued onto Winchester Art School for my NDD. The philosophy was that if one took Art one had to learn a craft, too. I chose printmaking, with a special interest in lithography. There was a good printmaking department run by Jim Heward. He was an interesting man. He attended the Carlisle School of Art and then during his national service he was trained by the army as a cartographic lithographer. When he left he went on to the Royal College of Art where he graduated in printmaking.

"My first job in art was printing silkscreen displays for Harveys of Bristol. I was in that job nearly two years, but after getting married I realized I was going to need a proper job. I answered an advert in the *Daily Telegraph* for a trainee print buyer and visualizer in the marketing and advertising department at Rothmans cigarettes. I got the job and I was trained to place print orders, to liaise with the commercial printers, and to visualize. This involved my sitting in on marketing meetings, listening to what had been talked about, and then, using magic markers, visualizing and sketching the image that had been verbally developed. I then took my sketch to the Finished Art department.

"Through this job I got to know Les White, who was the sales director at Curwen Press. When Curwen merged with Harley Print there was a wish to continue with the printing of fine-art lithographs, so I moved from Rothmans and took the job liaising with the artists who found their way to the newly established Curwen studio. I could not become one of the lithographic printers as I was not part of a union, and the industry was very strictly unionized at the time. Curwen had three different unions represented on the workshop floor as the proofer, flat-bed operator, and apprentice all belonged to different groups. Stanley Jones worked there at the time, splitting the week between Curwen and his duties as a lecturer at the Slade College of Art just across the road. Having spent time bemoaning the fact that I wanted to be a printer, I eventually bought a press and became a lithographer.

**Star wheel wooden etching press,
Cowfold Print Workshop, UK**

**Albion relief press, Cowfold Print
Workshop, UK**

"For the sake of interest it is worth discussing the various titles applied
to my profession. 'Master printer,' although used now to denote a person
who prints the work of the artists, was historically reserved to identify
somebody who was a trainer of apprentices. A 'lithographic artist' was
somebody who transferred the artist's image onto the stone or plate. I
call myself a 'master lithographer' because I cover all aspects of the job.
I receive the image, plan the color separations, transfer the image onto a
number of stones or plates, proof the image, return it to the artist who
makes any adjustments they require, make the changes, and finally, print
the edition. I have printed 28 lithographs for Arthur Boyd, who supplied
me with his image as a painting. It was a complicated process to create the
color separations, but I enjoyed the challenge.

"In the last 20 years I have also spent a good deal of time traveling around
Europe and Britain moving and rebuilding all types of printing presses.
I am one of the few people to regrain lithographic plates and have
established an Open Access workshop at Cowfold."

(Further details can be found in the workshop listings.)

The principle of the offset litho process is that the blanket on the roller of the press is able to offset the reversed image, and thereby transfer it to the paper the correct way round. The plate is attached to the left-hand bed, and the paper to the right-hand bed. The roller passes over the image; the drawing is the wrong way round on the roller but reverts to being the right way round when offset onto the paper.

When the plate has been processed it can be clamped into the press by the metal bar provided on the long left-hand side, or stuck to the bed with double-sided tape.

3.13.5

step by step:
printing the zinc litho plate

1 A bucket of water is prepared that also contains a small quantity of gum. This is required for the frequent dampening of the plate. Initially the sponge is wiped over the entire plate to distribute the gum. It is also essential to keep the surface damp, but not wet, to prepare for the inked roller. If the plate is too wet, the roller will slip; if it is too dry, the background will attract unwanted ink. When the paper is clipped into the press, each piece should be positioned in exactly the same place as this will help when registering subsequent colors.

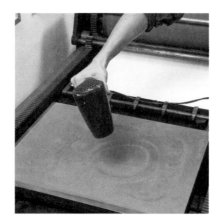

2 When the image has accepted sufficient ink the water is dried from the surface.

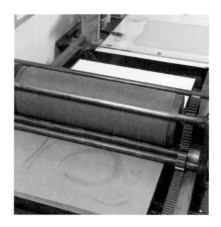

3 Initially the roller is passed over the plate while it is in a raised position, preventing either surface from coming into contact with the other.

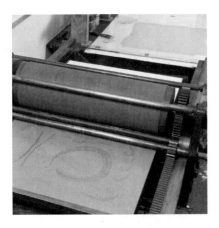

4 When the roller reaches the far end of the press it will automatically drop to the height of the plate. When rolled back it will first collect ink from the image on the plate, which can be clearly seen on the blanket.

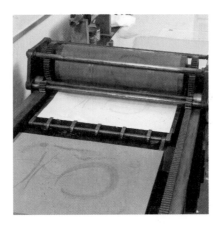

5 The roller will then put the ink down on the paper. When the roller returns to the original position it will automatically be raised in preparation for the next roll-up.

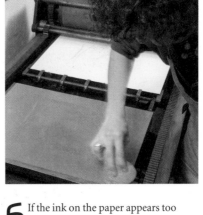

6 If the ink on the paper appears too pale, the plate can be damped again and re-inked. It is essential that the plate is damped each time before rolling or the image will scum. If a plate is accidentally rolled while it is dry the ink will attach to the nonprinting areas. It is then necessary to go over the surface with a damp sponge and roll up again, but this time with a light, snappy movement that will build up static and attract the ink back onto the roller. Unwanted ink must never be rubbed with a rag; this will just push it deeper into the grain. Neither must it be removed with mineral spirit, as this will introduce grease that will become part of the image.

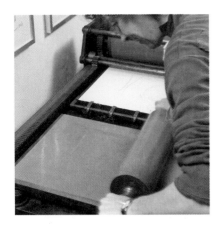

7 After the plate has been recharged with ink, providing the paper remains in the same position, it is possible to pass the press roller over again until the desired clarity of mark is achieved.

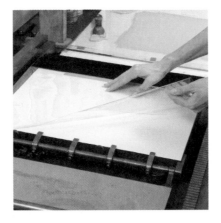

8 If registration is required to enable one color to be positioned correctly in relationship to another, an acetate sheet can be attached with tape to the right-hand side of the press and folded back when not in use. Alternatively, the sheet can be placed under the paperclips of the press, accurately fitting to the side of the bed and up to one corner. This sheet can be removed when not in use as it is simple to replace in the correct position each time, when required.

9 The plate is inked up and printed in the normal way, but this time the ink is put down on the acetate sheet.

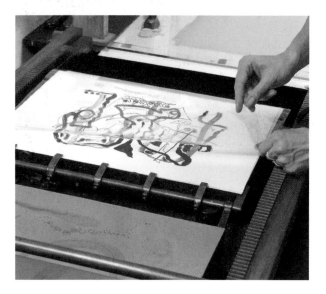

10 The print, showing the first color, is placed under the printed acetate sheet to assess the correct position of the second color. If the positioning of the paper does not allow for the use of the press clips to hold it in position, the paper can be attached to the bed of the press with masking tape. This can be removed from the print without harming the surface.

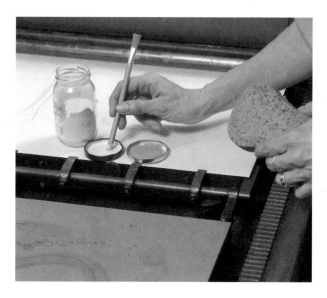

11 If there are small printing areas to be removed this is possible using an eraser, pumice powder, and gum etch or erazol. The rubber is dipped into the gum etch and then the pumice.

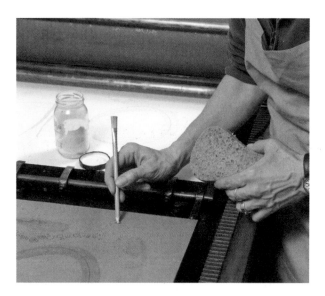

12 The eraser is gently eased over the area to be removed, until the surface is clean. Pressure should not be exerted as this will spoil the grain and make the plate unsuitable for future use.

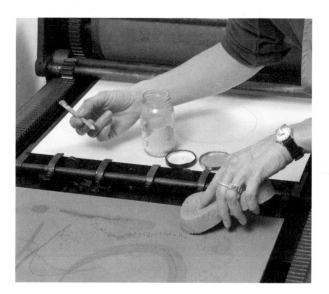

13 The residue of pumice is removed with a damp sponge and printing can continue. Alternatively, it is possible to prevent areas from printing by blocking the transfer of ink. By using small pieces of tissue paper placed over the unwanted areas, the ink is prevented from transferring to the blanket on the roller of the press.

Additions

Drawn areas can be added to a plate that has already been processed:

1. A solution of 1 part prep to 10 parts water is mixed.
2. The solution is dabbed onto the area to be redrawn, and washed off after 1 minute.
3. The new drawing is made.
4. The whole plate is then processed as a new image.

Although this procedure is successful, because of the labor involved it might be more convenient to print the work already prepared. You can then draw up a plate with the new marks and register those to the image already printed.

Preserving the image

When printing for the day is completed but the image is required at a later date:

1. Evenly distribute gum over the surface of the plate.
2. Rub the gum down to a thin layer, and dry.
3. Thoroughly wash out the printing ink with mineral spirit.
4. Wrap in a clean sheet of paper and store in a dry place.

When printing begins again:

1. Buff in the mix of ink and mineral spirit as before.
2. Wash the gum off with water.
3. Keeping the plate damp, roll up in ink, and continue printing.

Changing color

The procedure is the same as above:

1. Gum up over the inked image.
2. Wash out with mineral spirit.
3. Buff in the new color mixed with a little mineral spirit.
4. Wash off the gum with water.
5. Keep the plate damp and roll up in ink.
6. Continue printing in the new color.

Removing the image

When the image is not required for further printing:

1. Remove the printing ink with mineral spirit.
2. Wash the plate with water and a touch of dish detergent or degreasing agent.
3. Place the plate in a designated sink.
4. Pour on a small quantity of erazol.
5. Work the solution gently over the surface of the plate using a brush or an old squeegee blade.
6. After 4 minutes leave the plate to rest for a further 6 minutes, with the erazol completely covering the surface.
7. After the 10 minutes have elapsed wash the plate with water.
8. Repeat steps 4 to 7.

The grease has now been removed, but a shadow of the previous image may remain. If a second color is to be printed it is sometimes useful to have the shadow of the previous drawing to use as a guide to the marks for the next plate.

Prepping the plate

Before new work can begin the plate needs to be prepped, as shown on pp. 292–295, otherwise the surface will not be receptive to the grease in the drawing.

The grain

If the grain is treated with care, not scrubbed too heavily during processing, then the plate can be used for approximately five times before it will need to go back to be regrained.

Safety note

This process requires the use of dangerous solutions. Every care should be taken to protect the user by working in a well-ventilated room with the appropriate apparatus, in addition to wearing protective clothing, such as rubber gloves, goggles, and an apron.

The size restriction for imagery depends on the measurement of the bed of the press available for use.

Tim Mara
(British)
Power Cuts Imminent
30¾ x 38½in (78 x 98cm)
Edition of 30 printed by the artist.

This print involved 72 separate printings. The first colors were built up using complicated handcut stencils, while the final layer drops in the shadow detail with a single composite photographic stencil. Cellulose filler was used during the printing of this final stencil to isolate specific areas and allow them to be printed in separate colors. These prints are made in relatively small editions and often take months to complete.

screenprinting

introduction to screenprinting

Chambers dictionary defines screenprinting as "a stencil process in which the color applied is forced through silk or other fine-mesh cloth." Screenprinting is a stencil-making process that has its roots in the production of wall decoration, ceramics, and fabrics by the ancient cultures of the Egyptians, Chinese, and Japanese. It was not until the 1850s, however, that the Japanese developed stencils that were held together, first by human hair and then by silk, to allow the possibility of screenprinting as we know it.

The first patent on the process was taken out in Michigan in 1887, and rapid improvements occurred through the early half of the twentieth century. Silk gave way to much harder-wearing polyester meshes; indirect cut stencils and then indirect photostencils opened the door to more sophisticated imagery; and ink technology replaced paint. Screenprinting became one of the main commercial print processes used in textiles, packaging, and advertising.

It was not until the early 1960s that screenprinting's potential for expression as a fine-art medium was unlocked. Eduardo Paolozzi (1924–2005) has been given credit for this through his collaborations with the master printer Chris Prater at Kelpra Studio, London, as early as 1961. In New York in April 1962, Andy Warhol (1928–1987) used silkscreen for the first time in one of his largest money paintings, *200 One-dollar Bills*. In April 1964, Paolozzi and Kelpra embarked on a suite of 12 prints titled *As is When* (loosely based on texts by Austrian philosopher Ludwig Wittgenstein), which were published in 1965. At the same time, R. B. Kitaj and Joe Tilson were publishing screenprints through the Marlborough New London Gallery. It was clear that this new medium for artists had taken off and it was the beginning of an explosion of creative collaboration. Artists including the aforementioned Kitaj (b. 1932), Paolozzi, and Tilson (b. 1928), as well as Peter Phillips (b. 1939), Colin Self (b. 1941), and Derek Boshier (b. 1937) embraced the medium's potential to represent imagery from popular culture and challenge preconceptions about what could be seen as fine art. In addition, through the symbiotic relationship they enjoyed with their printers, these artists opened up a highly contentious debate on originality.

At the same time, artists of the Optical Art (or Op Art) movement realized that screenprinting was an ideal process for exploring ideas and publishing images as multiples at a relatively low cost. Bridget Riley (b. 1931) and Victor Vasarely (1908–1997) were strong exponents of this movement, capitalizing on the juxtaposition of strong, often complementary, flat or blended colors that screenprinting afforded. The medium became the means through which a generation of artists appropriated the language of a commercial print process for a fine art end.

The next major development came in the early 1980s, with the emergence of water-based inks. As universities and art colleges found it almost

impossible to comply with increasingly stringent health and safety regulations, water-based inks looked like the only way to save screenprint workshops from closure.

To begin with, water-based systems were seen as a second-rate alternative, but printmakers prepared to abandon long-held working practices discovered that this was not a poor version of the oil-based standard but almost a new medium. The facility with which fine detail could be printed and the development of photographic emulsions with wider exposure latitudes expanded the potential of the marks that could be printed. Screenprinting encroached on the territory of lithography because of the ease with which drawn and painted marks could be delivered onto a flat surface.

The most recent developments have centered around computer technology cutting out the darkroom process and enabling artists to create a range of screen positives at home. Ideas can be originated on the computer using programs such as Adobe Illustrator, and images can be scanned in and manipulated with Photoshop. Most home printers will deposit toner on Plexiglas sheets and these can be tiled to create larger images. Information can always be exported to print bureaus and output as traditional line film positives for large-format work.

Every new breakthrough has not invalidated the past but expanded the vocabulary of the medium. It is this continual process of change that has made screenprinting such an exciting arena to work within.

chapter 14 **equipment and materials**

Ian Brown
(British)
Screenprint; detail of floral border in
the Royal Pavilion, Brighton, UK

an overview of screenprinting equipment

A professional print workshop will usually be equipped with vacuum print beds using squeegee attachments; 50-tray drying racks; a Graphoscreen or printdown frame to expose photostencils, and a hydroblitz to wash out screen stencils, clean off ink during the print process, and reclaim screens after use.

It is still possible to make good prints on a budget and this section includes handprint frames, ball racks, and hanging exposure lamps combined with vacuum sacs, all of which can be used as a substitute.

Screens and meshes

With the emphasis today on using direct photographic stencils (photosensitive emulsions coated directly onto the mesh replacing photographic and handcut film stencils prepared, then adhered), it makes life simpler to standardize frame sizes. Frames can be wood or aluminum. All frames can slot into a drying cabinet with ease by keeping the outside measurement constant. Two good working sizes have outside measurements of 39 x 44in (99 x 112cm) and 44 x 56in (112 x 142cm).

Meshes are usually polyester and sold by the meter from a roll. To stretch your own screens, allow an extra 4in (10cm) all round to wrap around the stretching bars. Screen meshes come with a number prefixing the letter T printed along the edge of the fabric—for example, 30T, 77T, 90T, 120T. This figure describes the number of threads to a centimeter; 30T is a very coarse screen and 120T is a fine one. A coarse screen is useful for a heavy deposit of color; a fine one is useful for detail. When printing with water-based inks, a coarse screen would be 90T and a fine screen 120T. With oil-based inks, 77T is a standard mesh, whereas 90T will print fine-quality detail. Choose a yellow- or orange-colored fabric to improve definition when exposing photographic stencils.

4.14.2

step by step: **screen stretching**

1 Allow an extra 4in (10cm) of mesh to wrap around the stretching bars.

It is possible to make simple prints using cheesecloth. Cheescloth screens can be stretched in the same way canvases are, starting from the center of each side and working toward the corners, stapling against the side of the frame. Today most screens are either prestretched or stretched using roll bars that slide down to the size of your frame. Make sure the frame is smooth and free of splinters, allow 4in (10cm) each side to wrap around the bars, and stretch the mesh slowly and methodically by ratcheting up the same number of clicks on the bars as you circumnavigate the screen. If you are not confident to stretch by the feel of the tension on the mesh, mark off 19¾in or 39½in (50 or 100cm) in one dimension and then stretch the fabric to its preferred tension—usually 2.5 to 3% (check the manufacturer's recommendations).

Before gluing, place a board slightly smaller than the inside measurement of the frame on the fabric and add weights until the mesh is in direct contact with all of the frame profile. Then apply the adhesive with a piece of card and repeat when dry. It saves ink leakage near the edge of the frame if the adhesive is squeegeed ¼in (6mm) inside the frame edge.

Mark with a permanent marker pen the mesh count on the screen so that coarse, medium, and fine screens can be easily identified.

Traditional wooden frames are being replaced by aluminum ones.

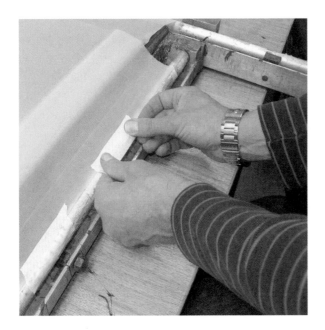

2 After carefully folding back the mesh, tape it to the bar.

3 Tighten the mesh evenly, corner by corner.

4 Weighting a board smaller than the frame size ensures close contact between frame and mesh prior to gluing.

5 Adhesive applied by card should slightly overlap the screen's inner edge.

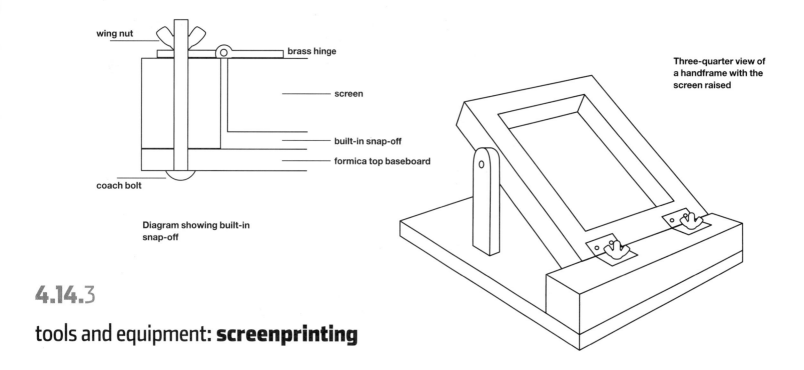

wing nut

brass hinge

screen

built-in snap-off

formica top baseboard

coach bolt

Diagram showing built-in snap-off

Three-quarter view of a handframe with the screen raised

4.14.3

tools and equipment: **screenprinting**

Squeegees

A squeegee is a flexible blade embedded in a wooden handle with which ink is pulled across the screen, forcing the ink through and onto the paper. As with screens, aluminum is tending to replace wood. Fabric-printing squeegees are often rubber, but polyester blades are the norm for printing onto paper, board, canvas, glass, plastic, and metal.

The convention is that blue blades are hard, green are medium, and orange are soft. Blue (hard) blades are best for detail. Most of the time when printing on paper you should use the standard green (medium blade). When printing onto a textured surface such as canvas, switch to a soft (orange) blade. This will flex and push ink into uneven surfaces that would be skimmed over by a standard squeegee.

Assemble a variety of squeegee lengths. The longest should be 4in (10cm) shorter than the width of your biggest screen to allow printing of the maximum area. At the other range of the scale, collect some smaller squeegees down to a width of 3 or 4in (8–10cm)—you will find these surprising useful.

Vacuum beds

A vacuum bed is the ideal piece of equipment for screenprinting. It is usually a flat bed pierced with holes attached to a vacuum pump. When the motor is switched on, air is drawn through the holes and this suction holds the paper in place during printing.

Frames are attached to the bed using a system of sliding bars and clamps. This part of the machine is counterbalanced with weights so that the screen stays down during the printing action, but also can be lifted clear, and stay clear without support, as a print is taken out and unprinted paper replaced against the registration marks.

Another critical factor in all beds is a device at the back and front of the machine to allow the printer to control the "snap-off." This is the height of the screen above the print surface. Unlike fabric printing, where the screen touches the printing surface, when printing on paper the mesh lies above the print surface and is brought down to meet the paper by the squeegee as it forces ink through. The mesh then rises up behind the squeegee and this enables a crisp, unsmudged print to be taken.

When buying a secondhand press, check the vacuum is strong enough to hold paper down and run a straight edge across the bed to check it has no hollows. Any significant hollows will require additional squeegee pressure to make a clean print and this may incur bleeding.

Handprint frames

A handprint frame should incorporate as many of the features as the vacuum bed as possible. Use good-quality brass hinges to minimize "play." Build in "snap-off" at the hinge end (see diagram above) and at the printer's end by taping cardboard scraps or a pencil under the nearside edge of the frame. Use a 2 x 1in (5 x 2.5cm) leg to support the screen while removing and replacing paper and spray the formica with a low-tack adhesive to hold down paper while printing.

Squeegees:
aluminum with green
(medium) and wooden with
orange (soft) blades

A well-used quad crown
vacuum print bed

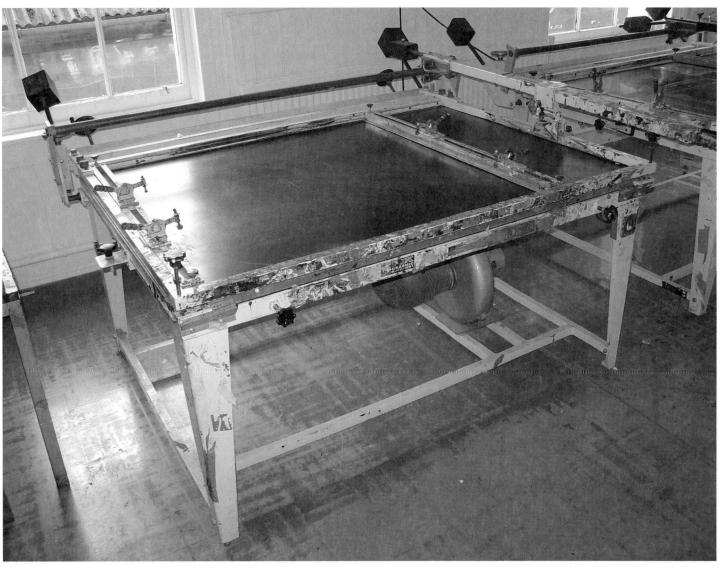

Inks

There are two major ink systems: oil-based inks and water-based inks.

Oil-based inks

This was the universal system until the early 1980s. It had its advantages and disadvantages. The colors are more vibrant, with some excellent metallic finishes and varnish. Because the key problem with this system was the quick-drying ink, mesh counts were more open—77T was a good standard—and ink deposits therefore thicker. This made overprinting and obliterating unwanted color easier, but printing fine detail more difficult. The strong solvents required to clean screens and retard the drying of ink while printing made this a somewhat toxic experience.

Water-based inks

Water-based inks have largely replaced oil-based inks in colleges and schools for reasons of health and safety. The main advantage of this system, apart from being user-friendly (screens are washed with water rather than solvent), is the ease with which fine detail can be printed. Compared with the oil-based system, the activity of printing is much less hurried and emerging problems can be resolved without fear of ink drying swiftly in the mesh. The disadvantages are that finer screens need to be used (and these are more expensive), the water in the inks tends to cockle the paper (so thicker paper stock must be sourced), and the ink does not obliterate previous colors. The latter is the most serious problem, but this can be diminished through pre-planning the order of printing color and stencils. Printing light colors first can reduce unwanted overprint.

Water-based pigment ready to use

Color-swatched oil-based ink cans

Exposure units

As the most flexible and effective way of preparing screen stencils is through the use of light-sensitive coated emulsions, an exposure system is vital. The light source is usually ultraviolet, with bulbs ranging in power from 25 to 3000 watts.

Possibly the cheapest form of exposure unit is a free-hanging bulb, with a ballast and a vacuum sac. The vacuum sac is a large plastic-reinforced bag into which a coated screen can be placed with a positive taped to the paper side (underside) of the screen. When the air is drawn out of the sac by the vacuum pump, a good close contact is made between positive and screen before the exposure is made.

The disadvantages of this system are the risk of punctures in the sac and the difficulty of keeping it clean and free of marks that may show up and expose.

Exposure unit and printdown frame

This is possibly the combination that will give the sharpest and most crisply resolved halftones or fine detail. The printdown frame is a large plate-glass sheet hinged with a rubber back. The positive is placed reading the right way round on the glass with a coated screen on top. Air is sucked out of this device, pressing the positive firmly against the screen.

The frame is rotated to face the lamp and the exposure is made. Because the lamp can be sited some distance from the screen there is little undercutting of the positive and an accurate screen stencil will always be made.

To prevent a hotspot in the center and to ensure an even exposure across the entire screen, the lamp should be placed a minimum of the length of the diagonal of the largest screen to be exposed.

Self-contained exposure unit

This is the most space-efficient and speedy exposure unit, good for busy workshops. It is similar to the printdown frame but is boxed in with the lamp below the glass. Because it is completely lightproof, there is no need to house this in a separate space. As it usually comes with two light sources, a mercury vapor lamp and fluorescent tubes or bulbs, it can also double up as a lightbox for spotting out positives.

The only disadvantage is the loss of very fine detail, which is only noticeable when working with fine halftone screens.

A self-contained exposure unit, often known as a Graphoscreen

A low-wattage ultraviolet bulb

Printdown frame and lamp in use

Washout unit with hydroblitz

Water washout unit

A water washout unit is needed for three purposes: to clean ink off screens in between printing colors; to wash off stencils and reclaim screens after printing; and to carefully wash out photostencils. One unit can manage all three purposes, although if space permits a separate stencil washout booth, backlit to examine the washing out of photostencils, is ideal.

Although stencil washout and ink removal can be managed using ordinary water pressure, a hydroblitz (a power washer/ pressure washer available from hardware stores that pumps water through a hose under pressure) is essential to remove photostencils and stubborn ink residues. Never start the hydroblitz directly pointed at your screen as this can put a hole in it.

Racks

A rack of some sort is vital to dry prints. The simplest are ball racks. These are wooden planks with shapes cut out to hold a glass marble held in place by a wire assembly. They usually come with 25 marbles. It is a good idea to suspend two of these in parallel, a little closer together than the width of the print stock.

After printing, each sheet is pushed up against two marbles. The weight of the paper holds the marbles in place and as a result the sheet dries hanging vertically.

This is the cheapest form of rack. The downside is that in a draft prints may blow together and consequently stick and smudge.

Also, when printing many colors on large paper there is a tendency to accumulate small marks or dents from the marbles. The standard racks are wire trays (usually 50) held to a vertical back support with springs allowing the printer to lift some or all of the trays to put in and take out paper—in much the same way as the vacuum bed operates (see p. 316).

Some drying rack designs incorporate an L-shaped section at the back that allows prints to catch and stay secure when the trays are lifted. If this is not the case, then it is a good idea to weave string from the bottom to the top of the racks (at the back) in a zigzag fashion to prevent paper slipping out.

**Ball racks are the cheapest
system for drying prints**

**A closeup showing the marble
and wire assembly**

Racks come in quite a large range of sizes, from 18 x 24 in (46 x 60.5cm), through to 32 x 48in (81 x 122 cm), 33 x 43in (84 x 109cm) and 35 x 50in (89 x 127cm).

Screen drying racks

In a workshop using screens coated with light-sensitive emulsion it simplifies matters if you keep screens to a standard size. Make a box to take horizontally stacked screens, utilizing 2 x 1in (5 x 2.5cm) runners to allow coated screens to be slid paper side (underside) down in front of fans blowing cold air. Hot air will dry screens faster but tend to bake the emulsion on, making it more difficult to remove after printing. This cabinet either needs to be made light-safe or be placed in a yellow or red safelight environment.

Try to avoid drying emulsion-coated screens in the same closed room with clean but wet screens, as the moisture will prevent the emulsion screens from drying properly. In the studio it is useful to have a similar drying rack to vertically stack wet screens, again with cold air fanned across them. This allows the screens to dry and be reused within 15 minutes. It is also a much safer way to dry screens than to prop them up around portable fans.

Standard 30 x 40in (75 x 101cm) racks

Screens coated with light-sensitive emulsion drying under red safelight conditions

chapter 15 **stencils**

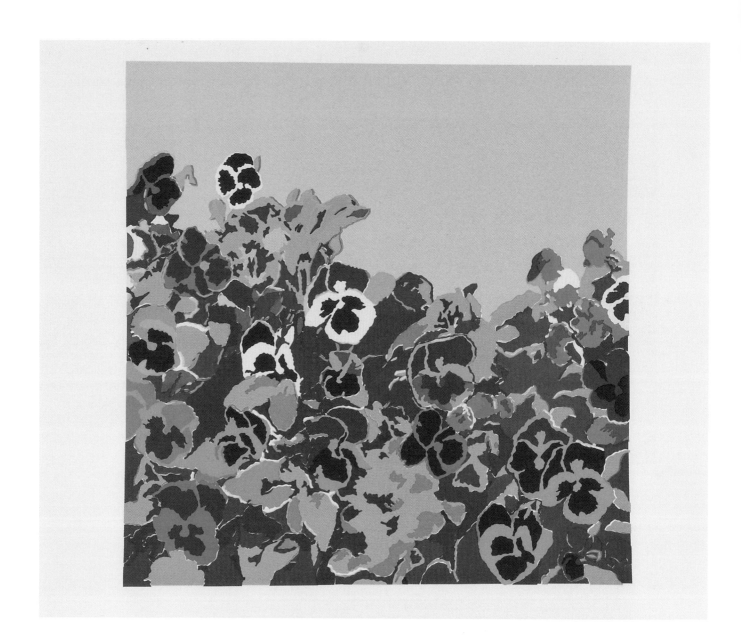

Jon Crane
(British)
Everyone Loves a Pansy
19¾ x 19¾ in (50 x 50cm)
Screenprint, 26 colors
Edition of 10

a brief history of stencils

The vocabulary of print quality available in screenprinting is largely dependent on choices made in the stencil-making process. There are four principal options, each with its own distinct language; most artists tend to gravitate toward the one that best delivers their own ideas.

All of the artists featured in the following section work to the strengths of a particular stencil-making process. This fleshes out and illustrates the distinct characteristics of each option, but good prints are often created through a mixture of these possibilities.

Cut stencils

These allow the artist to exploit the traditional strengths of screenprinting: sharp edges and flat color. In its simplest form, newsprint is used to block the screen with the shapes to be printed cut out. The strength of this technique is its cheapness; the disadvantages are the fragility of the stencil and its inability to be reused. As a consequence, cut stencil material was developed in the form of a stable backing sheet coated with a film that could be cut and stripped away while the uncut backing sheet supported it. The cut film would then be applied to a clean screen and a solvent used to soften it, allowing the film to adhere to the mesh. When dry, the backing sheet could be peeled away and the resulting stencil printed and reused at will. The advantage of this against the paper stencil was the use of the backing sheet to keep "floating shapes" in position, and that once attached to the screen, it could be printed through over and over. The disadvantage was the difficulty in attaching it securely to the screen mesh. If problems arose, the stencil needed to be recut.

Today, most screens are coated with a light-sensitive direct screen emulsion, which allows another generation of cut film to be used. Rubylith is a red emulsion attached to a dimensionally stable clear backing film. The red emulsion is cut as normal, but this time instead of stripping away the areas to print, these are left in and the rest is peeled away. When the rubylith positive is exposed against a photographically coated screen, the red emulsion shapes protect the screen coating from exposure and these shapes are washed away and can be printed. The original rubylith cut stencil remains undamaged and may be reused indefinitely.

Direct stencils

This technique allows the artist to translate the qualities of opaque three-dimensional objects into two-dimensional prints. The skill connected to this process is to find interesting objects and, through experimentation with screen exposure times, extract the optimum result in the form of a printable stencil.

Drawn and painted stencils

The ability to print drawn and painted marks opens up an enormous vocabulary of possibilities to the practicing artist. Clear acetate can be used as a support for painted marks, while Trugrain or Mark Resist allows the

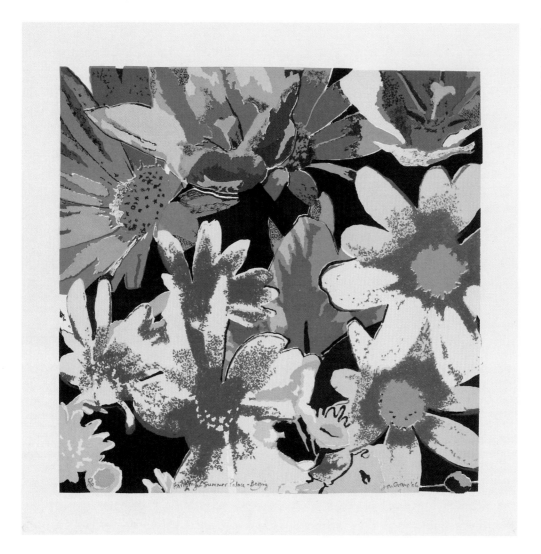

Jon Crane
(British)
Quazon City, Manila
23¼ x 23¼in (59 x 59cm)
Screenprint; water-based inks;
Somerset Satin White 300gsm paper
Edition of 10 printed by the artist

drawn mark to be exploited. The special characteristics of the latter
are a roughened surface on one side that enables materials such as soft
graphite, Conté, pastel, chalk, and even charcoal to deposit a visible
black mark dark enough to protect a coated screen from exposure.
The development of new photographic emulsions with a wide exposure
latitude allows an expanding range of drawn and painted marks to create
printable screen stencils.

Photographic stencils

As the practice of coating screens with a direct photographic screen
emulsion has largely replaced hand-cut stencils, in a sense all stencils are
photographic. However, the common understanding of photographic
stencils refers to those made from positives, having passed through a
photographic process in advance of exposure. A description of the standard
possibilities can be found on p. 347 (computer-generated positives).

Right: **Jon Crane**
(British)
Summer Palace, Beijing
23½ x 23½in (60 x 60cm)
Screenprint; paper cut stencil;
water-based inks; handmade
Somerset 300gsm paper
Edition of 12 printed by the artist
on a vacuum screenprinting bed at
Brighton Independent Printmaking,
UK

screenprinting process: **cut stencils**

Cut stencils provide a quality that was always seen as the hallmark of the screen process—sharp edges defining areas of flat color. Jon Crane makes his prints in the classic way using exquisitely cut paper stencils to create delicate flower imagery, maximizing the potential of the complex cut shape with vibrant color.

4.15.2

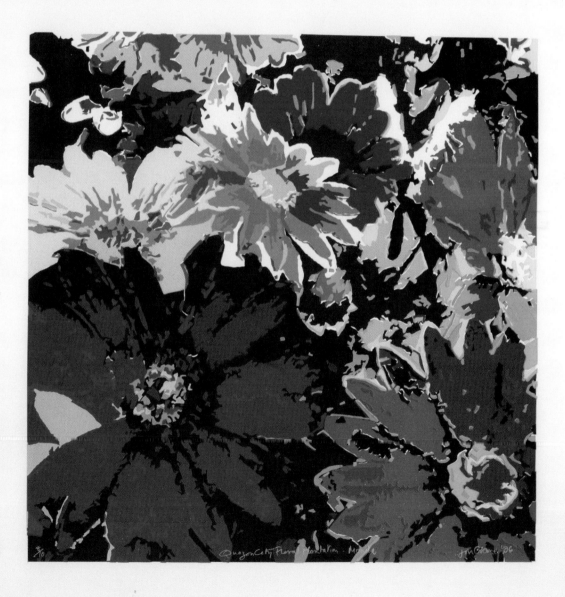

1 Original artwork is squared off with extended crosses, which act as a registration guide.

2 Tracing paper, the same size as the artwork, is placed over it and the square and extended crosses are traced. While the tracing paper is in place, trace off some of the basic shapes in the artwork separating the image and color.

4.15.3
step by step: **cut stencils**

Paper cutting as an artform can be traced back as early as the Han Dynasty (206 BCE–221 CE), about 200 years after the discovery of paper-making in China. Paper-cut art has become one of China's national artistic treasures, and through its history can be traced national cultural developments.

There was a strong tradition in Japan, from about the eighth century, where paper cuttings were first used as stencils in the process of dyeing textiles. Designs were cut into a base paper made from laminating several sheets of handmade mulberry paper together. A series of blades are used, in particular very thin, sharp ones for cutting curved intricate shapes. The mostly widely used imagery in the process of textiles for kimonos are flowers and geometric shapes. These paper-cut stencils are a pure artform and differ from the Chinese paper cuttings because negative elements of the design were cut away and floating islands were attached to the main body of the stencil first with human hair and in later years with fine strands of silk.

There is also a tradition of paper cutting in Jewish culture, where it was used in the making of wedding contracts. These paper-cut documents were often decorated with printing or calligraphy.

The tradition of paper cutting demands complete concentration from the master; one slip of the blade can completely ruin a stencil. The crisp and intricate cut designs are an artform in their own right. Such stencils have been collected and exhibited in museums and galleries throughout the United States and Europe.

Paper cutting for screenprinting floral imagery

My experience in screenprinting spans 40 years as a teacher and professional artist, but it was not until 2004, when I visited Nepal and China, that I experienced a spiritual desire to produce a series of paper-cut stencil screenprints. The reference points came from bringing threads of previous experiences together to produce an amazingly refined paper-cut stencil print using floral imagery.

During visits to Israel, Japan, and China I acquired reference material on the paper-cutting techniques outlined above. When I visited Japan, I was fortunate to spend time in the company of a paper-cutting master, who was using traditional skills to produce stencils for indigo dyed fabric.

When I visited Nepal for the first time, I stayed at the Kathmandu Guest House. The garden of this hotel was a peaceful haven from the noisy street life of Thamel. The garden was full of color from dahlias, pansies, and French marigolds. Sketching, painting, and taking photographs in the garden, especially the dahlias, gave me the reference point I had been seeking for my first successful paper-cut stencil screen print, which is titled *Kathmandu Guest House Garden* (see p. 330).

In the following step-by-step sequence I illustrate how I have encompassed the ancient techniques of paper cutting to produce my prints combined with the use of modern technology. The Adobe Photoshop program was used on my computer to produce my print composition cartoon.

3 The tracing is placed on a lightbox. The stencil paper/material is then placed over the tracing. First, trace the square of the artwork and the extended crosses. Second, trace the required shapes onto the stencil paper/material.

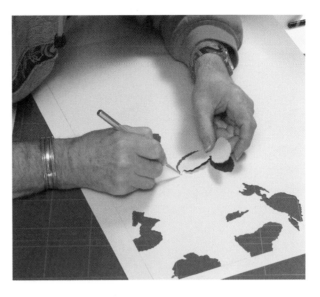

4 The stencil paper/material is then placed on a cutting board and the traced shapes are cut out with a fine, very sharp, cutting blade.

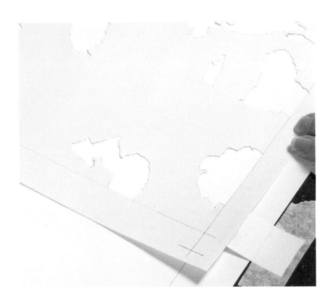

5 The stencil is placed on the first sheet of proof paper, which has been placed in the registration guides on the printing bed. Make sure that the squared lines and the extended crosses on both the proof paper and stencil paper/material line up. The stencil paper/material should be transparent enough to see the squared lines and extended crosses on the sheet of proof paper.

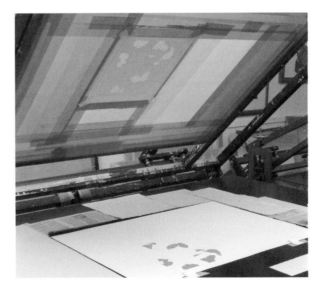

6 Now lower the open-mesh screen onto the stencil and print using a squeegee in the appropriate color for which the stencil was cut.

Registration

Different techniques and devices are used for the hand-screenprinting process to hold the paper in position and ensure perfect register of color/image on color/image. Using my well-tested device, it is important to start with a proof piece of paper, the same size and weight as that to be used to print your edition.

Draw an equivalent shape, in pencil, to that of the cartoon from which you have been working. These lines will guide you through every step of the process, because they provide an accurate position for the tracing and subsequent placing of the paper-cut stencils under the open mesh of the printing frame. The proof paper is held and placed in position on the printing bed with simple, folded guides that can be made from thin metal sheeting, thick paper, or plastic. These guides are folded and positioned as illustrated. The guides are fastened in position with masking tape. This device allows for perfect registration of each print, however many paper-cut stencils are printed in different colors.

Cut stencils: Troubleshooting

Look out for the following points:

1. If the cutting blade is not very sharp it will tear the fibers of the stencil paper/material rather than cutting through crisply.

2. Plenty of room is required around the cutting board so that the stencil paper/material can be swiveled around to ease cutting at different angles.

3. It is better to undercut your shapes by cutting on the inside if the traced line, because it is easier to clean up the stencil and cut to the line before printing.

4. When cleaning up your cutout shape, make sure your cutting blade is new and very sharp.

5. Avoid cutting along the line of the shape twice; this can affect the crispness of the shape to be printed.

6. It is important to use an #3 or #2 pencil when tracing the shape onto the stencil paper/material. If the pencil is very hard it will score into the fibers of the stencil; if it is very soft, it will circumscribe the shape with a thick line and not give an accurate tracing.

7. When the stencil is placed on the proof paper to create the first print, make sure the vacuum pump is on and you pull the ink across the screen with little force. Controlling the pressure you apply to the squeegee is very important.

8. Make sure you have some masking tape to hand when you lift the screen for the first time—the excess paper of the stencil that is not stuck to the open area of the screen needs fixing in place to the underneath of the screen before printing continues.

Jon Crane
British

4.15.4

profile: **Jon Crane**

"The first time I remember enjoying art was at secondary
school. At the age of 13 I won a scholarship to go to Chartsey House
School for Arts, Craft, and Music in London. This specialist school had a brilliant art department and
it was there that I really became involved in art. My father was a gilder and heraldic artist and painted coats of arms.

"Throughout my childhood he ran a workshop called Brilliant Signs
in Shepherds Bush, London, and he often took me round London on
a Sunday evening to show me his work in various locations. Following
school, I completed the foundation course at Camberwell School of Art.
I became the first student to take a joint degree in textiles and fine art.
When I left, Brian Elliot, who had organized projects and tutorials during
the course, wanted me to work as his assistant, as he was setting up a new,
innovative screenprinting department at the Slade School of Fine Art.

"I stayed at the Slade School for four years. I made screenprints while
I was there and was moderately successful at selling them. I was also
moonlighting within the textile fashion area, and I managed to sell work to
the fashion designer Mary Quant. This led to work with a small company
to develop methods to print onto leather. I built up a knowledge of the use
of dyes and different methods of printing onto leather and suede and, as
a consequence, I became involved with Bill Gibbs, printing on suede and
leather for his fashion show.

"In 1972 a post became available in the Fashion Department at the
Plymouth Art School. The school wanted to create a subsidiary course for
printed textiles, so I set up a screenprinting workshop where we printed

fabrics specifically for the catwalk. Around this time I was asked to do a
project in three colleges, two in London and one in Winchester. When the
projects finished, each college offered me a full-time post. I made a strict
rule that the students had to be working in the studio when I was there
and if they were not prepared to do this, then they were not dedicated
enough. This sense of pure dedication I found only at Winchester School
of Art. During my time there I became principal lecturer, then head of
department, and subsequently I was asked to write the MA course and take
responsibility for its running.

"Soon after leaving the Slade, my friend Jon Allen and I set up the Allen
Crane Studios. We took collections of designs to America and throughout
Europe. There were also exhibitions organized by the Design Council who
encouraged designers to exhibit their work. I visited many places with
the Allen Crane Studios, including Australia and the Caribbean. On the
island of St Vincent, I was asked to set up a screenprinting factory to give
employment to the locals, financially backed by the British Department of
Overseas Development.

"I always liked to push imagery as far as I possibly could through the
medium of screenprinting. This is why I started working with the cut stencil

Jon Crane
(British)
Kathmandu Guest House Garden
23½ x 23½in (60 x 60cm)
Screenprint; paper cut stencil;
water-based inks; handmade
Somerset 300gsm paper
Edition of 12 printed by the artist
on a vacuum screenprinting
bed at Brighton Independent
Printmaking, UK

method. I went to Japan, where I became really excited by their ancient craft of stencil work combined with screenprinting. One of the biggest problems in using cut stencils is the unattached pieces, referred to as 'floating islands.' On my return to Britain, I joked with my students that it was not surprising that there used to be so many ancient, bald Japanese men, as they would pull a hair from their head to stick to the pieces to stop them moving.

"I also went to China to study the way the Chinese handle this aspect and after I left Winchester, I spent three years at the London College of Printing concentrating on this method. The stencil process is not complicated but you do need a very good line tracing of the artwork. It is essential to have the ability to cut a line accurately between one stencil and another, so that when you print them they match exactly. Once the ink has been pulled across the screen, the pieces will adhere naturally. The maximum edition I have produced using a stencil is 100 prints using oil-based, not water-based, medium.

"When it comes to creating prints that I am really excited by, I naturally turn to flowers for inspiration. I suppose this came from my time working in the textile industry and the fact that my father was a keen gardener and grew all the old-fashioned herbaceous plants. Having been abroad, I

decided that the more unusual plants make serious and interesting prints, so this is where my inspiration has come from recently. With regard to scale, the majority of my work is 60cm square (23½in square). This image size came from time spent looking at the work of Andy Warhol, in particular the way he used flowers in his imagery.

"I do all my own preparation and printing, which is a long process. Each print starts off with an initial line drawing, which I sometimes convert into watercolor sketches. These are then fed into Photoshop, where I manipulate the imagery to reach the desired composition. My greatest inspiration is Matisse, and I consider that it is the color that dictates how we view the finished work. My prints can have up to 34 printed colors.

"Screenprinting has moved boundaries in art in the most visually exciting ways. Contemporary artists such as Peter Blake and Ron Kitaj use this medium to extend their work to a wider audience.

"I use screenprinting like a sketchbook; it is a method to produce an image in repeated form very quickly. All you need is a picture frame, a piece of nylon, paper, and ink, and you can immediately produce something to good effect."

screenprinting process: **direct stencils**

Direct stencils transform three-dimensional objects into two-dimensional prints. Success with this process relies on an imaginative choice of subject and skill in establishing the correct exposure to create the optimum screen stencil. Jane Sampson's prints are a witty illustration of this technique.

Jane Sampson
(British)
Black Basque
30 x 44in (75 x 112cm)
Screenprint
Edition of 10

**Picture showing elements
composed on an unexposed screen**

**Closeup of the boa and bow on the print
to show the conversion of 3D to 2D**

Jane Sampson co-founded Brighton Independent Printmakers, an open-access print workshop in Brighton, England in 2000.

The use of found objects in fine art has a long history. Artists from Marcel Duchamp to Damien Hirst have appropriated, assembled, incorporated, and collaged found objects into their work. For examples, look at the work of Picasso, Man Ray, Kurt Schwitters, and, more recently, Davis Mach.

I have exposed textiles (including clothing), plant materials (such as dried leaves and grasses), and manufactured objects (such as sequins, labels, paper clips, and buttons) directly onto the screen, using them as "found" positives, to create a series of artworks.

To begin with, I collected and chose objects I was reasonably confident would make interesting stencils. I then composed the image to fit on a single screen. I had already made a series of trial exposures to establish the optimum time to deliver the best detail.

The screen was exposed and the resulting screen stencils were blocked off using parcel tape, allowing me to print a single color at a time. First of all I printed the outline (a maribou feather boa) and whiskers (wire) in black, then the eyes (buttons) in green, and finally the bow in red. Providing the separate elements do not touch or overlap, this is the most efficient method of using a single screen to create a multicolor print. Using found objects is an art that comes from experience and practice; it is not an exact science. It may be unpredictable, but when successful, delivers remarkable detail and clarity.

Direct stencils: Troubleshooting

There are a few basic ground rules that need to be followed to obtain successful results.

1. The objects or fabrics chosen must block the light effectively. Fabrics generally only work if they are black, and of a reasonably coarse weave. Folds and creases will come out as solid areas in the print, since many layers will block the light. If using dried plant materials, only a silhouette will be reproduced on the screen.

2. The object you choose must be reasonably flat, which rules out most three-dimensional possibilities. It must not have any sharp protuberances capable of damaging the screen mesh while the exposure is taking place. Beware of zippers or hooks and eyes on clothing, for example. Anything sharp can puncture all but the most robust and coarse screen meshes.

3. The exposure times will vary widely. Deciding how long to expose a piece of fabric, for example, is a process of trial and error, and will depend on the wattage of your exposure lamp, its distance from the screen, the speed of your photo-emulsion, and the density of the fabric. If it washes out too much then it is underexposed. If it does not wash out enough, and the resulting print has lost detail, then you have exposed too long. All you can do is remove the stencil and try again.

Jane Sampson
(British)
Happy Cat
30 x 44in (75 x 112cm)
Screenprint
Edition of 10

screenprinting process: **drawn and painted stencils**

Drawn and painted stencils allow the artist to exploit his or her own personal visual language of handmade marks and bring this into the print process. This enables the finished print to carry with it the expressive nature of gesture. The following pages describe the way Terry Gravett, an English artist living and working in Ireland, explores his subject through drawing and how these ideas are brought to fruition in the screen process.

Below left: **Diary notes for print completed at the start of 2007. The color blobs were made with ink at the time of printing**

Below right: **Diary book drawing. Idea for tree containing broken busts**

Right: **Notes for *Tree with Fallen Head*. This later included a linocut of a Roman bust**

4.15.6

screen
screen B/G
woodgrain
or flat

screen

Gesso on wood

ke sets of
w square
it to Dublin
ne 28 NOV

Design for 1ft x 1ft
for American show
e on paper 15 x 15

cut
hole.

Sevol and diamond
pattern in
same

2 plates =
Line drawing
+ wash carborundu

ver

full plate ①

plate ②

linear
scratch

Terry Gravett
(British)
Fallen Bust
18 x 17in (46 x 45cm)
Screenprint

This print in the "Tivoli" series uses
a square format with a surrounding
plain border that firmly contains
the eruptive markmaking of the
main image. The linear drawing in
the bottom right corner is based on
a broken statue of a Roman head
lying in the grass of the Emperor
Hadrian's Tivoli Garden.

Drawings of Ionic scrolls at Miletus, Turkey

Broken architectural fragments, Miletus, Turkey

Broken column capitols at Priene, Turkey

The ancient classical world, particularly Roman civilization, is the source material for my images. Since visiting Leptis Magna and Sabratha in Libya at the age of 20, I have been fascinated by archeological sites around the Mediterranean and the broken sculpture and artefacts displayed in world museums. The open sites are closely associated with "The Grand Tour" that young aristocrats undertook in the eighteenth century. The subsequent visual art that was made by the cultured traveler as a topographical record was a stimulus to several centuries of Western artists, from Piranesi to Picasso. The titles given to my prints reflect this classical influence—*Tivoli*, *Romana*, *Ostia*, *Ephesus*, the "Museum" series, *Adelphoe*, and so on.

In some older work I used photographic elements and a semi-cubistic structure. The newer work seen here is looser and reflects my parallel interests in archeology and landscape drawing. The ruins of the Tivoli Gardens outside Rome, built by the Emperor Hadrian, are an oblique reference for these later works.

These images show reference ideas and images that I have incorporated into finished prints.

View over Ephesus. Sketchbook drawing

Drawing made from a sketch, of a Roman Bath House at Ephesus

tools and materials: **drawn and painted stencil**

Paper

As water-based ink is mostly used for screenprinting, it is essential to have a paper that is thick enough and stable enough not to curl. Use weights of 300gsm and over that are surface-sized. Experiment with various types to see how they react to the ink. The prints shown on these pages were printed on Magnani litho paper, 350 and 400gsm. It is fairly smooth and absorbent and not too white.

Registration

4.15.7

Paper should be trimmed at the corners of two right-angled edges. If the deckle is to be left, a small 1in (2.5cm) sliver each side of two corners can be cut with a ruler and sharp knife, with a further one at the end of the longer side. Registration stops should be no thicker than the paper. Thin plastic is best.

Screenprinting Inks

Registration stops

Water-based screen ink

The strong, concentrated pigment in these inks allows the color to remain extremely vibrant when a thumbnail portion is added to the clear flat base (transparent base). Opaque white will add density without greatly reducing the color. The drying time is fast, so retarder needs to be added. Wash-up should take place immediately after the final pull to ensure a clear screen.

Ink

Ink should be treated like paint, with plenty of careful mixing and testing. If you start printing with the wrong color you face the whole business of washing up. Take a small sample, thumbnail size, of what you think might be the right color and with a tiny squeegee print a small corner of your stencil. This can be done with the first color or more importantly when overprinting. It will help you determine opacity or transparency as well as color, and it's easy to wash up. This allows one to sample the color on a small area of a print many times without destroying several prints. It's also easy to clean up. Keep one of your prints out of the edition for this purpose and use it every time you test a new color through a new stencil.

Printing

Always have everything ready before starting to print. Make sure that the squeegee is sharp. Some synthetic composition squeegees (neoprene) can get very hard when old or cold. Some time on a radiator or a drenching with hot water will soon soften the blade. Note that leaving wooden-handled blades in water for too long will warp the wood and the plastic may fall out.

Printing and painting

Hand-painted areas can be drawn onto the print paper and then overprinted in the normal way. Drawing can also be made between printed colors. Use the same ink but not too thickly.

Monoprinting through the mesh

Flood the screen with ink in the normal return way. Lower the screen onto the printing paper and press the mesh with a finger, pencil, or corner of an old squeegee blade. The snap-off will prevent the color touching the paper except at the point of contact (your drawing). When dry, larger areas can be overprinted with paper or other stencils.

Final image: **Terry Gravett**
(British)
The Tree
17 x 18in (45 x 46cm)
Screenprint; Magnani 350gsm paper
Edition of 10

step by step: **drawn and painted stencil**

4.15.8

1 A wash-drawn stencil using the liquid wax method.

2 A selection of light-safe drawing implements: A pot of plumb red opaque paste; repro red sticky tape; dark-colored oil-based pastel; soft-grade pencil for drawing the lines on the Kodatrace film; Rapidiograph felt-tip pen (these come in a variety of sizes) used by commercial printers for spotting out film negatives; piece of repro red handcut or Rubylith film.

3 A stencil drawing made on Kodatrace with plumb opaque stopping-out liquid. (Alternatives to Kodatrace include Mylar Acetate by Duralar or Frosted Mylar by Grafix.) From this stencil two colors were printed: blue-gray and green. From one stencil it is possible to print more than one color by stopping out areas of the screen.

4 A screen with multi stencils. When printing one stencil the others can be covered with acetate sheet or stopped out with masking tape. This saves time when making stencils and resetting the screen on the table.

5 Opaque drawing on Kodatrace film representing the blue-gray color.

6 Closeup of the light gray stencil. This shows the plumb opaque and pencil drawing.

7 Printed proof sheet with gray and green in correct registration.

8 Closeup showing the wash texture overprinted on the red.

Some of the multi stencils on the screen can be stopped out with a filler. This can be done when the screen is on the printing table. This is a more permanent method than the acetate or tape but is good for small areas or blocking a part of an already printed stencil before reprinting. Some printers use the reduction method employed in lino cutting. By leaving the screen in register on the table, a stop-out drawing is made on the open screen and then printed. Printing and stopping out areas continues until many colors are printed and you run out of open mesh. This needs good planning but allows many colors to be printed from one open stencil.

Thin bitumen painted or scraped onto the mesh with a plastic phone card can be used to cover pin-holes, as can emulsion or rosin-based stop-out. These dry quickly and are easily removed with mineral spirit.

9 Print at an early stage with red, orange, blue, and gray printed.

10 Each color has its own drawn stencil on transparent film, ready for exposure onto the mesh.

After the screens have been made, the final commitment to making the print begins. The first color printed on a particular type of paper sets the flavor of the print. The adrenaline and fears begin. If the paper is stained with the wrong color or density of pigment, the print is finished before it has begun. I do not proof-print but go straight into the edition. This could be 40 prints, so one false move and they are wasted. This is a risky game to play, especially with 15 or more colors. Unlike painting, it is not possible to scrape off unwanted areas or heavily overprint without losing freshness and sensitivity. But, like the painter, I proceed until I arrive at a point where the print is finished to my satisfaction. Careful mixing of color and testing on the proof print and relating the next stencil to the last color is essential.

screenprinting process: **photographic stencils**

Photographic stencils allow the printmaker to explore the potential of the photographic image through a range of darkroom techniques. Images can be enhanced, broken down, and modified in a variety of ways to make the viewer respond, perhaps in an unexpected way, to the familiar. In this print I enlarge the four-color separation process.

4.15.9

The other intention behind making this print was to experiment with the relationship between the photographic and autographic mark. I have always liked the coolness, the one-step-removed, and secondhand nature of the photographic image. By enlarging the dot structure, this mechanical signature becomes very clear; the detail illustrated below shows what occurs when the mechanically screened dot collides with the painted brushstroke. Because the edition is made up by overprinting handpainted originals, each one is in a sense unique. As a consequence the separations are registered, using the acetate overlay system described on pp. 360–361. When printing an edition like this, where the prints are not identical, it should be made clear when annotating each print. These are described as variable prints and, if the edition was for example 25, marked VP 1/25, VP 2/25, and so on.

Detail showing underpainting and overprinted four-color separations

Ian Brown
(British)
Empire State from "Icon"
Series II
33½ x 47¼in (85 x 120cm)
Mixed-media screenprint

step by step: **photographic stencils**

4.15.10

1 The starting point for "Empire State" was the postcard. This was scanned and output as four separations using an inkjet printer onto a roll of thin paper 24in (60.5cm) wide. To give a relatively fine-quality finish, 4 pixels per dot were selected.

2 Each of the separations was marked cyan, magenta, yellow, and black before being exposed to create screen stencils. Then the image was quickly proofed onto mold-made paper 30 x 40in (76 x 101cm).

3 The prints were spread over worktables and overpainted with acrylic using a range of different sized bristle and house painting brushes. Working over the print allowed color to be dropped accurately where required.

4 The emphasis with this image was to generate a loose, gestural feel to the brushwork, and also to work up the paint surface to the point that it might interfere with the final reprinting. This detail shows how thick paint distorts the overprinted photostencils.

5 With the proofs prepainted, the separations could now be printed. The process colors should be printed yellow, magenta, cyan, and then black, but I often prefer to start with magenta, as it is easier to register a second color over magenta than over yellow. This separation was therefore printed magenta, yellow, and cyan. The black positive in a four-color separation is always the lightest, and although it can be missed out, it will sharpen the contrast in the finished print.

6 As it was not possible to enlarge the postcard sufficiently to fill the paper size, a white border was left surrounding the image. To soften this graphic quality, a warm ocher was splashed over the last of this uncovered paper. At this stage there is no evidence of print, just a loosely painted image. As it was not possible to enlarge the postcard sufficiently to fill the paper size, a white border was left surrounding the image. To soften this graphic quality, a warm ocher was splashed over the last of this uncovered paper. At this stage there is no evidence of print, just a loosely painted image.

Photographic stencils: Troubleshooting

1. On exposing a fine halftone, the best stencils will be made using a freestanding lamp and printdown frame where the lamp can be placed at a distance of at least the diagonal of the largest screen. In self-contained units, the lamp is often too close, and inevitably undercuts the smallest dots, which will not wash out and print.

2. When registering using the acetate overlay system, speed is of the essence if you wish to maintain fine detail. Have plenty of spare newsprint for proofing should drying-in occur.

Magenta

Yellow printed over magenta

Cyan printed over magenta and yellow

The color image

Application of Image > Grayscale

A black and white high-contrast screen positive on paper

4.15.11

process: **computer-generated positives**

The computer has largely replaced the darkroom for printmakers today. All the darkroom processes that had to take place under red safelight conditions can now be matched in front of a computer. The key challenge that the darkroom or computer addresses is the problem of delivering tone through the medium of screenprinting. Black pigment either passes through a screen stencil to make a black mark, or it doesn't. This is not the same experience as drawing, where tonal nuances can be achieved by a lighter touch.

Adobe Photoshop opens up the possibilities of using photographic images, and then exploring the tonal values that lie within them. First of all you will need to scan an image (see below) and then save it so that the file can be further manipulated in Photoshop. A wide variety of options lie ahead, but these are the basics.

(Note: this is a guide to using a home computer and printer. To create high-quality halftones or four-color separations it is essential to liaise with a print bureau. The following instructions are good for Photoshop CS2. Other versions vary, so be prepared to experiment.)

Scanning artwork
Open Photoshop and select File and Import to connect to the scanner. Crop the image and define the size to which it will be ultimately output and printed (this will be determined either by your own printer or the equipment at a print bureau, if working large).

The image should be scanned in at a resolution of 300 dpi. Select File > Save As and save as a TIFF. High-resolution files and large images will take up valuable hard-disk space, so burn to a CD or transfer to a memory stick.

Converting tone to black and white
A continuous-tone original can have the contrast increased to the point that the image is rendered completely in black and white. After scanning in your original photograph and saving it, open it up in Photoshop, select Image > Mode > Grayscale and your color image will convert to continuous tone (black, white, and a full range of grays). Go to Image > Adjustments > Brightness and take Contrast up to 100%. By sliding Brightness up and down the scale you will be able to choose the best point on the gray scale to deliver the detail you want from the image. Save it and print it to make a screen positive.

Lightest tone (highlight detail)

Just under the mid-gray

Mid-gray

Just over mid-gray

The darkest shadow detail

The five separations printed as a sepia monochrome

Making a tone separation

Repeat the process above but instead of saving the best image from the middle of the grayscale, select a range of them, from those that seem far too dark right through to others that appear too light. Save each one and print it. When these are turned into screen stencils and you mix up a range of tones from a single color (a monochrome),

you can rebuild the tonal values by printing the most open stencil (the darkest positive) in the lightest color, giving highlight detail, through to the smallest stencil (the lightest positive) in the darkest color delivering the deepest shadow detail. The more separations you make and print the more seamless your description of tone will appear.

Making a halftone and mezzotints

Continuous tone can be simulated by screening the image (converting it into mechanical rows of dots, the size of each dot representing tonal value). A fine screen of 175–200 lines per inch would appear almost continuous-tone when seen, for example, in a quality magazine or book. A coarse halftone (85 lines per inch) would be more equivalent to a newspaper image that simulates tone but with the halftone dot structure now visible.

To create a halftone, open up your image in Photoshop, select Image > Grayscale, go to Filter > Sketch > Halftone Pattern, make contrast 50, select Dot and choose size of dot (see illustration of size 10 and 50). Alternatively, you could use the route of Image > Mode > Bitmap and select Halftone Screen. A window will appear offering choices of dot shape and lines per inch. Experiment until you are happy, then save and print the image.

The standard halftone consists of rows of dots and as it is enlarged has a strong mechanical signature. To create a different simulation of tone, select Mezzotint. This is the Photoshop equivalent of the etching quality arrived at manually through the use of a mezzotint rocker on a plate. It is a more random arrangement of marks with an organic feel, and a useful alternative to the conventional halftone.

Making four-color separation positives

Open Photoshop and open your file. Select Image > Mode > CMYK. This will switch you from RGB (Red, Green, Blue)—the way color is read on a computer screen—to CMYK (Cyan, Magenta, Yellow, Black), the four-process printer colors. Go to Window > Channels. Four channels will appear. In the right-hand corner a button will allow you to Split Channels.

To impose a halftone dot to each of the channels go to Filter > Pixelate > Color Halftone. A box will appear with a default number (usually 8) denoting the number of pixels to a dot. When printing with 90–120T screens 4 is the lowest (and therefore finest) number to choose. Repeat and save each of your channels one by one as Cyan, Magenta, Yellow, and Black, then print.

Fine halftone dot screen (50)

Coarse halftone dot screen (10)

Coarse halftone (15)

Mezzotint screen

Alternatively, you could try Image > Mode > CMYK. Go to Window > Channels and click the top right triangle, Split Channels. Select Black file > Image > Mode > Bitmap. Then select Halftone Screen, Frequency lines/inch (note that 50 is fine and lower numbers are coarser), Angle 45 degrees, Shape (of dot), and save as a TIFF. Repeat the same instructions with Magenta 75 degrees, Yellow 90 degrees, Cyan 105 degrees, and Black 45 degrees. Then print your positives to include registration marks.

Printing files to make screen positives

Files can now be printed, ideally on acetate or on very thin paper. Alternatively, they can be transferred to a CD or memory stick and taken to a print bureau to output on film the required size. Ask for right-reading film positives, emulsion side up.

Ian Brown
British

4.15.12

profile: **Ian Brown**

"My interest and subject matter is the 'secondhand image'; that is, the already printed image. Some might think this is an odd place to find the source of a lifetime's work and it has, to an extent, puzzled me. The connection perhaps lies in my childhood. I grew up living in some exotic locations and my earliest memories are of a partitioned Vienna.

"Then I went to St Andrews in Scotland, followed by a spell in North Africa, before settling down on top of a mountain in Eritrea. In those days, Africa was a world away from England and the big event was the weekly arrival of the posted printed matter. I can still clearly remember the smell of the paper and the printing ink, and during my enforced siestas as a child I would pore over the text and images in these magazines, papers, and comics. It was the entry point for my creative imagination and the place where I discovered an alternative inner landscape.

"Later at school in Kent, I was lucky to have a good art teacher. Although art was not looked upon as a proper choice for a career, I chose a Foundation course at Canterbury College of Art, followed by a course in graphic design, where I encountered print in the form of etching and screenprinting. At last it started to make sense. Seeing R. B. Kitaj's prints of book covers at the Hayward Gallery in London was a revelation. Suddenly it became legitimate to be interested in print as a subject, and as a consequence I enrolled on a postgraduate printmaking course in Brighton. Leaving college was a big shock. It was like finding all your 'toys' had been taken away. I took work as a print technician, then worked as a commercial printer as well as doing some part-time teaching. Perhaps the defining

moment was arranging a bank loan to buy my first screen vacuum bed and inks on the back of a show. Print became a source of income primarily through sales in galleries, but also editioning for other artists when I was hard up, and through a range of commercial work. For example, I printed all the decorative papers for the restoration of the Prince Regent's breakfast room in Brighton Pavilion.

"In my career as a printmaker I have run down a few blind alleys, but the focus of my practice is an obsession with the printed image and how a response to that may be shifted by its translation through a variety of print processes. As a young man I was drawn to the coolness inherent in this activity. Now I see this as a given in the discipline, and my fascination with the photographic image has become somewhat ambivalent. I seek ways of interrupting this photographic language, partly through process and partly through the collision with the autographic or handmade mark. I am searching for ways of opening up a fresh dialog with these secondhand found images that still intrigue me.

"The artists that interest me are the obvious: Robert Rauschenberg, Sigmar Polke, Hughie O'Donaghue, Eduardo Paolozzi, and R. B. Kitaj.

Rauschenberg is the master at handling the photographic image with the fluidity of a painter. He makes liquid the tangible and I never tire of his work. Hughie O'Donaghue embeds print in paint as a means of investigating, among other things, time and memory. Paolozzi, through collage and especially in his Cloud Atomic Laboratory series of photogravures, combines the worlds of science, commerce, and kitsch iconography into a surreal reverie on life in the second half of the twentieth century. As I grow older my respect and admiration for these artists' work grows.

"I recently enrolled on a part-time MA in printmaking at Camberwell (University of the Arts, London), headed up by Finlay Taylor. I would recommend this course to anyone seeking a challenge to his or her thinking in an environment where printmaking has an expanding definition. Partly as a result of this program, I have revised my approach to print. I saw the edition of identical prints as a kind of gold standard, and I would ruthlessly destroy any print that fell short in a technical sense. I now embrace accident and error and see the dialog between control and abandon as critical to success.Printmaking absorbs me now as much as it did when I started, and I never lose the thrill of the instant transformation of an image at the pass of a squeegee. I see printmaking today as an activity with the same standing as painting, sculpture, and installation, although new developments in technology are changing the way we make and receive art. The growth of digital imaging, for example, is an exciting new avenue of enquiry, but it should not invalidate the processes of the past. We are at a point where the definition of print is in a state of flux, and the future looks all the richer as a consequence."

Ian Brown
(British)
Motion Pictures (Land); **one of a**
series, "Land, Air, Water"
60 x 40in (152 x 101cm)
Screenprint; Somerset Satin
410gsm paper
Variable edition of 30 in 16 workings
printed by the artist

chapter 16 **printing the screenprint image**

4.16.1

an overview of printing the screenprint image

Screenprinting is a versatile medium with a wide range of applications. It is possible to print on paper, board, wood, glass, metal, plastics, and a whole range of textiles. In fact, if it is flat and given the right ink, practically any surface can accept a screenprinted image.

The commercial example of screenprinting illustrated here (opposite page) is the floral border and decorative bamboo trellis printed during the restoration of the Royal Pavilion in Brighton, UK. In the sequence of photographs that follows, the process of preparing screens, exposing stencils, and then printing colors in register is illustrated and explained.

As a printmaker, I have printed on all the surfaces above by taking on commercial work to make ends meet. Often the diverse demands of these jobs have taught me new practical skills that have fed back into my own practice. Possibly one of the most interesting was a project connected to the restoration of the Royal Pavilion in Brighton. Originally a farmhouse, this building was enlarged and extensively renovated in an exotic fusion of Chinese and Indian ornamentation to become the extravagant residence of the Prince Regent (later King George IV). Some years ago I was asked if I could reconstruct from original fragments the repeat of some decorative papers used in the South Gallery (the King's breakfast room) in about 1815. While I was making tracings of every available sample, many seemed to be strangely familiar, and it finally became clear that in fact the originals had been printed in two ways as mirror-images. The room was lit from above and the decorative papers had shadows running in each direction to accentuate the illusion of the possibility of cast shadows.

Once the mirror-image concept had been discovered, the rest of the job was fairly straightforward. The final critical decision concerned the colorway. Of the range of original samples, reprinted several times and surviving in varying degrees of condition, which combination of colors would be most authentic? I printed versions and submitted them to committees that gradually arrived at a consensus. The finished prints were made on an acid-free archival inlay (paper) of a similar weight to the original. A heavy-duty mesh was used with multiple coatings of photo emulsion to maximize the thickness of the ink deposit. An additive was introduced to each color to ensure the final printed ink film was as thick as possible.

The decorative border of imaginary flowers I printed in my own workshop, but the sheer volume of the bamboo trellis demanded greater rack space. In the end I hired a workshop where I could print and fill five 30 x 40in (75 x 101cm) and one 60 x 40in (152 x 101cm) sets of racks. We still had to use all these racks, and empty to refill the first one, to complete a single color. Printing with oil-based inks at an average of three prints a minute, it would take an unbroken three and a half hours to print each color. By the time the job was complete, I had reached bamboo saturation point, and it was two years before a visiting relative persuaded me to enter the finished room.

The restoration team had handcut each length of bamboo and shaped them to create the trellis before painting a shadow beneath them, turning my miles of handprinted bamboo into something quite astonishingly beautiful, as can be seen from the main illustration shown on pp. 354–55.

screenprinting in practice

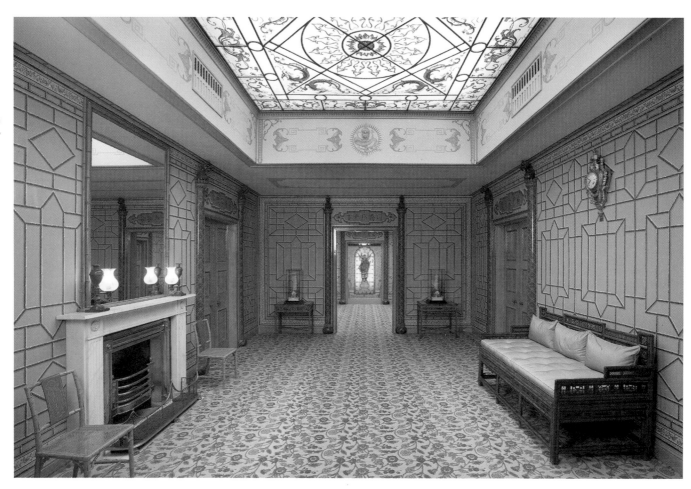

Brighton Royal Pavilion: The South
Gallery looking north
© The Royal Pavilion & Museums,
Brighton & Hove

The bamboo trellis printed in sheets

step by step: **preparing screens**

4.16.3

Coating screens

Direct stencils (coated screens) have several advantages over indirect (applied) stencils. Generally, a coated screen stencil is more robust than an applied screen stencil and if there are any problems it can be remade from the original positive instead of recutting to replace the damaged stencil.

Traditionally, screens are coated twice on the paper side (underside) and once on the squeegee side. You may wish to experiment and cut this down to one coat each side or one coat only on the paper side. The advantage of a thinner coat is partly cost. Less emulsion is used, but this also allows a more sensitive exposure to thin positives—photocopies on acetate, for example. A single coating is liable to pick up the edge of a positive and print it, so check carefully before printing and always re-expose underexposed screens.

Coating a screen with light-sensitive emulsion

1 Place the screen paper-side toward you and wedge it against a wooden strip to prevent movement. Pour the emulsion into a coating trough that is at least 2in (5cm) narrower than the width of the screen. Tip the lip against the bottom and, with a single confident stroke, pull it up to the top of the screen. Reverse the screen if you wish to make a second coat and repeat.

2 The screen should now go into a drying cabinet, paper side facing down under yellow or red safelight, and be dried using fans blowing cold air. It will take about 40 minutes to dry.

3 Before exposing with a new exposure unit, make a test exposure keeping certain constraints constant (the wattage of your lamp if it is variable and the distance of the lamp from the screen—at least the length of the diagonal of your largest screen), and decide how many coats of emulsion will be applied to the screens. Put together a range of positives, from the most translucent to the most opaque. Try photocopies on acetate, a range of drawn marks on mark resist or Trugrain, plus a range of painted marks of differing densities, from, for example, black acrylic on acetate and Indian ink on mark resist to photocopies on thin paper and standard paper as well as the perfect positive (an image on line film).

Run a strip of masking tape along the paper side (underside) of the screen with times marked on it in permanent pen; for example, with an 800-watt bulb 100sec, 200sec, 400sec, 600sec, 800sec.

Positive test and printed result with exposure times

4 Expose the screen, wash it out, print it in black, then write in the times with a pen before taping to the wall by the exposure unit. This will be a permanent visual example of the exposure times needed to obtain the optimum print quality from a range of positives. When working with coated screens bear in mind that they are light-sensitive. Take them from the drying cabinet and make the exposure without leaving the screen long under any light source. After the exposure take it straight to be washed out.

5 Wash the paper side all over first to make it evenly wet and then wash the stencil out carefully from the squeegee side. Check the screen against a light source to confirm that the areas you wish to print are indeed open. Further washing can often open up unresolved stencils.

Screen washed out on both sides showing correctly washed-out stencil

Blotting off unexposed emulsion with newsprint

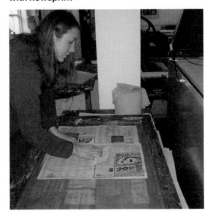

6 When satisfied, lay the screen paper-side down on clean newsprint and then blot water off the squeegee side with further sheets of newsprint. If the newsprint sticks to the screen, then it is not properly washed out, so take it back for another washout. Assuming everything looks good, slide the screen into a drying cabinet.

Laying the paper carefully against the registration marks while screening the final black on the *Empire State* print (see p. 343)

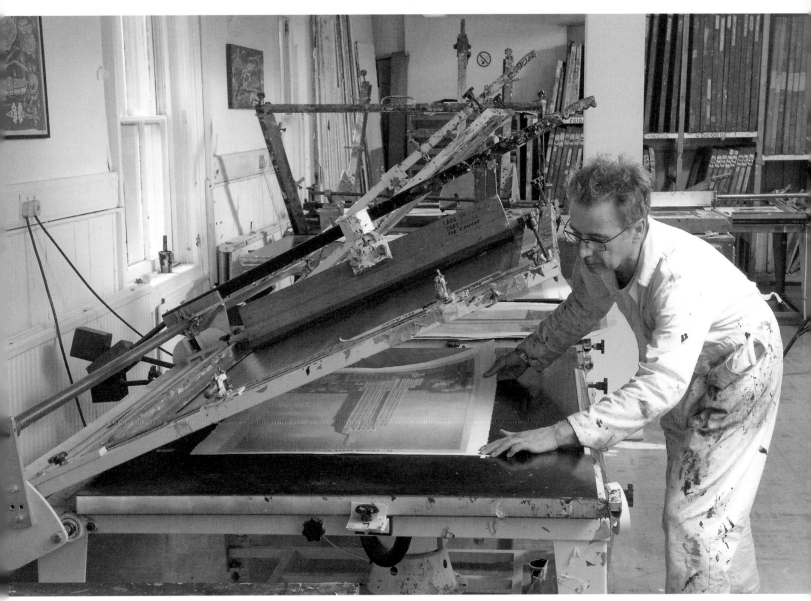

step by step: **making ready**

4.16.4

Spotting out pinholes on a lightbox

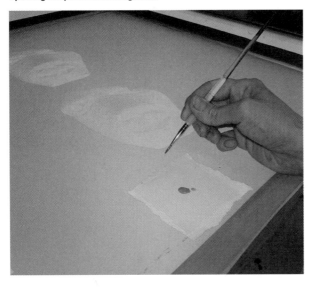

1 First of all, check the screen stencil. Any pinholes or unwanted marks that may print should be spotted out. This can be done with a filler or photo emulsion (re-expose when dry) or taped out with parcel tape on the paper side.

Clamping the screen securely to the vacuum bed

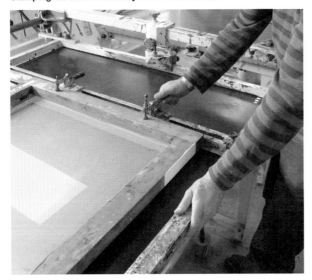

3 Put the unprinted paper stock on the part of the vacuum bed that is pierced with holes. This will indicate where to place the screen on the vacuum bed. Clamp it securely. Make sure the counterbalance weights are correctly placed to allow the screen to stay up unsupported, while moving paper in and out, and also down without being held while printing.

Taping up between the emulsion and frame edge

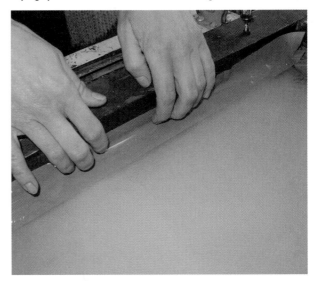

2 Using parcel tape, run a strip half on the frame and half on the mesh all around the screen to prevent ink seepage. If there are several stencils on a screen, tape out the ones nearest the one to be printed, again using parcel tape on the squeegee side.

Squeegee attached to a "one-arm bandit"

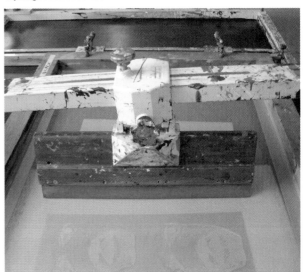

4 Select a squeegee about 4in (10cm) wider than the stencil. If attaching this to a one-arm squeegee bandit, clamp it firmly at its center and check the blade angle (both directions) is at 45 degrees.

**An ideal printing arrangement. The
stock is ready on clean newsprint beside
vacuum bed, then racks**

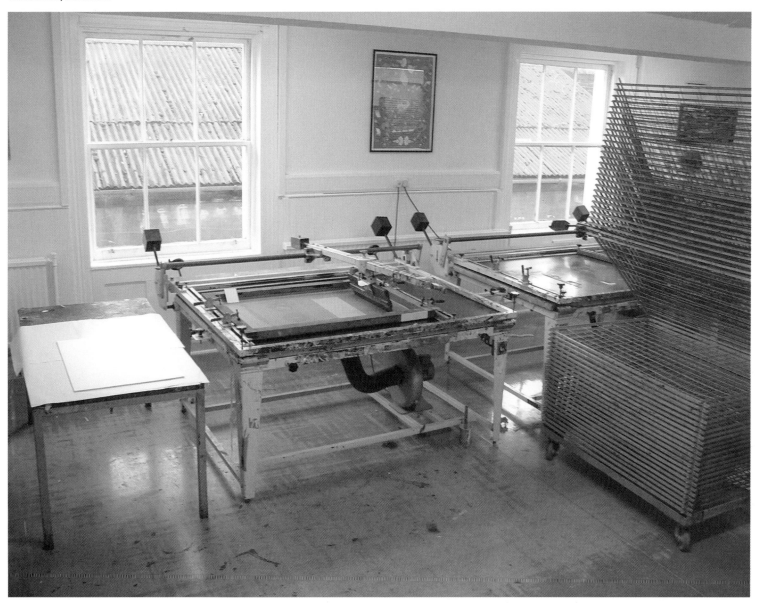

5 Mix the pigment thoroughly and ensure there is more than
may be required. Cut a piece of clean card to lift the ink as
it settles at the back of the screen during printing and spread it
evenly across the print area. Check the printing stock is ready
and beside the bed and that the drying racks are clear to accept
the printed sheets as the print run commences.

To print multicolored images where all colors align to make identical prints (editions), a thorough understanding of the principles of registration is imperative. Although most machine-cut paper is identical in size, assume that each piece of paper varies slightly from another, so that when printing on mold-made or handmade paper (where each sheet is unique), this technique will ensure the correct registration of unlimited colors.

4.16.5

step by step: registration

1 To print the first color, tape the screen positive onto the paper defining the margins of the completed print, usually centered on the sheet with more space along the bottom edge.

Black positive taped in position and aligned against the screen stencil. Three registration marks correctly placed.

Slide the paper with this positive attached under the screen until it aligns with the screen stencil. When satisfied, place two registration marks against one of the corners nearest you, and the third about 1in (2.5cm) in from the end of the longest side of the paper. By placing two marks together registration is reduced to two points (the fewer the better).

Acetate taped hingewise along the near edge with two pieces of masking tape holding it taut at the back.

2 For many prints, this alignment by eye is a satisfactory method to register color. However, after the first color, for absolute precision registration, acetate must be used. The reason for this is the difficulty in prejudging the screen stretch when printing. Every print is offset in the direction of the squeegee pull, by the squeegee stretching and shifting the screen stencil. Printing first onto acetate allows this offset to be taken into account.

First align the print roughly by eye—to within perhaps ½in (1cm) of dead register. Then tape a piece of acetate across the print so that the full image will print on the acetate yet there is sufficient paper exposed to allow print alignment without untaping the acetate.

Tape the acetate hingewise along the near edge with two pieces of tape holding it taut at the top. Remove the print from under the acetate and print the color. The image will now lie on the acetate in the exact position in which it will print (taking account of the stretch of the screen fabric as you pull the squeegee across).

The printer slides the lay copy (with the black positive taped in position) under the taut acetate to align against the red printed image.

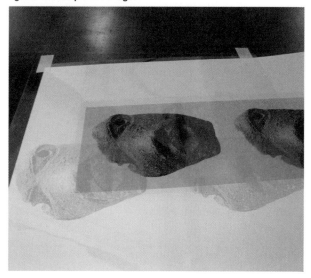

With the red printed image aligned precisely over the black positive, registration marks can applied against the lay copy.

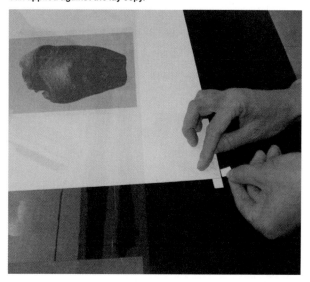

The hinged acetate hangs over the bed.

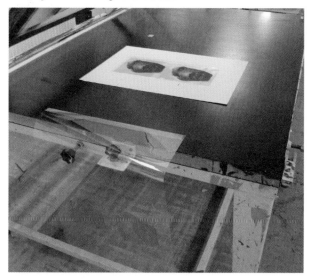

When checking registration or printing variable registered sheets, the printer should align the tape on the acetate with the tape on the bed.

3 Take the lay copy and slide it under the acetate to perfectly align the color. Place registration marks carefully against the crosses marked on this print, cut the tapes at the top, and then print the remainder of the edition. By continuing to lay each sheet against these marks and using the same squeegee pressure at all times, perfect register will be ensured. Large editions in many colors can now be completed with confidence.

4 Variably registered prints can be dealt with by using the hinged acetate, and constantly aligning the masking tape on the acetate with the tape left on the bed, to individually register each print. However, this is to be avoided if possible as it slows printing considerably and often leads to loss of fine detail as pigment dries on the screen.

Once you are satisfied the screen stencil is registered against the positive taped on your paper and the registration marks are in place, you are ready to print.

1 If you are printing by hand, run a line of pigment between the screen stencil and yourself. The line of pigment should be the same length as the squeegee.

2 Lift the frame up clear of the bed and paper, then push the pigment across the stencil with the squeegee. This charges the open mesh with pigment. This action is known as the flood pull.

4.16.6

step by step: **printing by hand**

A line of pigment the length of the squeegee blade

The flood pull charging the open stencil with ink

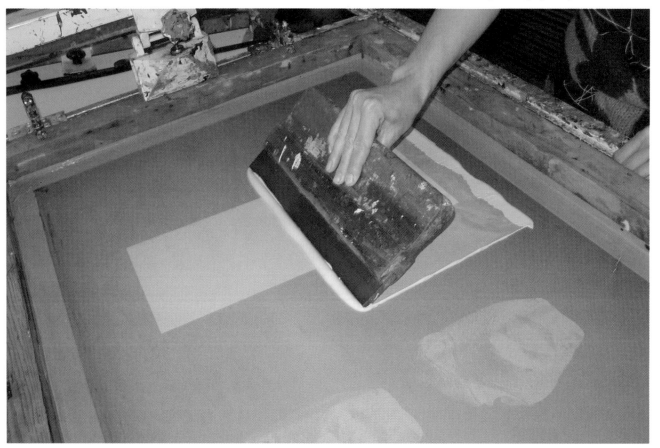

Sliding the paper against the three registration marks

3 Check your paper is against the registration marks.

The print stroke

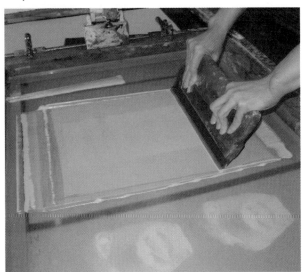

5 As you pull the blade toward you it will push the fabric down to make contact with the paper and force the pigment through the mesh. The fabric should rise up behind the blade to give a crisp print.

Angling the squeegee correctly with the pigment in front of the blade

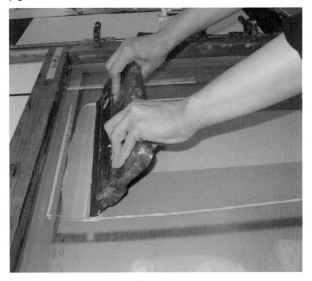

4 Lower the screen. Holding the squeegee with both hands and at an angle of 45 degrees to the mesh, pull the blade and the reservoir of pigment toward you.

Racking the print

6 Lift the screen up and immediately flood-pull pigment back over the stencil area. Examine the print for imperfections and continue this sequence of actions to complete the edition. If you are printing with oil-based inks you should be printing at a rate of three copies per minute to avoid drying problems with any fine detail. Water-based printing is far more forgiving. Place the prints in drying racks.

Scraping ink off the screen with card

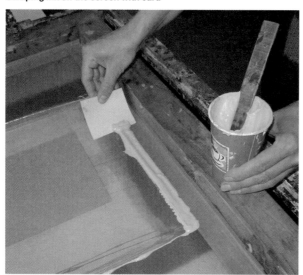

4.16.7

1 After the final print, don't flood-pull and charge the open mesh with ink, as you are about to clean the screen. Quickly scrape as much pigment as you can off the mesh with a piece of card and replace it in the pigment cup.

step by step: **washing up and removing stencil**

Power washing pigment off the screen

2 Peel off any tape that is protecting unused stencils and take the screen to the washout tank to rinse the remaining pigment off both sides. This should be done swiftly to avoid pigment drying in and blocking the screen. Some water-based pigments such as white are very prone to drying quickly and blocking screens, so particular care should be taken in cleaning colors that include a lot of white.

Sliding the wet screen into the drying rack

3 If you can quickly place the clean screen into a drying cabinet you will be able to print another color within 15 to 20 minutes.

Haze discoloration

The same screen after caustic treatment

4 The next stage is to remove the stencil. There is a range of stencil-removing products. Generally these need to be sponged methodically over both sides of the screen until the emulsion visibly dissolves. You should then hydroblitz from the paper side of the screen (vigorous blitzing near the frame edges on the squeegee side can separate mesh from frame).

After cleaning, screens will often have a faint trace (or haze) of previous stencils on the mesh. This will not affect future printing, but it is important to hold screens against a light source to differentiate between mesh discoloration and mesh blockage. If it is not possible to see through the screen it is blocked, probably by pigment.

5 Assuming a stencil remover has already been applied, allow the screen to dry and then wet the affected areas on both sides with any general-purpose cleaner (this powerful solvent will attack and dissolve oil-based ink and acrylics). When hydroblitzed again the pigment will usually come off.

Sometimes if a screen has been used and cleaned many times pigment and screen emulsion can become deeply bonded. There are caustic pastes available that will, when applied and washed off, not only remove these resistant areas but also remove all haze, bringing the screens back to a freshly stretched look. These pastes are toxic and should only be used as a last resort.

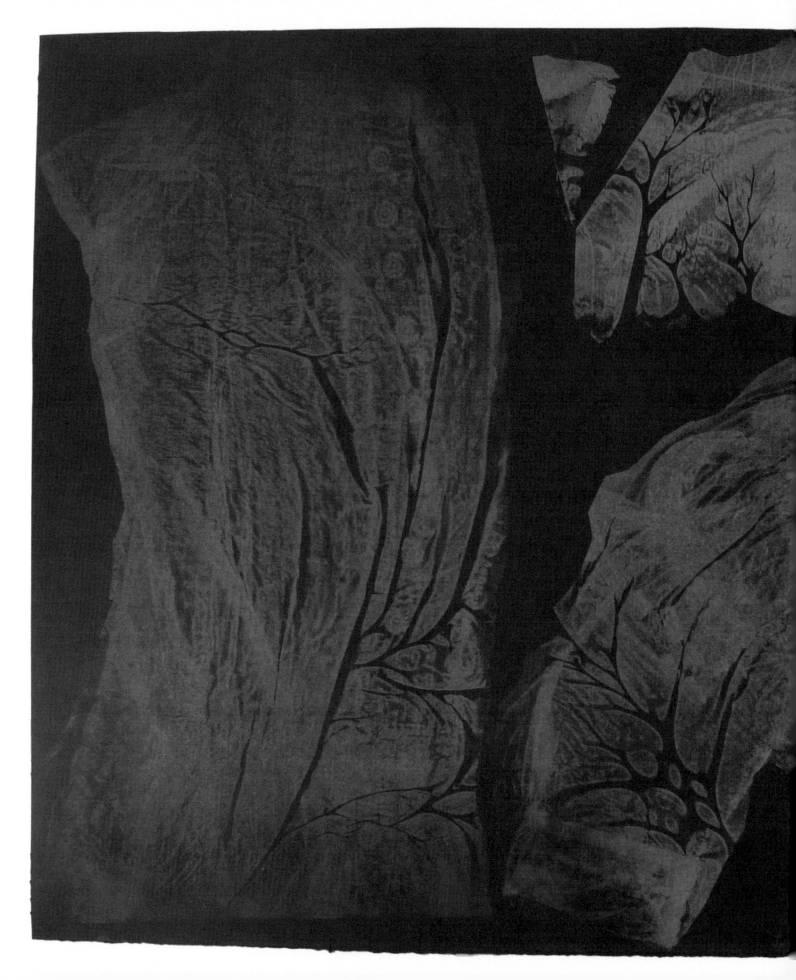

Noreen Grant
(British)
Edwardian Jacket
20 x 20in (50.8 x 50.8cm)
Monoprint
Printed by the artist on an etching
press

Korean handmade paper was placed
over the actual jacket (see buttons).
The paper was inked up in white
lithographic ink, torn into fragments,
offset onto black Fabriano Murillo
360gsm paper, and put through
the etching press. The image was
spectral—almost like an X-ray.

monotype

5

introduction to monotype

The terms "monotype" and "monoprint" are often used interchangeably when referring to this medium, so a useful starting point in exploring this form of printmaking is to investigate how the terms have been defined and applied.

Defining terms

The *American Heritage Dictionary* (2004) defines monotype as "A unique print made by pressing paper against a painted or inked surface." The *Encyclopedia Britannica* (2006) further emphasizes this definition, stating "The pigment on the plate is usually insufficient to make another print." However, this is potentially misleading as it is possible to pull a "ghost" or second print that, albeit fainter, is a direct second impression of the original image. In essence though, as the ghost does possess a more ethereal quality, it could be deemed an independent work. In the *Dictionary of Printmaking Terms* (2002), Simmons states that a monotype is a single impression from a printing surface that cannot be reused. Allowing that one of the qualities of printmaking is the possibility of producing an edition of works that are identical, this definition seems to move toward a clearer suggestion of the nature of the monotype/monoprint technique.

In contrast, based on descriptions of working practices both recent and historical, it seems that a monotype can be classified as a work produced from transient and unprocessed surfaces such as glass, acetate, or the back of a metal plate. Consequently, both the creation of the image on the printing surface and the piece of work produced are singular and cannot be replicated.

In addition, as "Monotype" was also the brand name of a famous typesetting company, it has been suggested that the term "monoprint" was adopted to distinguish it from this commercial venture.

So, for the purpose of simplicity, both monoprint and monotype apply to the production of singular works. However, a monotype is a singular print created through an acknowledged process that can be learnt and replicated to gain similar effects with different images; for example, a color image that requires a series of color separations. A monoprint is a singular work that can be produced without the need to undergo a series of steps.

For the purpose of this section, the term monotype will be applied when discussing the technique and the images created.

Categorizing the monotype

The nature of the monotype means that historically it has been difficult to define or categorize. Although the technique follows the printmaking template of reproducing images from one surface to another using ink and pressure, the marks made and the immediacy of approach are more closely associated with painting. Printmaking is traditionally a medium that allows the production of multiple copies or the editioning of the image from the initial plate, block, stone, or screen. In contrast, the monotype allows only one pull of the original image, followed by a "ghost" and a "mirror" print in some circumstances. While printmaking is traditionally seen as a way of making a painter's work more accessible, painters have often used monotypes in their preparatory sketches as a means of experimenting.

In order to counteract the natural bias of the dominant hand, classical painters assessed the balance of their work by studying the unfinished painting in a mirror. As the monotype also reverses the original image, monotypes could be utilized in a similar manner. Early engravers used this concept when counterproofing the plates in progress in order to assess the arrangement of the image while working on it.

The monotype, like painting, is very direct and allows great flexibility as to the range of marks that can be obtained. Marks can be made using brushes, rags, hands, and found objects. There are many ways to create the image on the printing surface, and the work can be produced quickly and spontaneously or slowly and in great detail, depending on how quickly the ink dries. Impressions can be reworked, corrected, and removed, as is possible in a painting.

The beginnings of monotype

The pure monotype first appeared in the fifteenth century. It is suggested that Giovanni Benedetto Castiglione (1616–1670), a master draftsman and painter, experimented with the technique. His surviving works show predominantly religious images, which he drew or painted onto a metal plate covered in ink and then printed. As monotypes involve the transferring of ink from the flat plate to the paper, any surface that has a tonal residue will transfer itself onto the paper and create an effect that cannot be obtained using other printmaking techniques. Castiglione may have been encouraged to experiment with monotype having seen the partly wiped plates of Rembrandt (1606–1669).

chapter 17 **color separation**

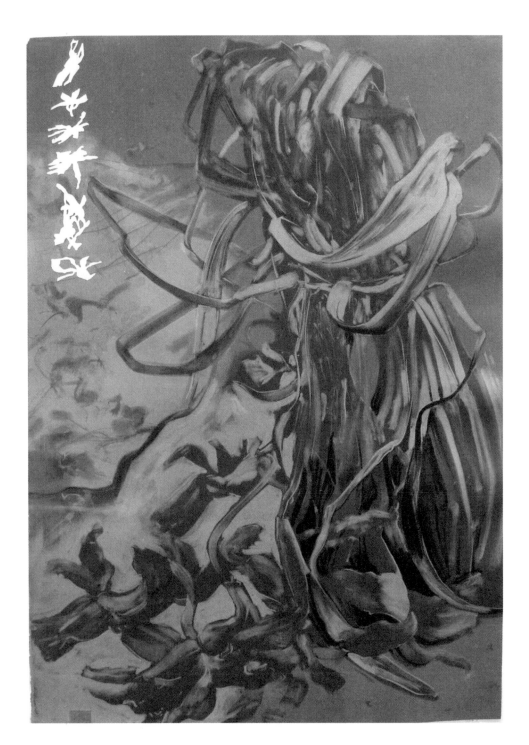

Mary Farrell
(American)
Winged
29¾ x 21¼in (75.5 x 54cm)
Monotype, Chine collé; etching ink
(various brands); Arches 88 paper
Unique print printed by the artist on a
Praga etching press at her studio

This image was printed as a
subtractive monotype (wiping the
ink away to draw the image). It was
printed numerous times to layer the
color. The Chine colléd elements are
the white claigraphic forms running
vertically on the left and the copper
square at the bottom of the sheet
directly under them. The white shapes
are the outlined cast shadow forms
from the flowers.

a brief history of monotype

Historically, the profile of the monotype within the art world has been undermined by the ambiguity of its classification. The medium was thought to fall between painting and printmaking, and was consequently excluded from museums and exhibitions. This was despite the interest in the process shown by high-profile European and American artists such as Degas (1834–1917), Whistler (1834–1903), Mary Cassatt (1844–1926), and Gauguin (1848–1903).

Degas experimented with monotypes predominantly between 1875 and 1885. Degas referred to his monotypes as "cooking" or "cuisine," as they gave him a way of exploring new avenues and techniques. The immediacy of the medium allowed him to experiment with shadow and light within the boundaries of his regular themes of café and theater life. Degas employed a variety of techniques in his monotypes. In "The Cardinal Family" series, he used Indian ink drawn directly onto the plate surface. In his landscapes, he painted onto the printing surface using colored, thinned oil paints. In the majority of his monotypes, however, he worked the ink with a rag, brush, or his hand to produce a tonally rich, atmospheric image. Maggie Hambling (b. 1945) used this method more recently in her "Jemma" series of the early 1990s.

There are many ways to create a monotype. Mary Cassatt, who moved in the same circles as Degas, Whistler, and Pissarro (1831–1903), executed a number of monotypes in 1894–1895 in a largely painterly style, using a rag and broad brushstrokes to manage the pigments. Matisse produced a series of monotypes in 1914 that complemented his drypoints and etchings of the period. On copper plates, he drew linear images into a solid spread of ink, which when printed produced a white line on an opaque, black background. Gauguin used watercolors on glass to produce his monotypes, as did Oskar Schlemmer (1888–1943), who produced 25 freely painted works on glass.

A number of American artists adopted the monotype technique in the late nineteenth century, including Frank Duveneck (1848–1919) and Maurice Prendergast (1859–1924). Japanese prints influenced Prendergast greatly, and he produced more than 200 monotype landscapes using watercolor.

Contemporary monotype artists incorporate new technology with more traditional methods, as illustrated in this section. Digital techniques, photography, stencils, collage, and relief and other printmaking methods are combined in works that continue to experiment with size and composition. The nature of the monotype encourages the modern artist to be spontaneous within the creative process in a medium that is both flexible and expressive.

tools, materials, and equipment: **monotype**

5.17.2

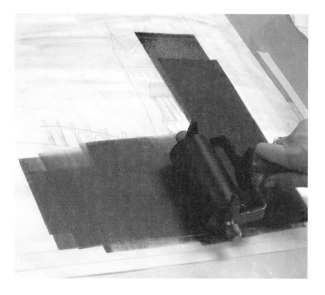

3 sheets of acetate, larger than the required image size; masking tape; oil-based ink; a small roller to apply the ink to the surface of the acetate

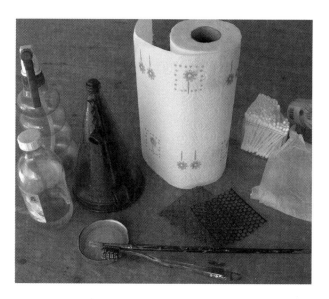

Markmaking materials include mineral spirit; paint and stipple brushes; absorbant towel;

perforated plastic sheet; cotton buds; tissue paper; wooden toothpicks

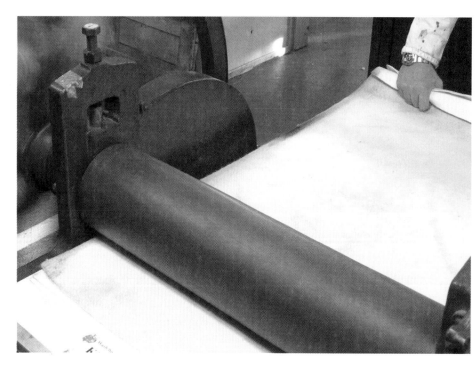

Printing: intaglio etching press with blankets

step by step: **printing a monotype using three acetate sheets**

Preparing and drawing the acetate sheets

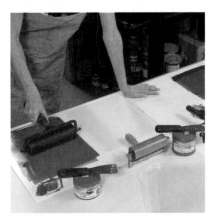

5.17.3

1 Prepare the required inks by rolling out an even layer of color on a flat board or piece of glass. An extender should be mixed with the ink to slow the drying time.

2 The master drawing of the image is attached to a baseboard with tape and needs to be reversed if the final print is required to be as the original drawing. The three pieces of acetate, cut to exactly the same size, are stuck down one by one over the drawing.

3 Each acetate sheet has a strip of masking tape surrounding the drawing area, and each sheet has an "x" on the bottom left-hand corner as a guide to correct registration when printing.

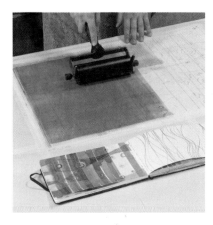

4 The top acetate sheet has been rolled with a thin, even layer of yellow ink that is thin enough to easily reveal the design underneath. The ink is removed as required and when the design has been completed, the yellow acetate is put aside ready for printing.

5 The second color, magenta, has had ink rolled onto the acetate sheet and the design has been created as with the previous color.

6 The third and final acetate sheet is rolled up in cyan ink, staying within the masking tape rectangle surrounding the drawing.

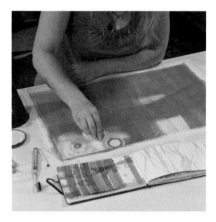

7 As with the previous two colors, the cyan ink is removed using cotton rag moistened in mineral spirit, tissues, cotton buds, and brushes.

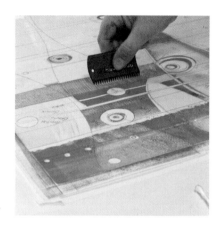

8 The areas of ink being removed will provide the possibility of white areas in the final print, or will allow areas of pure color to show from the subsequent two printings. A wax surfboard comb is being used on the cyan sheet to create uniform lines. This is an example of the variety of tools that can be utilized.

9 The final acetate sheet is now inked up ready for printing.

Printing the acetate sheets

10 To print the Plexi sheets, the prepared yellow acetate sheet is placed on the Rochat etching press.

11 Dampened handmade paper is laid carefully on top, making sure to register the corner of the paper to the corner of the acetate sheet. This task is best accomplished by two people.

12 The first color is printed by being rolled through the press. Note that the three blankets, two felts and a swanskin, are held with a firm grip.

13 The print is lifted to reveal the yellow ink that has transferred to the paper. The yellow acetate is removed from the press.

14 Note that the print with the yellow ink is now immediately laid on the bed of the press. The red acetate is lined up using the "x" on the corner, and placed over the top of the paper with the ink side down.

15 The print is rolled through the press once more, and the red acetate sheet is removed to reveal the first overprint.

16 Finally the cyan acetate sheet is laid down in the same way, and passed through the press.

17 The cyan acetate sheet is removed to reveal the finished print.

Ghost print

There will be enough ink remaining on the acetate sheets to print them for a second time, in the same order, on a new piece of damp handmade paper. This will produce a paler version of the image, which is sometimes more desirable than the first pull.

Mirror image

If the first print is holding a lot of ink, which is often the case, then a reverse of the image can be obtained. Place the print on the bed of the press and then place another sheet of dampened paper face down on top. Run the press through, and peel off the top sheet. It is necessary to carry out both the above procedures immediately after printing while the ink is still damp. All the prints should be pressed under boards to flatten them.

Preparatory line sketch

Watercolor sketch in preparation
for print

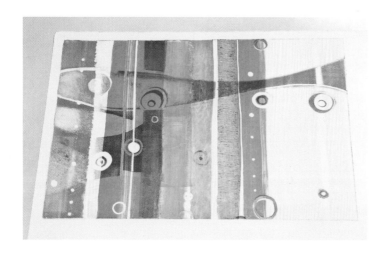

Left:
Sue Haseltine
(British)
Untitled—work in progress
30 x 22in (75 x 56cm)
Monotype; Fabriano handmade paper
Edition of 1 printed by the artist on
a Rochat etching press at Brighton
Independent Printmaking, UK

Monotype: Troubleshooting

Problem: The ink does not transfer from the paper to the acetate sheet, resulting in the print being too pale

Cause	Solution
The ink has started to dry before the work has been printed.	**1.** Add extender to the ink to make it dry more slowly.
	2. Prepare the acetate sheets more quickly.

Problem: One color is too dominant in the final image

Cause	Solution
An equal balance of ink is not being removed from each acetate sheet.	**1.** Remove a relative amount of ink from each color to allow the other two colors to show through.
	2. Providing the registration is not too tight, it is possible to re-dampen the paper (the ink will not move as it is oil-based) and print an additional acetate sheet at a later date.

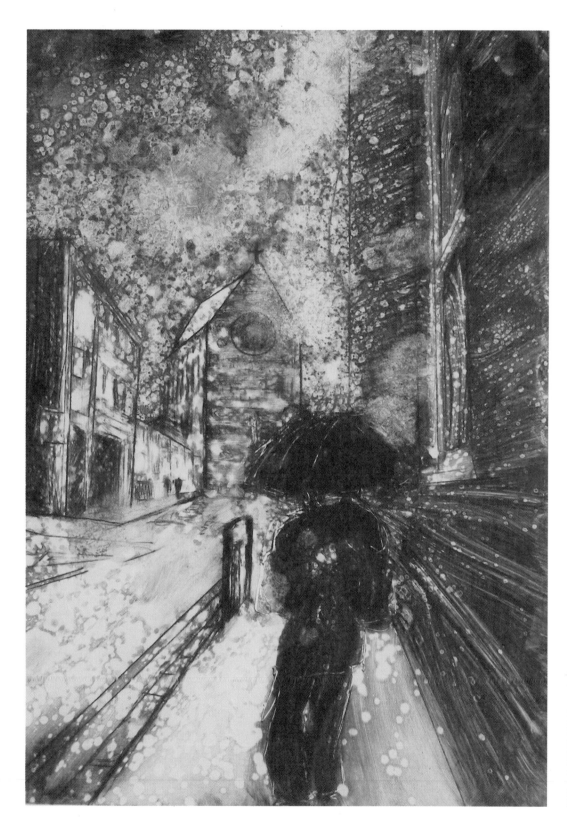

monotype in practice

5.17.4

Eileen Rosen
(American)
Storm Brighton
12 x 8¼in (30 x 21cm)
Monoprint—subtraction method
incorporating line on acetate and
mineral spirit sprayed from an
atomizer; T. N. Lawrence oil-based
intaglio ink (intense black mixed with
mid-blue); Fabriano paper
Edition of 1 printed by the artist on
a Rochat etching press at Brighton
Independent Printmaking, UK

chapter 18 **additional monotype methods**

Jane Beecham
(British)
Kite Flying
30 x 22in (75 x 56cm)
Monotype
Printed by the artist at Hastings
College, UK

A piece of acetate sheet was rolled
up with ink. The acetate was placed
face down on a sheet of paper and a
drawing made from the back. When
the sheet was lifted, the print was
revealed on the top surface of the
paper.

a brief history of additional monotype methods

Monotypes are unusual in that there is total flexibility within the medium. It is possible to produce a final image with very little technical equipment and to incorporate established processes such as screenprinting and digital technology.

When discussing the monotypes of Richard Diebenkorn (1922–1993), G. Norland commented that "almost every printmaker somewhere along the line has come to 'invent' monotype for himself." (*Monotypes*, 1976, p. 8). This statement identifies one of monotype's most important qualities. There is huge variance in the creative process, which encourages myriad approaches. Monotypes can be very graphic, economical, and understated in design, such as *Pommes* (1914) by Matisse, who simply drew into the ink to create a black and white image. Both Paul Klee (1879–1940) and Gauguin created trace drawings using a slightly different technique. A base paper was covered in an even layer of ink, a clean sheet of paper was placed over the inked surface, and the artist drew on the upper surface of the paper. The pressure of the drawing tool created the line by transferring the ink from the base sheet to the underside of the top sheet.

Imagery can also be painted directly onto the printing surface using oil or watercolor paints and then transferred directly onto the paper—a method utilized by William Blake (1757–1827). Within monotype, the processes are not remote but can be combined to produce one image. Contemporary artists use photography and computer graphics alongside the more traditional techniques to experiment and push the boundaries of each process, and overprinting allows the continuation of this work.

While Matisse used a printing press to print his monotypes, it is possible to produce a print without specialized equipment. The simplest monotype can be produced with a plate of glass, a roller, a brush, ink, mineral spirit, and the back of a spoon. Ink can be applied to the glass and either drawn into, as described above, or worked with mineral spirit, a brush, rag, or the artist's hands. To transfer the ink onto the paper, one applies even pressure. The lightly dampened paper is placed over the inked surface and pressure is applied over the whole area of the paper with a wooden spoon or a rolling pin.

Artists at any stage of experience or development can use the monotype technique. The process offers an opportunity to experiment with imagery, color separation, markmaking, tone, and texture in a manner that can be tailored to the level and requirements of the artist. There is opportunity to explore styles and ideas in a spontaneous and expressive manner, with the potential to produce imagery ranging from bold to ethereal.

step by step: **monotype printing**

5.18.2

1 It is helpful to have a random collection of materials to remove the ink, small rollers to apply the ink, and tape to obtain a clean, sharp edge.

2 Use ink in various colors, and rollers of various sizes. The ink does not have to be oil-based; a monoprint can be created with oil- or water-based ink or paint.

3 If the paper is not too thick an impression can be transferred by hand-rubbing or rolling, especially if the image is created on the surface of a sheet of glass. However, if an etching press is available, the creative potential of the medium is greater.

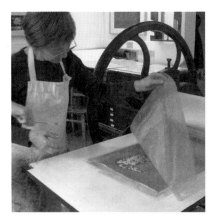

4 When using an etching press with materials other than acetate, the thickness of card or metal has to be considered to prevent damage to the blankets. Metal plates must have filed edges. Old etching plates with previously bitten areas, or the back of lithographic plates, provide an interesting surface to work on. Tissue paper torn into fragments can be pressed onto an inked-up surface resulting in white areas on the print. As each monoprint is unique, different wiping techniques can be used for each print.

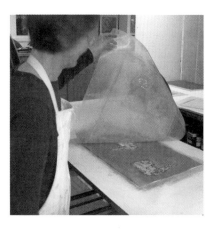

5 When using a press the paper can be thicker (200–350gsm). It can be printed dry, but generally a damp sheet, if using oil-based inks, will produce a better print.

6 The process is affordable as the materials used are relatively cheap. The printed acetate sheets are perpetually reusable if they are thoroughly cleaned each time.

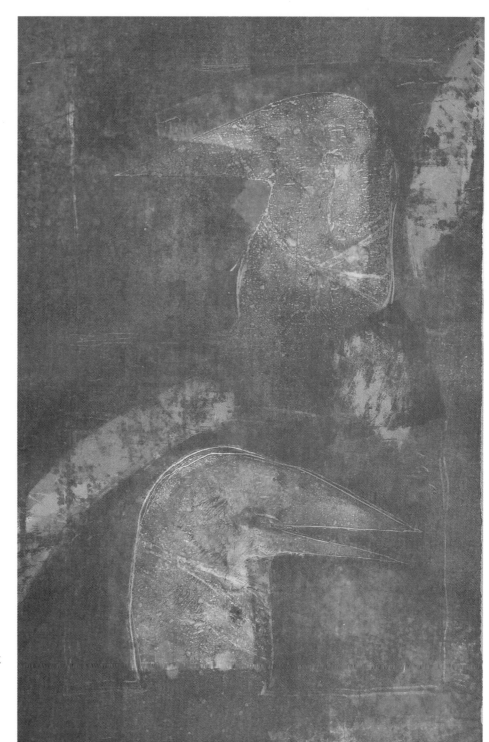

Pat Bennett
(British)
Two Bird Heads **(from the "Bird**
Head" series)
30 x 22in (75 x 56cm)
Monotype; copperplate oil and
extender mixed with ink
Printed by the artist on a Rochat
etching press at Hastings College, UK

The initial print is made from foil,
which is then distressed and
scratched, and printed again. The
process is organic, not a precise way
of working. The image is taken right
up to the edge of the paper.

monotype in practice

5.18.3

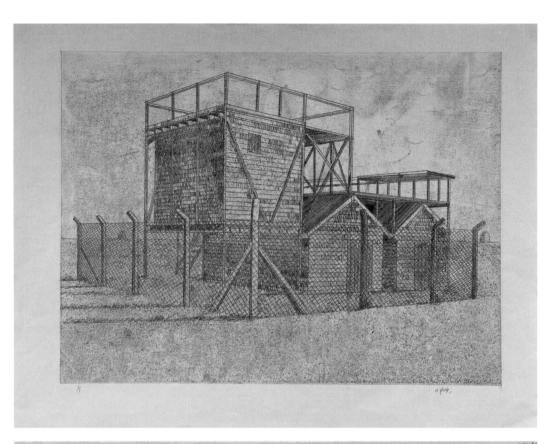

Nigel Plumb
(British)
Buildings I, II, III
30 x 22in (75 x 56cm)
Monoprint
Printed by the artist at Hastings
College, UK

The image is created through a series
of transfers from paper to plastic and
back to paper.

Building I: Roll up a sheet of acetate
with ink, place a piece of paper down
onto the ink surface, draw the image
on the back of the paper. Lift the paper
and the image is revealed on the
underside of the paper.

Building II: Put the acetate used
previously onto the press, ink side up.
Place a new piece of paper on top of
the acetate. Run through the press,
which will produce an image in the
negative.

Building III: The image is created with
three plates: magenta, yellow, and
cyan. The majority of the drawing was
carried out on the magenta.

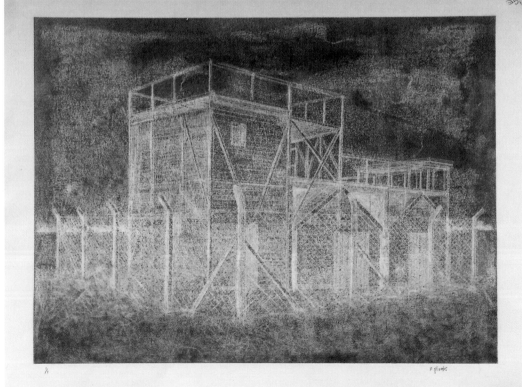

George Mundell
(British)
On the Waterfront
**12 x 9in (30 x 22.5cm)
Monotype: yellow, magenta,
and cyan inks
Printed by the artist at
Hastings College, UK**

Ana Maria Pacheco
(Brazilian)
Comedia I, 2006–7
31 x 24in (79 x 60.5cm)
Monotype heightened with pencil and
gold leaf; Charbonnel inks; Somerset
Textured Soft White 300gsm paper
Printed by the artist on a Rochat
press at Pratt Contemporary Art,
Sevenoaks, UK
Published by Pratt Contemporary Art
Image held in a private collection

Ana Maria Pacheco
(Brazilian)
Comedia III, 2006–7
31 x 24in (79 x 60.5cm)
Monotype heightened with pencil and
gold leaf; Charbonnel inks; Somerset
Textured Soft White 300gsm paper
Printed by the artist on a Rochat
press at Pratt Contemporary Art,
Sevenoaks, UK
Published by Pratt Contemporary Art

Rob Peel
Untitled
Monoprint
Printed by the artist at his studio

"These two examples are combined-process images using printing, painting, stencils, and collage. Ideas are generated through drawing on-site and in the studio. Qualities become the subject of further and continuous refining. The dialogue in the process of printing, the coming together of various elements and methods, will produce the image and anticipate the outcome. The outcome is never known, even up to the last minute of making. The end just becomes, is."

Right: **Sarah Young (British)**
Minotaur
12 x 10in (30 x 25cm)
Monotype
Edition of 1 printed by the artist at Brighton Independent Printmaking, UK

Colbert Mashile
(South African)
Large Head II
29¾ x 22¼in (75.5 x 56.5cm)
Monotype
Edition of 1

Right: **Colbert Mashile**
(South African)
Ka Masa
Paper size: 26 x 21in (66.5 x 53.3cm);
image size: 19½ x 15½in (49 x 39.5cm)
Drypoint, spitbite aquatint, aquatint,
and monotype; custom mix of Graphic
Chemical Sepia, Intaglio Printmaker
Primrose Yellow, Intaglio Printmaker
Warm Red, and Intaglio Printmaker
extender base etching inks for
monotype; custom mix of Intaglio
Printmaker Burnt Sienna and Graphic
Chemical Dark Brown inks for plate 1;
BFK Rives White 300gsm paper
Edition of 18 printed by Tim Foulds and
Jillian Ross on a Sturges etching press
at the David Krut Print Workshop,
Johannesburg, South Africa

Ka Masa **was created in collaboration**
with Tim Foulds. The 2-run print
began with a monotype printed
from a Plexiglas sheet and followed
by 1 copper plate both measuring
19¾ x 15¾in (50 x 40cm), printed
consecutively.

Colbert Mashile
South African

5.18.4

profile: **Colbert Mashile**

"I first remember enjoying art at the age of about five or six. I used to draw in the sand for hours on end. I studied at the Johannesburg Art Foundation (1992–1994) and then I did my BAFA at the University of Witwatersrand (1996–2000).

"It was around 2002 and 2003 when I first concentrated on printmaking. I was introduced to the medium by David Krut and it was at the David Krut Print Workshop (DKW) in Johannesburg that I first produced monotypes and drypoints. I collaborated with master printer Randy Hemminghaus from the USA, who had come to South Africa at the invitation of DKW.

"I always prefer working with a master printer as the collaboration introduces another dimension to the work that it would not have if I worked alone. I believe the inspiration to create my imagery comes from a vast well of experiences that derive from the fact that I am an African. I think South Africa is a place of extremes, which influences our culture, religion, history, and relation to modernity.

"South African artists Clive van den Berg and Dumile Feni are particular artists who have influenced me. Van den Berg has helped me to understand the importance of accepting oneself amid social expectations that can be harsh at times. Dumile, even though I have never met him, has taught me how to give expression, through one's work, to the insanity of being an artist. In addition, many Western and European artists have also influenced me in terms of technique and methodology. As in life, in printmaking things don't always turn out quite the way you wish or expect, so one has to adjust, adapt, and deal with the results of the process, which always brings surprising fulfillment."

**Colbert Mashile
(South African)**
Dikgomo
Paper size: 29¼ x 21in (74.4 x
53.3cm); image size: 19½ x 15½in
(49 x 39.5cm)
Drypoint and spitbite aquatint
with monotype; custom mix of
Charbonnel 55985, Charbonnel
55981, and Graphic Chemical Bone
Black etching inks for plate 1;
BFK Rives White 300gsm paper
Edition of 25 printed by Tim Foulds
and Jillian Ross on a Sturges
etching press at the David Krut
Print Workshop, Johannesburg,
South Africa

Dikgomo was created in
collaboration with Tim Foulds. The
2-run print began with a monotype
printed from a Plexiglas sheet and
1 copper plate both measuring
19¾ x 15¾in (50 x 40cm), printed
consecutively.

Right: **Colbert Mashile
(South African)**
Mokoko wa Mokgaka
**Paper size: 26 x 21in (66.5 x 53.3cm);
image size: 19½ x 15½in (49 x 39.5cm)
Drypoint and spitbite aquatint with
monotype; custom mix of Charbonnel
55981, Charbonnel 55985, and Graphic
Chemical Bone Black inks for plate 1;
BFK Rives White 300gsm paper
Edition of 13 printed by Tim Foulds
and Robert Maledu on a Sturges
etching press at the David Krut Print
Workshop, Johannesburg, South
Africa**

Mokoko wa Mokgaka **was created in
collaboration with Tim Foulds. The
2-run print began with a monotype
printed from a Plexiglas sheet and
1 copper plate both measuring
19¾ x 15¾in (50 x 40cm), printed
consecutively.**

road roller printmaking events

Every September, the San Francisco Center for the Book holds a road-roller printing event where the artists produce a 1-meter-square linocut that they print in the street with a road roller.

5.18.5

In conjunction with the city's festival of arts in May, artists in Brighton, UK, are commissioned to cut an image on a 1-meter-square lino block, ink it up, and print it with a road roller in the city's Pavilion Gardens.

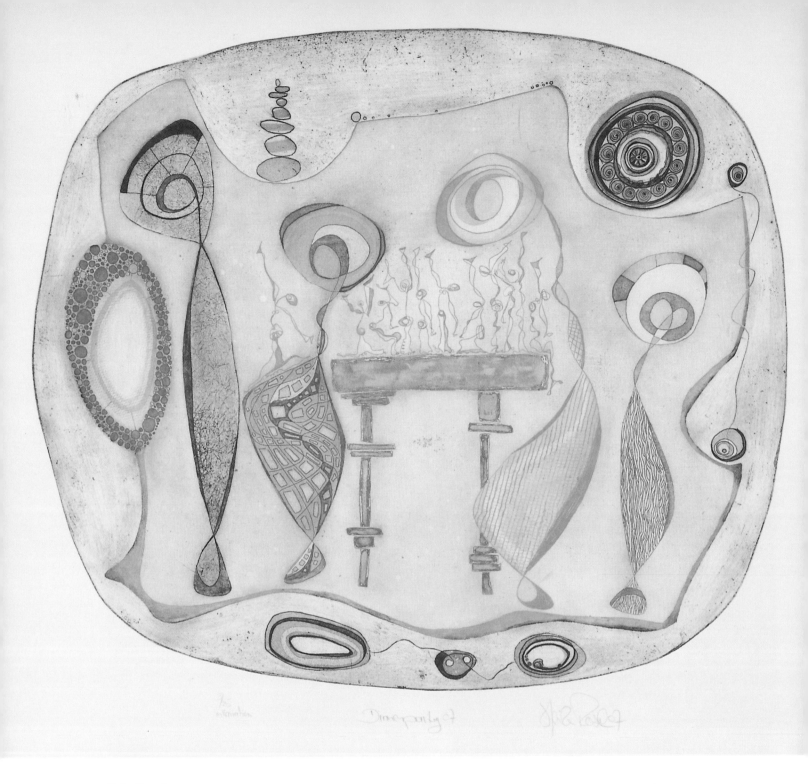

Heike Roesel
(German)
Dinner Party
18 x 16in (46 x 42cm)
Aquatint etching—steel plate cut at the
edges on a metal guilteen and hand
filed. Printed à la poupée; T. N. Lawrence
etching ink from a tube;
Printed by the artist on a Rochat
etching press at Brighton Independent
Printmaking, UK

resources

6

workshops

Art Spirit Gallery

415 Sherman Avenue, Coeur d'Alene, ID,
83814, USA
Tel: 011 01 208 765-6006
www.TheArtSpiritGallery.com
steve@TheArtSpiritGallery.com

The Art Spirit Gallery, located in downtown
Coeur d'Alene, Idaho, represents more
than 30 painters, sculptors, printmakers,
and craftspeople, with 140 artists listed and
more than 1,000 pieces currently available
in its inventory. The gallery focuses on a
combination of mature, well-established
artists and emerging artists who are seriously
engaged in an evolving study of their various
media.

The gallery hangs ten exhibitions of original
art each year, promoting local, regional, and
national artists. Each month, the gallery
is rehung with a new featured artist or
invitational show of original work, creating
a changing and vibrant art environment.
The Art Spirit also serves the community
by educating its patrons about the value
of original fine art and by participating in
community and state art organizations.

Opening receptions are held on the second
Friday of each month from April through
December in conjunction with the Coeur
d'Alene downtown Art Walks. The receptions
are popular community events, providing
opportunities to view the art, meet the artists,
and socialize with friends and neighbors.
Printmakers currently represented are Morse
Clary, Mary Farrell, Catherine Gill, and Yuji
Hiratsuka.

Art Master Gallery

Liliova 6, 110 00, Prague #1, Czech Republic
Tel: +420 777 315 326
www.inmodern.com
artmaster@inmodern.com

Located in the historical center of Prague,
Czech Republic, this art gallery has a wide
collection of contemporary painting from
leading Ukrainian, Georgian, Russian, and
Armenian artists. The gallery also hosts
exhibitions and takes part in European art fairs.

Belfast Print Workshop

Cotton Court, 30–42 Waring Street, Belfast
BT1 2ED, UK
Tel: 0044 (0)28 90231323
www.belfastprintworkshop.org.uk
info@belfastprintworkshop.co.uk

Belfast Print Workshop was founded in
1977 to offer artists access to comprehensive
facilities in traditional and contemporary
printmaking techniques. From the beginning,
as well as having a strong local membership,
the workshop operated a residency program
that is still a vital and successful part of its
activities. These printmakers/artists, from
different parts of the world, all with their
particular skills, diversity of ideas, and cultural
differences, have each brought something
positive that has benefited members as well
as adding to the wider artistic activities in the
local community.

In 2003 the workshop relocated to premises
in the developing Cathedral Quarter of
central Belfast, which offered considerable
potential for arts organizations to benefit
from the general revitalization of the area. As
well as a growing membership, the workshop
has a busy program of classes in the various
printmaking media, an editioning service,
artists' talks, and an ongoing program of
exhibitions in its gallery, which also holds a
stock of members' work.

Brighton Independent Printmaking (BIP)

Module B1, Enterprise Point, Melbourne
Street, Brighton BN2 3LH, UK
Tel: 0044 (0)1273 691496
www.brightonprintmaking.co.uk
bip@brightonprintmaking.co.uk

Ann d'Arcy Hughes and Jane Sampson
founded BIP in 2000 with the aim of securing
the future of traditional printmaking
combined with the development of the new
technology within the medium. BIP is an
open-access fine-art printmaking workshop
dedicated to the production and promotion
of printmaking as a fine-art medium. It is
run solely by volunteers: the regular staff and
the two directors are unpaid, and all earnings
are put back into the continued development
and running of the workshop. Invited tutors
receive a fee. BIP welcomes all those interested
in learning to use printmaking as a creative
process, from beginners to the accomplished.
BIP runs weekly day and evening classes
and weeklong summer schools taught by
experienced artists. The facilities are available
at an hourly rate. The workshop is open from
Tuesday through Friday. Some evenings and
weekends are also available.

Cowfold Gallery and Print Workshop

Cowfold Lodge, Henfield Road, Cowfold,
West Sussex RH13 8DU, UK
Tel: 0044 (0)1403 864237
Senefelder Press, 6 Hyde Lane, Upper
Beeding, West Sussex BN44 3WJ, UK

Plate Graining and Engineering Workshop at
Sakeham Farm, Albourne Road, Henfield.
West Sussex, UK
Tel: 0044 (0)1903 814331 (Andrew Purches,
Senefelder Press)
andrew@lenticular-europe.com

Originally established in the early 1970s by
Ian McVitie-Weston. In 1998, Ian invited
Andrew Purches to move the workshop,
which trades as the Senefelder Press, into
the coach house at Cowfold, when the barn
that he was occupying was demolished for
redevelopment. The aim of the collaboration
was to create an environment where a new
generation of artists could work.

Ian owns the gallery that can be found on the
ground floor at the front of the stone house.
He has been a supporter and buyer of fine
art for many years and has amassed a large
collection of work for sale, including work by
the artists Julian Trevelyn, Mary Fedden, and
Edward Bawden.

Andrew Purches is a master lithographer,
press engineer, and plate grainer. The print
workshop is housed in the stable buildings
in the grounds, where there are selections
of wooden and metal presses for stone and
plate lithography, etching, and letterpress
with an opportunity for artists to work in an
open-access capacity. Alternatively, artists and
publishers can commission the printing of
editions, a plate-graining service is offered,
and enquiries regarding the moving or
renovation of printing presses are welcomed.

The Curwen Print Studio

Chilford Hall, Linton, Cambridge CB21 4LE,
UK
Tel: 0044 (0)1223 893544
www.thecurwenstudio.co.uk
info@thecurwenstudio.co.uk

Specialists in collaborative artist original
printmaking to the highest standards in
edition or monoprint form. All methods
of lithography, stone, zinc, and photoplate.
Forty-nine years' experience. Visits by
arrangements are welcomed. Fine-art
printmaking for beginners through
masterclasses with expert and renowned
tutors. Course program and brochure
available. Screenprinting, etching, relief,
intaglio, monoprinting, stone, and plate
lithography. Open-access, educational
program, and outreach.

David Krut Print Workshop

P140 Jan Smuts Avenue, Parkwood, 2193,
Johannesburg, South Africa
Tel: +27 11 646-8595
www.davidkrutpublishing.com

David Krut Print Workshop (DKW) was
established in Parkwood, Johannesburg, in
2002 to facilitate a photogravure project with
William Kentridge and New York master
printer Randy Hemminghaus (who shared
studio space with David Krut Projects in
Chelsea, New York). What began as a short-
term collaboration grew into a fully fledged
print workshop, the aim of which was to
enable South African artists to collaborate
with overseas printmakers and train local
printmakers in printmaking skills that would
be internationally recognized.

Jillian Ross joined DKW in 2003, working
with Hemminghaus on his further visits to
DKW to originate and edition works with
William Kentridge, Penny Siopis, Deborah
Bell, Willem Boshoff, and Colbert Mashile.
Ross became workshop manager in 2004 and,
with assistant printmakers Niall Bingham
and Mlungisi Khongisa, has worked with
numerous South African artists, many of
whom had their first taste of printmaking at
DKW. Some of the artists have exhibited work
at David Krut Projects in Johannesburg and
New York.

DKW has two large etching presses and
a letterpress, and specializes in intaglio
techniques, facilitating the creation of
editioned and unique works that are
technically accomplished and often boldly
experimental. DKW forms part of David Krut
Arts Resource, which includes a publishing
and book distribution division and an arts
and culture outreach program in Soweto and
the Johannesburg inner city.

Fyns Grafiske Værksted

Hans Jensens Stræde 18–20, 5000 Odense
C, Denmark
Tel: 0045 66139973
www.fynsgv.dk

Established over 30 years ago, Fyns Grafiske
Værksted in Odense is an exceptionally
well-organized and creative environment
for printmaking. It has over 275 members,
and attracts professional artists from all over
the world. Applications for membership
are considered twice yearly by members of
the Workshop Committee. All profits go
straight back to the workshop to improve
and maintain facilities there. A gallery on site
promotes and sells prints, thereby generating
support for the workshop and its artists, and
promoting printmaking to a wider audience.
The studio is well equipped and very
accessible. Facilities include equipment for
etching, relief printing, lino/woodcut, and
lithography. Traditional and contemporary
techniques come together in the workshop, as
members with many different backgrounds
and skills work alongside each other. There
are several short courses each year in various
printmaking techniques to further enable this
exchange of knowledge. The workshop has
strong links with other printmaking studios
around the world, and participates in frequent
artist exchanges and residencies. It has strong
connections with the local art academy.

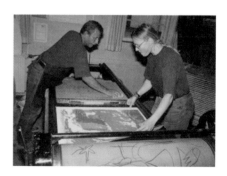

Grafisk Vaerksted Naestved

Groennegades Kaserne Kulturcenter,
Sygestalden 15 C, DK-4700 Naestved,
Denmark
Tel: +45-55 73 75 78 and +45-61 10 97 41
www.grafisk-kunst.dk
grafisk-kunst@mail.dk

The workshop was founded in 1988 in the
centre of Naestved in the southeastern part

of Zealand. The print studio is a cooperative of artists interested in working seriously and professionally with printmaking. It provides facilities for a variety of printing techniques including etching, aquatint, engraving, lithography, photogravure, linocuts, woodcuts, computer graphics, inkjet prints, and other related processes. Members have added benefits such as frequent courses and exhibitions arranged by the workshop.

The workshop provides opportunities for guest artists from other print workshops and from abroad as part of an artist-in-residence program. The studio does not give grants/financial support to guest artists and artists in residence. Accommodation facilities and use of workshop facilities are free but the artist must pay for the materials used. To celebrate its twentieth anniversary in 2008, the studio arranged an international mini print exhibition with 1,500 prints by 765 artists from 52 countries, and published an artists' book with photogravure prints by members.

Hart Gallery
113 Upper Street, Islington,
London N1 1QN, UK
Tel: 020 7704 1131
www.hartgallery.co.uk
info@hartgallery.co.uk

Hart Gallery was established in 1989. The flagship gallery in London holds nine special exhibitions a year. It is proud to represent a group of artists, sculptors, and studio ceramicists with national and international reputations both emerging and in mid-career. The London gallery is open five days a week. There is also a gallery in the village of Linby just north of Nottingham. Several exhibitions are held there every year, and are open by appointment only.

The Hong Kong Open Printshop
Unit 807
Jockey Club Creative Arts Centre, Pak Tin Street, Sham Shui Po, Kln Hong Kong
Tel: (852) 2319 1660
www.open-printshop.org.hk
contactus@open-printshop.org.hk

The Hong Kong Open Printshop was founded in 2000. It is the first nonprofit open printshop that is run by artists. The major objective is to promote visual art with an emphasis on imagemaking. Apart from creative works, it also tries to give back to the community by providing art services, so people from all classes and ages can enjoy art.

Besides international exchange exhibitions, HKOP has started the artist-in-residence scheme so that young or budding artists can be provided a space for their creative work and exchange. In promoting imagemaking, HKOP has been co-organizing printmaking or imaging courses and classes with schools and tertiary institutes in providing studio space and equipment support.

Recently, HKOP has also been partnering with social work institutions to cultivate creativity and artistic skills for underprivileged groups, from new immigrant children to pensioners, letting them share the joy of creating, to help them regain confidence and integrate better into the community.

Malaspina Printmakers
1555 Duranleau Street, Granville Island, Vancouver, BC, #V6H 353 Canada
Tel: 1 604 688 1724
www.malaspinaprintmakers.com

Malaspina Printmakers is a nonprofit artist-run center that is committed to the advancement and preservation of printmaking. Building on its foundation as a facility for artists to develop and maintain a studio practice, Malaspina has become a dynamic organization that provides the community with programs and activities that highlight professional development, education, and understanding of the medium. Such programs include an annual student scholarship, several artist residencies, a comprehensive exhibitions program, and a biannual publication. As a production studio, gallery, and educational center, Malaspina Printmakers supports the development of printmaking as a contemporary art form and promotes and preserves traditional print practice. The organization's main objectives are to advance knowledge of printmaking in the community and facilitate the critical and technical exploration of printmaking in contemporary visual art practice.

The center's programming and outreach activities, in tandem with Malaspina's continued support of printmakers to actualize their practice and develop their skills, make Malaspina Printmakers a truly unique organization in Vancouver, Canada.

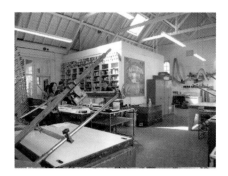

Peacock Visual Arts
21 Castle Street, Aberdeen, AB11 5BQ,
Scotland
Tel: 01224 639539
www.peacockvisualarts.com
info@peacockvisualarts.co.uk

Peacock Printmakers (Aberdeen) Ltd was
established in 1974 by a group of artists who
wanted to have a facility in the city for making
fine-art prints. By the early 1990s, Peacock
Visual Arts had developed into a professional
organization with the some of the most
impressive printmaking facilities in Scotland.
From its earliest beginnings of employing
just one, Peacock Visual Arts now employs
14 members of staff, numerous tutors, and
an ever-growing band of volunteers. Over the
years, Peacock Visual Arts has attracted many
artists to work in its lively and busy workshop.
The outcome has been a continuous and
steady stream of exciting and high-quality
innovative work.

Like all successful organizations Peacock
Visual Arts has embraced change and has
expanded and adapted to remain relevant to
the needs of new generations of artists and the
public. It now has the widest range of visual
arts production facilities openly available
in Scotland and provides expert training in
their use. Artists still make fine-art prints at
Peacock Visual Arts, but are also as likely to be
using video, photography, or digital imaging.

Pratt Contemporary Art
The Gallery, The Street, Ightham, Sevenoaks,
Kent TN15 9HH, UK
Tel: +44 (0)1732 882326
www.prattcontemporaryart.co.uk
pca@prattcontemporaryart.co.uk

Pratt Contemporary Art, founded in 1977, is
a fine-art printing and publishing studio that
has evolved through a multitude of different
activities, including sculpture, painting, and
drawing. Since its inception, the core activity
has been printmaking and the development
of new methods and materials as they become
available. One such development has been
the addition of the digital process. Now fully
integrated into the studio, this process is used
to originate work, to combine with other
techniques, and for the making of artists'
books. Works produced in the studios are in
a number of public and private collections in
the UK and elsewhere.

Rose Korber Art
48 Sedgemoor Road, Camps Bay, Cape Town
8005, South Africa
Tel: 0027 (0)21 438 9152
www.rosekorberart.com
roskorb@icon.co.za

Rose Korber is an independent art dealer
specializing in works by leading and emerging
contemporary South African artists. For
more than 17 years, she has played an
important role in introducing South African
artists to a local as well as an international
art market. Over the years she has become
widely known for showcasing the best of
innovative, contemporary South African art.
In a unique gallery attached to her home in
Camps Bay, Cape Town, clients can view an
extensive range of quality paintings, mixed-
media works, limited-edition original prints,
photography, sculpture, ceramics, handwoven
Rorkesdrift tapestries, and contemporary
African beadwork. Her clients include
corporations and institutions, as well as
local and international collectors, whom she
advises on quality, pricing, and investment.
She works closely, too, with many of South
Africa's prominent architects and interior
designers, selecting works to serve the needs of
their clients. Through her close ties with many
leading contemporary artists, Rose Korber has
ready access to their finest works.

San Francisco Center for the Book
300 De Haro Street, Suite 334, San Francisco,
CA, 94103, USA
Tel: +1 (415) 565 0545
www.sfcb.org
info@sfcb.org

Founded in 1996, the San Francisco Center for
the Book is home to the large San Francisco
Bay Area book arts community. In the course
of its short history, SFCB has become one of
the most active book arts programs anywhere,
with well over 300 classes and workshops,
more than 40 public programs, and several
exhibitions annually, and with a fully
equipped letterpress studio open for rental to
qualified printers. The Imprint of the SFCB,
the Center's publishing program, produces a
book each year from an artist-in-residence,
as well as several modest editions in the Small
Plates series. For Roadworks, the Center's
annual street fair, artists carve large 1-meter-
square linoleum plates, which are printed on
the street with a steamroller.

There are over 90 letterpress classes a year,
in addition to wood engraving, monotype,
encaustic printmaking, gocco, transfer
processes, linoleum, lithography, photo
processes, and more. The Center also offers
a complete bookbinding curriculum, and
a large number of classes in alternative
structures for artists' books.

Stoneman Graphics Gallery
Orchard Flower Farm, Madron Hill, Penzance,
Cornwall TR20 8SR, UK
Tel: 00 44 (0) 1736 361756
www.stonemanpublications.co.uk
linda@stonemangraphics.co.uk
Stoneman Graphics Gallery is an independent
gallery in the countryside just outside
Penzance, Cornwall. The spacious house was
originally built as a printmaking studio for
the late master printer Hugh Stoneman. Linda
Stoneman has since turned the workshop into
a gallery selling limited-edition prints, mainly
images produced by the artists whom Hugh
worked with over many years. Exhibitions
change every two months.

Thumbprint Editions Ltd
108c Warner Road, London SE5 9HQ, UK
Tel: 0207 7373271
www.thumbprinteditions.com
info@thumbprinteditions.com

Thumbprint provides platemaking and
printmaking facilities in intaglio and relief
techniques for artists who are not primarily
printmakers.

Women's Studio Workshop
P.O. Box 489, Rosendale, NY 12472,
USA
Tel: 1 845 658 9133
www.wsworkshop.org
info@wsworkshop.org

The Women's Studio Workshop is a visual
arts organization with specialized studios
in printmaking, letterpress printing, hand
papermaking, photography, book arts, and
ceramics. Artists are invited to work at WSW
as a part of our fellowship or residency
programs in any of these studios. Artists'
books grants are also available for artists
to hand-produce an edition of 50 to 100
artists' books on-site at WSW, or to work
with schools during our Hands-on-Art, Art-
in-Education residencies. Internships are
available to emerging artists in the studio
and in arts administration. Our Summer
Arts Institute and community workshop
series teaches new skills and techniques to
individuals with all levels of artistic experience
or background. The facilities are also available
at an hourly, weekly, or monthly rate. WSW's
mission is to operate and maintain an artists'
workspace that encourages the voice and
vision of individual women artists, to provide
professional opportunities for artists, and
to promote programs designed to stimulate
public involvement, awareness, and support
for the visual arts.

workshop listings

Artichoke Print Workshop
Bizspace S1
245a Cold Harbour Lane
London
SW9 8RR
UK
00 44 (0)207 924 0600
artichoketrading@btconnect.com
www.artichokeprintmaking.co.uk

Badger Press
Unit 4
Claylands Road Industrial Estate
Bishops Waltham
Near Winchester
SO32 1BH
UK
00 44 (0) 1489 892 127
info@badgerpress.org
www.badgerpress.org

Bath Artist Printmakers
3b Upper Lambridge Street
Larkhall
Bath
BA1 6RY
UK
00 44 (0)1225 446 136

Birmingham Printmakers
Unit 3C
90 Floodgate Street
Digbeth
Birmingham
B5 5SR
UK
00 44 (0)121 766 8545
info@birminghamprintmakers.org
www.birminghamprintmakers.org

Double Elephant Print Workshop
Exeter Phoenix
Gandy Street
Exeter
Devon
UK
00 44 (0) 7855 206 659
elephant.print@virgin.net
www.doubleelephant.org.uk

Edinburgh Printmakers
Workshop and gallery
23 Union Street
Edinburgh
EH1 3LR
UK
00 44 (0) 131 557 2479
enquiries@edinburgh.printmakers.
co.uk
www.edinburgh.printmakers.co.uk

Gainsborough's House Print Workshop
46 Gainsborough Street
Sudbury
Suffolk
C010 2EU
UK
00 44 (0) 1787 372 958
mail@gainsborough.org
www.gainsborough.org

Glasgow Print Studio Workshop
48 King Street
Glasgow
G1 5QT
UK
00 44 (0) 141 552 0704
gallery@gpsart.co.uk
www.gpsart.co.uk

Handprint Studio York
100 The Village
Stockton-on-the-Forest
York
YO32 9UW
UK
00 44 (0) 1904 400 488
handprintstudio@aol.com
www.handprintstudio.co.uk

Leicester Print Workshop
50 St Stephens Road
Highfields
Leicester
LE2 1GG
UK
00 44 (0)116 255 3634
info@leicesterprintworkshop.com
www.leicesterprintworkshop.com

London Print Studio
425 Harrow Road
London
W10 4RE
UK
00 44 (0) 208 969 3247
info@londonprintstudio.org.uk

Atelier Montmiral
Rue Gambetta
Castelnau De Montmiral
81140 France
00 33 (0) 563 40 51 55
bmnewth@yahoo.co.uk
www.ateliermontmiral.com

Oxford Printmakers Co-op Limited
Christadelphian Hall
Tindale Road
Oxford
OX4 1JL
UK
00 44 (0) 1865 726 472
opc@hotmail.co.uk
www.oxfordprintmakers.co.uk

St Barnabas Press
Belfast Yard
Coldhands Road
Cambridge
CW1 3EW
UK
00 44 (0) 1223 413 792
jameshill64@hotmail.com
www.stbarnabaspress.co.uk

Seacourt Print Workshop
78 Hamilton Road
Bangor
Co. Down
BT20 4LG
Northern Ireland
00 44 (0) 28 9146 0595
info@seacourt-ni.org.uk
www.seacourt-ni.org.uk

So-oh Fine Art
137 South 9th Street
Lincoln
NE
68508
USA
402 435 7664
soohfineart@neb.rr.com
www.so-oh-art.com

Spike Print Studio
133 Cumberland Road
Bristol
B51 6UX
UK
00 44 (0) 117 929 0135
spikeprint@btconnect.com
www.spikeprintstudio.org

West Yorkshire Print Workshop
75a Huddersfield Road
Mirfield
West Yorkshire
UK
00 44(0) 1924 497 646
print.workshop@btconnect.com
www.westyorkshireprintworkshop.
co.uk

Regional Print Centre Wrexham
Canolfan
Argraffu
Ranbarthol/Regional Print Centre
Yale College
Grove Park Road
Wrexham
LL12 7AA
UK
00 44 (0) 1978 311 794
printcentre@yale-wrexham.ac.uk

Zea Mays Printmaking
221 Pine Street
Studio 320
Florence
MA
01062
USA
liz@zeamaysprintmaking.com
www.zeamaysprintmaking.com

Sophie Aghajanian
sophieaghajanian@hotmail.com

Jim Allen
jamesrallen@hotmail.com

Heike Arndt
www.heike-arndt.dk

Hale Balta
halebalta@yahoo.co.uk

Eric Bates
eric@mistral.co.uk

Una Beaven
j.beaven@mail.com

J. Catherine Bebout
beboutc@mail.montclair.edu

Jane Beecham
janebeechman@beamingmail.com

Pat Bennett
boris@boristheblack.fsnet.co.uk

G. W. Bot
www.hartgallery.co.uk

Simon Brett
simon@simonbrett-woodengraver.
co.uk
www.simonbrett-woodengraver.
co.uk

Helen Brown
helmill@hotmail.com
www.helensprints.co.uk

Ian Brown
printsianbrown@hotmail.com

Cheung Chung-Chu
ccc@open-printshop.org.hk
www. open-printshop.org.hk

Jude Clynick
j.clynick@btinternet.com

Jon Crane
jon_35_crane@yahoo.co.uk

John Curtis
alison@harbourvilla.co.uk

Harvey Daniels
judy@harveydaniels.fsnet.co.uk

Ann d'Arcy Hughes
adarcyhughes@yahoo.co.uk
www.brightonprintmaking.co.uk

Chris Daunt
chrisdaunt4@yahoo.co.uk

Richard Denne
www.richarddenne.co.uk
richard.denne@btinternet.com

Ray Dennis
r.dennis@bton.ac.uk

Anne Desmet
www.annedesmet.com
www.hartgallery.co.uk

James Dodds
www.jamesdodds.co.uk
James@jamesdodds.co.uk

Susan Donne
susan_donne@hotmail.com

Jean Farrah
bip@brightonprintmaking.co.uk

Mary Farrell
www.theartspiritgallery.com
steve@theartspiritgallery.com

Oleksiy Fedorenko
artmaster@inmodern.com

Jo Ganter
www.hartgallery.co.uk

Peter Gates
info@petergates.co.uk

Chris Gilvan-Cartwright
www.gilvan.co.uk
chris@gilvan.co.uk

Gary Goodman
ggoodman@btinternet.com

Noreen Grant
dusters@mac.com

Terry Gravett
terrygravett@yahoo.co.uk

Zhang Guanghui
GuanghuiZ8@163.com

Jullan Hayward
bip@brightonprintmaking.co.uk

Yuji Hiratsuka
y.hiratsuka@oregonstate.edu

Hawley Hussey
http://homepage.mac.com/
baileyphoto/Sites/Hawley_
Hussey/index.html

Emily Johns
emilyjohns@btinternet.com

Stanley Jones
johnstanley.jones@virgin.net

Juliet Kac
julietkac@yahoo.co.uk

Colin Kennedy
colin@colinkennedy.co.uk

Belinda King
belindaking@btinternet.com

Peter Kosowicz
petekoz@waitrose.com

Ann Kresge
info@wsworkshop.org

Guy Langevin
http://sites.rapidus.net/guy_
langevin
Guy.langevin@tr.cgocable.ca

Manuel Lau
www.manuel-lau.net
manuelau@hotmail.com

Andrew Levitsky
artmaster@inmodern.com

Bernard Lodge
www.bernardlodge.co.uk
bernard.lodge@virgin.net

Monica Macdonald Ralph
tandm.ralph@ntlworld.com

Colbert Mashile
colbertmashile@gmail.com
www.davidkrutpublishing.com

Andrew Mockett
www.mockettandmoquette.co.uk

Alberico Moreno
laurence@olver.org

George Mundell
mundellg@hotmail.co.uk

Troy Ohlson
troy@troyohlson.com
www.troyohlson.com

Ana Maria Pacheco
pca@prattcontemporaryart.co.uk
www.prattcontemporaryart.co.uk

Rob Peel
Robert.peel3@ntlworld.com

Nigel Plumb
blackpaintings@madasafish.com

Trevor Price
www.trevor.co.uk
trevor@trevorprice.co.uk

Andrew Purches
andrew@lenticular-europe.com

Frances Quail
frances.quail@btopenworld.com

Hugh Ribbans
ribbans@ribbans.demon.co.uk
www.hughribbans.com

Cecil Rice
rice94200@yahoo.co.uk
www.Cecilrice.com

Heike Roesel
www.heikeroesel.co.uk

Eileen Rosen
ei_roses@yahoo.co.uk

Frances St Clair Miller
f.stclairmiller@btinternet.com

Jane Sampson
jane.sampson@btconnect.com
www.janesampson.com

Dmitry Sayenko
Nikodim-publish@mail.ru

Penny Siopis
Penelope.siopis@wits.ac.uk
www.davidkrutpublishing.com

Wendy M. Smith
wendysmith@dccnet.com

Judy Stevens
bip@brightonprintmaking.co.uk

Patricia Thornton
p.thornton17@ntlworld.com

Carolyn Trant
parvenu.c@ukonline.co.uk

Jenny Ulrich
jenny.ulrich@dsl.pipex.com

Derek Vernon-Morris
d.rolandmorris@btinternet.com

Hebe Vernon-Morris
hebevm1@yahoo.co.uk
www.brightonprintmaking.co.uk

Elisabeth von Holleben
v.holleben@gmail.com

Clive Vosper
bip@brightonprintmaking.co.uk

Sarah Young
sarah@sarahyoung.co.uk

suppliers

A.D. Colour—Screenprinting supplies
Unit 42
Walton Business Centre
44–46 Terrace Road
Walton-on-Thames
KT12 2SD
UK

Apex Printers Roller Co.
1541 N. 16th Street
St. Louis
MO 63106
USA
314-231-9752

Art Equipment—Printmaking equipment
3 Craven Street
Northampton
NN1 3EZ
UK
00 44 (0) 1604 632 447

Autotype International Limited —Polyester Lithograph plates
Grove Road
Wantage
Oxon
OX12 7BZ
UK
00 44 (0)1235 771111
www.autotype.com

Mati Basis
13 Cranbourne Road
London
N10 2BT
UK
00 44 (0) 208 4447833
steel.facing@blueyonder.co.uk

R. K. Burt & Co. Limited —Extensive range of papers
57–61 Union Street
London
SE1 1SG
UK
00 44 (0)207 407 6474
sales@rkburt.co.uk
www.rkburt.co.uk

F. Charbonnel—Inks and printmaking suppliers
13 quai de Montebello Court
Rue de l'Hotel Colbert
75005 Paris
France

Cornelissen—Artist and printmakers suppliers
105 Great Russell Street
London
WC1B 3RY
UK
00 44 (0)207 636 1045
info@cornelissen.com
www.cornelissen.com

Couleurs du Quai Voltaire —Printmaking suppliers
Magasin Sennelier
3 quai Voltaire
75007 Paris
France
00 33 142 607 215
www.magasinsennelier.com

Daler Rowney Ltd —Artist and printmaking supplies
Bracknell
Berkshire
RG12 8ST
UK
00 44 (0)1344 424621
www.daler-rowney.com

Chris Daunt—Engraving blocks and tool sharpening
00 44 (0)191 420 8975
chris_daunt@blueyonder.co.uk
www.chrisdauntwoodengraving blocks.co.uk

Edward Lyons—Printmaking Engraving tools
3646 White Plains Road
Bronx
New York 10467
USA
718-881-7270
www.eclyons.com

Fine Art Materials Inc.
346 Lafayette Street
New York
NY 10012
USA
212-982-7100

Future Engineering—Etching Presses
Unit 4
93 Kew Street
Welshpool
Perth
WA 6106
Australia
00 61 (8) 9470 3540
www.futureeng.com.au

Gibbon Inks
Sun Chemical Gibbon
3 High View Road
South Normanton
Derbyshire
DE55 2DT
UK
00 44 (0) 1773 813 704

Graphic Chemical & Ink Co. —Inks
732 North Yale Avenue
Villa Park
IL 60181
USA
800-465-7382
sales@graphicchemical.com
www.graphicchemical.com

Great Art —Art and printmaking supplies
Gerstaecker UK Ltd
Normandy House
1 Nether Street
Alton
Surrey
GU34 1EA
UK
welcome@greatart.co.uk
www.greatart.co.uk

Hunter Penrose Suppliers Limited—Professional printmaking suppliers
32 Southwark Street
London
SE1 1TU
UK
00 44 (0)207 407 5051
www.hunterpenrose.co.uk

Hunt Speedball —Water-based inks
Speedball Road
Stateville
NC 28677
USA
800-438-0977

Intaglio Printmaker— Printmaking supplies
9 Playhouse Court
62 Southwark Bridge Road
London
SE1 0AT
UK
00 44 (0)207 928 2633

Joop Stoop
12 Rue Le Brun
75013 Paris
France
00 33 (1) 5543 8996
www.Joopstoop.com

T. N. Lawrence—Printmaking supplies
208 Portland Road
Hove
BN3 5QT
UK
00 44 (0) 1273 260260
artbox@lawrence.co.uk
www.lawrence.co.uk

Melbourne Etching Supplies
33a St David Street
Fitzroy
Melbourne
Victoria 3065
Australia
00 61 (3) 9419 5666
www.mes.net.au

Nat Craft Limited—Screen equipment
Dabell Avenue
Blenheim Industrial Estate
Nottingham
NG6 8WA
UK
00 44 (0)115 979 5800

Praga—Printmaking supplies
50 Coronation Drive
Unit 17
Toronto
Ontario
MIE 4X6
Canada
1 416 281 0511

Harry F Rochat Limited—Press engineer and manufacturer
15a Moxon Street
Barnet
EN5 5TS
UK
Info@harryrochat.com
www.harryrochat.com

Rollaco Engineering—Press and roller manufacturers
72 Thornfield Road
Middlesborough
Cleveland
TS5 5BY
UK
00 44 (0)1642 813 785
sales@rollaco.co.uk
www.rollaco.co.uk

John Purcell Paper—Extensive range of papers
15 Rumsey Road
London
SW9 0TR
UK
00 44 (0) 207 737 5199
jpp@johnpurcell.net
www.johnpurcell.net

Screen Colour Systems
11 Carlton Road
London
W5 2AW
UK
00 44 (0)208 997 1964

Senefelder Press—Master lithographer, plate grainer, and press engineer
Andrew Purches
6 Hyde Lane
Upper Beeding
West Sussex
BN44 3WJ
UK

Senefelder Plate Graining and Engineering Workshop
Sakeham Farm
Albourne Road
Henfield
West Sussex
UK
00 44 (0)1903 814331
andrew@lenticular-europe.com

Sun Chemicals—Inks and coatings
Unit 1
Bardon
22 Business Park
Deveridge Lane
Coleville
LE67 1TE
UK
00 44 (0) 1530 275 009

bibliography

Books

Adhemar J. & Cachin F. (1974) *Degas. The Complete Etchings, Lithographs and Monotypes.* Thames and Hudson: London

Amano, Y. (2003) *The Complete Prints of Amano.* Harper Design International: New York

Antreasian, G. & Adams, C. (1970) *The Tamarind Book of Lithography: Art & Techniques.* Harry N. Abrams, Inc.: New York

Artmonsky, R. (2001) *Slade Alumni 1900–1914. William Roberts & Others.* Artmonsky Arts: London

Artmonsky, R. (2007) *Art For Everyone. Contemporary Lithographs Ltd.* Artmonsky Arts: London

Ayres, J. (1991) *Monotype—Mediums and Methods for Painterly Printmaking.* Watson-Guptill Publications: New York

Baglihole, R. (Intro.) (1983) *Practical Printmaking.* David and Charles Publishers Ltd: Newton Abbot

Banister, M. (1974) *Lithographic Prints from Stone and Plate.* A. Littlefield, Adams: New Jersey

Barr, A. Jr (1975) *Matisse, his Art and his Public.* Secker & Warburg: London

Batchelor, C. (2007) *Tea and a Slice of Art. The Lyons Lithographs 1946–1955.* Artmonsky Arts & Towner Art Gallery: London

Biggs, J. R. (1963) *The Craft of Woodcuts.* Blandford Press Ltd: London

Brett, S. (1994) *Wood Engraving. How to do it.* Silent Books: Cambridge

Brunsdon, J. (1965) *The Technique of Etching and Engraving.* B. T. Batsford Ltd: London

Carey, F. & Griffiths, A. (1990) *Avant-Garde British Printmaking 1914–1960.* British Museum Publications Ltd: London

Challis, T. (1990) *Print Safe—A guide to safe, healthy and green printmaking.* Estamp: London

Chamberlain, W. (1978) *Wood Engraving.* Thames & Hudson: London

Cliffe, H. (1965) *Lithography.* Studio Vista Limited: London

Croft, P. (2003) *Plate Lithography.* A & C Black: London

Daniels, H. (1971) *Printmaking.* Hamlyn: London

d'Arcy Hughes, A. (1993) *Lithography.* University of Brighton: Brighton

Darracott, J. (1980) *The World of Charles Ricketts.* Methuen: New York

Eichenberg, F. (1976) *The Art of the Print— Masterpieces, History, Techniques.* Thames and Hudson Ltd: London

Gilmour, P. (1970) *Modern Prints.* Studio Vista Ltd: London

Gilmour, P. (1977) *Artists at Curwen:* Tate Gallery Publishing: London

Gilmour, P. (1981) *Artists in Print.* British Broadcasting Corporation: London

Godfrey, R. T. (1978) *Printmaking in Britain— A general history from its beginnings to the present day.* Phaidon Press Ltd: Oxford

Gross, A. (1970) *Etching, Engraving and Intaglio Printing.* Oxford University Press: London

Hartill, B. & Clarke, R. (2005) *Collagraphs and Mixed-media Printmaking.* A & C Black: London.

Hayter, S. W. (1966) *New Ways of Gravure.* Oxford University Press: London

Hoskins, S. (2004) *Inks.* A & C Black: London

Hutt, J. (1987) *Understanding Far Eastern Art.* Phaidon: Oxford

Hutton, W. (1974) *Making Woodcuts.* Academy Editions: London

Ittmann, J. (Ed.) (2006) *Mexico and Modern Printmaking. A Revolution in the Graphic Arts, 1920–1950.* Philadelphia Art Museum: Philadelphia, PA

Leaf, R. (1976) *Etching, Engraving and Other Intaglio Printmaking Techniques:* Dover Publications Inc.: New York

Levinson, O. (1992) *The African Dream— Visions of Love and Sorrow: The Art of John Muafangero.* Thames and Hudson: New York

Longley, D. (1998) *Printmaking with Photopolymer Plates.* Illumination Press: Adelaide

Lumsden, E. S. (1962) *The Art of Etching.* Dover Publications Inc.: New York

Mackley, G. E. (1985) *Wood Engraving.* Gresham Books Ltd: Oxford

Man, F. H. (1970) *Artist Lithographers— A World History from Senefelder to the Present Day.* Studio Vista Ltd: London

Marsh, R. (1968) *Silk Screen Printing.* Alec Tiranti Ltd: London

Martin, J. (1993) *The Encyclopedia of Printmaking Techniques.* Quarto Publishing:London

Newell, J. & Whittington, D. (2006) *Monoprinting.* A & C Black: London

Norland, G. (1976) *Richard Diebenkorn Monotypes.* University of California: Los Angeles, CA

Oxley, N. (2007) *Colour Etching.* A & C Black: London

Parry, L. (Ed.) (1996) *William Morris.* Pearson: London

Peterdi, G. (1980) *Printmaking—The Classic Guide Revised and Updated to Include the latest in Printmaking Techniques.* Macmillan Publishing Co., Inc.: New York

Petterson, M. & Gale, C. (2003) *The Instant Printmaker—Printing Methods to try at Home and in the Studio.* Collins & Brown Ltd: London

Phaidon (1996) *The Art Book.* Phaidon Press Ltd: London

Pierce, R. (2006) *25/25—Belfast Print Workshop, Past and Present.* Belfast Print Workshop: Northern Ireland

Roberts, G. (2001) *Polyester Plate Lithography for Fine Artists.* Writers Press, Inc.: Boise, ID

Roberston, B. & Gormley, D. (1987) *Learn to Print Step by Step.* Macdonald & Co. Publishers Limited: London

Ross, J., Romano, C. & Ross, T. (1990) *The Complete Printmaker—Techniques/ Traditions/Innovations.* Roundtable Press Inc.: New York

Saff, D. & Sacilotto, D. (1978) *Printmaking— History and Process.* Wadsworth: Belmont, CA

Samuel, G. & Penny, N. (2002) *The Cutting Edge of Modernity—Linocuts of the Grosvenor School.* Lund Humphries: London

Sander, D. M. (1979) *Wood Engraving—A Complete Guide.* Peter Owen Ltd: London

Shure, B. (2000) *Chine Collé: A Printer's Handbook.* Crown Point Press: San Francisco, CA

Simmons, R. & Clemson, K. (1988) *The Complete Manual of Relief Printmaking—A practical guide to the tools and techniques of linocutting, woodcutting and wood engraving.* Dorling Kindersley Ltd: London

Simmons, R. (2002) *Dictionary of Printmaking Terms.* A & C Black: London

Smith, A. (2004) *Etching.* The Crowood Press Ltd: Ramsbury

Sotriffer, K. (1968) *Printmaking History and Technique.* Thames & Hudson Ltd: London

Stobart, J. (2001) *Printmaking for Beginners.* A & C Black: London

Tallman, S. (1996) *The Contemporary Print from Pre-pop to Postmodern.* Thames & Hudson Ltd: London

Thames & Hudson (1995) *Dictionary of Art Terms.* Thames & Hudson Ltd: London

Tooby, M. & Lee, S. (2008) *Hugh Stoneman— Master Printer.* Tate Publishing: London

Unno, H. (2003) *The Complete Prints of Yoshitaka Amano.* Harper Design International: New York

Vergo, P. & Lunn, F. (1996) *Emil Nolde.* Whitechapel: London

Walklin, C. (1998) *Relief Printmaking. A Manual of Techniques.* The Crowood Press Ltd: Ramsbury

Wax, C. (1990) *The Mezzotint. History and Technique.* Thames & Hudson: London

Weber, W. (1966) *History of Lithography.* Thames & Hudson Ltd: London

Weelan, A. J. (Ed.) (1982) *Printmaking Techniques.* Octopus Books Ltd: London

Welden, D. & Muir, P. (2001) *Printmaking in the Sun—An Artist's Guide to Making Professional/Quality Prints using the Solar Plate Method.* Watson-Guptill Publications: New York

Wenniger, M.A. (1975) *Collagraph Printmaking—The Techniques of Printing from Collage-Type Plates.* Sir Issac Pitman & Sons Ltd: London

Wenniger, M.A. (1983) *Lithography. A Complete Guide.* Prentice Hall Inc: New Jersey

Westley, A. (2004) *Relief Printing.* A & C Black: London

Woods, L. (Ed.) (2003) *Practical Printmaking—The complete guide to the latest techniques, tools and materials.* B.T. Batsford: London

Wye, D. (2004) *Artists & Prints. Masterworks from the Museum of Modern Art.* The Museum of Modern Art: New York

Catalogs

Austin/Desmond. *The Modern British Artist as Printmaker—Catalogue 3.* Carter Print Ltd: Berks

Austin/Desmond. *The Printmakers of Atelier 17.* Carter Print Ltd: London

Austin/Desmond. *The Modern British Artist as Printmaker—20th Century Images on Paper.* Carter Print Ltd: Berks

Gardens of Earthly Delight. (2005) Graphic Studio: Dublin

Sweetman, J. (1961) *Exhibition of Prints.* Leeds

Magazines

Printmaking Today. Vol 17 No 1. Spring 2008

Research News. Edition 19. Spring 2008. Centre for Research and Development: University of Brighton, Faculty of Arts & Architecture

glossary

A

à la poupée The application of multiple colors onto a single plate. See p. 140.

Abstract Expressionism A New York art movement that developed in the United States in the 1940s. Expressive and spontaneous methods were used to apply paint to the large canvases, such as throwing and dripping the materials. The act of painting was considered as important as the work itself, the belief that this approach would tap and release the creativity of the unconscious mind. Artists include Jackson Pollack, Robert Motherwell, Mark Rothko, and Helen Frankenthaler.

Acid bath The tray, otherwise known as a bath, that holds the acid used to bite etching plates.

Artist's proof Prints that are not included in the numbered edition. Traditionally used to compare and ensure continuity and similarity of color and tone in the image by the artist or master printer when printing the edition.

Aquatint box A resin-filled airtight box or cabinet. The powdered resin is agitated before an etching plate is placed inside to allow the particles to fall and settle onto the plate. Also known as a dust box or a resin box. Used in the aquatint process; see p. 42.

Aquatint In the intaglio process, resin powder is applied and melted to produce a tonal, textured surface on the metal plate. See p. 42.

B

Ball rack A horizontal rack that has balls built into the framework that grip the prints to allow the ink to dry without the images touching each other. Can be hung from the ceiling.

Baren A hand-tool, originating in Japan, used in the hand-printing of relief prints. Used to apply pressure in a circular motion to the back of the paper in order to transfer the inked-up image from the block to the paper.

Bauhaus In the 1920s, The Bauhaus School became the center of modern design in Germany, founded by an architect, Walter Gropius, in 1919. With simple, geometrical designs, the philosophy was to integrate art into the social domain, to make it affordable and accessible. Artists include Paul Klee, Joseph Albers, and Wassily Kandinsky.

Bed The flat, horizontal, wood or metal base on an intaglio, lithographic, relief, and screen-printing press upon which the block, paper, plate, or stone is placed.

Bevel The slanted edge created when a metal plate edge is filed down to prevent damage to the paper or blankets on the press.

Binding A substance added to pigment to thicken and hold the particles together.

Bite The action of the acid to the exposed areas on a metal plate.

Blanket The felts and swanskin blankets used to pack an etching press to apply the appropriate pressure when rolling through the paper, block, or plate to print the image. The rubber roller on a lithography press that picks up the inked image from the plate and transfers it to the paper to print.

Bleed The blurring of the image edges caused by the spreading of the ink. Usually occurs if too much ink is applied to the plate.

Blend The merge of more than one color on a roller, used in lithography and relief to apply more than one color in a single inking.

Blotting paper A loosely sized paper that is very absorbent. Used to remove excessive moisture from dampened paper before printing. Layered under drying (pressing) boards to aid the even drying of newly printed works.

Brayer A US term for a hand roller used to apply ink to a plate, block, or stone.

Burin A tool used in wood or metal engraving, also called a graver. The working tip can be pointed, lozenge-shaped, or elliptical.

Burnish To smooth or polish an area on a metal plate to prevent the retention of ink. Used for tonal purposes in mezzotint or aquatint and as a corrective measure to erase unwanted imagery.

Burnisher A steel tool with a smooth, curved, oval tip used to polish the surface of a metal plate.

Burr The flanges of metal that rise up on either side of a scratched or engraved line. In drypoint, the burr is retained to hold the ink. In metal engraving, the burr is usually removed. The surface texture created by the rocker in the mezzotint process is also known as the burr.

C

Carborundum The technical name is silicon carbide. A strong abrasive used for leveling and smoothing the surface of a lithography stone. Also a process in intaglio; see p. 122.

Charge To apply ink to a plate, stone, block, or roller.

Chiaroscuro An Italian term used to describe tonal gradients from light to dark.

Chinagraph pencil A greasy pencil used in lithography that creates a soft crayonlike mark.

Chine collé Traditionally, the printing of an image on a very light, delicate paper that is then adhered to a stronger, supporting paper. The application of color using colored paper rather than the use of ink on multiple plates or through the à la poupée technique. See p. 214.

Chromolithography A nineteenth-century term to describe a color lithographic process that was predominantly used to reproduce paintings and watercolors.

Collagraph A process that creates a block from the layering and gluing of natural and found materials to a base of card, wood, or metal.

Color separation To break down an image into separate color layers to enable the production of individual blocks, plates, acetates, or stones for each color.

Cross-hatching A series of parallel lines that cross each other at varying angles to create shade, form, and tone.

Cubism Invented by Pablo Picasso and Georges Braque, the objects are defined in two-dimensional terms but simultaneously display different aspects from various angles. This innovation early in the twentieth century encouraged a new approach to the interaction of form, subject, and space. Artists include Fernand Leger and Juan Gris.

CMYK Cyan, magenta, yellow, and black. The four colors in the halftone printing system.

D

Dabber A pad made of leather or cloth used to apply ink onto a plate or block and to spread melting hardground onto an etching plate. Also known as a dauber.

Deckle The irregular edge on handmade paper.

De-grease To remove the grease from the surface of a lithography or etching plate using an alkaline solution such as soap, methalyted spirit, or domestic cleaning products.

Direct emulsion A light-sensitive emulsion coated directly onto a screen that is then exposed and developed.

Direct press The paper is placed directly onto the plate, block, or stone and results in the image being printed in reverse.

Dolly A small pad of cloth or scrim used to dab ink onto small areas on a plate or block. Used in the à la poupée technique to achieve multicolored prints produced from a single plate.

Double Elephant A paper size: 1020 x 620mm.

Drying rack Metal racks that store prints horizontally while drying.

Dust box See Aquatint box.

E

Edition A set of prints produced from the same image, the quantity of which is written in the bottom left-hand corner of the work. This number does not include artist's proofs.

Elimination print Also known as a reduction print. Achieved by the gradual cutting away of the wood or lino block following the printing of each color stage. See p. 202.

Embossed print An inkless impression from the plate or block taken on damp paper. Also known as blind emboss. See p. 156.

End grain A block of hardwood cut across the trunk rather than the plank side of a tree. Used in wood engraving.

Engraving Gouging lines into a hard surface in order to create a design; see p. 81.

Estampe French umbrella term for an intaglio print.

Etch An abrasive substance that bites or cleans away areas of a plate or block. In etching, usually nitric acid used to bite a line into a metal plate. In lithography, nitric acid used in combination with gum arabic as part of the process to clean the non-greasy areas of the image.

Etched lino An alkali solution such as caustic soda used to etch a lino block. Also known as Caustic lino. See p. 210.

Extender A transparent additive for printing ink to dilute and loosen the ink.

F

False biting See Foul biting.

Fauvism French term, meaning "Wild beasts," coined in reaction to the burst of strong, vibrant color and lively brushwork typical of the work of this group of artists that included Henri Matisse and Andre Derain in the first decade of the twentieth century.

Feathering The use of a feather to agitate the acid when biting an etching plate to remove the bubbles that collect in the line being etched.

Felts The sheets of felt, otherwise known as blankets, that are placed between the roller and the press bed on an intaglio press to help control the pressure applied to the paper and plate during printing.

Fingers See paper grips.

Flooding In screenprinting, the filling of the screen with ink before each print to prevent it from drying out. In lithography, the slight blurring of the image edges on the print due to the overuse of ink when rolling up.

Foul biting The unintentional areas of bite that result from the lifting of areas of the etching ground when the plate is in the acid bath. Leaves a pitted, grainy surface. Also called False biting.

French chalk Part of the lithography process; rubbed onto plate or stone to protect the greasy image during the gum-etch stage of the process. Can also be lightly sprinkled onto a lithograph image to prevent the transfer of ink onto the blanket when printing a series of colors if the previous ink layer has not yet dried. Can be dusted onto a wood engraved block to show up the engraved image more clearly.

Furniture Umbrella term used to describe parts of a printing press.

G

Ghost In monotype, the second, paler print pulled from the monotype matrix. In lithography, the shadow of the previous image drawn onto the plate or stone.

Giclée A French term now used to describe fine-art inkjet computer prints. See p. 288.

Gouge A tool used in the cutting of relief blocks with either a U- or V-shaped tip.

Grain In lithography, the rough surface of a plate or stone. In relief printing, the natural grain of the wood evident on the block. The direction of the leather or nap on a roller.

Graver See burin.

Ground An acid-resistant substance used in etching and aquatint to protect areas of the image that do not require biting. Can be both hard- and softground.

Gum arabic A natural gum produced by the acacia tree and used in the lithographic process at the second gumming stage. Also used as a resist when markmaking. See pp. 28 and 36.

H

Halo A greasy or oily ring surrounding the image edge when using mineral spirit-based materials on a plate or stone in lithography. Can occur in general printing when using oil-based inks.

Hand coloring Color applied to the image by hand after printing has been completed.

Hand wiping The method of removing the surface ink from a metal plate with the palm of the hand before printing.

Hardground Acid resistant applied to the surface of an etching plate. See p. 28.

Hot plate In the intaglio process, the plate is placed on top of a metal surface that is heated in order to apply grounds and ink.

I

Impressionism Originating in France in the 1860s, the paintings avoided religious or historic subject matter in favor of everyday scenes. The interaction between light and color was of great importance, using pure pigments in a celebration of natural light. Artists include Mary Cassatt, Claude Monet, and Camile Pissaro.

Intaglio Printmaking medium in which the image is incised into a metal surface, filled with ink and transferred to paper. See p. 14.

J

Jigsaw block A wood block that is cut into pieces, allowing the different parts of the image to be inked separately before the block is pieced back together for printing. See p. 246.

K

Key image, plate, or block Printed first or last, this is the key layer if printing a series of color separations. Usually the outline or color that will make the image cohesive.

L

Levigator A weighty steel or iron disk that is used to grain the surface of a lithographic stone.

Lightbox A box with a frosted glass or plastic surface that has a light source inside. The light allows images to be traced easily when placed on the glass.

Linocut A relief block worked into linoleum. See p. 194.

Lithography A planographic printmaking medium. See p. 252.

M

Magnesium carbonate A white powder added to ink to stiffen it.

Marbeling A printmaking technique used to emulate the patterns within marble. See p. 62.

Mask To protect areas of an image using resistant substances such as gum, stop-out, or wax crayon.

Master lithographer/master printer A skilled practitioner who works in collaboration with an artist to print the designed image from the block, plate, or stone.

Medium A term used when referring to the various printmaking processes, for example, the etching medium.

Merge See blend.

Mesh The general term used to refer to the woven material stretched over a screenprinting frame.

Mesh count The diameter and number of threads per centimeter in a mesh.

Mezzotint The surface of the plate is textured with a rocker before the image is created using tonal values rather than line. See p. 84.

Monoprint/Monotype A singular image created on a surface of metal, glass, acetate, or from a screen. See p. 368.

Muller A flat-based, round piece of glass with a handle used to mix ink and grind pigments with a little oil or water.

Multiple block or plate printing A number of blocks or plates are registered and printed on top of one another to create an image.

N

Nap roller A suede leather lithographic ink roller.

Needle A steel tool with a sharp point used in etching to draw the image into the ground thereby exposing the metal that will then be bitten by the acid.

Newsprint Cheap, thin paper used for proofing.

Nitric acid Highly corresive. Diluted with water and used to etch zinc, copper, and steel plates.

O

Offset printing The image is first transferred from the plate to a cylindrical rubber blanket (roller) attached to the press then printed onto a piece of paper.

Open bite A broad area of the metal plate is exposed to the acid and bitten away leaving a shallow depression. When ink is applied, it clings to the edges of the bitten area allowing the middle to be wiped almost free of ink if required.

Overetching When the etching plate begins to break down if left for too long a period of time in the acid bath.

Overinking When too much ink is applied to an etching or lithographic plate, the image can fill in or blur, compromising definition.

Overprinting Colors are printed one on top of the other in a layered or multicolored image.

Oxidization The corrosion that occurs on a metal plate if it is left unprotected.

P

Packing On a relief press, paper sheets are placed on top of the block and paper to distribute the pressure.

Paper grips Also known as fingers. Small, folded bits of card or paper used to pick up clean paper during printing to prevent the transfer of smudges or dirty fingerprints.

Photogravure An intaglio print in which an image has been photographically transferred to a plate using carbon tissue. See p. 73.

Pigment The colored, usually powdered, particles in ink.

Plank side Used for woodcuts, the grain of the wood runs parallel to the length of the block and will often be worked into the image, as the grain texture is usually apparent.

Planographic Refers to the lithographic process where the image is created and printed from a flat, grained surface. Unlike the intaglio or relief techniques, there is no reliance on incised marks or depressions in the surface of the plate or stone.

Plate Thinner than a block, a plate is a metal, cardboard, or plastic surface used to create a printable image in both the intaglio and lithographic process.

Pop Art In the 1950s, an art movement developed that embraced the images of pop culture and the everyday, consumer society such as comic strips and mass-produced merchandise. Photomontage, paintings that mirror photography in their attention to detail, and collage are common works. Artists include Richard Hamilton, Jim Dine, and Robert Rauschenberg.

Prepasol A solution used to prepare the surface of a lithographic plate before drawing or markmaking.

Pressing boards Boards that are stacked with blotting paper and tissue paper in between each layer to dry and flatten intaglio prints.

Pressure washer A high-pressure water hose that is used to clean screens.

Proof A trial print produced to assess the development, color balance, and registration of an image.

Pull To print an image from a plate, stone, or block.

R

Red oxide Sprinkled onto a plate, then covered with a piece of paper to allow the non-greasy transfer of an image onto the plate surface.

Reduction print See elimination print.

Registration The means of ensuring multiple plate or block images are overprinted and aligned accurately.

Relief printing A printmaking process whereby the image is printed from the raised surface with the cutting away of the non-image areas. See p. 238.

Resin box See aquatint box.

Resist Solutions applied to areas of a plate or stone to maintain and protect the surface below. For example, gum can be used as a resist against mineral spirit-based drawing materials on a plate or stone in the lithographic process.

Retarder An additive to slow the drying of the ink.

Rocker In mezzotint, a steel, curved-edged tool used to texture the surface of the plate ready for the creation of the image. The tool is rocked back and froth across the plate allowing the teeth to pit the surface of the metal. See p. 100.

Roulette In the intaglio process, a steel tool with a spiked wheel that creates a texture on the surface of a metal plate.

S

Sand bag A small, round, sand-filled leather or canvas bag that allows the easy rotation of a wood engraving block during cutting.

Scraper In intaglio, a three-edged steel tool used to smooth the bevel and remove flecks or areas of metal from a plate when making corrections.

Screen A mesh of silk, metal, or synthetic textile is stretched over a frame of varying size, made of wood or metal. A stencil is created on the mesh. See p. 312.

Screen filler A thick liquid used in the nonprinting areas of the stencil to fill the holes between the mesh threads of the screen.

Screenprinting A technique that uses a squeegee to push ink through a screen onto the paper, material, wood, or card on the bed underneath. Also known as serigraphy or silkscreen. See p. 310.

Scrim In intaglio, a stiff, relatively loosely woven canvas used when wiping the ink from a metal plate before printing.

Scumming In lithography, unwanted areas of ink that transfer onto the non-image areas of the plate or stone.

Serigraphy See Screenprinting.

Smoking The ground on an etching plate is first applied on a hotplate and then smoked with the flame from tapers or a candle on the underside of the plate to darken the colour.

Softground Acid-resistant surface applied to the surface of an etching plate. Is receptive to the imprinting of various natural and manmade materials. See p. 36.

Solar plates An Australian term for the process that uses the Sun as a light source onto photopolymer etching plates.

Spit bite The application of acid onto the plate using a brush and either water or saliva to achieve a moody, tonal effect.

Spitsticker A tool used in wood engraving largely for the creation of curved lines.

Squeegee Screenprinting tool; a rubber or plastic blade attached to a wooden or metal frame used to push ink from one end of the screen to other and force it through the mesh.

Steel facing The process of facing an intaglio plate to increase the longevity of the image. The process is called electrodesposition.

Stencil In screenprinting, a stencil made from paper, card, painted on, or photographically or digitally composed is used to prevent the ink from passing through the screen in the non-image areas.

Stop out An acid-resistant material used to cover areas on a metal plate that do not require further exposure to the acid if the image is being bitten in stages.

Sugar lift In intaglio, the image is drawn on the metal plate using a water-soluble solution, usually containing sugar and the plate is covered with ground. When the plate is washed, the sugar dissolves, lifting away any ground that was in contact with it. See p. 54.

Surrealism Originating in France in the 1920s, Surrealism sought to express the unconscious. The paintings from the surrealist artists present a distorted, sometimes nightmarish, internal world devoid of societal logic. Artists include Salvador Dali, Joan Miro, and Frida Kahlo.

Swanskin One of the blankets used on an etching press to evenly distribute the pressure from the roller onto the paper and plate.

T

Tooth In screenprinting, the roughness of the fabric used on the screen. In lithography, the grain on the plate or stone that is needed to trap the greasy materials used to create the image.

Transfer paper A paper coated with a water-soluble solution, such as gum arabic. The image is drawn on the coated side which, once dampened, will transfer the marks onto the stone or plate.

Tusche In lithography, a grease-based drawing medium in the form of a liquid, paste, or stick.

Tympan A greased sheet of brass or plastic on a lithographic press along which the scraper bar moves to apply pressure to the stone or plate.

U

Ukiyo-e A significant period for Japanese woodcuts between the seventeenth and nineteenth centuries. Images of "the floating world" presented life in the Edo quarter, now Tokyo. Geishas, actors, landscapes, historical legends, and folktales were popular subjects.

V

Vacuum bed In screenprinting, a bed with a vacuum base that will hold the paper flat.

Viscosity The oil content and fluidity of a printing ink. See p. 150.

W

Woodcut The cutting of a block of wood from the plank side of a tree. See p. 168.

Wood Engraving The use of fine engraving tools in the cutting of a block taken from the end grain of a tree. See p. 226.

index

picture credits